EUROPEAN ART AT DARTMOUTH
Highlights from the Hood Museum of Art

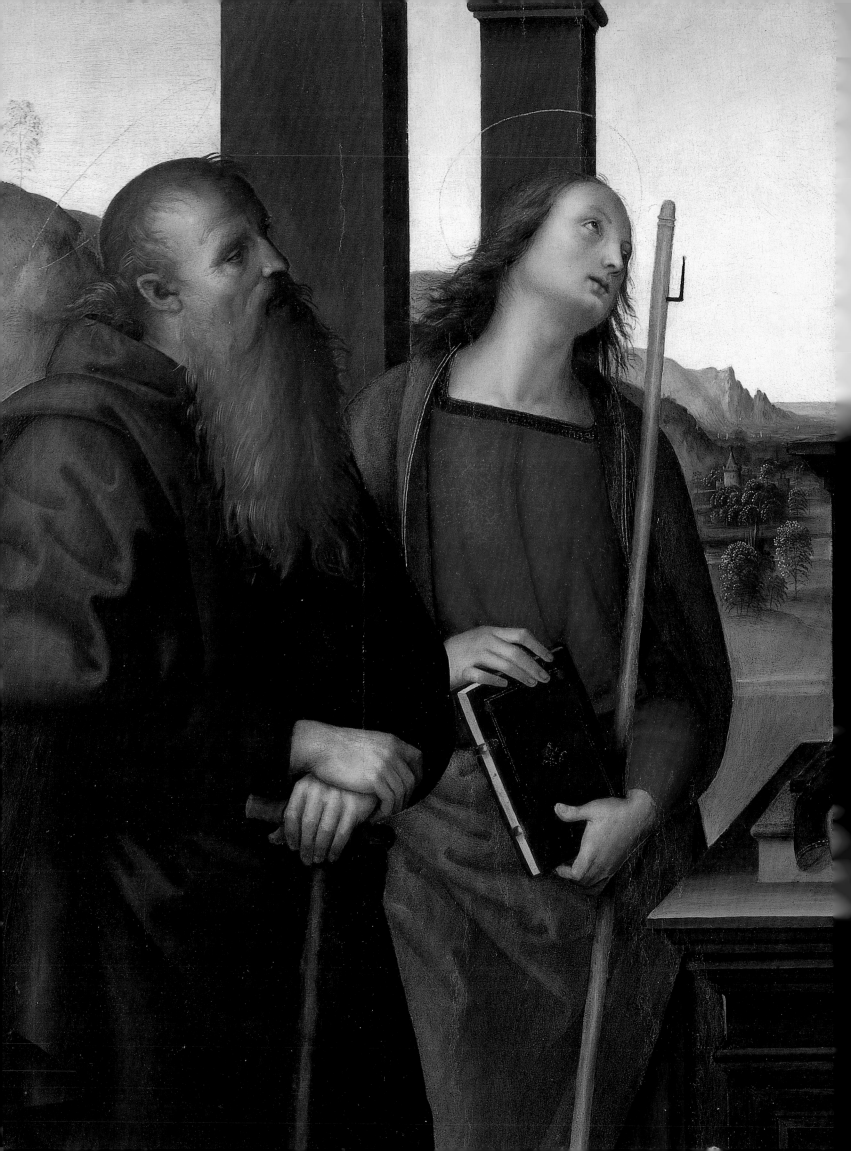

EUROPEAN ART AT DARTMOUTH
Highlights from the Hood Museum of Art

T. Barton Thurber

Hood Museum of Art, Dartmouth College
HANOVER, NEW HAMPSHIRE

University Press of New England
HANOVER AND LONDON

Published by
Hood Museum of Art, Dartmouth College
Hanover, NH 03755
www.hoodmuseum.dartmouth.edu
and
University Press of New England
One Court Street, Lebanon, NH 03766
www.upne.com

European Art at Dartmouth: Highlights from the Hood Museum of Art was published to coincide with an exhibition of the same title held at the Hood Museum of Art from August 30, 2008, through March 8, 2009. Some of the objects in this publication did not appear in the exhibition.

This publication and its related exhibition were organized by the Hood Museum of Art, Dartmouth College, and generously funded by Barbara Dau Southwell '78 and David P. Southwell T'88, the Philip Fowler 1927 Memorial Fund, the Marie-Louise and Samuel R. Rosenthal Fund, and the Cissy Patterson Fund.

Edited by Nils Nadeau
Designed by Dean Bornstein

All object photography is by Jeffrey Nintzel unless otherwise noted
Color separations by Professional Graphics, Rockford, Illinois
Printed and bound by CS Graphics PTE LTD, Singapore

Front cover: Pompeo Batoni, *Portrait of Lord Dartmouth*, 1752/3–56 (cat. 26)
Frontispiece: Perugino and workshop, *Virgin and Child with Saints*, about 1500 (cat. 6)
Opposite the foreword: Marius-Jean-Antonin Mercié, *Gloria Victus*, about 1874 (cat. 43)
In the acknowledgments: Louis Leopold Boilly, *Young Woman Reading in a Landscape*, 1798 (cat. 105)
Opposite the essay: Carle Vanloo, *Venus Requesting Vulcan to Make Arms for Aeneas*,
about 1735 (cat. 24)
Opposite catalogue: Sir Lawrence Alma-Tadema, *The Sculpture Gallery*, 1874 (cat. 41)
Opposite bibliography: Unknown, active in Rome, *Saint Francis Borgia,* about 1700 (cat. 21)
Back cover: Pablo Picasso, *Guitar on a Table*, 1912 (cat. 52)

Library of Congress Cataloging-in-Publication Data

Hood Museum of Art.

European art at Dartmouth : highlights from the Hood Museum of Art /
 T. Barton Thurber.—1st ed.
 p. cm.

Catalog of an exhibition held at the Hood Museum of Art, Dartmouth College,
 Aug. 30, 2008–Mar. 8, 2009.

Includes bibliographical references and index.

ISBN 978-1-58465-738-5 (cloth : alk. paper)—ISBN 978-1-58465-724-8 (pbk. : alk. paper)

1. Art, European—Exhibitions. 2. Art—New Hampshire—Hanover—Exhibitions.
 3. Hood Museum of Art—Exhibitions. I. Thurber, T. Barton. II. Title.

N6750.H57 2008

709.4'0747423—dc22 2008010754

CONTENTS

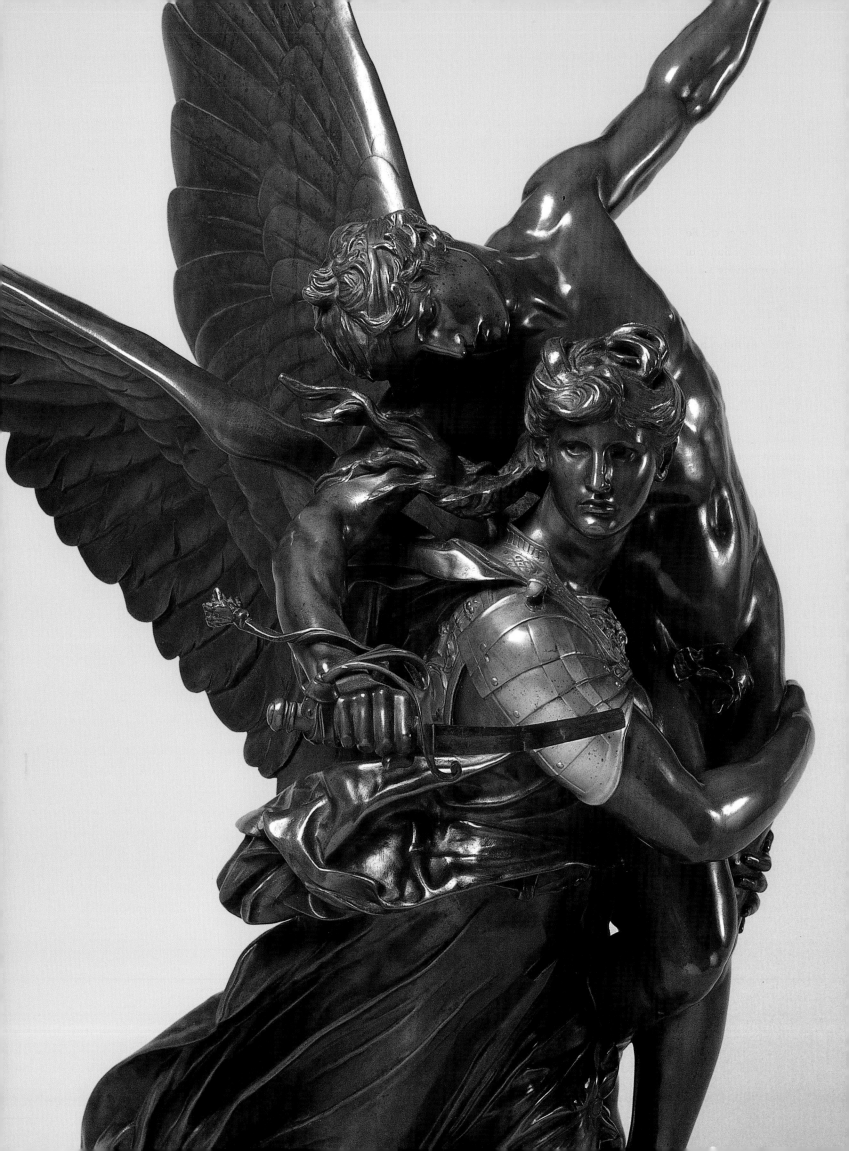

FOREWORD

In August 1826, representatives of Dartmouth College contacted William Legge, the Fourth Earl of Dartmouth and the grandson of the principal donor of Eleazar Wheelock's Indian Charity School, about obtaining a portrait of his grandfather. Lord Dartmouth replied "that he had only a single portrait of his grandfather, which, of course, he could not part with, but he would have a copy made of [a different painting]" (*Manuscripts* 1895: 2:489–91). In 1829, this replica of another picture of the Second Earl of Dartmouth arrived in Hanover, the first European painting to be added to the College's art collections. It was displayed for a hundred years alongside the portraits of the College's founders to commemorate the virtues and qualities of the individuals associated with the history of the institution. Eventually, in 2007, Dartmouth College acquired the celebrated portrait with which the family was unwilling to part in the early nineteenth century, Pompeo Batoni's portrayal of the Second Earl of Dartmouth from 1753–56 (cover illustration).

Compared to the original symbolic setting for the replica within an institutional portrait gallery, the display of the newly purchased painting in the custom-built galleries of the College's Hood Museum of Art allows it to become an integral component of Dartmouth's educational activities and public programs. Along with every other major acquisition, it enhances our ability to attract students, faculty, and other visitors to better understand and appreciate works of art of historic and cultural significance. The Hood Museum of Art is, above all, a teaching museum that privileges direct engagement with works of art within an interdisciplinary academic setting.

The present volume and companion exhibition constitute an unprecedented opportunity to publicize the unique characteristics of Pompeo Batoni's portrait of Lord Dartmouth, as well as other selected highlights from the European collection of the Hood Museum of Art. While many of these works can be found in various exhibition catalogues, monographic studies, and scholarly articles, this is the first comprehensive publication and the largest display of the museum's vast holdings of British, Dutch, Flemish, French, German, Italian, and Spanish art from the Renaissance to the early twentieth century. It is part of an ongoing series focusing on the museum's permanent collection, and it follows last year's celebration of American art at Dartmouth, organized by Barbara MacAdam. It will be supplemented by future volumes and exhibitions on modern and contemporary art (2009) and Native American art (2010).

While the Hood Museum of Art inherited sizeable holdings assembled since the founding of the College in 1769, especially prints, increased funding and donations from alumni and friends have permitted the addition of many important works by major artists that illustrate key aspects of the history of European art. Nearly two-thirds of the objects reproduced and described in this publication were acquired as gifts and purchases since the opening of the Hood Museum of Art in September 1985. We thank most warmly all those who have donated works of art and funds to the museum and acknowledge the encouragement and support of Dartmouth's administration and the museum's board of overseers. Special recognition is extended to President James Wright and Provost Barry Scherr, both of whom have demonstrated repeatedly their strong commitment to the visual arts. Jonathan L. Cohen, Class of 1960, Tuck 1961, has joined a series of distinguished leaders of the board who have contributed enormously to the growth of the museum's collections and resources. The vital effort of our board members is supplemented by the daily work of a dedicated staff, who are mentioned in the following section, and to whom I would like to add my heartfelt thanks.

I am especially grateful to the many colleagues, both in this country and abroad, who have contributed their expertise to this project. They have kindly assisted our current curator of European art, T. Barton Thurber, to elucidate the unique qualities of these exceptional works of art, many of which he has helped to acquire. The Hood Museum of Art has been most fortunate to have the curatorial skills of a scholar and teacher of the highest standard, one who inspires and motivates Dartmouth's talented students. I greatly admire and appreciate his tireless pursuit of objects of superb quality and intrinsic value, as well as his ability to communicate his passion for them to multiple audiences.

The recent acquisition of the portrait made of the Second Earl of Dartmouth during his Grand Tour to Italy in the 1750s marks an important addition to the Hood's collection. It reflects the early history of the formation of the College and the culture of the Enlightenment with which both Eleazar Wheelock and William Legge were closely associated, and it points to a future rich with possibility in Dartmouth's continued and increasing ability to procure high-quality examples of some of the great trends of the pictorial tradition. The story of European art at Dartmouth will undoubtedly continue to develop, and as always we look to the College's devoted alumni and friends to mark the next chapter in its evolution. We hope each one will enjoy this significant publication.

BRIAN P. KENNEDY
Director

ACKNOWLEDGMENTS

The remarkable array of works included in this catalogue and exhibition demonstrates the richness and diversity of the Hood Museum of Art's European collection. It is an unprecedented opportunity to publicize the philanthropic, scholarly, and professional contributions of generations of Dartmouth College's donors, administrators, directors, curators, faculty, students, and staff members. This is the second in a series of publications and displays aimed at presenting a portion of the museum's many treasures. The credit for committing the resources necessary to realize this enormous endeavor belongs to Brian Kennedy, the museum's director, whose leadership and support have been crucial throughout the entire planning and implementation process. Further encouragement and advice is continually offered by other colleagues, including Juliette Bianco, Katherine W. Hart, Barbara MacAdam, and Barbara Thompson.

As discussed in the introductory essay, the museum's holdings initially evolved as an integral part of the Dartmouth College Library. Although fine arts objects and textual resources have long been housed and administered separately, they nevertheless retain many common historic and artistic connections. Under the supervision of Jeffrey Horrell, the Dartmouth College Library staff offered immeasurable support in researching and interpreting these relationships. In particular, Jay Satterfield, the special collections librarian, shared his knowledge and passion for the material. He also kindly agreed to the inclusion in this catalogue of an illuminated manuscript and three illustrated books from Rauner Library. Furthermore, Patricia Cope, Sarah Hartwell, Patti Houghton, Barbara Krieger, and Joshua D. Shaw regularly provided assistance in accessing the College's records and archives. Laura Graveline, the visual arts librarian, also helped with many requests, as well as serving on the committee for the past few years that approved gifts and acquisitions.

Over the course of the eighteen-month-long development of this catalogue and exhibition, a number of student and summer interns donated their time, assembled documentation about each object, and often supplied fresh perspectives about specific works of art. Moreover, their inexhaustible energy and sincere enthusiasm were invaluable in sustaining the momentum of the project. Particular recognition must be extended to Hannah Blunt, Matthew Cronkite, Alexander D. Fidel, Class of 2008, Jessica I. Hodin, Class of 2007, Marissa A. Slany, Class of 2008, and Page B. Wagley, Class of 2009.

Since the opening of the Hood Museum of Art in 1985, there have been three curators responsible for the regular maintenance, display, study, and growth of the European collection: Hilliard T. Goldfarb, Richard Rand, and myself. We have been aided by many academic and professional colleagues, whose expertise greatly informed our understanding and appreciation of the unique qualities of many works of art. During my tenure, foremost amongst these individuals were the faculty of Dartmouth College's Department of Art History, especially Adjunct Assistant Professor Jane Carroll, Associate Professor Allen Hockley, Professor Jim Jordan, Professor Joy Kenseth, Professor Adrian W. B. Randolph, and Associate Professor Angela Rosenthal. Additional support for co-organized events came from the department's staff, including Elizabeth W. Alexander, Elizabeth S. O'Donnell, and Janice B. Smarsik. Other faculty members consulted during the course of researching the history of European art at Dartmouth, to whom we extend our sincere thanks, were Professor Emeritus Jere R. Daniell, Professor Richard L. Kremer, and Professor Margaret E. Spicer.

Since 2000, Dartmouth College's Fannie and Alan Leslie Center for the Humanities has generously cosponsored a number of symposia and lectures, some of which helped to elucidate different aspects of the museum's holdings. Without the resources of the Leslie Center and its commitment to the interdisciplinary study of art and culture, it would have been much harder—and perhaps impossible—to organize several scholarly programs aimed at better understanding Europe's artistic and intellectual heritage. The Hood is grateful as well to the Andrew W. Mellon Foundation, whose endowment at the museum has fostered a close relationship with faculty members and made possible many scholarly programs in conjunction with the European collections.

Over the years, all of the Hood's staff members have made noteworthy contributions to the preservation, interpretation, and development of the museum's European collection. In the case of this project, several individuals devoted a considerable amount of time to preparing the catalogue. Chief among them were Kathleen O'Malley and Jeffrey Nintzel, who diligently oversaw the assembly of the illustrations, most of which needed new photography. Their professionalism and attention to detail—in addition to a large amount of patience—assured the success of this portion of the volume. Similar credit must be given to Nils Nadeau, who carefully supervised every facet of the production process. His editorial experience was crucial in maintaining the high standard of excellence that he has brought to all of the museum's publications. Kellen Haak facilitated the acquisition, conservation, and preparation of some objects, and Deborah Haynes aided in maintaining and locating relevant records. During all phases of the planning for the exhibition, the Education Department, under the direction

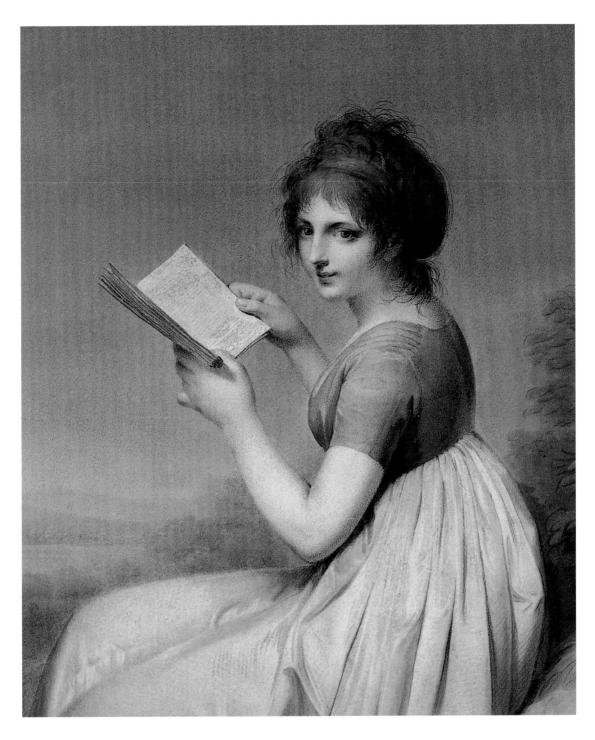

of Lesley Wellman, shared their considerable expertise about how to make the display both accessible and enjoyable. Patrick Dunfey designed the handsome installation and worked with John Reynolds and Matt Zayatz to realize it. Many others in the Exhibitions Department and Business Office provided invaluable assistance in arranging myriad details, but special mention must be made of the efforts of Nancy McLain and Christine MacDonald. Fundraising for the project was gratefully aided by Sharon Greene. Every aspect of the catalogue and exhibition was the product of a devoted team of colleagues, who have demonstrated repeatedly their profound commitment to presenting exceptional works of art for the benefit of the college and regional communities.

Finally, special recognition must be extended to Barbara Dau Southwell, Class of 1978, and David Southwell, Tuck Class of 1988. Their remarkable contributions have permitted us to add extraordinary objects to the museum's collection, and to greatly expand alumni awareness about the importance of the arts for students. Most importantly, we want to express our deepest gratitude and appreciation for their support of this catalogue, the first significant publication on European art at Dartmouth College.

T. BARTON THURBER
Curator of European Art

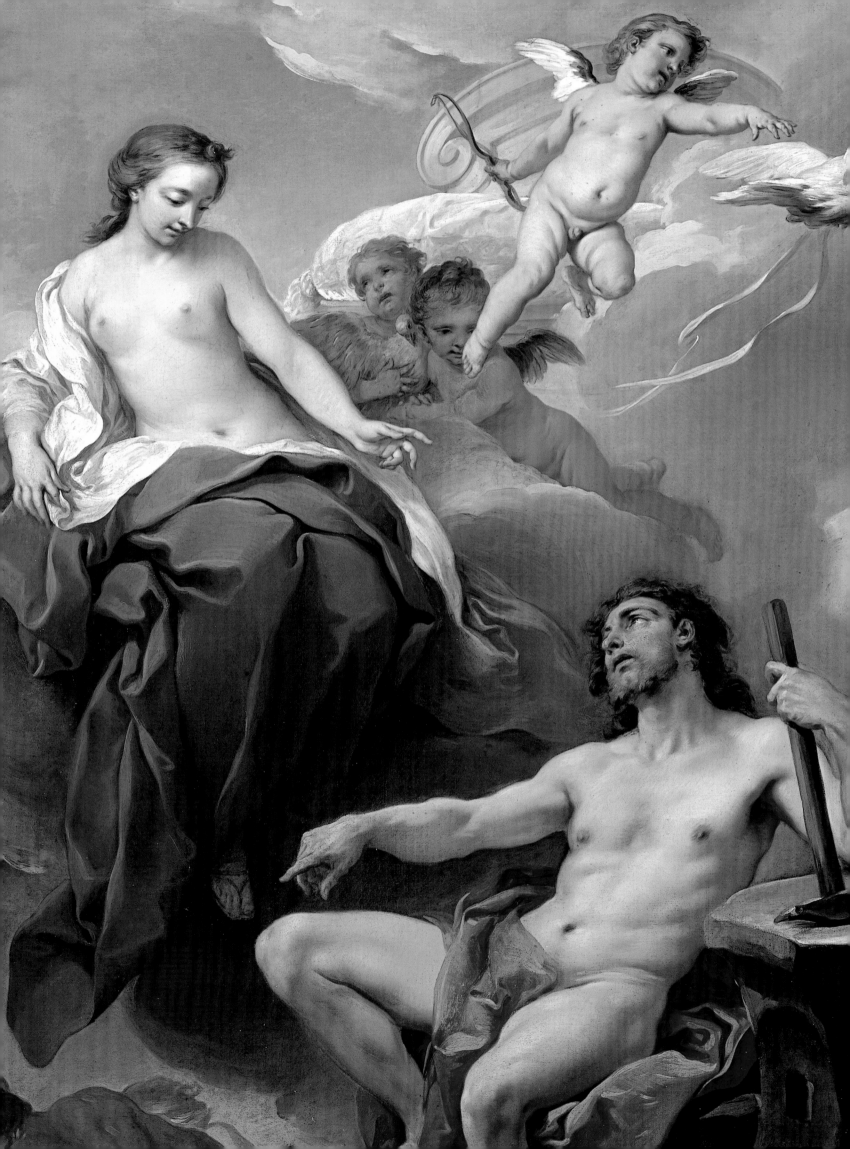

Dartmouth Collects European Art, 1783–2008

T. Barton Thurber, *Curator of European Art*

PROLOGUE: ORIGINS, BUILDINGS, AND ADVOCATES

THE earliest known reference to European art at Dartmouth appeared in the commencement address of 1774 by John Wheelock (1754–1817), Class of 1771, son of the College's founder and a tutor who would later become its second president from 1779 until 1815.[1] In a large tent erected on the east side of the main building of the rural campus, with several invited scholars, trustees, and other visitors in attendance, Wheelock cited a work by Raphael in his "oration on the imitative arts."[2] Drawing on later interpretations of a Latin phrase by the Roman poet Horace, *ut pictura poesis* ("as is painting so is poetry"), Wheelock compared the qualities of painting, music, and poetry, thereby elevating the status of visual forms of expression to that of literature and the other liberal arts. Regarding painting, one of Wheelock's ancient paradigms was Pliny's mid-first-century anecdote about the legendary early-fourth-century BCE competition between Zeuxis and Parrhasios in the creation of optical illusions. Wheelock's modern exemplar was Raphael's thirteen-foot-tall *Transfiguration* of 1516–20 (fig. 1), a renowned picture considered by writers of the seventeenth and eighteenth centuries to be a supreme example of heroic narrative painting. Wheelock's description expressed his intense reaction to it: "What inexpressible Beauty clouds [our Saviour's] Person!—How beautiful the Suspension of Moses and Elias!—How equally striking the submissive Posture of his three Disciples!—The scene in all its Parts is Grand!—all Sublime!"[3] The use of the terms "Beauty" and "Sublime" reflected contemporary European ideas about the power of images to produce intellectual and emotional effects. Thus, judging by the available historical and philosophical sources, an understanding and appreciation of exceptional works of art was considered essential even in the early years of Dartmouth College.

Wheelock knew, however, that there were few opportunities to look at original European paintings and sculptures, either in Hanover or anywhere else in North America.[4] The study of such art was limited primarily to secondary sources. Like the celebrated *Discourses on Art* delivered from 1769 to 1790 by Sir Joshua Reynolds, the foremost English painter of the eighteenth century, the original president of the newly formed Royal Academy, and Britain's first public orator on art, observations about old master paintings were intended to elicit general principles that did not need to be illustrated. The literary mode was employed to present clear posi-

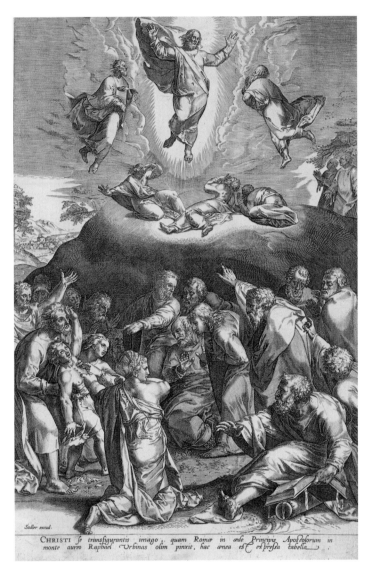

FIG. 1. Johannes Sadeler after Raphael, *Transfiguration,* late 16th century, engraving. Promised gift of Robert Dance, Class of 1977.

tions with regard to accepted "standards of taste" about the value of studying nature and the significance of art.[5]

Over the course of the next century, there was a gradual shift from rhetorical references to direct engagement with objects. As one Dartmouth professor later noted, "Education in art is almost meaningless" without access to actual works.[6] Not surprisingly, the limited number of authentic objects collected over the years generally found a place in or near the library (fig. 2), which moved from

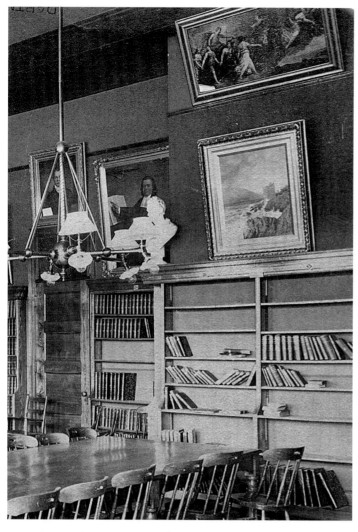

FIG. 2. Reading room in Wilson Library, c. 1890s, featuring Brumidi's copy of Guido Reni's *Aurora* above. Courtesy of the Dartmouth College Library.

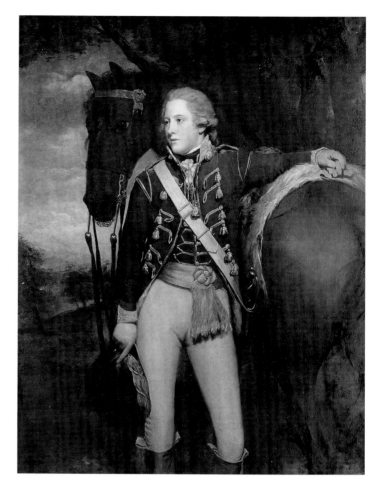

FIG. 3. Sir Henry Raeburn, *Captain Patrick Miller,* 1788–89, oil on canvas, exhibited at Dartmouth College in early 1918. National Gallery of Art, Washington, D.C.: Gift of Pauline Sabin Davis; 1948.19.2. Courtesy of the National Gallery of Art, Washington, D.C.

one building to the next.[7] Yet throughout this period of time there were no courses to foster the interpretation of art, in spite of repeated efforts to introduce the subject into the curriculum from the middle of the nineteenth century onward.[8] Finally, in 1905, during an era of considerable growth in the number of American institutions introducing formal instruction in art history,[9] the College offered its first Renaissance and Baroque art courses. Their appearance corresponded with a generous gift in 1904 by Henry L. Moore, Class of 1877 and a longtime trustee, who established the Guernsey Center Moore Fund "to purchase objects of artistic merit and value, to be kept, exhibited, and used by [the Trustees of Dartmouth College] to encourage and promote the interest and education in art of the students."[10] Moore's donation, set up in memory of his son, who died in his sophomore year in 1901, marked the College's first acquisitions endowment.

Throughout the twentieth century a number of enlightened faculty members, administrators, and benefactors reaffirmed the fundamental need for students to gain firsthand knowledge about art through direct contact with original paintings, sculptures, and works on paper. One of the earliest and most enthusiastic propo-

nents was George B. Zug (1867–1943), who had taught art history at Dartmouth from 1913 to 1932. Zug, educated at Amherst and Harvard, came to Hanover after traveling extensively throughout Europe and teaching at the University of Chicago. Immediately after arriving he introduced the practice of working with originals, both in the classroom and in temporary exhibitions. During the first three years of his tenure, for example, he coordinated fifteen installations in the Little Theater of Robinson Hall. Many of these were monographic displays, sometimes focusing on European printmakers, such as the French nineteenth-century artists Honoré Daumier and Jean-François Millet. At least one significant exhibition in early 1918 featured several important old master landscapes and portraits, including, for example, Henry Raeburn's extraordinary portrayal of Captain Patrick Miller, 1788–89, now in the collection of the National Gallery of Art (fig. 3).[11] Zug arranged for this particular loan and several others from the Duveen Brothers, a major international art-dealing firm in New York and London from the late nineteenth to the mid-twentieth centuries, as well as five other galleries in New York.[12] The securing of such prominent loans ninety years ago for the benefit of the Dartmouth community and public was an incredible accomplishment.

As one of the directors of the newly established College Art Association (CAA), Zug called for more colleges and universities to organize loan exhibitions. As he concluded in one report presented at the annual meeting in Cincinnati in 1917, "Familiarity with examples of various types of art should be the result of all teaching of the history of art, and for such work . . . the art exhibition in the college is absolutely essential to success in teaching."[13] Zug also emphasized the interdisciplinary appeal of these displays, which "[made] it possible for Professors of Art, of Psychology, of History, and of English to assign technical exercises, problems or papers based on actual observation of the originals . . . [that could] not be solved by the use of the best reproductions."[14] In one case he noted that five hundred students from three departments at Dartmouth had assignments based on the works in a single exhibition.

Zug involved students in all aspects of the research, organization, and installation of his presentations. Students helped to select objects, arrange loans, write labels, produce posters, and set up exhibits. These types of practical experiences were considered important for enhancing undergraduates' knowledge about art, both intellectually and professionally. Their work on these exhibitions, which also included public talks, also gave them the opportunity to interact with local residents of all ages, social classes, and educational backgrounds "from villages within a radius of fifty miles."[15] One of Zug's main goals was to use the success of his displays to persuade the administration of the necessity and usefulness of a separate building for the College's growing permanent collection, temporary exhibitions, and related classes. Such a structure, he argued, would be "especially adapted to the undergraduate mind and experience . . . to arouse a wide and sympathetic acquaintance with original works of great art."[16]

Zug was not the first to advocate the creation of a fine arts building at Dartmouth. Thirty-two years before, the Reverend Samuel C. Bartlett (1817–1898), Class of 1836 and College president from 1877 to 1892, predicted that "at no distant time the College will see a well-appointed . . . Art Building."[17] Bartlett made his statement in June 1885 at the end of his public remarks at the commemoration of Wilson Hall, which was built as a library with a gallery of pictures on the top floor. Bartlett's sentiments were echoed by the Reverend Henry Fairbanks (1830–1918), Class of 1853 and secretary of the College's Construction Committee, who added that "the Art building and galleries that must come soon . . . will—[along] with the opportunity to study English literature, composition, and elocution—furnish means for securing refined taste, elegance of scholarship, and facility of expression."[18]

At the time of the opening of Wilson Hall it was already evident that the needs of the growing art collection exceeded the available space in the new building. At the same time the Department of Art grew in importance and in size, with a total of seven faculty members by the end of the 1920s. The opportunity to consolidate the fine arts holdings, classrooms, offices, and library in one building came in 1929 with the inauguration of Carpenter Hall, a "dignified

FIG. 4. Carpenter Hall, opened 1929. Jens Frederick Larson, architect. Courtesy Dartmouth College Library. Photo by Paul Weber.

and proper place . . . for instruction in Art" (fig. 4).[19] Named in honor of a gift by the prosperous manufacturer and banker Frank P. Carpenter (1846–1938), it contained seven galleries on the upper level for temporary exhibitions and permanent displays. Additional space for these activities arose with the opening of the Hopkins Center in 1962, dedicated to Ernest M. Hopkins (1877–1964), Class of 1901, a tireless supporter of the arts at Dartmouth who served as president of the College from 1916 to 1945. The new complex included two more exhibition galleries, primarily intended for special installations. Over the course of successive decades, while paintings, sculptures, works on paper, and other objects rapidly accumulated at Dartmouth, the works were stored and displayed in various buildings located throughout the campus. Finally, in 1976, Peter Smith, at that time director of the Hopkins Center, cogently outlined the need for an independent art museum "devoted to the exhibition and contemplation of works of art . . . to teach students the kind of connoisseurship and visual discrimination which can make the crucial difference for artist and art historian alike, as well as for the future patron, collector, critic, trustee or curator."[20] The funding to meet this goal was assured in 1978 when the College received a large bequest from Harvey P. Hood (1897–1978), Class of 1918 and a College trustee from 1941 to 1967. The donation was supplemented by additional gifts from members of the Hood family and other benefactors. On September 28, 1985, the Hood Museum of Art opened to the public (fig. 5).

FIG. 5. Hood Museum of Art, opened 1985. Charles W. Moore and Center-brook Architects. Photo by Timothy Hursley.

As outlined below, the new museum inherited many fine examples of European art assembled since the founding of the College, especially an extraordinary array of prints. There were also some other noteworthy pre-nineteenth-century objects. Yet old master paintings, sculptures, and drawings were in truth rarely purchased before the museum's establishment. With the support of alumni and friends, the museum began to receive financial support for the acquisition of distinctive works of art, which were supplemented with other notable gifts. As a result, during the last twenty-three years the collection has received a number of significant objects illustrating key aspects of the history of European art. At this point, in addition to the established commitment to incorporate the study of art as an integral component of the curriculum, Dartmouth now has the ability to represent some of the great trends of the European pictorial tradition.

While the facilities, collections, programs, and funding have evolved considerably since the first European objects arrived at Dartmouth, the central objective has remained the same: to acquire "objects of artistic merit and value . . . to encourage and promote the interest and education in art" (as stipulated by the Guernsey

Center Moore 1904 Memorial Fund). The donor's aims recalled a similar notion expressed less than a decade before by Charles Eliot Norton (1827–1908), the earliest professor of art history in the United States, who specialized in ancient and medieval art: "It is through the study and knowledge of works of the fine arts . . . that the imagination—the supreme faculty of human nature—is mainly to be cultivated."[21] Over a century later, in 2005, the staff of the Hood Museum of Art reaffirmed the continued relevance of these sentiments by stating that the institution's "purpose . . . is to inspire, educate, and collaborate with our college and broader community about creativity and imagination through direct engagement with works of art of historic and cultural significance."[22] The latest plans for the future of the European art collection have been formed with a profound appreciation for the achievements and ambitions of previous generations of dedicated trustees, administrators, faculty members, directors, curators, donors, and other supporters.

EARLY COLLECTING AND DISPLAYS OF OLD MASTERS

Although John Wheelock taught history at Dartmouth for over three decades, he had a passion for inquiry that encompassed many branches of the sciences and arts.[23] His correspondence also revealed an interest in collecting various objects, which led to attempts to "procure articles towards furnishing a museum of natural curiosities . . . and [artifacts] of different sorts in the various nations."[24] In the area of the fine arts, he wrote about both painting and architecture, revealing a familiarity with eighteenth-century aesthetic theories that laid the foundation for the study of art at the College well into the nineteenth century.

The earliest known European objects to be collected at Dartmouth were "a few coins and curiosities obtained by President John Wheelock in his tour in 1783" to France, Holland, and Great Britain.[25] The main purpose of the trip was to raise funds and procure donations of books and scientific instruments. Other accounts referred to his efforts to assemble a variety of geological, botanical, and zoological specimens in order to introduce visual demonstrations for instruction in what was then called natural philosophy.[26] Wheelock's twenty-page report, submitted to the trustees upon his return in February 1784, contained a reference to the "antiquities and curiosities" he had seen in Paris, as well as a brief passage about the history of French architecture.[27] The latter details read as follows:

> On the buildings of the country is inscribed the history of the progress of civilization. The unpolished stone, and the irregular shape of antient [sic] Cathedrals and domes sufficiently shew that the Gothic ages knew no rules of architecture; and that the hand of the Barbarian was unaccustomed to the chisel. Other buildings display the first dawning of the Arts; while others still more modern have the marks of that proportion and beauty which procede from art and taste.[28]

Wheelock's observations about regularity and proportion as the principal means of producing intrinsic beauty—contained in a report on the trip's financial benefits for the College—reflected the ideas of one of the most influential English Enlightenment philosophers on aesthetics, Henry Home, better known as Lord Kames (1696–1782).[29] Although Kames's writings were already studied in America as early as 1776,[30] it would be hard to imagine that Wheelock's sojourn in England did not at least reinforce his opinions on the subject.[31] Thus, more important than any material objects that Wheelock may have brought back from his trip to Europe, the experience influenced his intellectual development and undoubtedly informed his teaching of history for the next two decades.[32]

Isolated from the vast cultural resources of Europe, Americans interested in old masters in the late eighteenth and early nineteenth centuries were limited to collecting primarily prints, treatises, and other publications. As a result, following the example of John Wheelock, several Dartmouth students traveled to Europe soon after graduation to expand their studies on the subject. George Ticknor (1791–1871), Class of 1807 and later a renowned professor of modern literature at Harvard, left in 1815 and returned in 1819. During his sojourn in Göttingen, Germany, in 1816–17 he hired a private tutor to instruct him on ancient and modern architecture and painting.[33] As he wrote to a friend before embarking on his travels, "I began a course of studies which I well knew I could not finish on this side of the Atlantic, and . . . I must spend some time in Italy, France, Germany, and Greece."[34] Similarly, Nathaniel H. Carter (1788–1830), Class of 1811 and later a journalist, went to England, Scotland, France, Italy, and Switzerland from 1825 to 1827. Carter's eloquent letters about his impressions of European monuments and works of art were published regularly in his own journal, the *New York Statesman,* and reprinted throughout the country.[35] His missives were later collected in a remarkable two-volume publication, *Letters from Europe . . . ,* which first appeared in 1827 and was reissued in a second edition in 1829.

Most of the authentic old master paintings that arrived in North America from colonial times to the early 1800s were British portraits,[36] many representing ancestors and dignitaries, especially members of the royal family. This emphasis on biographical subject matter continued to grow throughout this period, making portraiture the most sought after type of painting. By the eighteenth century, some of America's early colleges and other institutions commissioned portraits of British benefactors for historical and commemorative purposes. In 1722, for example, Harvard College ordered the London artist Joseph Highmore to paint a full-length portrayal of Thomas Hollis, who had donated funds for the expansion of the library and other academic needs.[37] When the original was destroyed by fire in 1764, a copy of another English portrait of Hollis was obtained to replace it.[38]

Apparently, Dartmouth never followed the practice of obtaining portraits of its first English and Scottish sponsors, perhaps due in part to the outbreak of the Revolutionary War soon after its

FIG. 6. Dartmouth gallery of paintings in Wilson Hall, c. 1890s, featuring a painted copy of the portrait of William Legge, the Second Earl of Dartmouth, by Sir Joshua Reynolds in the background on the right. Courtesy of the Dartmouth College Library.

founding in 1769.[39] Although the College's administrators maintained long-term relationships with several of its British benefactors, some of whom reestablished their financial support during John Wheelock's trip in 1783, there were no portraits of these individuals. Finally, in 1829, a copy of a full-length painting of William Legge (1731–1801), the Second Earl of Dartmouth, after whom the College was named, was donated by a grandson, William Legge (1784–1853), the Fourth Earl of Dartmouth (fig. 6).[40] Sir Joshua Reynolds painted the original in 1757–58. It was displayed in the Foundling Hospital in London, established in 1739 as a residence for abandoned and orphaned children, which was another institution that benefited from Lord Dartmouth's charitable contributions and prestige.[41] The replica was prepared by Samuel William Reynolds (1773–1835), a prolific British painter and printmaker. An article in the *New York Mercury* of July 8, 1829, announced the arrival of the painting in the United States, noting that it portrayed "an early friend to our country, worthy to be remembered on its proudest anniversary [on the Fourth of July]."[42] When the picture was exhibited publicly in New York, Hartford, and Boston on its way to

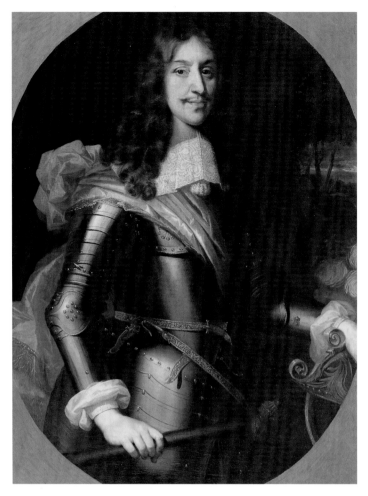

FIG. 7. Unknown Flemish artist, *Portrait of a Nobleman in Armor,* about 1660, oil on canvas. Gift of Albert George Hoit, Class of 1829; P.842.2.

Figure 8. Unknown Flemish artist, *Portrait of a Noble Lady in Widow's Weeds,* about 1660, oil on canvas. Gift of Albert George Hoit, Class of 1829; P.842.1.

Hanover, one observer noted—with excessive exuberance—that "The merits of the execution, independent of all other considerations, drew golden opinions."[43] After it arrived at Dartmouth in August, it was housed in the new "Gallery of Paintings" in Thornton Hall alongside representations of the institution's founders.[44]

Reproductions of notable Renaissance and Baroque paintings executed in oil were frequently exhibited in the United States in the nineteenth century. John Vanderlyn, an American painter who produced replicas of famous pictures for his clientele, defended the prevailing attitude in the early 1800s toward such paintings: "Copies would be infinitely preferable in every respect to originals of inferior masters. They would in exhibiting the various excellencies, which respectfully distinguish each of the great masters, serve as comparison to the student and lover of art."[45] Even decades later, several charter members of both the Metropolitan Museum of Art in New York and the Museum of Fine Arts in Boston advocated that the new institutions should—at least initially—focus on acquiring and exhibiting high-quality reproductions of European masterpieces.[46]

Albert Hoit (1809–1856), Class of 1829, a New Hampshire native and professional artist, donated to Dartmouth a pair of seven-

teenth-century Flemish portraits (figs. 7 and 8).[47] While the identities of the sitters and the attributions of the artists who executed them were unknown—although they were later considered to portray Charles I and his wife Henrietta[48]—their provenance was exceptional. Hoit acquired them in Rome during his extended sojourn there from 1843 to 1844.[49] His visit to the Eternal City coincided with the liquidation of the largest early-nineteenth-century art collection in Europe, owned by Emperor Napoleon's uncle, Cardinal Joseph Fesch (1763–1839). Some of the finest paintings that had been housed in his residence at the Palazzo Falconieri were sold in a series of auctions held between 1843 and 1845, including works by Leonardo, Michelangelo, and Raphael.[50] *Portrait of a Woman* (no. 157) and *Portrait of a Man Covered with Armor* (no. 158) were listed in the catalogue published in 1841.[51] The handwritten inventory prepared after Fesch's death in 1839 described the paintings in the palace's so-called Wouwerman room, named after the seventeenth-century Dutch artist who was renowned for his landscapes and genre scenes.[52] The portraits acquired by Hoit were originally displayed alongside thirty-one other paintings, some attributed to Rubens and Rembrandt, as well as one of Philips Wouwerman's largest battle scenes (now in the National Gallery, London). In spite

6

of Hoit's modest standard of living at this point in his career, a year after returning home he donated the pair of paintings to the College, the first non-Dartmouth-affiliated pictures to enter the collection.[53] They were presumably displayed in the library in Reed Hall along with the portraits of alumni, presidents, and trustees in the small "Gallery of Paintings" there.[54]

The next European acquisition occurred about twenty-five years later, when Moses Titcomb (1801–1881), Class of 1879H, donated a copy after Guido Reni's *Aurora* (see fig. 2) executed by the nineteenth-century artist Costantino Brumidi (1805–1880).[55] Reni's fresco, painted in 1614 for the Borghese family's villa on the Quirinal Hill in Rome (now Palazzo Rospigliosi–Pallavicini), was renowned for its elegant disposition and embodiment of ideal beauty. The version of *Aurora* donated to Dartmouth College was of particular value because it was by Brumidi, an Italian émigré who had executed a number of prominent commissions in North America after arriving in New York in 1852. Most importantly, over a twenty-five-year period he oversaw and painted most of the murals in the United States Capitol Building, from 1854 until his death.[56] Brumidi's oil copy reproduced the original colors of Reni's fresco, suggesting that he may have painted it in situ in his native Rome, where he lived and worked for forty-seven years.[57]

The donor, Moses Titcomb, who served as the superintendent of the Senate Documents Room in Washington, D.C., from 1844 to 1877, commissioned Brumidi to paint portraits of himself and his father and had a friendship with the artist.[58] Titcomb resided in Franklin, New Hampshire, after his retirement and became acquainted with George W. Nesmith (1800–1890), Class of 1820, who was himself a retired state superior court judge and longtime trustee of Dartmouth.[59] Nesmith arranged for Titcomb to receive an honorary degree in 1879. A few weeks later the trustee received the painting as a gift to the College, the first major donation of a European work of art by someone who was not an alumnus or directly affiliated with the College. It was also a rare depiction of a historical subject in relation to the preponderance of portraits in the collection. Nesmith sent a letter to Dartmouth's president, Samuel C. Bartlett, to announce the gift, emphasizing the mythological iconography with its extensive references to various Homeric poems.[60] By contrast, the public acknowledgment of the donation that appeared in the *Dartmouth* celebrated the artistic merits of the copy and its relationship to Reni's "masterpiece."[61] These diverse interpretations highlighted the multiple didactic functions of copies after old master paintings, which were further enhanced by its prominent display in the new Wilson Hall gallery—at some point even located above the portrait of the College's founder, Eleazar Wheelock (see fig. 6).

By 1901 a catalogue of the works of art in the upstairs gallery of Wilson Hall was published. In spite of the limited number of European paintings, the author made a special reference to the presence of several pictures by notable artists and the distinguished provenance of the portraits donated by Albert Hoit.[62] In addition,

FIG. 9. Dartmouth gallery of paintings in Wilson Hall, c. 1890s, with a display of photographs of old master works of art. Courtesy of the Dartmouth College Library.

there was a list of fifty-nine photographs of famous Flemish, French, German, Italian, and Spanish paintings and sculptures from the fifteenth through the nineteenth centuries. Most of these reproduced Renaissance masterpieces, some of which were conspicuously displayed in the Paintings Gallery (fig. 9).[63] The status associated with the collection of "art photographs" marked the growing importance of visual demonstrations in the teaching of art history. These materials formed the foundation of what would eventually become a large and valuable collection. Already by the 1870s the renowned artist and critic John Ruskin (1819–1900) regularly used photographs to illustrate his lectures at Oxford.[64] In the absence of original objects, replicas and reproductions provided important educational tools for the study of European art.

By 1897 photographic reproductions were employed in at least one course at Dartmouth focusing on European fine arts. The class was offered annually by Professor Gabriel Campbell (1838–1923), who began teaching aesthetics the year before in the Department of Philosophy. At the end of the published course description Campbell noted that classes would be accompanied by "photographic and stereopticon illustrations."[65] In the last quarter of the nineteenth century, stereopticons (early slide projectors) became increasingly popular in Europe and the United States when large audiences needed to view photographic images. The technology improved dramatically around 1890 with the introduction of electricity, simpler equipment, and new developing processes, which made projectors and slides more readily available—but still very expensive.[66] George D. Lord (1863–1945), Class of 1884, who taught classical art at Dartmouth starting in 1891, used slides.[67] Moreover, Homer

E. Keyes (1875–1938), Class of 1900, who taught the first European art history classes at Dartmouth beginning in 1905, planned his lectures with references to slides in the margins of his notes.[68] These technical innovations had an enormous impact in the classroom by supplementing verbal descriptions and interpretations with visual displays.

Keyes introduced northern and southern European Renaissance and Baroque art history courses in 1905 and continued to teach them until 1913.[69] The establishment of the new Department of Fine Arts corresponded with the development and enlargement of the campus, faculty, and student body, as well as a significant reform of the curriculum in the last decade of the nineteenth and the first years of the twentieth centuries.[70] During Keyes's tenure, the library, which administered the art collection, began amassing primary and secondary materials to aid research and study of the new subject. One of the first important acquisitions, around 1910, was a two-volume set of the first edition of the mid-eighteenth-century *Magnificences of Rome* and *Imaginary Prisons* by Giovanni Battista Piranesi (cats. 95–96). This rare compendium of all of Piranesi's prints produced up to 1753 was purchased by Sir Robert Throckmorton (1702–1791), the Fourth Baronet of Coughton Court in Warwickshire, early the next year.[71] No further documentation has survived on the subsequent history that led to its later acquisition by Dartmouth College in the early twentieth century.

The opening of Carpenter Hall in 1929 marked the beginning of a new era in the history of art education at Dartmouth while providing renewed momentum in the development of the College's holdings of European objects. One of the inaugural exhibitions in June of that year featured Dutch, British, and French art from the mid-1600s to the late 1800s from the collection of Robert Jackson (1880–1973), Class of 1900.[72] It was the beginning of a series of exhibitions of European art, including traveling displays organized by the Museum of Modern Art (MoMA) and the American Federation of the Arts (AFA). In the case of MoMA, Dartmouth was one of eleven institutions beginning in the early 1930s to participate in the new program that circulated thematic and monographic exhibitions around the country.[73] Initially, the New York museum assumed responsibility for half of the cost of the shows on the condition that the balance could be raised by the participating institutions. Dartmouth continued to finance these displays for several decades. In one instance, the Carpenter Art Galleries exhibited fifty etchings selected from Francisco Goya's *Disasters of War* series and Otto Dix's *The War* portfolio in April 1939.[74] During that academic year alone the total attendance was reported to be 6,130.[75]

The years between 1935 and 1940 signaled a period of great prosperity for the expansion of the European collection. Led by a triumvirate of leading collectors, including Abby Aldrich Rockefeller (1874–1948), William Preston Harrison (1869–1940), and A. Conger Goodyear (1877–1964), Dartmouth received a number of prominent gifts of works on paper.[76] Their donations included mostly nineteenth- and early-twentieth-century American and French drawings, which ranged—in the case of the European objects—from a figural sketch by Henri Fantin-Latour (cat. 113) to a nude study by Henri Matisse (cat. 123). As the director at the time of the Carpenter Art Gallery, Churchill P. Lathrop, later observed, these contributions "enabled [us] to start the snowball rolling" in terms of building a collection.[77] Another important donation in 1940 was a bequest from Julia L. Whittier for an endowment "for the purchase of works of art for the Department of Fine Arts in Dartmouth College."[78] It was only the second fund established for acquisitions, and it more than doubled the assets available for purchasing American and European objects.

In the seventeen years between the end of World War II and the opening of the Hopkins Center, the College continued to organize impressive exhibitions, attract important gifts, and better utilize its growing holdings for academic and non-curricular programs. Though the close-knit relationship between individual faculty priorities and the administration of the collection led to a decline in certain collecting areas, including European art, there were important events associated with old master works during this period. One of the highlights was an exhibition in 1959 of two dozen paintings owned by Richard H. Rush, Class of 1937.[79] These dated from the Renaissance to the impressionist era and included many examples that were later donated to the College; several works given by Mr. and Mrs. Rush are included in the present catalogue (cats. 10, 12, 15, 32, and 33). A year later another significant exhibition featured twenty-three paintings and over fifty prints after William Hogarth and works by other eighteenth-century British artists owned by Earle W. Newton (1917–2006).[80]

After six years of planning, the Hopkins Center opened its doors in 1962 as the first fine arts facility in the nation to combine multidisciplinary academic, extracurricular, visual, and performing arts under one roof. The additional gallery spaces, located at the heart of the complex, provided a new impetus to the exhibition program. Along with traveling shows organized by MoMA and the AFA, there were more rotating displays of works from the growing permanent collection and specially organized loan exhibitions. These initiatives led to an even greater awareness of the role of the fine arts at Dartmouth by alumni and others. In one case, the presentation of a selection of old master drawings from the collection of George Abrams (1920–2001) in 1969 led to the donation of sixty-five works on paper dating from the Renaissance to the early twentieth century from this renowned collector.[81] Once again, within only a few years after the construction of the Hopkins Center, the new uses and increased level of activities led to the need for even more and better equipped spaces, especially to provide room for curricular programs. By early 1970 the director of the Hopkins Center Art Galleries, Truman H. Brackett Jr., Class of 1955, noted, "The considerable demand for the display of original material necessitated the refurbishment of the older Carpenter Galleries across the campus for special teaching and study collections. It is our hope that eventually we may bring these functions together under a single roof."[82]

At each stage in the development of the College's holdings of European art, greater visibility and accessibility led to more donations and financial contributions. However, one consequence of the separation of the temporary exhibition galleries in the Hopkins Center from the permanent collection spaces in Carpenter Hall was a decreased emphasis on curricular concerns, particularly those associated with old master painting and sculpture.[83] As a part of a dynamic studio program and performing arts center, the displays in the newer structure naturally tended to highlight modern and contemporary objects. The distance may have also contributed to the eventual division of the department into distinct faculties for art history (based in Carpenter Hall) and the fine arts (situated in the Hopkins Center). The situation was further complicated by the fact that the exhibition galleries, storage areas, and offices were located in three different buildings. As Peter Smith noted in 1976 in a report in preparation for a major fundraising campaign for the arts, "Dartmouth lacks the one thing that would give to the study and display of the fine arts what the Hopkins Center has so conspicuously given to the performing arts: space commensurate with achievement and need, and a focus for increased attention."[84] One might have added that such a structure was particularly important for the continued growth of gifts, funding, and exhibitions of European art as well.

PRINTS FROM THE RENAISSANCE TO THE LATE NINETEENTH CENTURY

During much of the nineteenth century, many major American museums had not yet been established and there were no university courses on the history of printmaking. Private collectors were the principal experts in the field, which was based initially on secondary sources, and they gradually refined their knowledge through acquisitions and examinations of those examples owned by their contemporaries. Collectors assembled their prints according to traditional criteria of national and regional schools, individual artists, and rarity. The popular press described the contents of some of the finest examples, which in turn served as models for others interested in the graphic arts of other countries.[85]

In the case of Dartmouth College, in an era in which there were few print connoisseurs in America, two of its graduates in the early 1800s were known to have either collected or carefully studied Renaissance and Baroque woodcuts, engravings, and etchings. No explanation has been provided to account for this premature interest, and sadly, none of these examples made their way back to Hanover. Nevertheless, already by the early twentieth century Dartmouth had introduced courses and teaching exhibitions that focused on the history of printmaking for the benefit of generations of students. Many alumni—along with others as well—eventually became generous supporters of the College's graphic arts programs and activities, thereby creating an extensive European print collection.

Numerous references to prints were recorded by the twenty-five-year-old George Ticknor, Class of 1807, in his journal on "Modern Arts" of 1816–17, kept while he studied in Göttingen.[86] His observations ranged from notes about the origins of engraving (attributed to "Andrea Mantegna in 1460–70") to large Renaissance workshops established by Raphael and Dürer ("when engraving was just coming into light"). Ticknor also compared various reproductions of a single work of art in order to be able to better understand a particular artist's "genius"—often favoring older examples over more recent ones. It was apparent that he had learned much about prints at an early age through his close friendship with Francis Calley Gray (1790–1856), a fellow Bostonian and the leading American connoisseur before 1850. Ticknor's interest in graphic media continued throughout his lifetime, as the following passage from 1824 on the new process of lithography illustrates:

> It has already been applied with more or less advantage, wherever the methods on copper, wood and type metal have heretofore prevailed. . . . We do not indeed believe that it will, either here or anywhere else, supersede a method, which has produced such masters as have engraved on copper from Marc Antonio [Raimondi] to [Raphael] Morghen.[87]

Ticknor looked to prints essentially to study "all the celebrated Performances and Inventions of the most eminent Masters [whose work] never crossed the Seas." They were a means of becoming "acquainted with the magnificent Structures, beautiful Statues, inimitable Paintings, etc. with which . . . other countries—and particularly Italy—are adorned."[88]

The precise motivations behind the formation of one of the earliest large European print collections in the United States, assembled by George P. Marsh (1801–1882), Class of 1820 and later a congressman, have never been thoroughly understood.[89] Family records indicate that framed prints hung in his childhood home in Woodstock, Vermont, including *The Three Fates* by Ferdinando Gregori of 1770 after a painting ascribed to Michelangelo in the Palazzo Pitti in Florence.[90] The decorative function of such works was relatively common in affluent East Coast residences from the late eighteenth century onward. Yet the shift from purchasing them as domestic ornaments to studying them as aesthetic objects was highly unusual at this time. Already as a student at Dartmouth, Marsh purchased reference books on engraving,[91] demonstrating particular enthusiasm for contemporary foreign writers who prepared lists of prints that were required to form a fine collection.[92] After graduation he had begun to acquire old master prints by mail order and on trips around the country, ultimately amassing—without ever leaving America—over 1,300 examples dating from the Renaissance to the Age of Enlightenment.[93] As his wife later described it, Marsh "conceived the idea of forming a collection of engravings that should illustrate . . . chronologically the progressive stages in the history of that beautiful art."[94] Unfortunately, when he was forced to sell his prints due to financial difficulties in 1849, Dartmouth was not considered as a possible repository—and it was unlikely that the

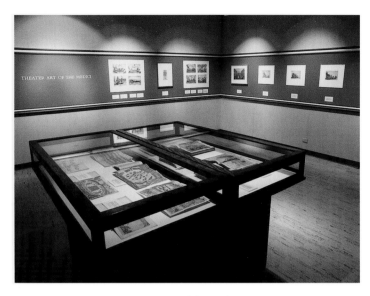

FIG. 10. The exhibition *Theater Art of the Medici,* Hopkins Center, 1980. Courtesy of the Hood Museum of Art.

College would have been willing or able to make that kind of purchase. Instead, Marsh sold them in 1850 to the Smithsonian, the first collection of its kind to be acquired by a public institution in the United States.[95]

Although the College began acquiring European prints already in the early twentieth century, such as the extraordinary set of first-state impressions of Piranesi's *Magnificences of Rome* and *Imaginary Prisons,* it relied primarily on gifts. The earliest etching donated to Dartmouth was an impression of Piranesi's *Basilica of Constantine* from the same series of views, given in 1915 by Benjamin A. Kimball, Class of 1854. The gift followed the introduction of the first course dedicated entirely to the study of the history of prints, offered in fall 1914 by George B. Zug and entitled "Engraving and Illustration"; Zug's material ranged from "Dürer to Rembrandt and masters of the nineteenth century."[96] Three years later an announcement in the *American Magazine of Art* noted that another class with a more ambitious syllabus, co-taught by Zug, was "believed [to be] the first time that such a comprehensive course will treat the history of both . . . etchers and lithographers—from the fifteenth to the twentieth century."[97] The teaching of graphic arts at Dartmouth was further enhanced with the hiring in 1937 of Ray Nash (1905–1982) to regularly instruct students about the history and art of printmaking. He set up a workshop in the basement of Baker Library that served as an invaluable seminar room and laboratory for countless students until his retirement in 1970. Beginning in the late 1930s, outside speakers such as Philip Hofer (1898–1984), the director of Harvard University's rare book library, were invited to campus to deliver lectures. Hofer, who served as a visiting lecturer at Dartmouth for at least a decade beginning in 1939, became an early supporter with gifts in 1939 and 1940 representative of the German Renaissance and Dutch Golden Age.[98] Subsequent donations between 1948 and 1954 greatly enlarged the holdings of woodcuts, engravings, and etchings from the late fifteenth through the beginning of the

twentieth centuries. Some of the more noteworthy examples were given by Dr. Franz H. Hirschland, parent of two Dartmouth graduates; Helena M. Wade in memory of her husband, Alfred Byers Wade, Class of 1895; and Mrs. Hersey Egginton, parent of a member of the Class of 1921. This period of growth was capped in 1974 when the children of Mrs. Harvey Fisk donated in her memory over 130 old master prints.

These generous donors were undoubtedly attracted by the energy and influence surrounding the curricular study, collection building, and exhibition program associated with graphic media during this era. In addition to displays of several traveling shows arranged by MoMA and other institutions, there were numerous temporary presentations of the College's permanent holdings. Not surprisingly, Piranesi was a favorite subject, with many installations of his striking etchings. Nearly two hundred examples of the work by this particular artist owned by Dartmouth were eventually catalogued by Lawrence Nichols, Class of 1976, in a well-documented publication that served as his senior thesis.[99] The most important loan exhibition of European prints organized before the opening of the Hood Museum of Art was *Theater Art of the Medici,* developed in 1980 by Arthur R. Blumenthal, curator of art from 1975 to 1982 (fig. 10).[100] In addition to sixteen prints and drawings from the College, eighty-two works were borrowed from twelve other institutions and eight private collections located in three different countries. The 222-page catalogue was praised by one reviewer for helping to provide a "secure footing for a true evaluation of the importance of Florentine celebrations for later European developments—specifically, the manner in which a local festivity can be expanded into an event of international artistic and political importance."[101]

For nearly 180 years, old master prints served as the best source for generations of Dartmouth students in their study and appreciation of European art—either as reproductions or as independent works. Gradually, from the beginning of the twentieth century onward, graphic media provided the means to represent fully the stylistic diversity, iconographic complexity, and expressive potential of artists working from the Renaissance to the early modern era. The groundwork constructed over time paved the way for the next chapter in the evolution of a rich and varied teaching collection: the opening of the Hood Museum of Art.

OTHER EUROPEAN HOLDINGS

Over the years Dartmouth became a repository for a range of other objects as well. They were rarely pursued in any systematic way but instead acquired on the basis of their availability or merely because benevolent alumni offered them as gifts. For the most part, these artifacts arrived in a somewhat haphazard manner. Nevertheless, there were many treasures that provided material for several special exhibitions, curricular displays, and scholarly investigations.

The earliest examples to be collected were "specimens of different coins in the various nations," as John Wheelock described them

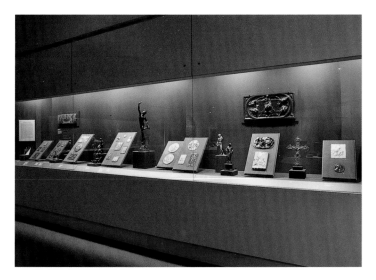

FIG. 11. Installation of *European Bronzes from the Collection of Roger Arvid Anderson, Class of 1968,* Kim Gallery, Hood Museum of Art, 1996. Photo by Jeffrey Nintzel.

in 1784 in a letter to an acquaintance in Amsterdam.[102] In addition to those that Wheelock brought back himself, Nathan Robinson, Class of 1793, contributed several others.[103] Small, durable, portable, and easily reproduced, these objects transmitted a wealth of information about different countries' aspirations and accomplishments. In addition, the inscriptions, heraldry, emblems, symbolic devices, and allegorical figures on the reverse suggested a particular attribute, a favorite idea, or an ambition. Like coins, portrait medals produced from the early fifteenth to the end of the eighteenth centuries fulfilled a desire to celebrate and immortalize Europe's elite. Combining all of the aforementioned elements, portrait medals provided an ideal medium for the transmission of political,

religious, and cultural information to friends and close associates. An exhibition of Bowdoin College's Molinari Collection in late 1976 at Dartmouth demonstrated portrait medals' rich and complex content, as well as their attractive appearance. An alumnus, Roger Arvid Anderson, Class of 1968, who saw the display, began assembling his own remarkable assortment of medals and plaquettes. A large number of these and other Renaissance bronzes and later sculptures were deposited on long-term loan at the Hood Museum of Art, where they have been used often for installations, programs, and research (fig. 11).

The largest quantity of European decorative arts was donated in 1958 by Ralph S. Bartlett (1866–1960), Class of 1889, who presented the Department of Anthropology with an array of Russian books and objects, including icons, liturgical crosses, textiles, porcelain, and seventeenth- and eighteenth-century silverware.[104] As Anne Odom, Curator Emerita of Hillwood Museum and Gardens, recently wrote,

> These he had collected in the 1920s on regular trips to Russia in a period when the Soviet authorities were selling works of fine and decorative art to finance industrialization. Bartlett, who first visited Russia in 1911, was clearly an educated buyer, and became a dealer, selling many objects in his store, *Old Russia,* on Arlington Street in Boston from 1928 to 1939.[105]

Some of the finest works dated from the period between the earliest tsars of Russia and the age of Catherine the Great (fig. 12). A recent gift of funds from Claude-Albert Saucier, Class of 1975, in honor of Pauline Saucier Murray, permitted the purchase of a Russian imperial porcelain plate that complemented the collection.

During the last century there were also many fine pieces of

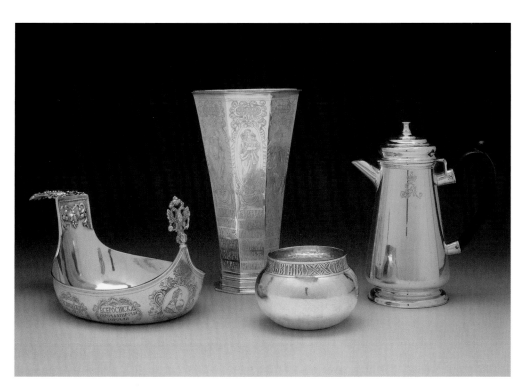

FIG. 12. Selected Russian decorative objects dating from the late seventeenth to the early nineteenth centuries. Gifts of Ralph Sylvester Bartlett, Class of 1889 (left to right: 159.2.19450, 159.2.19461, 159.2.19471, 159.2.22444), and a purchase through a gift from Claude-Albert Saucier, Class of 1975, in honor of Pauline Saucier Murray (above, 2005.85).

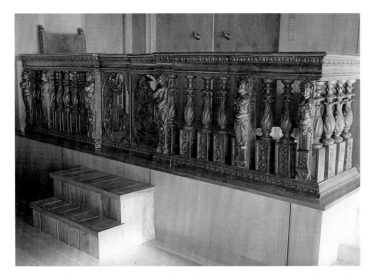

FIG. 13. Unknown Italian artist, *Altar Balustrade,* about 1600, walnut. Gift of Mr. and Mrs. Ray Winfield Smith, Class of 1918; F.975.4.

European furniture that were given to Dartmouth. In one case, Ray Winfield Smith (1897–1982), Class of 1918, whose avocation was archaeology with a special interest in glass, donated several remarkable objects.[106] Chief among the Renaissance furnishings was an entire wooden balustrade dating from about 1600, reportedly from a church in Bergamo, Italy (fig. 13). During this period, following the conclusion of the Council of Trent in 1563, many reform-minded bishops required the addition of balustrades in front of altars to add "beauty and ornament" to existing ecclesiastical structures, as well as to separate functionally liturgical and public spaces.[107] The skillful carvings and complex iconography made this an especially accomplished work of this kind. Other original items—or those thought to have been antique—were conspicuously displayed throughout the campus. An oak fireplace mantel attributed to the sixteenth century in Carpenter Hall (fig. 14), donated by Robert Jackson, Class of 1900, became the central focus of the new art library constructed in 1929.[108] More recent scholarship indicates that it was most likely modeled after a similar one made for the king of France, Francis I, in the Château de Blois. Even though it was evidently made after about 1800 in France, it nevertheless represents the ideas and symbols of the Renaissance.

There was also a variety of other types of works on paper that found their way to Dartmouth. Chief amongst these were over 1,500 twentieth-century European war posters. Most of them were given by Willis S. Fitch, Class of 1917, and Edward Tuck, Class of 1862, as well as other generous alumni donors who had either participated in or supported Allied efforts during the world wars.[109] Posters functioned as the predominant means of mass communication in the first half of the 1900s, before the advent of radio and newsreel films, and the patriotic purpose attracted many notable artists. One especially representative work of the Great War produced by Jules-Abel Faivre (1867–1945), *On Les Aura!* ("We'll get 'em!"), blended a traditional design, the latest lithographic innovations, and the liveliness of commercial posters to create a powerful

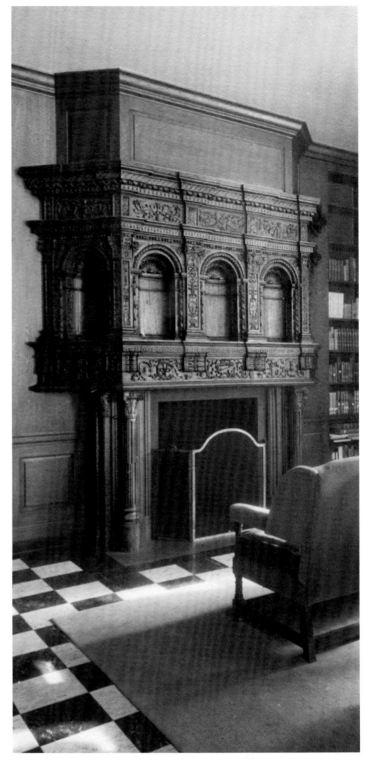

FIG. 14. Oak fireplace mantel in Carpenter Hall, probably nineteenth century, donated by Robert Jackson, Class of 1900. Courtesy of the Dartmouth College Library. Photo by Paul Weber.

work of art (fig. 15).[110] The strong diagonal movement, subtle colors, eye-catching graphic, and straightforward message were essential in evoking support for the common foot soldier.

Far fewer in number but extremely important for documenting the history of art is a limited collection of European photographs dating from the middle of the nineteenth century to the early

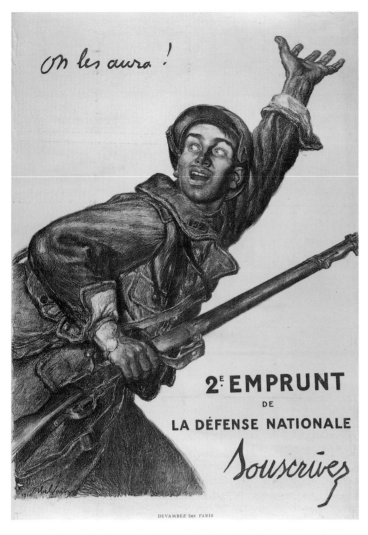

FIG. 15. Jules-Abel Faivre, *On les aura! (We'll get 'em!), Second French War Loan,* 1916, color lithograph. Gift of Willis S. Fitch, Class of 1917, and of Edward Tuck, Class of 1862; PS.987.6.1252.

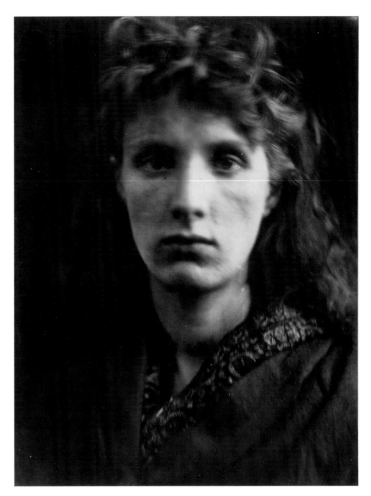

FIG. 16. Julia Margaret Cameron, *The Mountain Nymph Sweet Liberty,* from *Portfolio of Twelve Victorian Photographs,* June 1866, albumen print. Anonymous gift; PH.967.96.9. Photo by Jeffrey Nintzel.

modern era. Some of the earliest and best examples appeared in a portfolio of a dozen images by Julia Margaret Cameron (1815–1879) that was given anonymously in 1967. The British photographer employed a soft-focus technique, expressive lighting, and conventional compositions adapted from old master paintings to imbue her subjects with a powerful spirituality that separated her from commercial portraitists of her day. *The Mountain Nymph, Sweet Liberty,* for instance, is a striking image that conveys a personal and psychological connection with the viewer (fig. 16).

From a "number of valuable foreign curiosities" received from the Reverend Jeremy Belknap in 1791 to the 315 Russian decorative arts objects given by Ralph Bartlett over 160 years later,[111] Dartmouth has accumulated an extensive and varied collection of European art objects other than paintings, sculptures, drawings, and prints. Although there are no immediate plans to expand most of these holdings, such as the decorative arts, they remain invaluable for exhibition, teaching, and research purposes.

MODERNISM COMES TO DARTMOUTH

The opening of the Hopkins Center in November 1962 marked the culmination of years of interest in modern European and American art at Dartmouth College. There was a ten-day schedule of events to celebrate the new structure, designed by one of the leading architects of the mid-twentieth century, Wallace K. Harrison (1895–1981), Class of 1950H. The inaugural program featured exhibitions, lectures, and the presentation of honorary degrees highlighting the significance of avant-garde aesthetic principles and the contributions of individual contemporary artists. The agenda included, for example, an exhibition of impressionist painting from 1865 to 1885 (fig. 17), with loans from distinguished museums and private collections; a lecture titled "Picasso's Paris at the Turn of the Century"; and a "Convocation of the Arts," with ceremonies and related displays celebrating the work of the German-born abstract artist Hans Hofmann (1880–1966) and the foremost postwar Italian engineer-architect, Pier Luigi Nervi (1891–1979).[112] Most importantly from the point of view of the College's holdings of European art,

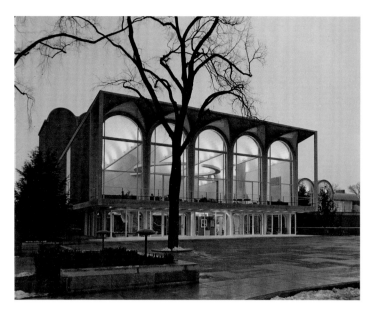

FIG. 17. Hopkins Center for the Performing Arts, Wallace K. Harrison, architect. Courtesy of the Dartmouth College Library.

Dartmouth received a number of remarkable gifts of paintings, sculptures, and works on paper produced in the first half of the twentieth century. One particular donor, A. Conger Goodyear, a well-known collector and museum trustee in Buffalo, contributed several drawings and established an endowment of $20,000 for the purchase of original works to be awarded to a few exceptional students "to encourage art collecting."[113] Overall it was a fitting commemoration of the early efforts to advance the study and appreciation of modern art. It was also an especially auspicious beginning for the new "center for art and culture," according to President Emeritus Ernest Martin Hopkins, who added that he felt it would in due course become "the heart and soul of Dartmouth."[114]

The study of late-nineteenth- and early-twentieth-century art had been introduced into the curriculum at the College nearly fifty years before the opening of the Hopkins Center, when George B. Zug arrived in the fall of 1913.[115] His appointment occurred during an era in which there were few art history courses in America that analyzed recent movements and artists. Several months before arriving at Dartmouth, Zug visited the Armory Show in New York, officially known as the International Exhibition of Modern Art, which constituted an unprecedentedly large display of such works in the United States. He then published a series of articles leading up to and following the opening of a smaller installation of these objects at the Art Institute of Chicago in the spring of that year.[116] Although he was highly critical of the most innovative examples, calling cubism a "freak product," Zug eventually acknowledged the value of post-impressionism: "[It is] a genuine endeavor worthy of respectful attention . . . [and] the beginning of something new and positive."[117] Compared to numerous malicious critics who denounced modernist works on moral grounds, his opinions were based on aesthetic criteria and revealed an effort to evaluate the movement in the context of the history of European art.

Zug established a foundation for the study of modern art at Dartmouth, which he further developed through an exhibition program that often featured work by contemporary artists. He was later assisted by Churchill P. Lathrop, who arrived in the department in 1928 and became director of the galleries in 1937. Both Zug and Lathrop actively encouraged students to learn about the latest aesthetic theories and works of art through courses, invitations to artists to come to Dartmouth, and the development of the collection.[118] One of the key acquisitions of this period was the commission for José Clemente Orozco to paint the grand mural cycle *The Epic of American Civilization* from 1932 to 1934 in Baker Library.[119] The chair of the department at that time, Artemas Packard, indicated that the initial idea for the project emerged through an exhibition of Orozco's lithographs at Carpenter Hall in 1930.[120] Another important event aimed at promoting greater understanding of recent artistic developments occurred in April 1935, when the "Symposium on the Issues of Modern Art" was held in Hanover. It included a number of leading American proponents of contemporary aesthetics, such as John Dewey, Max Eastman, Frank J. Mather, and Edward F. Rothschild.[121] Dewey, who had helped Dr. Albert C. Barnes set up a school using his private collection of impressionist and early modern paintings for the cultivation of objective habits of perception, delivered a paper titled "The Function of Art in Contemporary Society."[122]

Although the College's holdings of modern European art grew gradually during the next two decades, they were given a significant impetus through the backing of Evelyn and William B. Jaffe (d. 1972), Class of 1964H. Their three sons attended Dartmouth in the middle of the twentieth century, and through their experiences they recognized that there was still enormous potential to strengthen the role of the visual arts on campus. As a result, between 1954 and 1965 they generously donated a variety of French modernist sculptures and paintings, some of which were selected for inclusion in the present exhibition and catalogue (cats. 46 and 53). They also sponsored the Jaffe-Friede Art Gallery in the new building and provided funds for other acquisitions.[123] Jaffe was an attorney who, along with his wife, had formed a large and eclectic art collection. They were benefactors of both the Metropolitan Museum of Art and MoMA and were well-known in New York's leading cultural and social circles. He used his influence when he later became the first chairman of the Hopkins Center Art Advisory Committee, formed in 1960, to appoint several prominent modern art personalities, such as Alfred H. Barr (1902–1981), the first director of MoMA; Dominique de Menil (1908–1998), who, along with her husband, John, acquired numerous important modernist works; and Joseph H. Hazen (1898–1994), a lawyer and film producer with a substantial art collection ranging from Van Gogh to Picasso.[124]

One of the key events that Jaffe used his connections to promote was an exhibition in 1970 held at Knoedler's in midtown Manhattan to benefit the acquisitions fund of the Hopkins Center Art Galleries. Titled *The Protean Century, 1870–1970*, it comprised sixty-

FIG. 18. The exhibition *The Protean Century, 1870–1970*, New York, Knoedler & Company, 1970. Courtesy of Knoedler & Company.

FIG. 19. *Studio of Gertrude Stein, 27 rue de Fleurs, Paris* (detail), winter 1914–15. Hanging on the wall on top right is Picasso's painting *Guitar on a Table* of 1912 (cat. 52), donated in 1975 by Nelson A. Rockefeller, Class of 1930. Courtesy of the Baltimore Museum of Art, Cone Collection.

three European and American paintings, sculptures, and drawings, nearly a third of which came from the College's permanent collection and the remainder of which were on loan from Mr. and Mrs. Jaffe and other prestigious private lenders (fig. 18). In fact, the Jaffes either owned or had donated 15 percent of the works in the display. Jaffe used the occasion to highlight Dartmouth's commitment to building its holdings of original objects of "superior merit," especially modern examples that had been acquired through gifts since the opening of the Hopkins Center seven and a half years before. In his catalogue preface he wrote, "This splendid exhibition is abundant evidence of the interest of the College's alumni and friends in its art program."[125]

Another major lender to the exhibition was Nelson A. Rockefeller (1908–1979), Class of 1930, then governor of New York, who served as its honorary chairman. Among his six Dutch, French, and Swiss paintings and drawings featured in the display were representative works by Vincent Van Gogh, Georges Braque, and Paul Klee. It was not the first time that Rockefeller had lent his prestige and objects to major events organized by his alma mater, but his donations were limited to generous financial contributions to non-art-related areas. Finally, in late 1975, while serving as vice-president of the United States, Rockefeller gave Dartmouth a magnificent cubist painting by Picasso, formerly owned by the famous expatriate literary figure Gertrude Stein (fig. 19, cat. 52), in lieu of a significant cash donation. The accompanying letter announcing the gift acknowledged that the College could decide at some point to sell it, which was precisely the intention of several administrators.[126] The faculty and the director of the Art Galleries at that time, Jan van der Marck, persistently opposed the sale, which led to protracted and at times bitter exchanges. At one point it was proposed to deaccession a number of works of art to raise funds equal to the value of the painting.[127] Apparently, the death of the donor in early 1979

ended the debate, and the work became—and remains—one of the foremost treasures in the collection.

It was Rockefeller's influence that led to a series of extraordinary gifts of mainly French paintings and works on paper by Wallace K. Harrison, the architect of the Hopkins Center, and his wife, Ellen. Harrison had strong personal and professional ties with both the future U.S. vice-president and Dartmouth President Emeritus John S. Dickey, which led to an honorary degree in 1950. Harrison's selection in 1956 by the building committee, chaired by Rockefeller, to design the campus's new center for the arts solidified his relationship with the College. From 1961 to 1977 Mr. and Mrs. Harrison donated 135 objects, the majority of their private collection of twentieth-century art, to Dartmouth (including cats. 57, 58, 129, 130, and 131).[128] They gave many exceptional works, including, for example, six paintings by Fernand Léger executed between 1933 and 1945. The most outstanding gift from Harrison and his wife was a series of prints by Picasso known as the *Vollard Suite* of 1930–37, which—with the later acquisition of the portraits of the publisher—constitutes one of the few complete sets in the United States. Collectively, the numerous gifts over an extended period of time ranked Mr. and Mrs. Harrison among the leading donors of early modern art. As a result, through the design of the Hopkins Center and the array of personal donations, Wallace K. Harrison's vision and generosity greatly enhanced the physical presence and significance of the visual arts at Dartmouth.

GENESIS OF
THE HOOD MUSEUM OF ART

In September 1985, the newly constructed museum named in honor of Harvey P. Hood, Class of 1918, opened to the public. As a reviewer for the *New York Times* reported,

> The collection . . . of more than 40,000 pieces . . . was formed by the donations of Dartmouth friends and alumni over the past 200 years. The result is a potpourri of artifacts, sculpture, old master paintings, [and] modern art. . . . The museum is divided into nine galleries, each devoted to showing one or another category of art.[129]

The consolidation of the campus's disparate galleries, offices, storage facilities, and teaching spaces into "an independent entity" finally provided the opportunity "to develop the resources necessary to serve its diverse audience of students, scholars, and the general public."[130] The full significance of this achievement was especially evident to older alumni, who had witnessed various iterations aimed at displaying the College's growing art collection and better integrating it into the curriculum. As Robert S. Weil, Class of 1940, wrote to then-director Jacquelynn Baas after he visited the new complex for the first time, "When I took courses at Dartmouth the extent of art was Carpenter Hall. I still carry around what I learned, but just think how much more your undergraduates can learn today at the Hood Museum."[131]

Within only a few months after the inauguration, there were offers of additional funds and gifts aimed at increasing accessibility to significant examples of European art through acquisitions, special exhibitions, and other programs. One major step toward achieving these goals was the hiring in 1985 of the first full-time curator in this area, Hilliard T. Goldfarb, who greatly enhanced the care, interpretation, and development of the collection. With regard to accessions, Goldfarb stated early on in his tenure, "Our concern is to create a broad base of holdings which can serve the teaching needs of the faculty and the visual enrichment of the student body and Upper Valley public, while adhering to the high standards of quality."[132] A number of objects selected for inclusion in the present catalogue were acquired or donated in the late 1980s, but the principal purchase was unquestionably an early painting by Claude Lorrain (cat. 11). The picture was emblematic of the artist's incredible skillfulness in rendering fantastic natural scenes imbued with limpid light and familiar architectural elements to evoke pastoral and classical themes. The addition of this work considerably strengthened the representation of first-rate French paintings in the collection, as well as providing a solid foundation for any presentation on the history of landscape art.

It was a fortuitous coincidence that the building opened the same year that Adolph Weil Jr., Class of 1935, celebrated his fiftieth reunion. Three months before the official event, Mr. Weil and his

FIG. 20. Members of the German Club in 2005 in the Bernstein Study-Storage Center view the museum's collection of prints by Albrecht Dürer donated by Jean K. Weil in memory of Adolph Weil Jr., Class of 1935. Photo by Joseph Mehling '69.

wife, Jean, toured the facility, later writing that "it was really thrilling to see the new museum that will take the place of the small gallery."[133] Over the course of the next two decades, the entire Weil family became generous supporters of European art at Dartmouth. In addition to Mr. and Mrs. Weil, there were their son, Adolph III, daughters Laurie and Jan, and son-in-law Wallace Darneille, Class of 1973; Mr. Weil's brother and fellow collector, Robert, Class of 1940; Robert's wife, Virginia; and their son, Robert, Class of 1973. Beginning in 1986, Mr. Weil became deeply involved with the arts at Dartmouth through his appointment to the Board of Overseers of the Hopkins Center and Hood Museum of Art. Motivated by a strong belief in the importance of the study of original works of art, he and his wife assisted the museum by lending prints from his collection to exhibitions, making a number of significant donations, and providing funds for additional acquisitions. After his sudden death in 1995, Mrs. Weil gave another extraordinary group of 121 old master prints in his memory. Through these generous gifts they enriched the collections of the museum immeasurably, sharing their deep love of the arts with students and the broader community (fig. 20).

From 1988 to 1995, Mr. Weil supported three scholarly exhibitions that featured his prints: *A Humanist Vision: The Adolph Weil Jr. Collection of Rembrandt Prints* and *Fatal Consequences: Callot, Goya, and the Horrors of War*, both curated by Hilliard T. Goldfarb, and *Two Views of Italy: Master Prints by Canaletto and Piranesi*, organized by Richard Rand, Goldfarb's successor. In honor of all 257 old master and nineteenth-century woodcuts, engravings, etchings, and lithographs donated by Mr. and Mrs. Weil, the museum published a catalogue, *A Gift to the College,* in 1998. During a trip in 2006 to see an exhibition of Rembrandt prints at the museum, most of which were drawn from the family's gifts (fig. 21), Mrs. Weil commented, "There is nowhere else on earth these prints should be. This is the right place for them."[134]

FIG. 21. Professor Joy Kenseth and students examining prints in the exhibition *Rembrandt: Master of Light and Shadow; Etchings from the Collection of the Hood Museum of Art,* 2006. Courtesy of the Hood Museum of Art.

FIG. 22. Exhibition *The Age of the Marvelous,* Hood Museum of Art, 1991. Photo by Jeffrey Nintzel.

Within six years of its opening, the museum launched its most ambitious European exhibition ever, *The Age of the Marvelous,* curated by Joy Kenseth, a professor in the College's Department of Art History. It provided a coherent picture of a trend prevalent throughout Europe from the second half of the sixteenth through the end of the seventeenth centuries of gathering disparate items—illustrated books, paintings, sculptures, decorative works, natural objects, scientific instruments, maps, and prints—with the aim of

comprehending supernatural, natural, and artificial phenomena. The resulting sense of discovery produced the modern idea of progress as well as an enduring desire for novelty. The centerpiece of the installation was a reconstruction of a *Wunderkammer,* or "Room of Wonders," of the sort that nobles and wealthy merchants of the day would use to hold their diverse collections (fig. 22). As described by a reviewer for the *New York Times,* the space, based primarily on an illustration by Ferrante Imperato in the 1599 book *Dell'historia naturale,*

included not only a stuffed alligator, hung upside down from the ceiling, but also pottery from the Iron Age, a Bernard Palissy plate with a raised snake winding across it, a stuffed peacock, a porcelain bowl from the Ming Dynasty, various Greek busts, a narwhal tusk, two wheel-lock rifles with elaborately inlaid handles, a butterfly collection, and so on, in seemingly endless profusion. Flanking the door of this jumble-filled room are paintings by the 16th-century Italian artist Giuseppe Arcimboldo of human figures representing summer and winter, each composed of seasonal fruits and plants. In a vitrine nearby is an enamel and silver snail whose body is a large nautilus shell; a delicately crafted figure of an American Indian sits atop the shell, silver reins in his hands, riding the snail. The dizzying plenitude found in collections of this sort is related to the love of sheer excess found in the Baroque art of the time.[135]

The exhibition later traveled to the North Carolina Museum of Art, Raleigh, the Museum of Fine Arts, Houston, and the High Museum of Art, Atlanta. The 485-page catalogue with its nine essays and 225 entries was highly praised as a useful source for documenting an era when poetic and scientific explanations coexisted.[136]

In 1995, in recognition of the ten-year anniversary of the opening of the museum, then-director Timothy Rub noted, "We have traveled a considerable distance over the past decade."[137] He went on to list various accomplishments, such as—in the case of European art—special exhibitions, purchases and gifts, educational programming, and expanded accessibility through the Internet. At the end of the year, Richard Rand organized a display of fifty-eight prints that had been acquired since 1985, more than half of which had been bought with funds from eleven different endowments and donations. He wrote,

The criteria by which a college museum judges a work of art worthy of acquisition are multifarious; in developing its collection of European prints, the Hood has sought to represent a judicious balance of artistic periods and schools, a range of subject categories, and a variety of printmaking techniques. Primary considerations have been the aesthetic merit and quality of individual impressions, and their relationship to works already in the collection.[138]

FIG. 23. Exhibition *Intimate Encounters: Love and Domesticity in Eighteenth-Century France,* Hood Museum of Art, 1997–98. Photo by Jeffrey Nintzel.

By this time the Hood's holdings of European prints from the Renaissance to the early modern era were notable for their size, distinguished by exceptional quality, and invaluable for the study of the history of printmaking. The great strides made in building the collection reflected prolonged efforts aimed at establishing the museum as an essential asset in the life of students, faculty, and regional communities.

In late 1997 the museum organized a superb loan exhibition entitled *Intimate Encounters: Love and Domesticity in Eighteenth-Century France,* the first major show in the country devoted to French genre painting. Richard Rand, the curator, selected fifty-one paintings and twenty-five prints by well-known artists such as Chardin, Greuze, and Fragonard (fig. 23). The figures in these works—aristocrats and peasants, young and old—performed acts of labor (washing laundry, peeling vegetables, carpentry work) as well as acts of leisure (picnicking, bathing, hunting). The catalogue included five essays that sought "to explain these phenomena by setting them in a broad cultural context, [revealing] ... the discursive function of images which too often are treated as straightforwardly illustrative."[139] The exhibition traveled to the Toledo Museum of Art and the Museum of Fine Arts, Houston, where it received additional popular and critical attention.

In the late 1990s the Hood was named as a partial beneficiary of a multi-million-dollar bequest from Lansing Porter Moore, Class of 1937, and his wife, Florence Bennett Moore. Lansing Moore was an active member of his class and a leader of the Dartmouth Club of Long Island, serving as its president in the 1980s. Gifts from Florence Moore in the early 1990s completely restored the Hopkins

Center Theater—which was renamed the Moore Theater—as well as the theater lobby and the Top of the Hop. Most of the funds in the bequest were applied to a building for psychology and brain sciences named Moore Hall. Timothy Rub, then director of the museum, made the decision to use its portion of the proceeds to create an acquisitions endowment that significantly enlarged the amount of monies available each year for purchasing works of art. These funds led to a number of noteworthy European acquisitions, including works by Perugino, Giordano, De Heem, Trevisani, Boilly, and Braque (cats. 6, 17, 18, 20, 105, and 122).

Two of these purchases deserve particular mention given their impact on the European collection. In the first case, a large, late-fifteenth-century panel now attributed to Perugino and his workshop was acquired at Sotheby's New York in January 1999 (cat. 6).[140] It depicts a *sacra conversazione,* or "Holy Gathering," with the Virgin and Child and four saints. In March 2006 a group of experts on Italian painting gathered to examine the work and discuss their findings in a public colloquium (fig. 24). The new attribution was accepted by all of the participants, who were surprised to discover that—given its size, refinement of some of the figures, and good condition—it had largely eluded scholarly attention.[141] In the other case, a canvas signed by Jan Davidsz. de Heem was purchased in London in early 2006 (cat. 17).[142] It is an exciting example of the still-life genre and is a work by one of Holland's most gifted painters. It was praised by one expert as a "tour de force," and another described it as a "triumph of illusionistic painting in its rendering of textures, space, and the effects of light."[143] Both works have attracted considerable attention from scholars and other visitors.

FIG. 24. Colloquium *Who Really Wielded the Paintbrush? Seeking Answers through Scholarly Examinations and 21st-Century Technologies,* 2006, focusing on the museum's painting by Perugino and workshop (cat. 6) and funded through the museum's Andrew W. Mellon endowment. Courtesy of the Hood Museum of Art.

FIG. 25. Professor Edward Bradley with a student in 2006 examining *Venus Requesting Vulcan to Make Arms for Aeneas,* about 1734–35, by Carle Vanloo (cat. 24). Photo by Joseph Mehling '69.

The growing strength of the permanent collection has allowed for the development of several sizable exhibitions drawn largely from the Hood's diverse array of objects. In 2001, 2004, and 2006 the museum organized a thematic display, a selection of drawings and watercolors, and a monographic presentation, each curated by the current curator of European art. *Antiquity in Rome from the Renaissance to the Age of Enlightenment, Rococo to Modernism: European Drawings and Watercolors,* and *Rembrandt: Master of Light and Shadow* reflected the breadth and quality of its collections. Moreover, the various programs that accompanied these exhibitions, such as symposia, lectures, and other educational activities, were increasingly aimed at diverse audiences.

In honor of the twentieth anniversary of the founding of the Hood Museum of Art, generous alumni, alumnae, and friends of Dartmouth promised or made a number of important gifts. These included contributions from Robert Dance, Class of 1977, Patricia Hewitt and Dale C. Christensen Jr., Class of 1969, Harry T. Lewis Jr., Class of 1955, Tuck 1956, and Dr. David G. Stahl, Class of 1947. The largest and most significant donation came from Jane and W. David Dance, Class of 1940, who largely financed the purchase of a magnificent picture of about 1735 by Carle Vanloo (fig. 25, cat. 24). They had already supported many acquisitions since 1988, especially sculptures, such as works by Carrier-Belleuse, Mercié, Carpeaux, and others (cats. 42, 43, and 44). The decision to make additional funds available was described by Dance in the following manner in

his recently published memoir: "Today with [my son's] help and [my wife's] enthusiasm Dartmouth has a fine collection" of works obtained with the family's support. "The Dance name is now displayed throughout the museum. Since the Hood seemed to be spending our money so wisely, we decided to add it to some trusts that we had set up to benefit Dartmouth. As fast as the funds became available, [we were] told that the museum had acquired [another] impressive painting."[144] As Dartmouth Provost Barry Scherr wrote in the preface to the volume commemorating these gifts, "These important resources help the museum's curators shape the collection in ways that will benefit students, faculty, and the general public by filling gaps and building upon strengths."[145]

The most recent major European acquisition was a celebrated portrait of the great benefactor, William Legge, the Second Earl of Dartmouth (1731–1801), after whom the College was named (cover and cat. 26). The museum purchased the painting by Pompeo Batoni at Sotheby's London in June 2007 with funds generously given by Jane and W. David Dance, Class of 1940, Jonathan L. Cohen, Class of 1960, Tuck 1961, Frederick B. Whittemore, Class of 1953, Tuck 1954, Barbara Dau Southwell, Class of 1978, and David Southwell, Tuck 1988, Parnassus Foundation/Jane and Raphael Bernstein (Dartmouth parents), and an anonymous donor (fig. 26).

From the point of view of the College, the painting portrayed the principal supporter of Eleazar Wheelock's Indian Charity School, who in 1766 met Samson Occom—the first Native American student at the school (then in Connecticut) to travel to England to raise money. In spite of serious reservations about the initial foun-

FIG. 26. Carolyn Pelzel, Vice President for Development, Dartmouth College, David P. Southwell Tu'88, Frederick B. Whittemore '53, Tu'54, President James Wright, Barbara Dau Southwell '78, Jonathan L. Cohen '60, Tu'61, Robert Dance '77, Brian Kennedy, Director, Hood Museum of Art, stand alongside Pompeo Batoni's portrait of Lord Dartmouth (cat. 26) moments after it was unveiled during a ceremony in October 2007. Not present but recognized during the event are Jane and Raphael Bernstein and an anonymous donor. Photo by Joseph Mehling '69.

dation of the College named in his honor,[146] Lord Dartmouth later assisted President John Wheelock after the American Revolution in his attempt to recover funds from British philanthropic organizations and to find additional donors. As Wheelock wrote in early 1784, "[I] applied to the Earl of Dartmouth for a testimonial. He is a most sincere friend to the Institution. . . . His Lordship readily complied with my desire . . . to testify that all monies had been expended with fidelity, economy, and prudence."[147] His letters helped to overcome the objections of some opponents of the school's new mission and greatly facilitated the "offer of services" and expression of "sentiments of a great regard to the Institution" by a number of other Englishmen.[148]

For the Hood Museum of Art, the acquisition garnered unprecedented support for the use of special funds to purchase works of art of outstanding aesthetic quality and historical significance. It also added another extraordinary picture to the collection by the most acclaimed portrait painter in late-eighteenth-century Rome. Batoni's iconic images of British travelers popularized the depiction of informally posed sitters either in open-air settings highlighting Italian landscapes or in enclosed interiors with renowned antiquities. It also reflected the values and tastes of the leading figures promoting the aims of the Grand Tour to Italy, which had long been considered an essential ingredient in the proper education of many young English, Irish, and Scottish noblemen.

Acquisitions of this kind considerably enhance the museum's ability to respond to the growing needs of larger and more diverse audiences by promoting understanding and enjoyment of the visual arts. These purchases would not be possible without the support of alumni and friends. Chief among those who have made the most significant donations toward increasing the scope and quality of the European collection since the opening of the Hood Museum of Art are Jean and Adolph Weil Jr., Class of 1935, Jane and W. David Dance, Class of 1940, and Barbara Dau Southwell, Class of 1978, and David Southwell, Tuck 1988. Their generosity has laid a solid foundation for the future development of European art at Dartmouth.

1. Wheelock published his address later that year under the title *An Essay on the Beauties and Excellencies of Painting, Music and Poetry* (Hartford: Printed by Ebenezor Watson, 1774, reprinted Hanover, N.H.: Charles Spear, no date [possibly 1810]).

2. Jeremy Belknap, "Diary of a Trip to Dartmouth College" (1774), Massachusetts Historical Society, Belknap Papers, Box 5, Folder 14, published by Edward C. Lathem (Hanover, N.H.: Dartmouth Publications, 1950), 17. See also *Life of Jeremy Belknap . . .* (New York: Harper and Brothers, 1845), 70, and Frederick Chase, *A History of Dartmouth College and the Town of Hanover,* ed. John K. Lord (Cambridge, Mass.: J. Wilson, 1891–1913), 1:290.

3. Wheelock, *An Essay,* 10–11. The American painter John Singleton Copley wrote to his brother Henry Pelham in 1774 that Raphael was "the greatest of the modern painters" (*The Letters and Papers of John Singleton Copley and Henry Pelham, 1739–1776* [Boston: Massachusetts Historical Society, 1914], 301). He also noted that his own *Ascension* of 1775 (now in the Museum of Fine Arts, Boston) was modeled after the *Transfiguration* (ibid., 39).

Although George Ticknor, Class of 1807, later minimized his educational experiences at Dartmouth and his relationship with its president (most likely as a result of later disagreements), it is interesting to note certain similarities between Wheelock's description and Ticknor's account of seeing an authentic Raphael painting for the first time, the *Sistine Madonna*: "I had often heard of the power of fine paintings, and I knew that Raphael was commonly reckoned the master of all imitation, and that this was one of the highest efforts of his skill; but I was not prepared for such a vision" (Dresden, September 22, 1816, *Life, Letters, and Journals of George Ticknor,* 2 vols. [Boston: Osgood, 1876], 1:109).

4. In the first dozen years after the establishment of the Boston Atheneum in 1807, for example, fewer than five European paintings and sculptures entered the collection (David B. Dearinger, "200 Years of Collecting for the Boston Atheneum," *American Art Review* 19, no. 3 [May–June 2007]: 161).

5. Wheelock, *An Essay,* passim.

6. Churchill P. Lathrop, "The Story of Art at Dartmouth," *College Art Journal* 10, no. 4 (Summer 1951): 404.

7. In the nineteenth century, the art collections moved with the texts from Dartmouth Hall to Thornton in the late 1820s, to Reed in 1840, and to Wilson in 1885.

8. Lathrop, "The Story of Art at Dartmouth," 401–2.

9. E. Baldwin Smith, *The Study of the History of Art in the Colleges and the Universities of the United States* (Princeton, N.J.: Princeton University Press, 1912), reprinted in Craig Hugh Smyth and Peter M. Lukehart, *The Early Years of Art History in America . . .* (Princeton: Princeton University Press, 1993), 12–36.

10. Cited in Churchill, "The Story of Art at Dartmouth," 403–4, and in Barbara J. MacAdam, "American Drawings and Watercolors at Dartmouth: A History," in MacAdam, *Marks of Distinction: Two Hundred Years of American Drawings and Watercolors from the Hood Museum of Art* (Hanover, N.H.: Hood Museum of Art, Dartmouth College, in association with Hudson Hills Press, 2005), 28 and 44 n. 5. Moore continued to support the arts at Dartmouth by funding annual lectures beginning in 1917 (*Dartmouth Alumni Magazine,* cited in William J. Tucker, *My Generation: An Autobiographical Interpretation* [Boston: Houghton Mifflin, 1919], 361).

11. "Exhibition of Old Masters," *Dartmouth Alumni Magazine* 10, no. 4 (February 1918): 199. The checklist included mostly French, Dutch, and British portraits of the seventeenth and eighteenth centuries, as well as a number of landscapes attributed to Ruysdael, Turner, and Canaletto. For the provenance of the Raeburn painting, see John Hayes, *British Paintings of the Sixteenth through Nineteenth Centuries* (Washington, D.C.: National Gallery of Art, 1992), 188–91.

12. Getty Research Institute, Inventory of the Duveen Brothers Records, 1876–1981, Accession Number 960015, Series II.D, Correspondence with Museums, 1909–1967, Box 331, Folder 10 (1917–1918).

13. "Non-Technical Laboratory Work for the Student of the History of Art," in *Bulletin of the College Art Association of America* 1, no. 3 (November 1917): 90.

14. Ibid., 88.

15. Ibid., 89–90.

16. Ibid.

17. *Dedication of Rollins Chapel and Wilson Hall* (Printed for the College, 1886), 55–56. A brief reference about the need for such a structure also appeared in a letter from one of the trustees, George W. Nesmith, to Samuel Bartlett in June 1879 (Dartmouth College Library [hereafter DCL], Rauner Special Collections [hereafter RSC], Manuscripts 879380).

18. *Dedication of Rollins Chapel and Wilson Hall,* 55–56, also cited in Lathrop, "The Story of Art at Dartmouth," 402.

19. *Dartmouth College Catalogue* (December 1930), 11.

20. *A Program of Support for the Arts at Dartmouth* (Hanover, N.H.: Dartmouth College, 1976), cited in Jacquelynn Baas, "A History of the Dartmouth College Museum Collections," in *Treasures of the Hood Museum of Art* (Hanover, N.H.: Hood Museum of Art, Dartmouth College, in association with Hudson Hills Press, 1985), 19.

21. "The History of the Fine Arts," *Educational Review* 5 (April 1895), cited in *Letters of Charles Eliot Norton,* ed. Sara Norton and M. A. DeWolfe Howe, 2 vols. (Boston: Houghton Mifflin Company, 1913), 2:8.

22. *Annual Report, 2005–6* (Hanover, N.H.: Hood Museum of Art, Dartmouth College, 2006), 98.

23. *Life, Letters, and Journals of George Ticknor,* 2 vols. (Boston: J. R. Osgood, 1876), 1:5.

24. See, for example, DCL, RSC, Manuscript 784251.1, Letter to Baron van Hazerswoude, Amsterdam, April 8, 1784, 2v.

25. John K. Lord, *A History of Dartmouth College* (Concord, N.H.: Rumford Press, 1913), 601.

26. David M'Clure and Elijiah Parish, *Memoirs of the Rev. Eleazor Wheelock . . .* (Newburyport, N.H.: Published by E. Little & Co., C. Norris & Co., 1811), 131–32, and Baxter Perry Smith, *History of Dartmouth College* (Boston: Houghton, Osgood and Company, 1878), 78–79. See also a more skeptical assessment of the trip's benefits to the College, presented by Leon B. Richardson, *History of Dartmouth College* (Hanover, N.H.: Dartmouth College Publications, 1932), 208–9. All of these sources are summarized and discussed in W. Wedgwood Bowen, *A Pioneer Museum in the Wilderness* (Hanover, N.H.: Dartmouth College Museum, 1958), 9–11.

27. DCL, RSC, Manuscript 784157, "Account of My Tour in Europe Relative to the Prosperity of Dartmouth College."

28. Ibid., 5.

29. Especially chapter 24 in the *Elements of Criticism*, 2 vols. (Edinburgh: A. Kincaid & J. Bell; London: Printed for A. Miller, 1762), 2:338–80. Copies of the first American edition of Kames's publication appeared on the list of books available in 1799 in the Hanover Bookstore (*Catalogue of Books . . .*, 16), as well as in Dartmouth's earliest known collection, called the Woodward Library. Similar references can be found in the writings of Wheelock's contemporary, Thomas Jefferson, discussed by Kenneth Hafertepe, "An Inquiry into Thomas Jefferson's Ideas of Beauty," *Journal of the Society of Architectural Historians* 59, no. 2 (June 2000): 216–31.

30. Timothy Dwight, a tutor at Yale and its future president, used it for his class on rhetoric and belles lettres (Leon Howard, *The Connecticut Wits* [Chicago: University of Chicago Press, 1943], 26 and 86, cited in Hafertepe, "An Inquiry," 229 n. 6).

31. Kames's ideas were regularly discussed, for example, in lectures presented at the Royal Academy during this period of time (David Watkin, *Sir John Soane: Enlightenment Thought and the Royal Academy Lectures* [Cambridge: Cambridge University Press, 1996), 42 and 50–53.

32. It is hard to avoid associating Wheelock with the myriad references to architecture in the two volumes of the *Letters from Europe . . .* by Nathan H. Carter, Class of 1811, such as the following description of the Ferrara Cathedral: "It is a Gothic pile, irregular in its form and its style of architecture . . . [exhibiting] few traces of taste and genius" (2 vols., 2nd ed. [New York: G & C & H Carvill, 1829], 1:395).

33. "Modern Arts" (1816–17), with additional annotations made while in France and Italy (DCL, RSC, Codex 002169).

34. *Life, Letters, and Journals of George Ticknor,* 1: 24.

35. Evert A. Duyckinck and George L. Duyckinck, *Cyclopedia of American Literature . . .*, 2 vols. (New York: Charles Scribner, 1856), 1:100.

36. On the bulk of the older, non-British works of art in North America in the early nineteenth century, see James Jackson Jarves, *Italian Sights and Papal Principles Seen through American Spectacles* (New York: Harper and Brothers, 1856), 107–8: "Cargoes go annually to the United States, where . . . [after the addition of] varnish, regilding, and a little retouching . . . they are duly offered for sale as so many Titians, Vandycks, Murillos, or other lights of the European schools."

37. Robyn Asleson, "Atlantic Crossings: British Paintings in America, 1630–1930," in *Great British Paintings from American Collections: Holbein to Hockney,* eds. Malcolm Warner and Robyn Asleson (New Haven: Yale University Press, 2001), 23–24.

38. Laura M. Huntsinger, *Harvard Portraits* (Cambridge, Mass.: Harvard University Press, 1936), 75, cited in Asleson, "Atlantic Crossings," 24.

39. Early-nineteenth-century references to a "lost" full-length portrait of the Second Earl of Dartmouth by John Singleton Copley, "supposed to have been in Dartmouth College," remain ambiguous (*Manuscripts of the Earl of Dartmouth*, 3 vols. [London: Printed for H. M. Stationery Office by Eyre and Spottiswoode, 1887–96], 2:489.

40. On "the Picture of my Grandfather which I had the pleasure of presenting to your institution," see the letter from the younger Lord Dartmouth to President Nathan Lord of September 6, 1830 (DCL, RSC, Manuscripts 830506). For a summary of the history of the College's efforts to secure a portrait of the Second Earl of Dartmouth, beginning as early as 1826, see *Manuscripts of the Earl of Dartmouth* (2:489–93). His grandson also donated a number of books on science and English literature, which "he has understood would have been presented [to the College] had not his connection with the institution been put a stop by political events" (ibid., 493).

41. On the primary role of art in the Foundling Hospital, due in large part to William Hogarth's tenure as its first governor from its establishment until 1760, see "The Foundling Museum," *Burlington Magazine* 143, no. 1180 (July 2001): 403.

42. Churchill, "The Story of Art at Dartmouth," 399.

43. Ibid. The poor condition of the original was already recorded by 1851: "Sir Joshua Reynolds' picture [of the Earl of Dartmouth] is a melancholy example of those experiments in colouring to which the great painter was addicted. The face is of a cadaverous hue, and drapery sadly blistered" (Charles Knight, ed., *London,* 6 vols. [London: Henry G. Bohn, 1851], 3:340).

44. Baas, "A History of the Dartmouth College Museum Collections," 14, and Barbara J. MacAdam, "Dartmouth Collects American Art, 1773–2007," in MacAdam, *American Art at Dartmouth: Highlights from the Hood Museum of Art* (Hanover, N.H.: Hood Museum of Art, Dartmouth College, in association with University Press of New England, 2007), 2–3. The symbolic significance of the pair of portraits of Eleazar Wheelock and Lord Dartmouth was repeatedly reaffirmed, for example, in some of the late-nineteenth-century installations in the Gallery of Paintings in Wilson Hall, as well as in the 1904 celebrations commemorating the laying of the cornerstone for the rebuilding of the campus's main building, Dartmouth Hall. In the latter case, the pictures were displayed "on either side of the platform" in College Church, the central site of the ceremonies (Ernest Martin Hopkins, *Exercises and Addresses Attending the Laying of the Corner-Stone of the New Dartmouth Hall* [Hanover, N.H.: Printed for the College, 1905], 13). On the deliberations regarding the commission of a "painting of the College buildings and surrounding scenery intended as a complement to the Earl of Dartmouth" portrait, see Lord's Report to the Board of Trustees of 1830 (DCL, RSC, Manuscripts 830900.2, 14v).

45. Marius Schoonmaker, *John Vanderlyn, Artist, 1775–1852: Biography* (Kingston, N.Y.: Senate House Association, 1950), 44, cited in David A. Brown, "Raphael's Prestige," in Brown, *Raphael and America* (Washington, D.C.: National Gallery of Art, 1983), 22. Albert G. Hoit, Class of 1829 (discussed below), apparently spent most of his time in Europe copying old master paintings. In 1845 he exhibited two replicas after seventeenth-century landscapes in Boston after his return to the United States (Patricia L. Heard, *With Faithfulness and Quiet Dignity: Albert Gallatin Hoit, 1809–1856* [Concord, N.H.: New Hampshire Historical Society, 1985], unnumbered pages). See also Robert S. Duncanson's disappointment with the large number of mid-nineteenth-century American artists interested solely in copying European masterpieces: Joseph D. Ketner, "The Light of Europe: The 'Grand Tour,'" in *The Emergence of the African-American Artist: Robert S. Duncanson, 1821–1872* (Columbia: University of Missouri Press, 1993), 73. Nathaniel Hawthorne recorded a conversation with a painter in Florence in 1858 in which the artist lamented that the copying of pictures had become so prevalent that it endangered the "existence of a modern school of painting" (*Passages from the French and Italian Note-Books of Nathaniel Hawthorne,* 2 vols. [Boston: Houghton Mifflin, 1899], 2:28).

46. Neil Harris, "The Gilded Age Revisited: Boston and the Museum Movement," *American Quarterly* 14, no. 4. (Winter 1962): 552–54.

47. *Portrait of a Noble Lady in Widow's Weeds,* about 1660s, oil on canvas, 44½ x 34 inches (P.842.1), and *Portrait of a Nobleman or Gentleman in Armor,* about 1660s, oil on canvas, 44⅞ x 34 inches (P.842.2). The similar format, scale, date, and country of origin of the two portraits suggest that

they were intended as a pair, although they appear to have been executed by different artists. Given the woman's distinctive clothing, which indicates that she is a widow, the male portrait may have been done posthumously.

48. George H. Evans, *Catalogue of Portraits and Other Works of Art in the Gallery of Dartmouth College* (Hanover, N.H.: no publisher, 1901), 33–34.

49. For biographical details and references to Hoit's correspondence, see Heard, *With Faithfulness and Quiet Dignity.*

50. George Ticknor visited Cardinal Fesch and toured the palace's painting galleries in the fall of 1818, recording in his journal, "The Cardinal has the finest private gallery of pictures I have seen" (*Life, Letters, and Journals,* 1:181). He returned again in December 1836 (ibid., 2:64).

51. *Catalogue des tableaux composant la galerie de feu son Eminence le Cardinal Fesch* (Rome: Joseph Salvucci et Fils), 9.

52. Rome, Archivio di Stato, Notai Capitolini, Ufficio 11, notary Augusto Apolloni, 1839, vol. 609, f. 213v, nos. 3249 and 3250 (transcribed for the Getty Provenance Index Database).

53. As discussed above, during Hoit's tenure at Dartmouth, College officials were keenly interested in obtaining a portrait of the Second Earl of Dartmouth. He may have considered his donations as a complement to the effort to obtain authentic old master paintings for the collection.

54. Trustee Meeting Minutes, DCL, RSC, July 26, 1836, cited in Baas, "A History of the Dartmouth College Museum Collections," 20 n. 27.

55. Oil on canvas, 27 x 53 inches (P.880.4). Some of the earliest copies after Reni's paintings to be found in the United States are recorded in the early nineteenth century in the collection of the Pennsylvania Academy of Fine Arts, donated by Joseph Allen Smith (1769–1828), cited in E. P. Richardson, "Allen Smith, Collector and Benefactor," *American Art Journal* (1969): 16.

56. Barbara A. Wolanin, *Costantino Brumidi: Artist of the Capitol* (Washington, D.C.: U.S.G.P.O., 1998).

57. Another copy of Guido Reni's *Aurora* by Costantino Brumidi was sold in Washington, D.C., by Adam A. Weschler & Son, Inc., on December 13, 2003 (*Antiques and the Arts Weekly* [December 5, 2003]: 82).

58. Wolanin, *Costantino Brumidi,* 159.

59. Charles H. Bell, *The Bench and Bar of New Hampshire* (Boston: Houghton, Mifflin & Co., 1894), 119–21.

60. DCL, RSC, Manuscript 879380, June 30, 1879. Nesmith lamented to Bartlett that there was as yet no permanent place to display the painting.

61. Ser. 3, 36 (September 5, 1879): 9.

62. Evans, *Catalogue of Portraits,* 8–9.

63. Ibid., 38–40. The photographs were donated by Edward Spalding, Class of 1833.

64. Trevor Fawcett, "Visual Facts and the Nineteenth-Century Art Lecture," *Art History* 6 (December 1983): 452.

65. *Dartmouth College Handbook* 9 (Hanover, N.H.: Dartmouth Christian Association, 1897–98), 215.

66. Fawcett, "Visual Facts," 453–54, and Robert P. Spindler, "Windows to the American Past: Lantern Slides as Historic Evidence," in *Art History through the Camera's Lens,* ed. Helene E. Roberts (Langhorne, Penn.: Gordon and Breach, 1995), 136.

67. DCL, RSC, "Description of Stereopticon Views . . . ," 1904. For biographical information on Lord, see *Who's Who in New England,* ed. Albert N. Marquis, 2nd ed. (Chicago: A. N. Marquis & Co., 1916), 683.

68. "Miscellaneous lectures," about 1905, DCL, RSC, Manuscript 905940, passim.

69. *New York Times* (March 10, 1913), 17. For a brief biography and references to Keyes's achievements in the *Dartmouth Alumni Magazine* and the *Dartmouth,* see Scott B. Meacham, "Charles Alonzo Rich Builds the New Dartmouth, 1893–1914," M.A. thesis (University of Virginia, 1998), chap. 2, n. 68. See also *Who's Who in New England,* 630.

70. See, for example, William Jewett Tucker (President Emeritus of Dartmouth College), *My Generation: An Autobiographical Interpretation* (New York: Houghton Mifflin Company, 1919), 90–99.

71. On the distinctive quality and provenance of the Piranesi collection acquired by Dartmouth College, see Richard Rand, "Canaletto and Piranesi: An Introduction," in Rand and John Varriano, *Two Views of Italy: Master Prints by Canaletto and Piranesi* (Hanover, N.H.: Hood Museum of Art, Dartmouth College, 1995), 21–23. See also Andrew Robison, *Piranesi: Early Architectural Fantasies: A Catalogue Raisonné of the Etchings* (Washington, D.C.: National Gallery of Art, in association with the University of Chicago Press, 1986), 240–41, n. 18.

72. DCL, RSC, Manuscript 301, Robert Jackson, Miscellaneous Correspondence, 1929.

73. The Museum of Modern Art Department of Circulating Exhibitions, I.24.18.3 (1932–36), including correspondence between Professor Artemas Packard and Alfred H. Barr Jr., director of MoMA.

74. Ibid., II.1.117.6, and Hood Museum of Art (HMA) Archives, Philip A. White, "Tenth Anniversary Report of the Carpenter Galleries," typescript (July 1939), 24.

75. Ibid., 27.

76. For detailed biographical information and a discussion of these donors' associations with Dartmouth, see MacAdam, "American Drawings and Watercolors at Dartmouth," 30–34.

77. HMA Archives, draft of a letter from Churchill P. Lathrop to A. Conger Goodyear, June 5, 1961, cited in MacAdam, "American Drawings and Watercolors at Dartmouth," 33–34.

78. Cited in Lathrop, "The Story of Art at Dartmouth," 409. For basic biographical information on Mrs. Whittier and the history of the fund, see MacAdam, "American Drawings and Watercolors at Dartmouth," 34.

79. *The Richard H. Rush Collection,* exhibition catalogue (Hanover, N.H.: Carpenter Art Galleries, 1959).

80. *Hogarth and His School: Paintings and Prints from the Collection of Earle W. Newton,* exhibition brochure (Hanover, N.H.: Carpenter Galleries, Dartmouth College, 1960). The majority of these works now forms the core of the Earle W. Newton Center for British and American Studies at the Savannah College of Art and Design.

81. *Selections from the Collection of Dutch Drawings of Maida and George Abrams,* exhibition catalogue (Wellesley, Mass.: Wellesley College Museum, 1969). Dartmouth was the first venue.

82. *The Protean Century, 1870–1970: A Loan Exhibition from the Dartmouth College Collection, Alumni and Friends of the College* (February 10–28, 1970), exhibition catalogue (Hanover, N.H.: Dartmouth College, 1970), ix.

83. Jacquelynn Baas, "From 'A Few Curious Elephant Bones' to Picasso," *Dartmouth Alumni Magazine* 77, no. 11 (September 1985): 43, and Baas, "A History of the Dartmouth College Museum Collections," 18.

84. *A Program of Support for the Arts at Dartmouth,* cited in Baas, "A History of the Dartmouth College Museum Collections," 19.

85. Helena E. Wright, "Print Collecting in the Gilded Age," *Imprint: Journal of the American Historical Print Collectors Society* 29, no. 1 (Spring 2004): 5.

86. "Modern Arts," passim.

87. George Ticknor, "Griscom's Tour in Europe," *North American Review* 18 (January 1824): 365–66, cited in Marjorie B. Cohn, *Francis Calley Gray and Art Collecting for America* (Cambridge, Mass.: Harvard University Art Museums, distributed by Harvard University Press, 1986), 208.

88. From a late-eighteenth-century collector's guide, *Sculptura Historico-Technica: or the History and Art of Engraving,* 4th ed. (London: J. Marks, 1770), 1, cited in Cohn, *Francis Calley Gray,* 184.

89. For a brief summary on the history of Marsh's prints, see Wright, "Print Collecting in the Gilded Age," 3.

90. University of Vermont Library, Special Collections, George P. Marsh Papers, "List of Articles in Woodstock trunks," undated, cited in Wright, "Print Collecting in the Gilded Age," 12 n. 15. The celebrated painting in Florence is now attributed to Francesco Salviati.

91. For example, in 1799 the Hanover Bookstore listed copies of the American edition of *Secrets of Arts, or Approved Directions for Engraving . . . ,* 1st or 2nd ed. (Norwich, Conn.: Printed by T. Hubbard, 1795 or 1798), 25.

92. Wright, "Print Collecting in the Gilded Age," 4.

93. *Catalogue of the Library of George Perkins Marsh* (Burlington: University of Vermont, 1892), v, cited in Wright, "Print Collecting in the Gilded Age," 3.

94. Caroline C. Marsh, *Life and Letters of George Perkins Marsh* (New York: Scribners, 1888), 23.

95. Wright, "Print Collecting in the Gilded Age," 3.

96. *Catalogue of Dartmouth College* (Hanover, N.H.: Printed for the College by the Rumford Press, 1914), 152.

97. *American Magazine of Art* 8, no. 6 (April 1917): 245–46.

98. *Renaissance News* 2, no. 1 (Spring 1949): 14.

99. Lawrence W. Nichols, *Piranesi at Dartmouth: Etchings by Giovanni Battista Piranesi in the Dartmouth College Collections* (Hanover, N.H.: Hopkins Center, Dartmouth College, 1976).

100. *Theater Art of the Medici,* exhibition catalogue (Hanover, N.H.: Dartmouth College Museum and Galleries, distributed by University Press of New England, 1980).

101. Review by Meg Licht in *Journal of the Society of Architectural Historians* 40, no. 3 (October 1981): 242.

102. DCL, RSC, Manuscrpt 784251.1, Letter to Baron van Hazerswoude, April 8, 1784, 2v.

103. Bowen, *A Pioneer Museum in the Wilderness,* 11.

104. On the Bartlett donation, see Anne Odom, "American Collectors of Russian Decorative Art," in *Treasures into Tractors: The Selling of Russia's Cultural Heritage, 1917–1937,* forthcoming.

105. Ibid.

106. HMA Donor Files. Mr. Smith's most noteworthy gift was the terracotta, black-figure Panathenaic amphora of about 480–470 BCE (C.959.53).

107. See, for example, Charles Borromeo, *Instructiones fabricate et suppellectis ecclesiastice,* 1577 (Vatican City: Libreria Editrice Vaticana, 2000), passim. On the context in Bergamo at this time, see Giles Knox, "The Unified Church Interior in Baroque Italy: S. Maria Maggior in Bergamo," *Art Bulletin* 82, no. 4 (December 2000): 679–701. Unfortunately, there is no information on the precise provenance of this piece.

108. Dick Hoefnagel and Jeffrey L. Horrell, "The Sherman Art Library Fireplace-Mantel: From Paris to Dartmouth," *Dartmouth College Library Bulletin,* new series 29, no. 2 (April 1989): 72–82.

109. For an overview of the entire collection, see Diane Miliotes, "On All Fronts: Posters from the World Wars in the Dartmouth Collection," in *War Posters,* exhibition brochure (Hanover, N.H.: Hood Museum of Art, Dartmouth College, 1999).

110. Ibid., 2.

111. On the gifts from Belknap, the founder of the Massachusetts Historical Society, see Bowen, *A Pioneer Museum in the Wilderness,* 11.

112. In addition to the impressionist exhibition, which included twenty-five paintings, there were thirty contemporary sculptures lent by Governor Nelson A. Rockefeller and others, as well as prints by late-nineteenth- and early-twentieth-century masters (described in detail by Churchill P. Lathrop, "Director's Report," in *Bulletin: Dartmouth College Hopkins Center Art Galleries* 1 [January 1966]: 1–2). See also the notices and reviews that appeared in *Art Journal* 22, no. 3 (Spring 1963): 180 and *Dartmouth Alumni Magazine* 55, no. 3 (December 1962): passim.

113. On the establishment of the annual fine arts awards in memory of the late Professor Adelbert Ames Jr., see the HMA Donor Files. See also the announcements in *Dartmouth Alumni Magazine* 55, no. 3 (December 1962): 16, and *Bulletin* 1 (January 1966): 2.

114. *Dartmouth Alumni Magazine* 55, no. 3 (December 1962): 17.

115. "French and American Painting," second semester, "focusing on 19th century and contemporary art" (*Catalogue of Dartmouth College* [Hanover, N.H.: Printed for the College by the Rumford Press, 1913], 173).

116. Sue Ann Prince, "'Of Which and the Why of Daub and Smear': Chicago Critics Take on Modernism," in *The Old Guard and the Avant-Garde: Modernism in Chicago, 1910–1940,* ed. Sue Ann Prince (Chicago: University of Chicago Press, 1990), 98–100.

117. Cited in ibid., 100.

118. For more on Churchill P. Lathrop's career at Dartmouth, see MacAdam, "American Drawings and Watercolors," 44 n. 2, and the *New York Times* (January 7, 1996), 30.

119. For more information about the planning, execution, and reception of Orozco's project, see Jacquelynn Baas, "'The Epic of American Civilization': The Mural at Dartmouth College," in *José Clemente Orozco in the United States, 1927–1934,* eds. Renato González Mello and Diane Miliotes (Hanover, N.H.: Hood Museum of Art, Dartmouth College, in association with W. W. Norton and Company, 2002), 142–85. There does not seem to be any record of Zug's role in bringing Orozco to Dartmouth, but his interest in this form of art was recorded as early as 1908, when he published the article "Contemporary Mural Painting" in *The Chautauquan* 50 (April): 229–47 and created a course titled "Great Periods of Mural Decoration" at the University of Chicago.

120. Letter from Artemas Packard to Alma Reed (Orozco's New York dealer), May 22, 1931 (DCL, RSC), cited in Baas, "'The Epic of American Civilization,'" 149.

121. White, "Tenth Anniversary Report of the Carpenter Galleries," 11.

122. Southern Illinois University—Carbondale, Special Collections Morris Library, The Center for Dewey Studies, docs. 05768 and 08099. Eastman was associated with a progressive journal that periodically published articles on international artistic matters, such as a succession of contributions on the relevance of abstraction, dadaism, and surrealism that appeared in the magazine *Art Front* in late 1934 and early 1935 (Virginia Hagelstein Marquardt, "Art on the Political Front in America: From *Liberator* to *Art Front*," *Art Journal* 52, no. 1, Special Issue on Political Journals and Art, 1910–1940 [Spring 1993], esp. 79–80). Mather, director of the Princeton

Art Museum since 1922, had donated 118 contemporary French and German etchings from his own collection to the Metropolitan Museum of Art in 1923. He did not, however, actively acquire modern art for his alma mater. He felt that teaching museums should only collect works by artists who had been dead for at least twenty years ("The Museum of Historic Art at Princeton University," *Art in America* 32 [1944]: 189, cited in Barbara T. Ross, "The Prints and Drawings Collection: The Early Years," *Record of the Art Museum, Princeton University* 55, nos. 1–2, Special Issue on *An Art Museum for Princeton: The Early Years* [1996]: 143). In spite of the title of Rothschild's book of 1934, *The Meaning of Unintelligibility in Modern Art* (Chicago: University of Chicago Press), in the preface he stated, "This book is concerned with the understanding of meaning in art as a way to enjoyment."

123. On Jaffe's munificence toward Dartmouth College's art collections, see the brochure by Churchill P. Lathrop, "A Collector's Choice: Selected Gifts Presented by Mr. and Mrs. William B. Jaffe . . . , 1955–1972" (Hopkins Center, Dartmouth College, 1972), 1.

124. The first meeting of the Art Advisory Group was held in October 1960 (MoMA Archives, Alfred H. Barr Jr. Papers, I: 343).

125. *The Protean Century, 1870–1970*, vi.

126. HMA donor files and DCL, RSC, Papers of John G. Kemeny, DP-13 (46): R file, and DP-13 (51): Gifts.

127. Ibid.

128. For the history of Harrison's gifts and his long association with the Rockefeller family and Dartmouth College, see *Thank You, Wallace K. Harrison*, exhibition catalogue (Hanover, N.H.: Hood Museum of Art, Dartmouth College, 1985). All of the gifts were given anonymously until 1985, when Ellen Harrison gave her permission to alter the credit lines.

129. Douglas C. McGill, "New Hood Art Museum Opening at Dartmouth," *New York Times* (September 26, 1985): C-17.

130. Baas, "A History of the Dartmouth College Museum Collections," 19.

131. HMA Donor Files, letter to Jacquelynn Baas, November 3, 1987, with copies to President Freedman et al.

132. "Recent Accessions in European and Graphic Art at the Hood," *Dartmouth Alumni Magazine* 78, no. 7 (April 1996): 44.

133. HMA Donor Files, letter to Jacquelynn Baas, June 11, 1985.

134. Private conversation.

135. Charles Hagen, "A Commodious Omnium-Gatherum at Dartmouth" (November 10, 1991): 33.

136. Amy Golahny, "Review of 'The Age of the Marvelous,'" *Sixteenth Century Journal* 24, no. 4 (Winter 1993): 972–73.

137. *The Hood Museum of Art, 1985–1995*, brochure, 1.

138. *A Decade of Collecting: 1985–1995; Old Master and Nineteenth-Century European Prints*, exhibition brochure, 2.

139. Katie Scott, *The Burlington Magazine* 140, no. 1142 (May 1998): 334.

140. Oil and tempera on panel, 69¼ x 67⅜ inches (P.999.2).

141. The only known references are J. A. Crowe and G. B. Cavalcaselle, *A History of Painting in Italy, Umbria, Florence, and Siena from the Second to the Sixteenth Century*, ed. Langton Douglas, 2nd ed., 6 vols. (London: J. Murray, 1903–1914), 5:369, and Filippo Todini, *La pittura umbra dal Duecento al primo Cinquecento*, 2 vols. (Milan: Longanesi, 1989). Crowe and Cavalcaselle attributed the painting to Tiberio d'Assisi, a pupil of Perugino, while Todini—based only on a photograph—considered it to be by Giannicola di Paolo, another assistant.

142. Oil on canvas, 28 x 34¾ inches (2006.11).

143. Arthur K. Wheelock Jr., *In Celebration of Jan Davidsz. de Heem's Still-Life with Grapes*, exhibition brochure (Hanover, N.H.: Hood Museum of Art, Dartmouth College, 2006), unpaginated, and Joy Kenseth, "Splendor at the Table: The Artistry of Jan Davidsz de Heem," *Hood Quarterly* 16 (Summer 2006): 4–5.

144. *Memoirs: W. David Dance* (Naples, Fla.: privately printed, 2007), 167–68.

145. *Celebrating Twenty Years. Gifts in Honor of the Hood Museum of Art* (Hanover, N.H.: Hood Museum of Art, Dartmouth College, 2005), 8.

146. Richardson, *History of Dartmouth College*, 1:112ff.

147. Wheelock, "An Account of My Tour in Europe," 11–12. For an interpretation of the significance of this passage, see Leon B. Richardson, "John Wheelock's European Journey," *Dartmouth Alumni Magazine* (January 1933): 11, n. 17.

148. Ibid., 17.

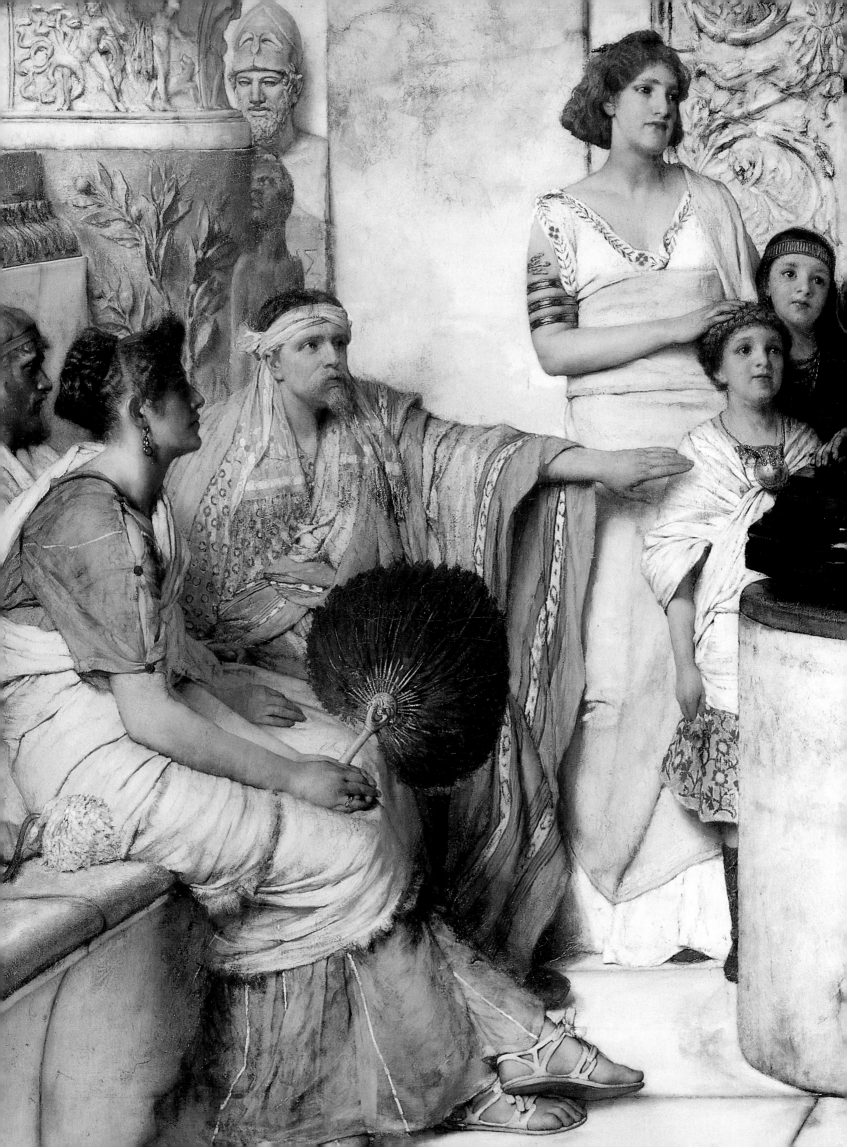

Catalogue

Contributors

In addition to the author, whose initials are TBT, twenty-nine other scholars prepared almost half of the following catalogue entries or modified previously published texts to accommodate the format of this volume. Some of them are Hood staff members and Dartmouth faculty, past and present. Their initials appear at the end of each entry.

[JMB]	Juliette M. Bianco	[MWL]	Margaret W. Lind
[LRB]	Laura R. Braunstein	[BJM]	Barbara J. MacAdam
[DB]	Duncan Bull	[JPM]	J. Patrice Marandel
[JLC]	Jane L. Carroll	[FM]	François Marandet
[MD]	Michele Danieli	[KP]	Kelly Pask
[PE]	Patricia Emison	[AWBR]	Adrian W. B. Randolph
[MCG]	M. C. Gaposchkin	[AR]	Angela Rosenthal
[HTG]	Hilliard T. Goldfarb	[TR]	Timothy Rub
[KWH]	Katherine W. Hart	[SLS]	Stacey L. Sell
[AG]	Anne Grace	[MAS]	Margaret A. Sullivan
[KH]	Karen Hearn	[KJS]	Kurt J. Sundstrum
[WBJ]	William B. Jordan	[NT]	Naoko Takahatake
[JRJ]	J. Richard Judson	[GST]	Geoffrey S. Taylor
[BK]	Brian Kennedy	[BEW]	Barbara E. Will
[JK]	Joy Kenseth		

Note to the Reader

This catalogue highlights selected European works from Dartmouth's collections, dating from the fifteenth century through the 1930s. Entries are organized in rough chronological order according to two different categories: Paintings and Sculpture; and Drawings and Prints. All measurements are outside dimensions unless otherwise noted, with height preceding width, then depth (when applicable). Dimensions are to plate for intaglio prints, and to the image for lithographs and relief prints. Dimensions for drawings, watercolors, and paintings are to the outside edges of the support (paper, canvas, and so on).

Published sources relevant to each entry appear in abbreviated form at the conclusion of each entry, with full citations listed in the bibliography.

A complete inventory of the Hood's European collections, as well as the museum's other holdings, may be found through the museum's online catalogue, accessible via its Web site (www.hoodmuseum.dartmouth.edu).

Paintings and Sculptures

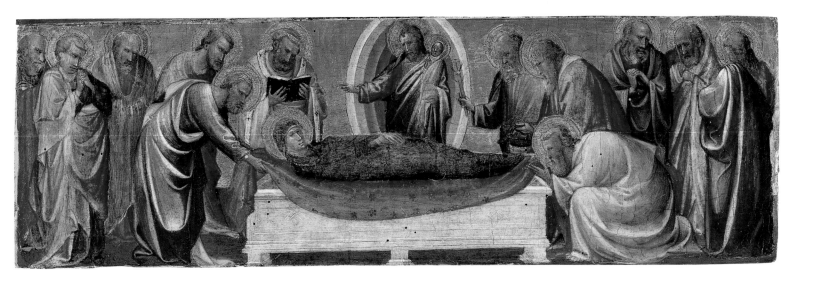

1. Gherardo Starnina, Italian, about 1354–about 1413

The Dormition of the Virgin, about 1405–10

Tempera and gold leaf on panel, 7 x 22¼ inches
Gift of Mr. and Mrs. Ray Winfield Smith, Class of 1918; P.975.5

This *predella* panel represents the *Dormition of the Virgin,* a subject with a long history in early Christian and Byzantine art. The apostles, led by Peter, appear to be conducting a funerary Mass over Mary's remains, while a priestly, mandorla-framed Christ at center blesses his mother's immortal and therefore "sleeping" body with his right hand and cradles her living soul (in the form of a baby) in his left arm. *Predelle,* set at the foot of altarpieces, served to elevate and render more visible the iconic images of the main panels, which provided a backdrop to liturgical rites. The smaller *predelle* provided artists with the opportunity to develop stories and appeal to the attentive viewer seeking a more narrative approach to devotion. In this case, the sensitively represented gestures and expressions of the funeral cortège relate the human tragedy of death. Some of the apostles wring their hands, others find refuge in the appurtenances of the ceremony (the book and the holy water), and still others seem to turn to one another in disbelief and grief.

Although the panel has suffered some damage and has been restored a number of times, the artist originally responsible for painting it was clearly very skilled. The figures on the far right, especially, demonstrate that this artist not only received up-to-date training but also was able to offer nuanced interpretations of human physiognomy. Standing with his back toward the viewer, the figure on the far right is especially striking; few painters before Masaccio (1401–1428) could represent weighty sculptural form so convincingly. If the artist is indeed Gherardo Starnina, this panel would tend to support those art historians who consider him to be a participant in the revival of interest in Giotto's art in the early fifteenth century; conversely, it would seem to undermine arguments that see Starnina, following his return from Valencia, as spurring an interest among Florentine artists in the style modern art historians have labeled "International Gothic." [Kanter 1994: 135, fig. 28]

AWBR

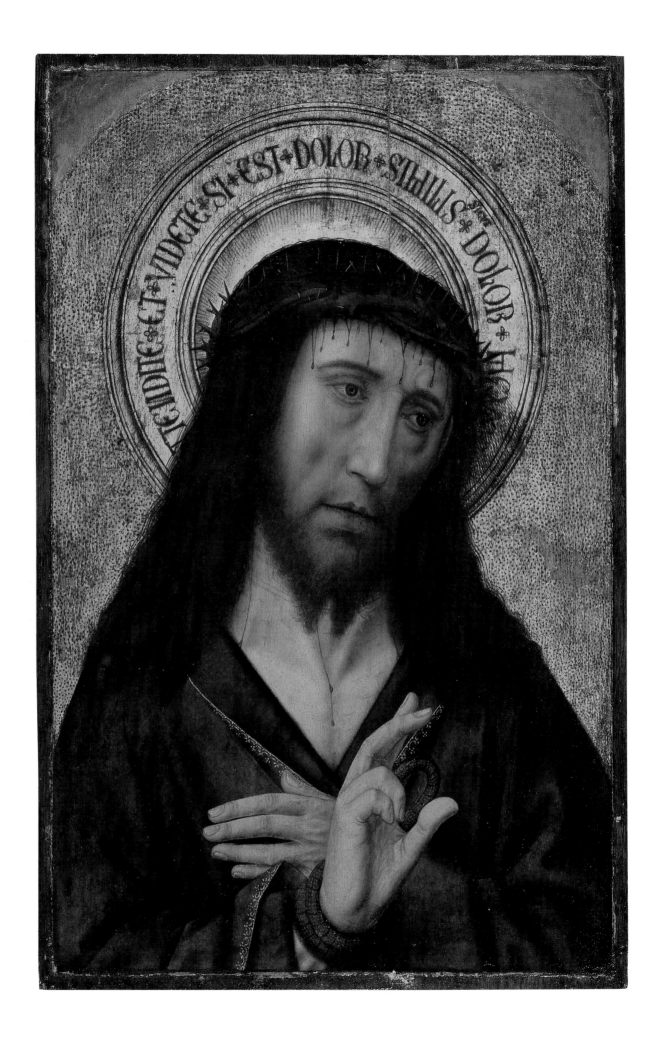

2. Workshop of Albrecht Bouts, Netherlandish, about 1452/55–1549

Christ with the Crown of Thorns, about 1500

Oil and gold leaf on panel, 2⅞ x 16¼ inches
Inscribed on the halo of Christ: Attendite et videte si est dolor similis sicut dolor meus ("Look and see if there is a sorrow like my sorrow")
Purchase made possible by gifts from Olivia and John Parker, Class of 1958; the Mrs. Harvey P. Hood W'18 Fund; Mr. and Mrs. A. Brooks Parker III, Class of 1955; and the Friends of the Museum; P.986.67

Albrecht Bouts lived in Leuven (now Belgium), where he specialized in ecclesiastical and private religious pictures. This painting followed a model often repeated by the artist, his father, Dirck (about 1410–1475), and their studios. It expressed a new vision of the humanity and suffering of Christ through the fusion of two traditional modes of representation: the Salvador Mundi, a triumphal image of Christ as the Savior of the World, and the Man of Sorrows, a devotional image of the dead Christ displaying the wounds of his Passion. The work acknowledges the suffering of Jesus, who, in response, raised his hand in blessing. A study done in 1938 documented the existence of forty-three other examples of this type from the Bouts circle, thirty-four of which were single images of Christ and the remaining nine paired with images of the Virgin and Child (cited in Hand, Metzger, and Spronk 2006: 310 n. 6).

Encircling Christ's head are the Latin words *Attendite et videte si est dolor similis sicut dolor meus* ("Look and see if there is a sorrow like my sorrow"), from a devotional prayer popularized in northern Europe in the early fifteenth century. According to John Hand of the National Gallery of Art (private conversation), the inscribed halo is highly unusual in this region during the late 1400s and early 1500s.

Another unique aspect of this painting can be seen in the photograph below, taken in raking light, which helps to highlight repairs to previous scratches on the face. The eyes and mouth are typically considered the clearest and most obvious indications of the vitality of the represented figure, and thus they are often mutilated to remove the signs of life. This damage is characteristic of the iconoclasm practiced in northern Europe during the Reformation in the sixteenth century. Some Protestant reformers at this time argued that Christians should concentrate on religious worship in prayer, music, and congregational fellowship without the distraction of intermediate art forms. TBT

FIG. 1. Raking image of the scratches on the surface of the painting, possibly dating to the sixteenth century.

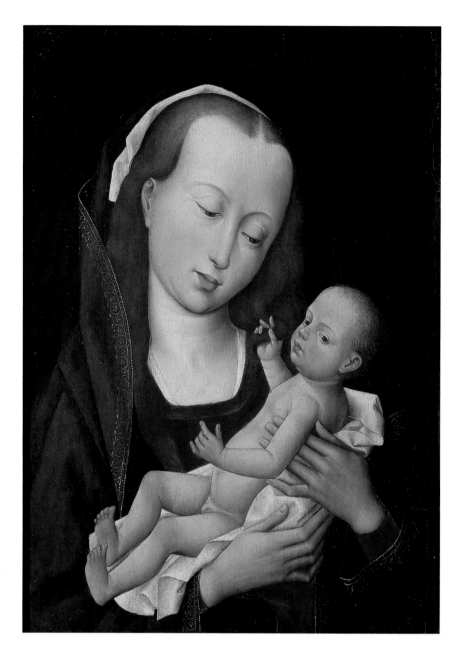

3. Master of the Magdalen Legend, Netherlandish, active about 1475/80–1525/30

Virgin and Child, about 1490–1500

Oil on panel, 15⅞ x 11¼ inches
Purchased through the Mrs. Harvey P. Hood W'18 Fund and the
Robert J. Strasenburgh II 1942 Fund; P.985.53

This devotional panel is a variant of the type of half-length depiction of the Virgin and Child popularized in the middle of the fifteenth century by the Netherlandish artists Rogier van der Wyden (about 1399–1464) and Robert Campin (1375/79–1444). They apparently influenced the painter who executed this picture, who has traditionally been identified as the Master of the Magdalen Legend, someone most likely active in Brussels and named after an altarpiece containing scenes from the life of Mary Magdalen (now dispersed).

A number of similar Virgin and Child depictions have been attributed to this artist as well.

Another characteristic shared with the work of Rogier is the new medium of oil paint. Here the artist, taking advantage of oil's technical possibilities, used translucent glazes to achieve a richness and depth of color not possible in other media. These features are heightened by the lack of any background details, which make the figures appear more isolated.

A number of portraits have been associated with the Master of the Magdalen Legend, many of which may have originally formed diptychs with the Virgin and Child compositions (such as those discussed in Hand, Metzger, and Spronk 2006: 156–161, no. 23). The present panel has a later frame, so there are no indications of the presence of hinges on either side, where a donor portrait would have been traditionally located—most likely to the right facing the Virgin and Child. TBT

4. Unknown Burgundian Master, active late fifteenth century

Saint Barbara, about 1470–90

Polychromed wood, height 37½ inches
Gift of Edward A. Hansen and John Philip Kassebaum, Class of 1985P; S.981.102

Three female saints were exceptionally popular in the late Middle Ages: Margaret, Catherine, and Barbara. This sculpture of the latter saint is a perfect example of the cult statues often mounted in chapels and churches. Barbara was a pagan princess whose father kept her safe in a tower he built for her, but he then persecuted her when she announced her conversion to Christianity. She was renowned for her learning, especially her ability to outreason the pagan philosophers. In this piece, Saint Barbara is shown with three of her many attributes: the crenellated tower, her crown, and a book. She is thus simultaneously of elevated status, wise, and clever. For example, she had a third window placed in a tower to symbolize the Trinity. Such a figure would have been particularly appealing to the communities of female religious, which were comprised of the daughters of the nobility. This work may have been executed for such a group, who looked to the virgin martyrs as models for committed faith.

The present work is related in style and symbols to statues of the saint found in Pontaubert, a village southeast of Paris, and in the Musée Rolin, Autun. The numerous points of commonality in costume and figure type firmly place the statue in the Burgundian school, identified by its propensity for oval heads, soft facial features, and long, loosely curled hair. Yet the aforementioned comparative examples are larger and carved from stone rather than wood. The figure of Saint Barbara is stylistically simpler, with fewer drapery folds and a more impassive face, suggesting that it most likely was commissioned by provincial patrons.

The attributes of this work have been given greater emphasis. The three windows in the tower are clearly visible, and the pages in the volume she holds are divided into three parts, which is particularly unusual. Both symbols refer to the Trinity, the locus of Saint Barbara's devotion, and they are given equal emphasis and weight, so that the sculpture seems to assert that the components of active devotion are identical parts faith, sacrifice, and knowledge of the word of God. In this sculpture, faith and doctrine literally go hand in hand. [Gillerman 1980: 344–45] JLC

5. Unknown Bavarian Master, active about 1500

Saint Joseph with the Christ Child, about 1510

Oak, height 28½ inches
Gift of Mark Lansburgh, Class of 1949; 2007.70.2

Saint Joseph is a problematic figure in the early church. He is rarely mentioned in the Bible though found frequently in apocryphal texts. Those tales vary in detail but always contain three elements: Joseph was a carpenter, the protector of the Virgin, and the foster father of Jesus. In the 1400s, Joseph began to play a greater part in theological discussions concerning his role in the incarnation and the nature of his marriage to Mary.

The present work is thus a rare early expression of adoration for the earthly father of Christ. In northern Europe, the rise of the cult of the Holy Clan, a veneration of the extended family of the Virgin that included her sisters and their husbands, expanded Joseph's visibility and gave him a place in popular culture as a nurturing father. In fact, the Vulgate refers to Jesus as *fabri filius,* the carpenter's son, making the connection between God the Father, who crafted the world, and Joseph, the mortal parent, who was an artisan on earth.

The saint is depicted in the sculpture leading the Christ Child along, guiding him metaphorically on the journey through this world. Joseph's right hand grasps the wrist of Jesus, whose bowed stomach and drapery folds seem to indicate forward movement. Both Joseph and Jesus are dressed simply. In addition, Joseph has stuck a drill into his belt, alluding to his trade and his role as the family provider. Jesus holds a round object in his right hand; its ball-like shape evokes the orb of rulership and the apple of Adam, whose sin Christ will redeem. Below the main figures, on the corbel, two carpenters work at their craft. This gesture, along with Joseph's patronage of carpenters, suggests that this work may have been commissioned by a carpenters' guild for a small chapel. Its scale and unpolychromed surface indicates a less wealthy patron, while the delicacy of the carving and the graceful folds are evidence of a master. [Lansburgh 1977: no. 17] JLC

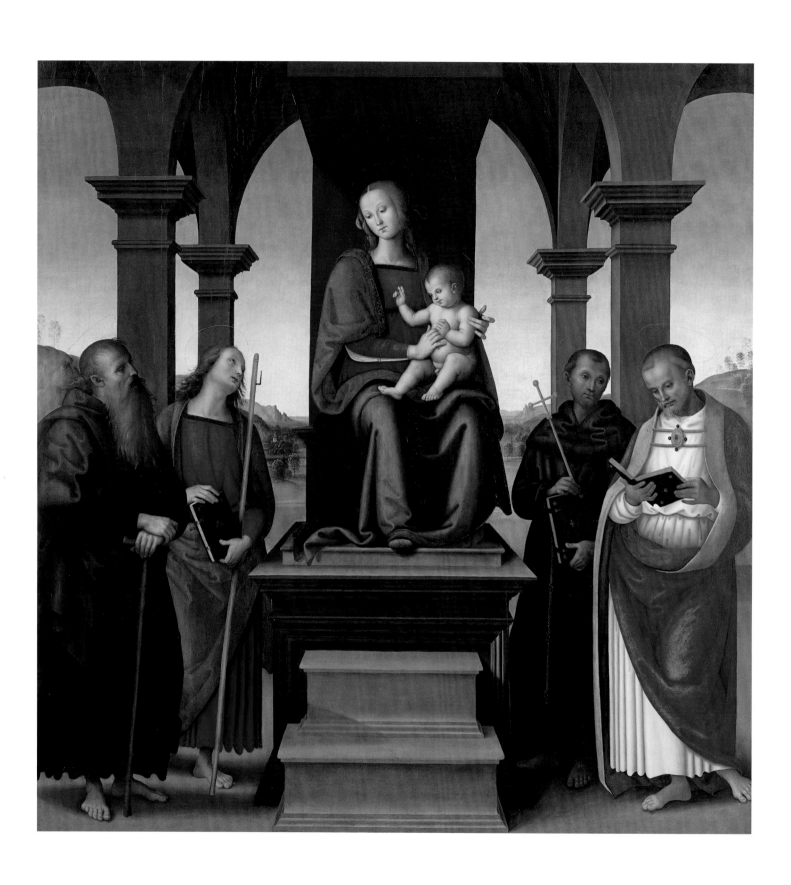

6. Pietro Vannucci, called Perugino, and workshop, Italian, about 1450–1523

Virgin and Child with Saints, about 1500

Oil and tempera on panel, 69¼ x 67⅜ inches
Purchased through the Florence and Lansing Porter Moore 1937 Fund;
P.999.2

Regarded by many of his contemporaries as the leading painter associated with the revival of Italian art at the end of the fifteenth century, Pietro Perugino was widely praised for introducing a style of painting characterized by a unique mastery of perspective, light, and color. As Giorgio Vasari (1511–1574) later noted, his pictures were "so pleasing that they filled not only Florence and Italy, but also France, Spain, and other countries" (1550: 544). By the early 1490s, Perugino had the most active studio in Florence, which produced major altarpieces, stained-glass windows, frescoes, and other works.

As a result of his numerous projects, Perugino employed a large workshop of assistants and collaborators, chief among them Raphael (1483–1520). As Rudolf Hiller von Gaertringen of the Kunstammlung der Universität Leipzig has demonstrated (2004: 155–65), in order to expedite the production schedule and maintain complete control of the design process, Perugino recycled his full-size preparatory drawings, called cartoons. Consequently, figures and details often reappeared in several works with slight variations in orientation, arrangement, and color.

The composition of this devotional painting is a type known as a *sacra conversazione,* or holy gathering, showing the Virgin and Child with Saints Anthony Abbot and James on the left and Saint Francis and an unidentified local saint on the right. Earlier images of this type took the form of polyptychs (multipaneled paintings) comprised of a central panel that featured the Virgin and Child with separate, framed panels attached on either side bearing images of saints. During the fourteenth century, artists sometimes eliminated the separate panels, and by the fifteenth century it was common for all of the figures to be grouped within a single, unified space, as they are shown here. The square format, architectural setting, and symmetrical configuration recall several other works painted by Perugino in the late 1490s and early 1500s.

The large scale and subject of *Virgin and Child with Saints* indicate that it was undoubtedly commissioned as an altarpiece, although its original location remains unknown. The painting was owned of Edward Solly (1776–1848), an English merchant and prominent art collector living in Berlin, who sold it and 676 other works to the Kaiser Friedrich Museum in 1821. Other than nineteenth-century references in the museum's guidebooks, where it was attributed to Perugino, the only descriptions of the painting were

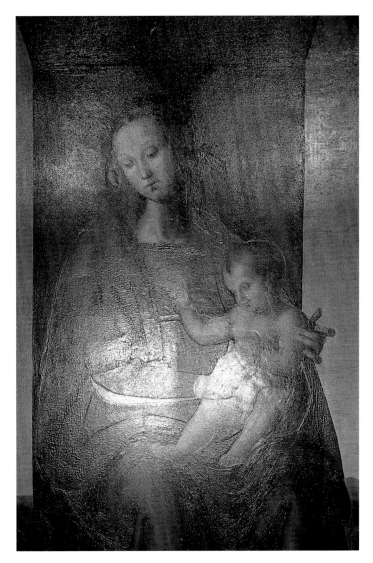

FIG. 1. Reflected-light detail of the central portion of the panel. Courtesy of the Williamstown Art Conservation Center, Inc.

published by Crowe and Cavalcaselle (1903–14) and Todini (1989), the latter based on photographs. The former scholars considered it to be "Perugino's design and type [but executed] by someone in the shop" (5:369). A colloquium in 2006 with George Bisacca, Rudolf Hiller von Gaertringen, Laurence B. Kanter, Marcia Hall, and several colleagues from Dartmouth College concluded that it was the work of the master and one or more assistants.

FIG. 2. Digital infrared image showing the hands of the two saints on the left. Courtesy of the Williamstown Art Conservation Center, Inc.

Comparative research and technical analyses reveal characteristics consistent with the new attribution. In particular, several figures share a number of design similarities with other examples produced by Perugino and his workshop, such as Saint Francis and the unidentified saint to the right of the enthroned Virgin and Child, who bear a remarkable resemblance to Anthony of Padua and Jerome (in reverse) in the altarpiece for San Francesco al Prato in Perugia. Moreover, reflected light imaging of the paint thicknesses shows that the areas of flesh are painted more thinly than the surrounding sky and draperies (fig. 1), a phenomenon found in other works by Perugino—and even Raphael before his move to Rome (Roy 2004: 17).

The present painting also contains several indications suggesting that more than one artist was involved, such as the different initial modeling of the two pairs of hands on the left that can be seen clearly using digital infrared imagery (fig. 2). In addition, there is evidence that both traditional egg-tempera paint and the newer technique of oil paint were employed (visible in the different coloring of the faces, with the lighter ones with the greenish undertones done in egg-tempera). The head of Saint Anthony Abbot on the far left, painted in oil, is worth particular attention. Even though the new technique allows a greater range of effects, the entire conception is different. Beginning with the underlayers, digital infrared imagery reveals dark strengthening marks not found in any of the other fig-

FIG. 3. Digital infrared image of Saint Anthony Abbot on the far left. Courtesy of the Williamstown Art Conservation Center, Inc.

ures (fig. 3). The finished face appears more naturalistic than any of the others, almost as though it were based on a life study—a feature found in only a few of the artist's finest paintings.

Once considered to be entirely executed by studio assistants, the altarpiece has received increased scholarly attention since the Hood Museum of Art acquired it in 1999 and has begun to elucidate myriad relationships to other works completed by Perugino at the height of his career. TBT

7. Master of Saint Jerome, Italian, active late 15th century

Saint Jerome in Penitence, about 1490

Terracotta, 22 x 16 x 2¼ inches
Collection of Roger Arvid Anderson, Class of 1968; EL.S.995.3

This terracotta relief, exceptional for its iconographic inventiveness and deft execution, was created by an unknown master from the Veneto, possibly from the circle of Bartolomeo Bellano (about 1437/38–1496/97) or Giovanni Minello (about 1440–1528). Renaissance Christians embraced as an archetype the spiritual life led by Saint Jerome (331–420), which resulted in the growing popularity of his image. Jerome's translation of the Bible into Latin (the Vulgate) and his status as a Church Father were largely responsible for his posthumous promotion to cardinal, alluded to by the *galerus ruber* (cardinal's hat) at the lower right. The representation of the saint in the wilderness refers to the four years Jerome spent as a hermit seeking God's wisdom in the desert of Chalcis. It was there, in the vicinity of Bethlehem—depicted in the background—that he suppressed aberrant thoughts through self-flagellation. The lion is a reference to Jerome's only lifetime miracle. According to medieval legend, the lion became a loyal companion after Jerome removed a thorn from his paw. In the Renaissance the representation of the saint's self-abasement and tamed lion comprised a metaphor for the victory of ecclesiastical law over sinful temptation. An object of this size containing episodes in Jerome's life that resonated with Christian penitents, hermits, and monks likely was created for domestic or monastic settings.

The building within the cave is unusual among depictions of the saint. It likely alludes to the group of monasteries and nunneries near Bethlehem founded by two of Jerome's most faithful followers, Paula (347–404) and Eustochium (about 368–419/20). The cave-like outcropping framing this edifice may be interpreted variously: Jerome spent the last thirty-four years of his life in a rock-hewn monastic complex, while a cave also figures prominently in the story of the entombment of Jerome's bodily remains. [Planiscig 1921: 170]

KJS

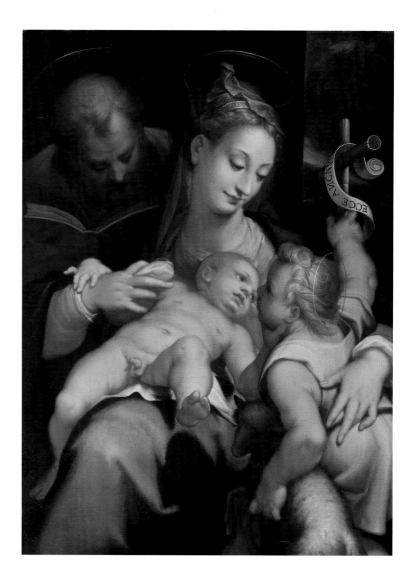

8. Denys Calvaert, Flemish, active in Italy, about 1540–1619

The Holy Family with the Infant Saint John the Baptist, about 1570–73

Oil on canvas, 34¾ x 25½ inches
Signed top center: Dionisio Calvaert de Antversa
Purchased through the Mrs. Harvey P. Hood W'18 Fund; P.994.3

Denys Calvaert's painting was acquired in 1994, soon after it appeared at Sotheby's in New York. Six years earlier it had been sold through Galerie Gismondi in Paris. No other provenance information has been found before that time.

The unmistakable signature in the center along the top edge of the canvas eliminates any scholarly doubt about the correct attribution of the painting. Denys Calvaert, born in Antwerp, arrived as a young man in Bologna, where he lived and worked for the rest of his life. The late-seventeenth-century biographer Carlo Cesare Malvasia notes that the artist first belonged to the studio of Prospero Fontana (1512–1597), then moved around 1568 to the studio of Lorenzo Sabatini (about 1530–1576), with whom he traveled to Rome from 1573 to 1575.

The present picture appears to date from the time of Calvaert's collaboration with Sabatini, which was relatively early in his long career. This is the opinion of art historian Angelo Mazza (1995: 21–49), who does not provide a precise date but does relate it to other contemporary Bolognese works. It reveals greater stylistic independence than the artist's later paintings of the 1580s and onward, which share considerable affinities with the style of Federico Barocci (about 1535–1612).

The painting was likely executed after *The Mystic Marriage of Saint Catherine* in Leipzig and *Vigilance* in Bologna, both dated to around 1568 and linked to the style of Sabatini and another Bolognese artist, Orazio Samacchini (1532–1577; see Sander 1995: 30 and Bentini et al. 2006: 185–87). *The Holy Family with the Infant Saint John the Baptist* may be compared with the *Immaculate Conception* in the church of Sant' Antonio Abate in Bologna, which Malvasia indicates was produced early in Calvaert's collaboration with Sabatini (Twiehaus 2002: 190–91). A preparatory drawing for the finished composition in the Chicago Art Institute supports the proposed date of about 1570–73 (Folds, McCullagh, and Giles 1997: 48, no. 53). The sheet was executed in black chalk and brush and pale brown wash, heightened with lead white, and squared for transfer.

Another version of *The Holy Family with the Infant Saint John the Baptist* with the same dimensions can be found in the Museo di Capodimonte in Naples (De Castris 1994: 268). Later on in his career Calvaert reutilized his own designs to create a large number of small pictures on copper for commercial purposes. The use of canvas for the paintings at the Hood Museum of Art and Capodimonte (as well as a smaller version in Leipzig) is another indication of the early date of their execution. MD

9. Circle of Hans Krumper, German, 1570–1634

Mars, early 17th century

Bronze, height 17¾ inches
Purchased through a gift from Jane and W. David Dance, Class of 1940;
S.988.5

In the fifteenth and sixteenth centuries, Italian sculptors began to produce statuettes, small-scale figurines representing primarily mythological subjects modeled after ancient examples. The fashion for collecting these decorative objects was stimulated by the excavation of Roman bronzes and emblematic of the interest in reviving classical forms and themes. By around 1600 several northern European artists working in Augsburg and Munich introduced these types of sculptures into Bavarian cities, where they were in turn disseminated to courts throughout the Hapsburg Empire.

The superb figure of Mars, the Roman god of war, may have been designed as the upper portion of a three-tiered bronze andiron, similar to other ornamental sculptures representing Olympian warrior deities or mythological heroes made in the Veneto region in the late Renaissance (Bliss 1997: 144–50). Based on other surviving pairs from this period, the pendant most likely would have been surmounted by a female goddess, such as Venus or Minerva.

While there are a number of surviving statuettes of this kind (cited in Bliss 1997: 153 n. 3), the elaborately detailed surface treatment of this work is of a very high quality. The swaggering *contrapposto* and other features correspond in many respects with a helmeted figure on the right in two bronze relief scenes depicting the *Martyrdom of Saint Daniel* of 1592–93 by Tiziano Aspetti (about 1559–1606) in the Cathedral in Padua (private correspondence, Charles Avery 1995). It also recalls a colossal marble statue of David of 1590–92 by Girolamo Campagna (1549–1625) that flanked an entrance to the Public Mint in Venice.

The name of Hans Krumper, who apprenticed with a Dutch sculptor active in Italy and who himself traveled there in the early 1590s, has been tentatively connected with this commission. Krumper eventually became a leading sculptor, decorator, and architect at the court of the Duke of Bavaria and worked on a number of small-scale bronzes for the palatial Residenz in Munich. TBT

10. Cornelius Johnson, English, active in England and the Netherlands, 1593–1661

Portrait of an Unknown Gentleman, 1620

Oil on panel, 26 x 19⅜ inches
Signed and dated bottom right: Co. Johnson. / fecit. 1620
Gift of Julia and Richard H. Rush, Class of 1937, Tuck 1938; P.962.132

This signed and dated portrait of a gentleman is among the earliest known works by the prolific English portrait-painter Cornelius Johnson. Although the date inscribed on it was previously misread as 1629, subsequent cleaning has revealed it to be 1620, which corresponds better with the sitter's choice of fashion and the style and format of the painting within Johnson's oeuvre.

Johnson was born in London in 1593; his family, of German origins, had recently migrated to England from Antwerp. Little is known of his early life, though his manner of painting makes it likely that he received at least some of his training in the Netherlands. His first known works are signed and dated 1619 and include a pair of three-quarter-length portraits thought to depict Sir Thomas and Lady Boothby (formerly with the Weiss Gallery, London), a head-and-shoulders image titled *Unknown Lady* (Cleveland Museum of Art), and two head-and-shoulders portraits of an unknown elderly lady and gentleman (Lamport Hall Trust, Northants). The sitters in the Cleveland and Lamport Hall portraits are presented in fictive brown stone ovals that are very similar to the example in the present portrait. Johnson favored this format early on, and it echoes both contemporary portrait engravings and the look of English portrait miniatures at this time.

Unlike most other English artists, Johnson generally signed and dated his works. Other head-and-shoulders portraits from 1620, all in the same fictive brown stone oval format, include the following:

Susanna Temple, later Lady Lister (Tate, London); *Unknown Young Man,* "aged 22" (Holburne Museum of Art, Bath); and *Sir Alexander Temple,* "aged 37" (Viscount Cobham, Hagley Hall, Worcester, and repetition at Yale Center for British Art, New Haven). The Lamport Hall, Holburne, Hagley, and Yale works all bear the sitter's age inscribed in an identical italic script that is similar to the one used by Johnson for his signature. It is possible that the painting in the collection of the Hood Museum of Art may have been commissioned from Johnson by the same client as one or some of these other early head-and-shoulders portraits.

In Britain, Johnson painted portraits on every scale, from the miniature to the full-length. In December 1632 he was appointed "picture-drawer" to King Charles I, although the arrival in London of Flemish painter Sir Anthony van Dyck (1599–1641) in the same year may be the reason why Johnson seems to have received few actual royal commissions. In 1643, during the Civil War in Britain, Johnson migrated to the Low Countries, where he worked in Middleburg and Amsterdam before settling in Utrecht, where he died a prosperous man in 1661.

The early history of this interesting and attractive picture is unknown. It is not mentioned in the basic catalogue raisonné of Johnson's works, published in 1922 by Alexander Finberg, nor is there any record of it in the photographic archive at the Witt Library, Courtauld Institute of Art, London. KH

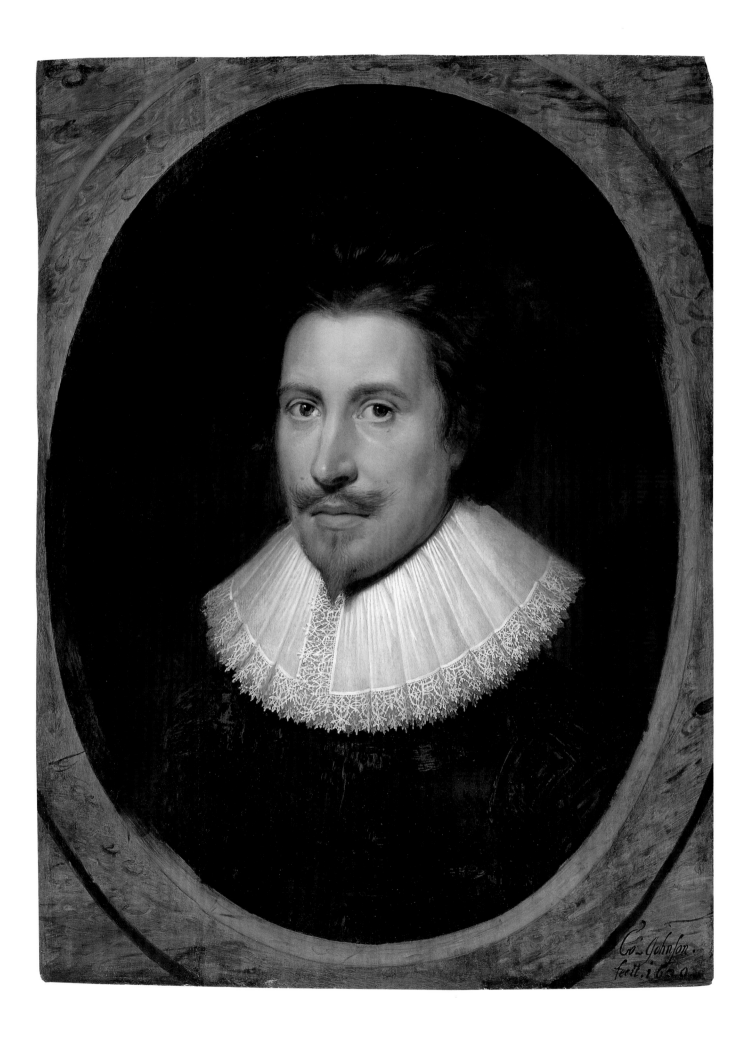

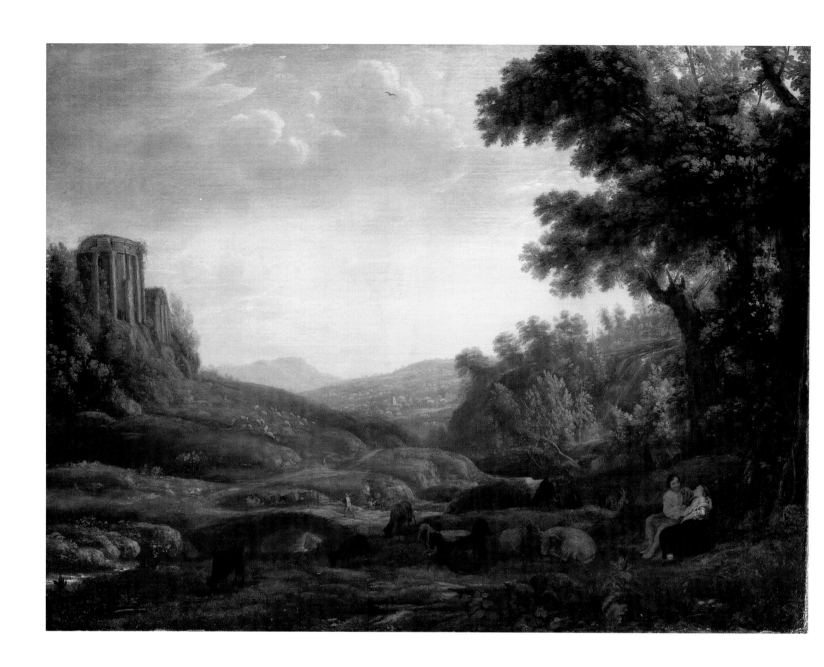

11. Claude Gellée, called Claude Lorrain, French, active in Italy, 1600–1682

Landscape with Shepherd and Shepherdess, about 1636

Oil on canvas, 29⅛ x 38¼ inches

Purchased through gifts from Peter and Kirsten Bedford and Julia and Richard H. Rush, Class of 1937, and through the Mrs. Harvey P. Hood W'18 Fund, the Guernsey Center Moore 1904 Memorial Fund, and the Katharine T. and Merrill G. Beede 1929 Fund; purchased through gifts by exchange from Mr. Richard Andrew Aishton, Class of 1918, in memory of Mrs. Kate Aishton Mecur; Ralph Sylvester Bartlett, Class of 1889; Mrs. Frank U. Bell; Mr. and Mrs. Paul S. Cantor, Class of 1960; Mrs. Moses Dyer Carbee; Professor Bernard Grebanier; Evelyn A. and William B. Jaffe, Class of 1964H; Ruth M. and Charles R. Lachman; Bella C. Landauer, Class of 1923P; Mr. and Mrs. Charles F. Mc-Goughran, Class of 1920; Richard H. Mandel, Class of 1926; Earle W. Newton; Mr. and Mrs. Klaus Penzel; Anton Adolph Raven; Eleanor St. George, in memory of her husband, Charles St. George; Mr. and Mrs. M. R. Schweitzer; Mr. and Mrs. John F. Steeves, Class of 1911; George C. Stoddard, Class of 1918; Howard Swift, Class of 1952; Mr. and Mrs. Jesse D. Wolff, Class of 1935; Dr. Myron Wright, Class of 1937; and through the Julia L. Whittier Fund and the William B. Jaffe and Evelyn A. Jaffe Hall Fund; P.989.21

Claude, known as Le Lorrain after the duchy in which he was born, greatly influenced landscape painting during his lifetime and well into the nineteenth century through his paintings and over thirteen hundred drawings. Apparently in response to an increasing number of forgeries, Claude began preparing pen and brown ink wash drawings in the mid-1630s that recorded the pictures he sold, often annotated with information about patrons and dates. The sheets were bound together in his *Liber Veritatis,* or "Book of Truth" (now in the British Museum), which later served as a partial register of his painted oeuvre—a virtually unique instance of an artist creating his own illustrated catalogue. High-quality prints after the drawings in the album later appeared in a two-volume set produced by Richard Earlom (1743–1822).

As indicated in the *Liber Veritatis* (LV 7), the present painting was created for shipment to Paris with no mention of a specific client. It was long considered to have been lost, until it emerged in the English art market in 1980 from a private collection, where it

FIG. 1. Richard Earlom, after Claude Lorrain, *Landscape with Shepherd and Shepherdess,* from the *Liber Veritatis,* 1774–77, etching and mezzotint, 5½ x 7½ inches. Gift of Mr. and Mrs. Adolph Weil Jr., Class of 1935; MIS.989.26A [7].

FIG. 2. Richard Earlom, after Claude Lorrain, *Port Harbor Scene,* from the *Liber Veritatis,* 1774–77, etching and mezzotint, 5½ x 7½ inches. Gift of Mr. and Mrs. Adolph Weil Jr., Class of 1935; MIS.989.26A [6].

had resided since the eighteenth century. While the composition includes the Temple of the Sibyl in Tivoli, the work does not depict a specific site. Claude made various studies from life in the countryside around Rome and Tivoli in the early 1630s, including one of the Temple of the Sibyl now at the Morgan Library (Roethlisberger 1968: no. 39). The temple also appears prominently in earlier landscape paintings now in Melbourne and Bowhill (Roethlisberger and Cecchi 1975: nos. 39 and 41).

Marcel Roethlisberger suggested that this painting may be a pendant for LV 6 (1983: 74–75, no. 11), a port harbor scene that is now lost but is known through the artist's drawing, an enlarged copy dated 1636, and the Earlom print (fig. 2). The original, traceable until 1870, had the same dimensions as the painting in the Hood's collection, and, according to his handwritten notations on the back

of each sheet, Claude sent both works to Paris. The paintings may well have been intended to contrast morning (sunrise) with late afternoon (sunset), urban with country, and sea with land. They were reminiscent of the harbor and countryside of the future golden age in Virgil's *Fourth Eclogue,* though they did not visually transcribe the Roman poet's description. Claude's extraordinary talent in synthesizing the Venetian and recent Bolognese landscape traditions with the vivid naturalism of northern European painters resulted in a personal voice that was eminently consonant with the poetic interests of his time. The Hood's painting produces its own visual poetry, reflecting a taste for pastoral subject matter that permeated the period. [Kitson 1980: 834 and 837, figs. 20 and 22; Goldfarb 2002: 337, no. 153]

HTG

46

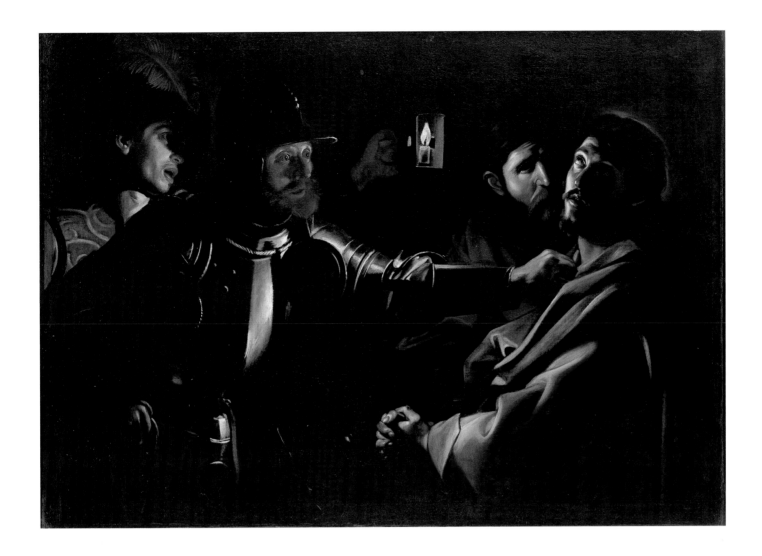

12. Master Jacomo, also known as the Candlelight Master, possibly French, active in Rome about 1612–40

The Arrest of Christ, 1620s

Oil on canvas, 41¾ x 56¾ inches
Gift of Julia and Richard H. Rush, Class of 1937, Tuck 1938; P.985.49

There were a number of talented followers of Caravaggio (1571–1610), one of the most influential painters of the seventeenth century, who explored naturalism and the dramatic use of chiaroscuro. Like many of those who emulated his style, the artist of this work combined a realistic portrayal of common figure types with spectacular artificial lighting. This composition concentrates our attention on the central action, limiting the number of figures to two soldiers on the left and Christ in the foreground on the right, in front of Judas. All traces of violence and confrontation are kept to a minimum. The only physical contact between the figures is the outstretched arm of the soldier grabbing the collar of Christ. The nighttime scene is illuminated entirely by the lantern, selectively revealing only those features that convey the range of the figures' responses to the betrayal.

Following the pattern of several other early-seventeenth-century depictions of the subject, the painter has eliminated all references to the Garden Gethsemane, greatly reduced the number of soldiers who have come to arrest Christ, and ignored the severing of Malchius's ear—all details that generally appeared in earlier representations of the scene (Varriano in Mormando 1999: 202).

The format and size of this canvas, as well as the style, number, and arrangement of half-length figures in the painting, bears a remarkable similarity to the *Denial of Saint Peter* of about 1630 in the collection of the Palmer Museum of Art at Pennsylvania State University (Slatkes 2003: color plate 3). This painting has recently been attributed to Master Jacomo, also known as the Candlelight Master. Over the past several decades, the painting owned by the Hood Museum of Art has been attributed to a number of Italian, French, and Dutch followers of Caravaggio. Most recently, Axel Hémery of the Musée des Beaux-Arts in Toulouse has suggested that this picture was executed sometime in the 1620s by a French artist active in Rome, possibly the Candlelight Master (*Nicholas Tournier* 2001: 180–81, fig. 65). [Nicholson 1990: 1:88 (entitled *Judas Embracing Christ*)]

TBT

13. Juan van der Hamen y León, Spanish, 1596–1631

Landscape with Garland of Flowers, 1628

Oil on canvas, 33½ x 41 inches
Signed and dated lower right: Juan Bander Hamen faᵗ. / 1628
Purchased through the Phyllis and Bertram Geller 1937 Memorial
Fund; P.964.42

The son of a Spanish mother and a Flemish courtier in the service of Philip II (1527–1598) and Philip III (1578–1621), Juan van der Hamen y León became one of the most famous and prolific still-life painters of the seventeenth century. Although he painted other subject matter, including religious scenes and portraits, his elegant depictions of luxurious tabletop settings and decorative floral arrangements most vividly reflected the highly stylized and sometimes ostentatious lifestyle of the Spanish court.

With paintings like this one and its pendant in the collection of the Meadows Museum in Fort Worth, Texas, Van der Hamen became in 1628 the first Spanish painter to adopt the new genre of the floral wreath, already popular in both Flanders and Italy. Ap-

parently searching for the most satisfactory way to use this decorative genre, the artist experimented with three distinct scenes in the center of each picture. The first was a pair of three-quarter-length female martyrs, visible now only with X-ray; the second was a set of Old Testament histories; and the third was a pair of landscapes of the type painted in Rome by Paul Bril (1554–1626) and disseminated through engravings by Flemish printmakers, of which Van der Hamen owned many examples. The surviving left portion of the landscape depicts a luminous vista of a gentle river beside which a pilgrim kneels before a hermit saint, with villages and craggy rock formations in the distance.

A recent conservation effort revealed in the damaged section a figure of Moses and a camel, while almost all vestiges of the shadowy wooded landscape painted over this have vanished. Conservators decided, then, to simply mask out the hopeless losses and restore those parts of the landscape that are well preserved. The latter is painted with a silvery light and a sensitive, spontaneous touch, recalling the many small landscapes—some of them circular, others square—that were described in the painter's studio and in private collections following his death. [Jordan 2005: 233–40, no. 45] WBJ

14. Roelof van Vries, Dutch, about 1630/31–after 1681

Landscape with Ruins, about 1665–70

Oil on canvas, 24⅜ x 30⅛ inches
Gift of Mr. and Mrs. Jesse D. Wolff, Class of 1935; P.973.386

Roelof van Vries was born in Haarlem, the preeminent center of seventeenth-century Dutch landscape painting. A follower of Jacob van Ruisdael (1628/29–1682), the city's most celebrated landscapist, Van Vries usually represented woodland and country scenes, river views, and dunescapes. His *Landscape with Ruins,* a picture from the latter part of his career, offers a view of the Dutch countryside on a typically cloudy day. The remains of an old castle framed by trees dominate the scene and serve as a backdrop for a variety of figures, including a young couple on horseback, a boy and his dog, a beggar, and, in the distance, two hunters with their hounds. Although composed in the studio, Van Vries's painting gives the impression of having been painted on the spot, largely because of

the artist's convincing depiction of natural and manmade forms and close observation of details such as the worn bricks of the castle walls and the cartwheel tracks in the sandy road.

Dutch patrons prized works of this type not only for their naturalistic treatment of familiar locales but also for their historical associations and symbolism. The architectural relic that figures prominently in Van Vries's composition is probably one of the many medieval monuments damaged during the Dutch wars for independence. As in many other landscapes of the period, such ruins took on a "patriotic significance" (Kuretsky 2005: 23), serving as eloquent reminders of Holland's heroic struggle against her Spanish oppressors. Viewed more broadly, the battered castle, like the dead tree at the left side of the picture, alludes generally to mortality and the impermanence of earthly things. Simultaneously, however, the painting affirms life and the processes of renewal: vigorous oak trees, cottages, and a makeshift dovecote emerge from the castle ruins, thus evoking nature's endless cycle of death and regeneration.

JK

15. Circle of Pieter van Laer, Dutch, 1599–about 1642

Street Scene with Morra Players, second quarter of the 17th century

Oil on canvas, 18½ x 15⅞ inches
Gift of Julia and Richard H. Rush, Class of 1937, Tuck 1938; P.962.153

This picture represents a type of genre subject—small anecdotal street scenes of peddlers, tradesmen, beggars, gamblers, and other simple folk—that was popularized by Dutch and Flemish artists working in Rome during the seventeenth century. These painters became known as the *bamboccianti* because of their association with the foremost artist of the group, Pieter van Laer, who was nicknamed "*Il Bamboccio*" (clumsy little fellow or simpleton) on account of his crippled physique. Even though the *bamboccianti*'s images of "low life" offended contemporary Italian artists and critics, who favored noble and heroic subjects, they appealed to and were enthusiastically patronized by collectors from both the aristocracy and the bourgeoisie.

The present picture shows a group of men playing *morra,* a hand game of ancient origins that is still popular today, especially in Mediterranean countries. Roughly akin to "rock, paper, scissors," it is a game in which certain gestures—an open palm, clenched fist, extended fingers—win out over others. As a simple form of entertainment that even the poor could enjoy, it was frequently represented by the *bamboccianti,* who were keen observers of everyday life. In this painting, the game is being played on a street outside a tavern: a young man and woman converse just outside the tavern's entrance, while in the middle distance a peddler with his knapsack walks by. All of the figures in the composition, despite their humble social position, are dignified by the smooth articulation of their forms and their harmonious integration with the surrounding architecture. While the treatment of the figures, as well as the picture's strong light effects and simplified description of architecture, recalls the works of several of the *bamboccianti,* it also brings to mind the style of Dutch artist Johannes Lingelbach (1622–1674), who worked in Rome from about 1644 to 1651. JK and TBT

16. Cornelis Saftleven, Dutch, 1607–1681

Barn Interior, about 1665

Oil on panel, 23½ x 26⅜ inches
Purchased through the Julia L. Whittier Fund and the
William S. Rubin Fund; P.983.10

Cornelis Saftleven was an unusually versatile painter and draftsman whose wide-ranging subjects included biblical and mythological themes, allegories, portraits, landscapes, cattle markets, and scenes of peasant life. Born into a family of artists, he lived in Rotterdam, where, in 1667, he was appointed dean of the painters' guild. Although best known for his highly original images satirizing human foibles, he also contributed significantly to the development and popularization of a distinct category of genre painting, the barn or farmhouse interior. Cornelis, his younger brother Herman (1609–1685), and the Antwerp artist David Teniers II (1610–1690) began to make pictures of this type in the 1630s. All three artists, sometimes working in collaboration (James 1994: 134–35), drew inspiration from the low-life scenes of Adrian Brouwer (1605/6–1638), one of the undisputed masters of seventeenth-century genre painting.

This picture, from about 1665, is one of Saftleven's later and finest representations of a barn interior. The rustic setting, effectively captured by warm earth tones and an open, informal composition, contains several charming vignettes showing peasant folk and their animals. Both amusing and moralizing in its content, the picture contrasts the idleness and negligence of the foreground figures—a young couple sneaking an embrace, and a boy playing with puppies—with the virtuous work of a farmer and a milkmaid who appear in the distant background. These opposing behaviors are underscored by the confrontation between the cat, a standard symbol of lust and laziness, and the dog, a legendarily faithful and vigilant animal. Like many contemporary popular sayings, as well as observations made a century earlier by Desiderius Erasmus (about 1466–1536), Rotterdam's most famous native, the picture alerts the viewer to the folly of idleness while promoting the value of industry. As indicated by the milk ewes, cows, and goats in the center of the composition, Saftleven ties this message to dairy farming, an industry that contributed significantly to Holland's economic prosperity. Just as idleness could threaten this industry, so dutiful attention would guarantee its continued success. [Sutton 1987: 294–95, no. 96] JK

51

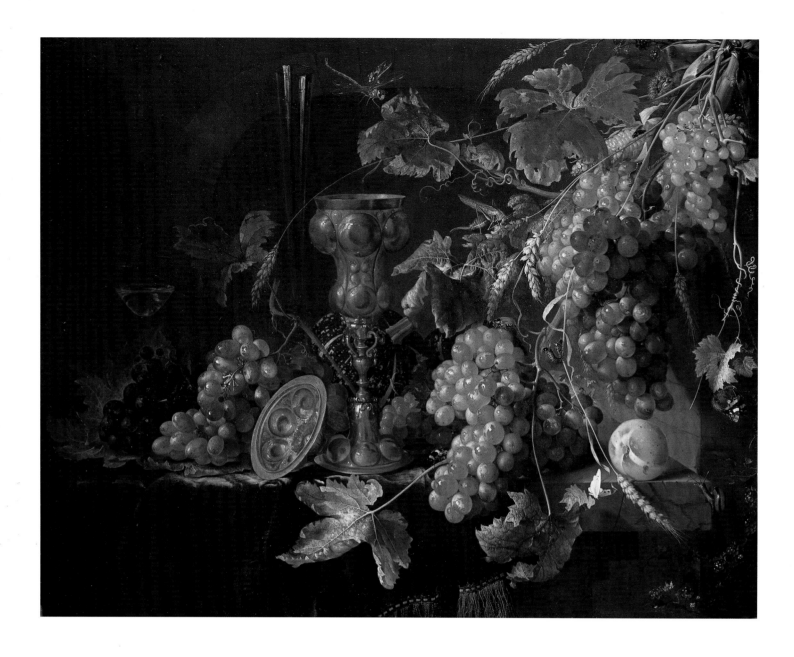

17. Jan Davidsz. de Heem, Dutch, 1606–1684

Still-Life with Grapes, 1660s

Oil on canvas, 28½ x 34¾ inches
Signed upper left corner: J Dˢ De Heem f.
Purchased through the Mrs. Harvey P. Hood W'18 Fund and the
Florence and Lansing Porter Moore 1937 Fund; 2006.11

Still-Life with Grapes, a spectacular painting by the seventeenth-century Dutch artist Jan Davidsz. de Heem, is an exciting example of the still-life genre and a work by one of Holland's most gifted painters. De Heem, a native of Utrecht who spent most of his adult life in the city of Antwerp, was an extraordinarily famous and influential painter of still-life in the northern and southern Netherlands. He was the key figure in the development of *pronkstillevens* (fancy or sumptuous still-lifes), admired then as now for his uncanny ability

to simulate the appearance of fruit, flowers, and beautiful objects fashioned from silver, gold, or other precious materials.

Still-Life with Grapes, a *pronkstilleven* that probably dates from the 1660s, testifies to De Heem's standing as an artist of the first rank. A triumph of illusionistic painting in its rendering of textures, space, and the effects of light, it presents a lavish display of natural and manmade objects, including grapes and pumpkins, a costly silver-gilt goblet, delicate wine glasses, and a velvety green cloth with gold fringe. Every item has been depicted with utmost attention to visual truth, and the smallest details—the curling tendrils of a grape vine, myriad tiny insects, and even reflections of the artist's studio window on the bosses of the goblet—have been meticulously and faithfully represented. The close observation of details and superior craftsmanship of Still-Life with Grapes would have easily met the expectations of seventeenth-century Netherlanders, who placed

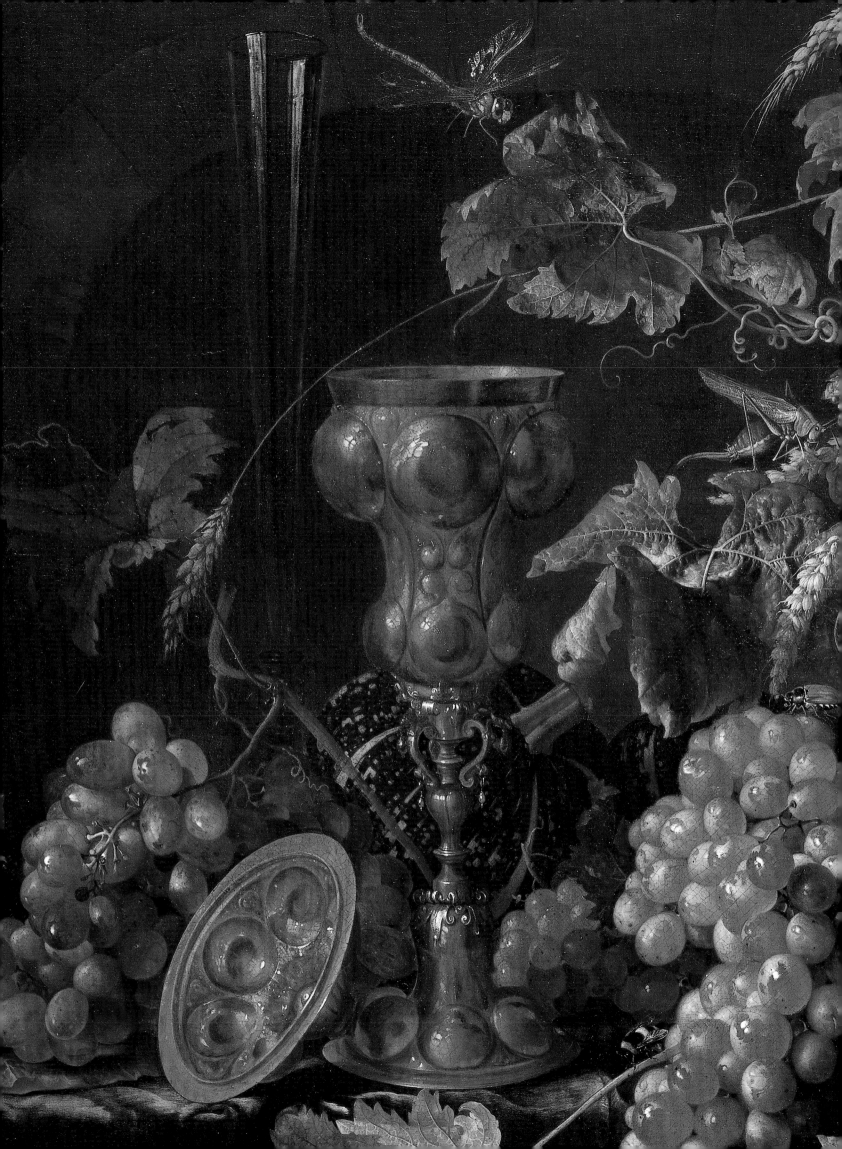

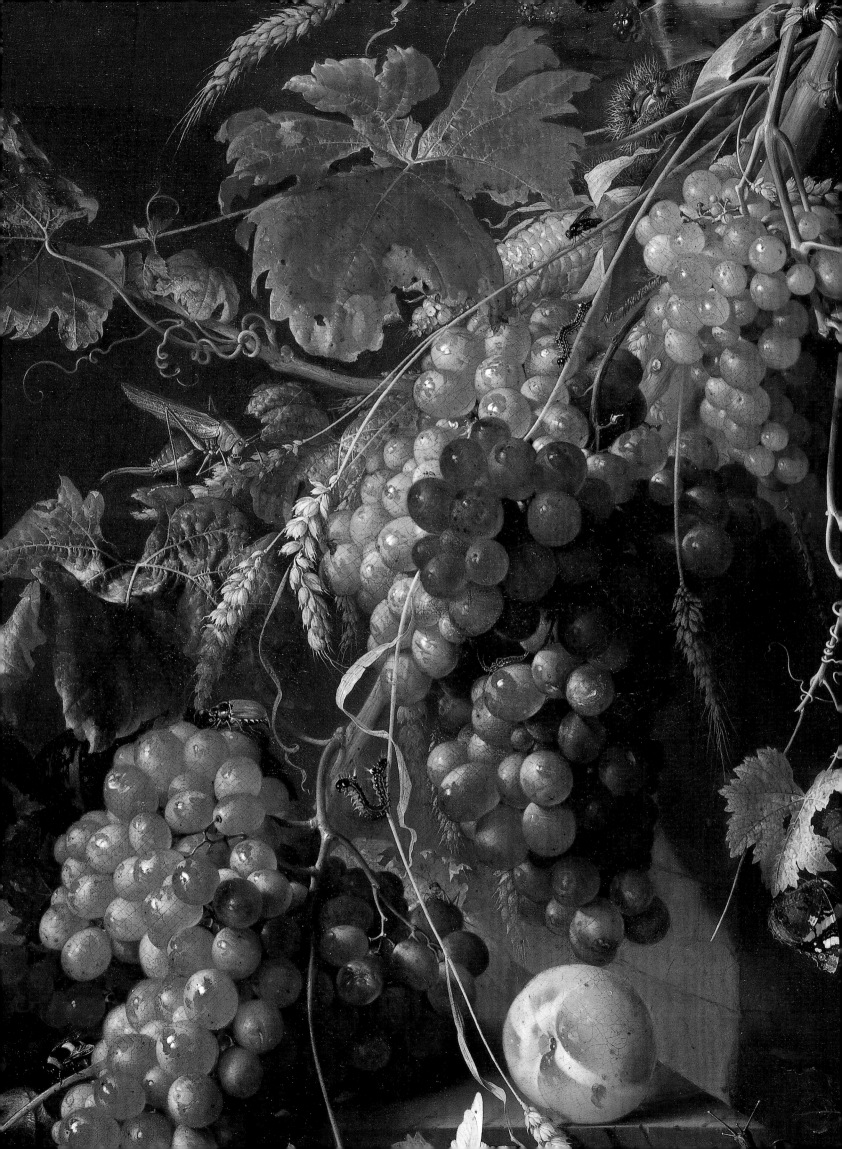

FIG. 1. Jacob Hoefnagel, *Youth Flowers Eternally,* from the *Archetypa Studiaque,* 1592, engraving, 6⅛ x 8⁵⁄₁₆ inches. Purchased through the Class of 1935 Memorial Fund; 2006.58.3.

the highest value on the artist's ability to record with "a sincere hand and a faithful eye" the objects that came into his view. These expectations coincided with the broader culture's deep interest in the natural sciences and optics. Animal and plant life were being studied and documented as never before, and previously unknown worlds appeared in the lenses of the microscope and telescope (fig. 1). The new science that emerged at this time was marked by the conviction that knowledge was to be gained chiefly through vision. "I admit nothing but on the faith of the eye," remarked the English philosopher Francis Bacon in 1620. "Those who aspire to discover and know . . . must go to the facts themselves for everything."

About the time De Heem painted *Still-Life with Grapes,* the Dutchman Johann Comenius (1592–1670) published his new theories of education. Seeing is believing, he argued, and the good scholar studies the physical world first-hand as well as through images, learning how to distinguish one thing from another. Visual discrimination was the key to the acquisition of knowledge. De Heem's painting reflects this goal in many ways: the metal goblet is compared to vessels made of glass; the exterior of the goblet is juxtaposed with an interior view of its lid; three different types of grapes are represented; and the plump grapes are in turn compared to the globular bosses of the gilded cup. The picture, in short, invites the viewer to compare, distinguish among, and learn about the colors, shapes, and textures of things.

De Heem's painting offers much more than knowledge of the physical world, however. Like many other still-life paintings from the period, it contains a hidden symbolism. The many objects in the picture can be appreciated for what they are—products of nature or art—but to a seventeenth-century viewer they also revealed a

specifically Christian meaning. The grapes, wine, wheat stalks, and corn are traditional symbols of the Eucharist; the peach is a symbol of salvation; the many insects, because of their short life spans, collectively refer to death. The Eucharistic meaning of the painting is emphasized especially by the goblet in the center of the composition: framed by a stone arch just barely visible in the painting's background, it is given pride of place as if it were a chalice containing the Communion wine. The meaning of Christ's sacrifice also is suggested by the cascading arrangement of the grapes, wheat stalks, and corn, especially in relation to the nails depicted in the upper left and right corners of the picture. Perhaps an allusion to the lowering of Christ's body from the cross, it also brings to mind Christ's words in John 12:24: "Verily, verily, I say unto you, except a corn of wheat fall into the ground and die, it abideth alone; but if it die, it bringeth forth much fruit." A masterful combination of Christian content and superbly rendered forms, *Still-Life with Grapes* encourages the viewer to ponder the central mystery of Christianity as it celebrates objects of the material world.

De Heem's sophisticated handling of pictorial elements, so admired by his contemporaries, is clearly visible in this sumptuous still-life. The various objects of the composition are deftly woven together and set into a space that seems continuous with our own. The glowing colors and sparkling highlights enliven the picture visually and, above all, create an impression of richness and splendor. The beauty of the painting, like its content, attracts the viewer's attention and provides "sweet fodder for the sight." [Meijer 2005; Kenseth 2006; Wheelock 2007] JK

18. Luca Giordano, Italian, 1634–1705

Allegory of Touch (or Carneades with the Bust of Paniscus), about 1658–60

Oil on canvas, 50½ x 40¼ inches
Purchased through the Mrs. Harvey P. Hood W'18 Fund and the
Florence and Lansing Porter Moore 1937 Fund; P.999.51

The vast body of work of Luca Giordano, one of the most celebrated artists of the Neapolitan Baroque, included religious scenes (fig. 1), mythological subjects, and vast decorative fresco cycles executed in Naples, Venice, Florence, and Madrid. His early development was deeply influenced by the dramatic lighting and bold naturalism of Caravaggio (1571–1610) and Jusepe de Ribera (1591–1652).

This painting ranks among the greatest early works of Giordano presently in the United States. It originally belonged to a series of ten "portraits" of philosophers—attributed to Ribera—that was in the Carvallo collection in Villandry, France, at the beginning of the past century. The attribution to Giordano was made by August Mayer (1923: 204) and has been universally accepted. The subject, identified by Delphine Fitz Darby (1957: 199ff), is the stoic philosopher Carneades (213/14–129 BCE) gone blind, who recognizes the bust of the young Pan (Paniscus) through the sense of touch. Stylistically close to the work of Ribera, the painting also borrows its narrative mode from the Spanish master, and its composition follows Ribera's *Allegory of Touch* (Pasadena, Norton Simon Museum), which depicts a blind man tracing with his fingers the features of a marble head, and *Giovanni Gonnelli* (Madrid, Museo del Prado)—also titled *The Touch*—where the blind sculptor is presented with his hands resting on a sculpture. Other paintings by Ribera that may have affected Giordano's composition are his numerous half-length representations of St. Jerome holding a skull, the saint's

meditation on death being replaced in the case of Carneades with a more earthly reaffirmation of the power of the senses. Indeed, as in Ribera's allegorical portraits, Giordano's Carneades may be construed as an allegory of touch.

As in many of his early images of "philosophers"—imaginary portraits of famous classical thinkers, or more generic representations of astronomers or mathematicians—he particularly emphasizes physiognomy here. In the absence of "actual" portraits (if one excludes some ancient busts of Seneca or Cato), the artist's challenge in these works was to create a believable likeness of a subject known only through literary sources. Giordano demonstrates in this painting his mastery at depicting such qualities as nobility, resignation, and strength, which not only define the character of his subject but also lend the painting its power.

It is unclear for whom these paintings of philosophers were intended. Their austere beauty suggests patrons more interested in the intellectual qualities of these compositions than their seductiveness. Neo-Stoicism was prevalent among Neapolitan intellectuals, and the choice of some of the philosophers painted by both Ribera and Giordano reflects this: Carneades, Diogenes, Cato, and Seneca. Other subjects, however, seem barely connected with, if not completely opposed to, this philosophical tradition. It is also legitimate to inquire if Giordano himself took part in the philosophical debates of his time. The self-image the artist acquired through his later work seems to almost contradict the introverted and somber mood of his early production. [Whitfield and Martineau 1982: 169–70, no. 61; *Luca Giordano* 2001: 252, no. 133] JPM

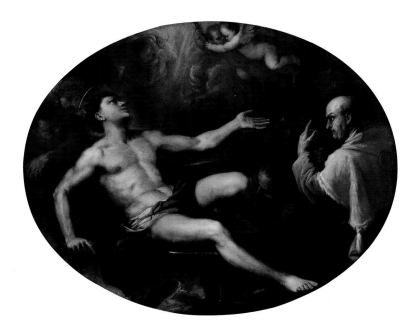

FIG. 1. Luca Giordano and studio, *The Martyrdom of Saint Lawrence,* about 1696, oil on canvas, 60½ x 79¼ inches. Gift of Julia and Richard H. Rush, Class of 1937, Tuck 1938; P.971.32.

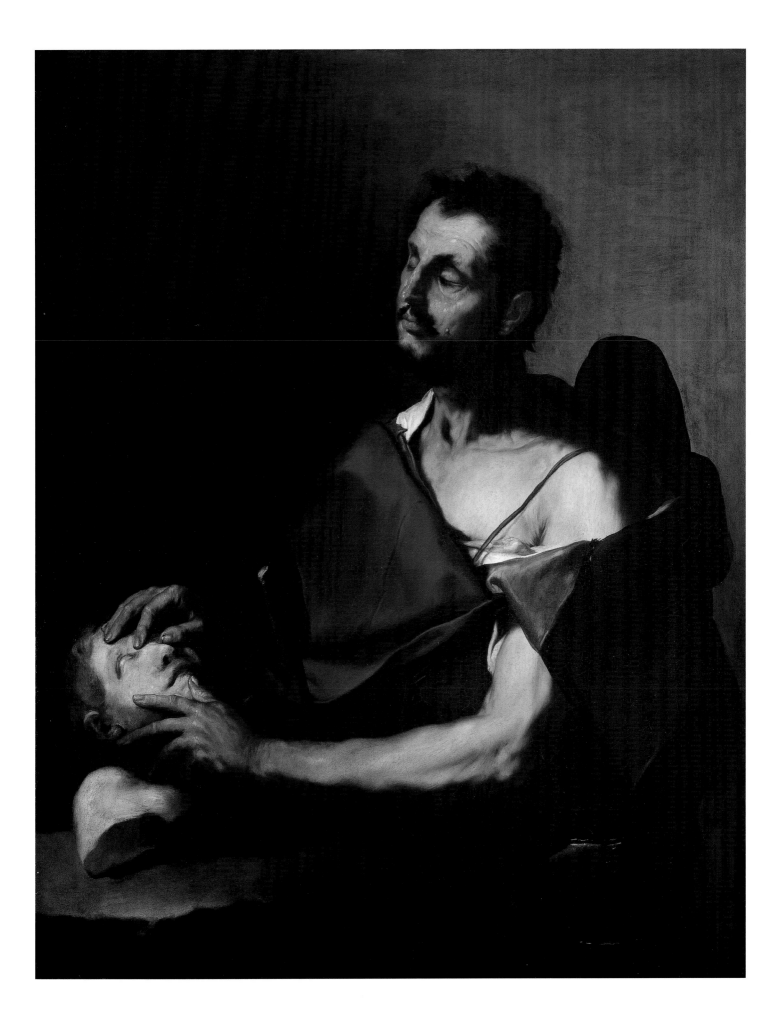

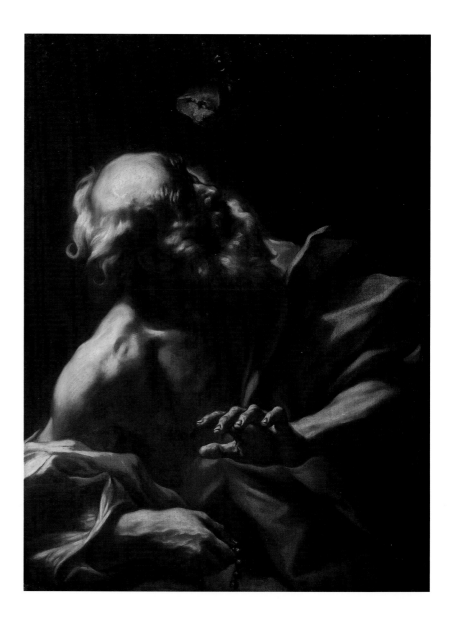

19. Giovanni Battista Beinaschi, Italian, 1636–1688

Saint Paul the Hermit, about 1665

Oil on canvas, 38 x 28¾ inches

Bequest of the Estate of Martin F. Huberth Jr., Class of 1925; P.976.12

Saint Paul (about 228–341), who is considered the first Christian hermit, was born in Egypt of wealthy parents. In order to escape persecution by the Romans in the middle of the third century, he fled to a remote mountain retreat. He reportedly lived meagerly during his long exile and, according to a biographical account written by Saint Jerome (about 347–419/20), received half of a loaf of bread every day from a raven—like the Old Testament prophet Elijah (ninth century BCE).

In this composition, the saint is shown against a dark, neutral background, clutching a rosary and gazing intently at the raven overhead. A single light source outside the picture shines from above, heightening the chiaroscuro effects. The upward-turned face and forceful gesture of his left arm stretching forward add considerable movement to the scene, especially in comparison to earlier representations of the subject. A number of half- and full-length paintings of Saint Paul the Hermit by Jusepe de Ribera (1591–1652),

for example, appear far more static and contemplative. Compared to Ribera, however, whose primary interest was in studying the human face to reveal the individual's mind and inner spirit (Fitz Darby 1962: 304), Giovanni Battista Beinaschi strives to capture the drama of divine intervention.

Beinaschi was a prolific engraver and draftsman as well as a painter. He initially worked at the court in Turin, but by 1652 he had moved south to Rome, where he studied late Renaissance and early baroque masters, especially Giovanni Lanfranco (1582–1647). He often adopted Lanfranco's characteristic low viewpoint and dramatic foreshortening to enhance the monumentality of his figures. Beinaschi eventually moved to Naples, where he settled until his death. He was commissioned to execute a number of ceiling frescoes in various churches throughout the city for the principal religious orders. His energetic style of modeling and lively play of light have sometimes led to the confusion of his work with that of Giacinto Brandi (1621–1691), to whom the present canvas was initially attributed after it entered Dartmouth College's collection (*Acquisitions* 1979: 36–41). TBT

58

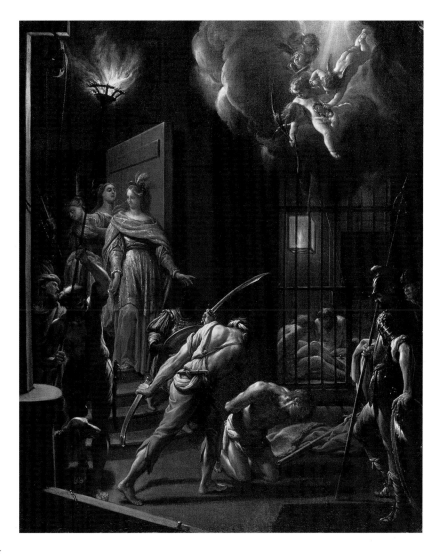

20. Francesco Trevisani, Italian, 1656–1746

The Beheading of St. John the Baptist, about 1690

Oil on canvas, 26½ x 22 inches

Purchased through the Florence and Lansing Porter Moore 1937 Fund; 2005.59

Francesco Trevisani's *Beheading of St. John the Baptist* is typical of the small-scale paintings he produced for connoisseurs and collectors throughout his long and brilliant career in Rome. It can be compared with two slightly smaller paintings, the *Martyrdom of the Four Crowned Saints* and the *Crucifixion of Saint Andrew,* acquired by the Earl of Exeter from the artist in 1699 (Brigstocke and Somerville 1995: 36). Whereas the others both reproduce large altarpieces by Trevisani, the present work does not appear to depend on any known precedent. Its strong chiaroscuro and generally dark tone evoke the style of Antonio Zanchi (1631–1722), Trevisani's first teacher in Venice, where the Istrian-born artist trained before moving to Rome about 1678. It is thus likely to date from earlier in Trevisani's career, perhaps around 1690. Later works tend to show a clearer, lighter palette, and their somewhat spindly figures give way to the more solid anatomies of the early years of the eighteenth century.

Trevisani's decision to set the scene at night may have been influenced by his desire to demonstrate his skills as a tenebrist. It allowed him to give Salome's shimmering fabrics their maximum impact in the austere surroundings of the prison. He further emphasizes the gruesome atmosphere by the gallows-like apparatus acting as a repoussoir at the left. His only other known representation of the Baptist's beheading—an event described in the Bible in Mark 6—is an even smaller canvas at Bremen (Höper 1990: 301), where he shows the severed head being placed by the executioner onto the charger.

The height of the picture corresponds to three Roman *braccie*. This was a standard size, and many paintings of this format are recorded in the paintings-cabinet of Cardinal Pietro Ottoboni (1667–1740), the greatest patron of the time, in whose household Trevisani lived from 1698 to 1743, dispatching many works to patrons such as Louis XIV of France, Carlos III of Spain, and João V of Portugal (Di Frederico 1977; Olszewski 2004). [Bull 2008: 12, fig. 13] DB

59

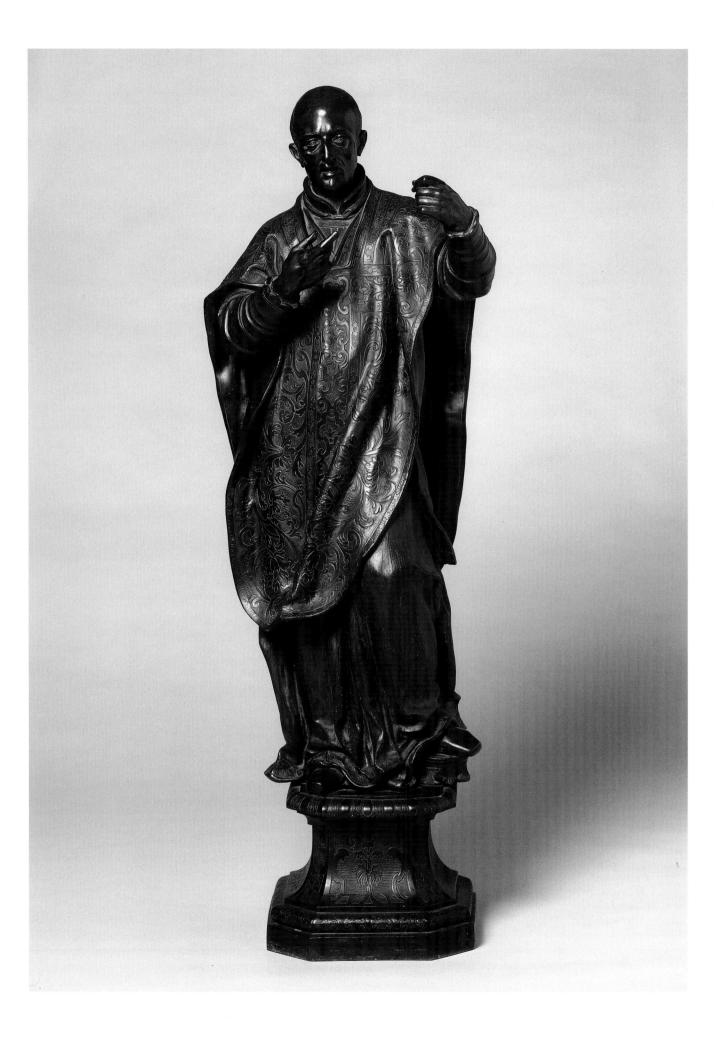

21. Unknown, active in Rome

Saint Francis Borgia, about 1700

Bronze, height 43⅝ inches (with base)
Purchased through a gift from W. David Dance, Class of 1940,
in memory of Jane Dance; 2007.58

In 1671, Francis Borgia (1510–1572) was canonized, only the third Jesuit to be honored thus (all of whom had been declared saints within a fifty-year period in the seventeenth century). In the 131 years since the founding of the Society of Jesus, the Jesuits had become the most numerous and influential of the new orders of secular clergy. They were at first regarded with suspicion by the papacy but gradually became the most powerful force in the Roman Catholic Counter-Reformation. Early on in their history, prominent Jesuits defended the need for the sumptuous decoration of their churches. Although the style was often determined by the taste of the patron, the wide horizons of their activity rendered the Jesuits supremely important as agents in the transmission of art and culture across the globe.

Saint Francis Borgia was born Francisco de Borja y Aragón at Gandia near Valencia, Spain. He was the great-grandson of Pope Alexander VI (reigned 1492–1503) on his father's side, and of King Ferdinand II of Aragón (reigned 1479–1517) on his mother's side. After succeeding to the Duchy of Gandia upon his father's death in 1543, he became a supporter of the newly established Jesuit Order. The death of Borgia's wife in 1546 led to him taking preliminary Jesuit vows and eventually making a solemn profession in 1548. After returning from a pilgrimage to Rome, he was granted permission in 1551 to abdicate his duchy, the same year he was ordained. He was eventually elected the third Father General of the Jesuits in 1565 and held the post until his death.

The present bronze bears the distinctive facial characteristics of the saint, including the strong brow and long nose with a break high on the ridge that are evident in other images. The figure wears a chasuble to celebrate mass, adapted from the iconography of the order's founder, Saint Ignatius Loyola (1491–1556). He most likely held a crucifix in his left hand instead of a chalice, with which he was also associated. His proper left foot rests on an overturned crown, symbolizing his abdication of the Duchy of Gandia in order to enter the Society of Jesus.

Many of the features in the present bronze correspond with an important statue of Saint Francis Borgia that was commissioned in about 1688–89 from Cirro Ferri (about 1634–1689) for two altars in the Gesù in Rome dedicated to Saint Ignatius and Saint Francis Xavier (Lo Bianco 1997: 447–49). Ferri's gilt bronze sculpture (with a restored chalice and paten) measures about thirty-three inches and was one of eight statues executed by the artist and installed in the church in 1690.

The realistic, classical *contropposto* of the present bronze employs a more simplified style, limiting the movement in the surface of the garments, removing excessive folds, and formally emphasizing the monumental appearance of the saint. The variety of textures used on the surface, both in the wax and after the casting, lends a naturalistic quality to the work.

The origins of the artist responsible for this work have varied considerably in geography and chronology since it was first published. It seems clear, however, that the sculptor was someone connected with the Jesuits, well-versed in the Roman artistic traditions associated with the Society of Jesus (including those derived from Ferri), and capable of subtle iconographic variations. [Brink Goldsmith et al. 1990: cat. no. 12; Burke 1993: cat. no. 12; Ferri Chulio 1998: 190]

TBT

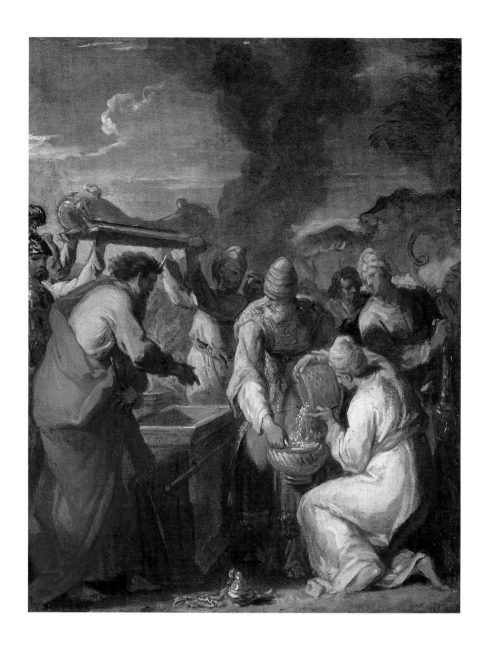

22. Hyacinthe Collin de Vermont, French, 1693–1761

Moses and Aaron at the Ark, about 1738

Oil on paper mounted on canvas, 16¼ x 13¾ inches
Purchased through the Hood Museum of Art Acquisitions Fund and
a gift from the Cremer Foundation in memory of J. Theodor Cremer;
P.993.5

This oil sketch was a preparatory study for a painting shown by
the artist at the Royal Academy Salon in 1738. The finished work
then entered the vestry of the Convent of the Capuchins on Rue
Saint-Honoré in Paris. Subsequently, Collin de Vermont furnished
the same religious structure with two other paintings also illustrat-
ing scenes from the Old Testament (Dézallier d'Argenville 1749;
Hébert 1779; Salmon 1991). Based on a subject in Exodus, the com-
position here represents Moses ordering Aaron to place a vase filled
with manna in the Ark of the Covenant, bearing witness to the
grace of God given to his faithful in the desert. The consecration of
the manna in the Old Testament was considered a prefiguration of
the Eucharist.

The tendency to compress the figures together in a semicircle is
characteristic of Collin de Vermont, who then echoes the shape in
the serpentine-like silhouette of Aaron intersecting with the line
formed by the witnesses and mirrored in the plume of smoke ris-
ing through the air. Equally typical of the painter is the artificial
agitation that shrouds the faces of the principal figures. The effect
of the paint, golden yet coarse, applied to the suit of clothes on the
high priest Aaron recalls certain history paintings executed by Col-
lin de Vermont's master, Hyacinthe Rigaud (1659–1743), including
Presentation in the Temple (Louvre), which may in fact be traced
back to the art of Rembrandt (cats. 87–89).

Curiously, Collin de Vermont is one of the very first French art-
ists for whom such a large number of oil sketches survive. Far from
being simply "the rococo era" or the period of "gallant taste," des-
ignations under which it continues to be reduced, French painting
from the start of the eighteenth century maintained grand histori-
cal subjects from preceding centuries, like the present innovative
example. FM

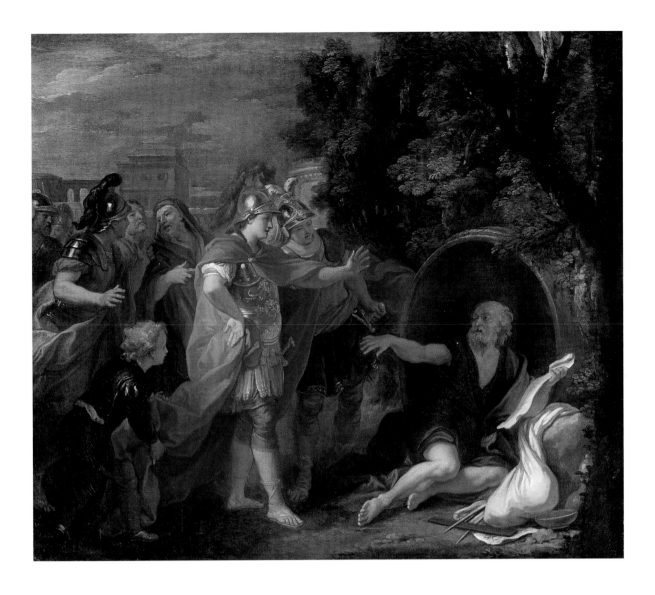

23. Louis de Silvestre, French, 1675–1760

Alexander and Diogenes, about 1750

Oil on canvas, 18⅞ x 22 inches
Purchased through the Mrs. Harvey P. Hood W'18 Fund; P.993.6

According to several ancient authors, Alexander the Great (reigned 336–323 BCE), the Macedonian monarch and patron, once asked the Cynic philosopher Diogenes (fourth century BCE) what he desired. He replied that he wanted the emperor to stand aside because he was blocking the sun. In this painting the emperor Alexander, trailing his long red cape held by a young page, stands before Diogenes. Splayed nonchalantly in his barrel, the philosopher languidly extends his arm in the direction of Alexander in a sign of contempt. Along with the famous bas-relief of Pierre Puget (1620–1694), finished in 1689 (Louvre), this painting constitutes one of the rare representations of Alexander and Diogenes in French art; the subject, after all, had the potential of casting doubt over the authority of the sovereign.

Acquired as a work by Louis de Boullogne (1654–1733), the present author has reattributed it to the painter Louis de Silvestre. In spite of extensive research (Schnapper 1973, Marx 1975, Salmon 1997, and Marandet 2004), Silvestre's style continues to be confused with that of the Boullogne brothers, from whom he received his training. The arrangement of characters is typical of Silvestre, however, who places a dignitary and his attendants in the scene across from an interlocutor, who, in this case, appears to be beneath Alexander's stature. In depicting Diogenes, Silvestre distinctly modeled the pose (in reverse) after the one used by Raphael for the same figure in his famous fresco *The School of Athens* (1509–10). The character behind Alexander, who directs his gaze toward the viewer, appears to be a self-portrait of the artist.

Based on its style, the canvas seems to belong to a later period in the career of Silvestre, following his return around 1750 to Dresden, where he was named First Painter to the King of Poland, Stanislaus Augustus (reigned 1764–95). In addition to the originality of the subject, this painting constitutes a rare testament to Silvestre's late work, which is remarkably elusive in North America today (with the exception of two mythological paintings at the John and Mable Ringling Museum of Art). FM

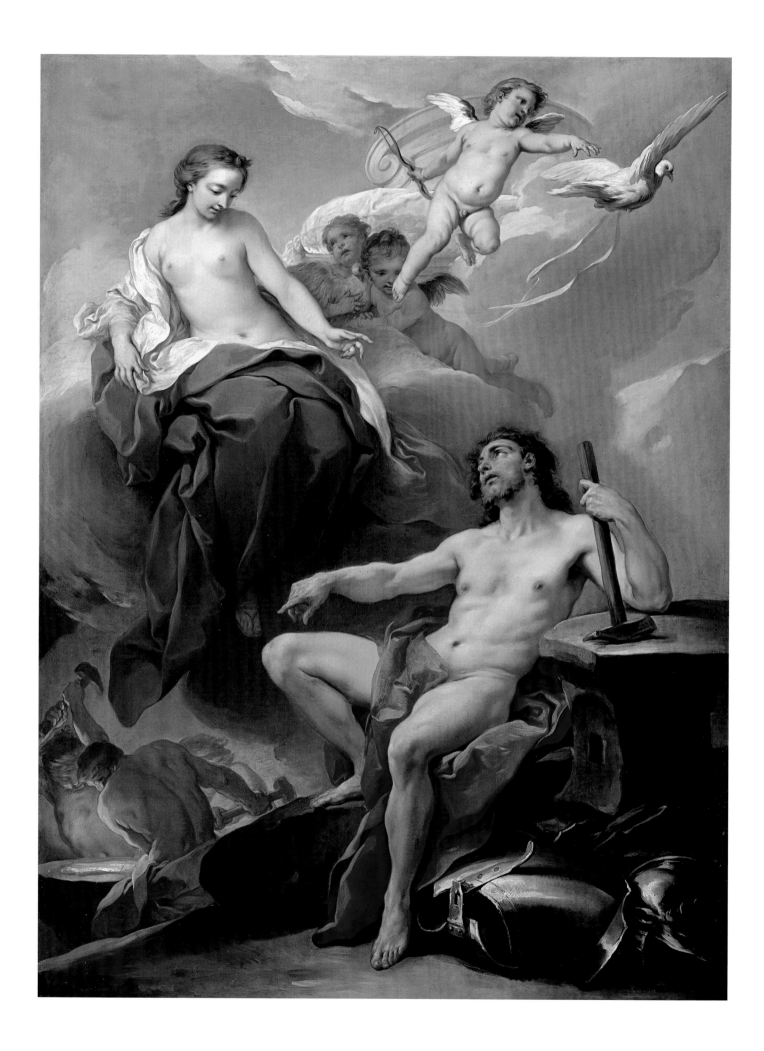

24. Charles-André Vanloo, called Carle Vanloo, French, 1705–1765

Venus Requesting Vulcan to Make Arms for Aeneas, about 1735

Oil on canvas, 50¾ x 38¾ inches
Purchased through a gift from Jane and W. David Dance, Class of 1940, and the Mrs. Harvey P. Hood W'18 Fund; P.2005.2

By the time Carle Vanloo returned to Paris in 1734, he had already been awarded top prizes at the art academies of France and St. Luke in Rome, had been honored by the pope, and had served as a painter in Turin at the court of King Charles Emanuel III (reigned 1730–73). Within two years Vanloo would establish himself as a professor at the French Royal Academy and receive the first of a number of prestigious appointments. During the short time between his return from a six-year sojourn in Italy and the commencement of his highly successful career as one of the leading painters in eighteenth-century France, Vanloo executed a number of works that revealed his ability to assimilate various stylistic influences. In several cases he combined classical figural types and a fashionable rococo palette to create mythological subjects that were acclaimed for their refined design and command of diverse artistic traditions.

Venus Requesting Vulcan to Make Arms for Aeneas of about 1735 depicts a scene from the eighth book of Virgil's *Aeneid*, in which Venus begs Vulcan to forge weapons for her illegitimate son, Aeneas. The same subject had been assigned to Charles-Joseph Natoire (cat. 25) by the Royal Academy as his official reception piece, submitted after an extended period of time in December 1734. Vanloo clearly modeled his composition—in reverse—after Natoire's slightly larger canvas, but he consciously simplified the crowded scene by reducing the number of figures, increased the scale of the principal characters, and introduced a more nuanced arrangement. While some of Vanloo's modifications were already employed by François Boucher (1703–1770) in a large painting of the same scene in 1732, all of the eighteenth-century compositions were derived from a ceiling fresco representing Venus and Vulcan by Pietro da Cortona (1596–1669), executed in the Palazzo Pamphili in 1651–54. Vanloo also demonstrated his understanding of and appreciation for classical sculpture by basing the pose of Vulcan on an ancient sculpture known as the "Barberini Faun" while including a deliberate reference to another renowned antique marble, the "Belvedere Torso," in the rendering of the back of one of the Cyclopes. Similar Hellenistic sculptural allusions were prominently featured in the young artist's reception piece presented to the Royal Academy later in 1735. At the same time, the central character of Vulcan displayed Vanloo's virtuosity at rendering the human figure. His considerable talent as a draftsman won him a prize in Rome, and he became especially noted for his finished sketches of nude models. For centuries figure drawings were based on the poses of ancient statuary (fig. 1), making the practice both an academic and an antiquarian pursuit. Overall *Venus Requesting Vulcan to Make Arms for Aeneas* demonstrated Vanloo's mastery of both classical antiquity and anatomy, and it contributed to his reputation for producing imaginative works of art based on the tenets of the so-called Grand Style, which were aimed at introducing a new grandeur and nobility to French painting. [Piotrowska forthcoming] TBT

FIG. 1. Jean Restout the Younger, *A Nude Man Seated,* 1734, black and white chalk, 16¾ x 20⅝ inches. Purchased through the Mrs. Harvey P. Hood W'18 Fund; D.990.20.

25. Charles-Joseph Natoire, French, 1700–1777

The Rest by a Fountain, about 1737

Oil on canvas, 27¼ x 35⅞ inches
Signed center left [C] Natoire. / .f.
Purchased through the Mrs. Harvey P. Hood W'18 Fund and the
Miriam and Sidney Stoneman Acquisition Fund; P.995.43

Charles-Joseph Natoire, who served as the director of the French Academy in Rome from 1751 to 1777, came into prominence after winning the Grand Prix in 1721. He worked in Italy from 1723 to 1729 and was received into the Royal Academy in 1734. In Rome he oversaw the training of such painters as Jean-Honoré Fragonard (1732–1806) and Hubert Robert (1733–1808).

Natoire's popularity spread immediately upon his return from Rome, when he was commissioned in 1737 to decorate the private apartments of Louis XV (reigned 1715–74) at the Château de Fontainebleau. Natoire completed six canvases representing scenes of hunting and fishing that were installed as overdoors in the large and small dining rooms, where they remained in place until 1793 (Boyer 1949: 70–71).

The painting in the collection of the Hood Museum of Art is an autograph version of one of the Fontainebleau canvases, now in a private collection in Italy. Like many decorative pictures, it has been cut down and was probably also originally vertical in format. Its genesis is unclear: too highly finished to have served as a preparatory study, it may be a replica—it is the same scale as the vertical canvas—perhaps kept by the artist as a record of his prestigious commission. The presence of numerous *pentimenti,* or visible alterations, and the sheer brio of the brushwork, however, suggest that it predates the one now in Italy.

Whatever its origins, *The Rest by a Fountain* is a testament to the sophistication and elegance of decorative painting during the reign of Louis XV. The subject is an idealized melding of social and class types, all brought together in a rugged landscape setting. A hunting party has stopped to rest at an elaborate and overgrown fountain. One hunter waters his horse, to the apparent consternation of a young herdsman, while two others sit on the ground, picnic basket and wine bottles close at hand. Two riders gallop into the scene in the background on the right.

The theme of the hunt—the focus of most of the paintings commissioned at this time for Fontainebleau—was especially popular in art during the reign of Louis XV. The king's interest in the sport resulted in a series of commissions on the subject from a number of artists (Conisbee 1981: 157–59). Famous for its vast hunting grounds, Fontainebleau was a particularly appropriate setting for such scenes. Yet *The Rest by a Fountain* is also a paean to the pleasures of being outdoors. Using landscape as a setting for social interaction and flirtation, it continues the tradition of the *fête galante,* literally "gallant party," that was invented by Jean-Anotine Watteau (1684–1721) in the previous generation. A variety of social types has converged on the site to hunt, tend to their herds, or simply take in the sun. Contrasting elements underscore the traditional dichotomy between city and country. Moreover, the intermediary figure of the reclining gentleman who, dressed in city clothes, assumes the pose of an ancient river god represents an ideal merging of nature and culture. The magic of Natoire's painting lies in its synthesis of these disparate elements into a convincing and beautiful whole. [Based on entry in Rand 1996: 119–21, no. 15]

26. Pompeo Batoni, Italian, 1708–1787

William Legge, Second Earl of Dartmouth,
about 1752/53–56

Oil on canvas, 38 1/2 x 29 inches
Purchased through gifts from Jane and W. David Dance, Class of 1940,
Tuck 1941; Jonathan L. Cohen, Class of 1960, Tuck 1961; Frederick B.
Whittemore, Class of 1953, Tuck 1954; Barbara Dau Southwell, Class of
1978, and David Southwell, Tuck 1988; Parnassus Foundation/Jane and
Raphael Bernstein; and an anonymous donor; 2007.34

27. Pompeo Batoni

Robert Clements, later First Earl of Leitrim,
about 1753–54

Oil on canvas, 39¾ x 29¾ inches
Purchased through a gift from Barbara Dau Southwell, Class of 1978, in
honor of Robert Dance, Class of 1977, a gift of William R. Acquavella,
and the Florence and Lansing Porter Moore 1937 Fund; P.2002.6

By the time William Legge, the Second Earl of Dartmouth (1731–
1801), and Robert Clements, later First Earl of Leitrim (1732–1804),
traveled to Rome in the early 1750s, the so-called Grand Tour to
Italy was already considered an essential ingredient in the proper
education of many upper-class Europeans, especially young English,
Irish, and Scottish noblemen. Guided by early published accounts
and traveling according to standard itineraries that sometimes last-
ed for years, travelers from the British Isles sought to reconstruct
Roman antiquity by visiting the sites described in ancient literature
and using surviving sculptures to elucidate illustrious figures and
notable events in classical history. It was also at this time that in-
creasing numbers of foreign visitors to Rome commissioned por-
traits as mementos of their journey.

By the early 1750s, Pompeo Batoni had secured the majority of
the portrait trade in Rome and had popularized the depiction of in-
formally posed sitters, either in open-air settings highlighting Ital-
ian landscapes or in enclosed interiors with renowned antiquities.
The portrait of Lord Dartmouth, grandson of the First Earl, whom
he succeeded in 1750 (and later a prominent benefactor of the Col-
lege), and the portrayal of Robert Clements, the son of the Irish
Deputy Vice-Treasurer and Teller of the Exchequer, exemplify the
features employed by Batoni. These elements were later imitated by
other European artists and made him the most celebrated painter in
Rome during his lifetime.

When Lord Dartmouth and Robert Clements arrived in Rome
in 1752 and 1753, respectively, Batoni was already acclaimed as
the leading portraitist in Rome and would soon be recognized as
one of the most important throughout Europe. Over the course
of the next three decades, he received commissions from some of
the greatest art patrons on the continent. Batoni's sitters generally

admired the apparent elegance and refinement of his style, as well
as his ability to depict both social status and self-esteem. Connois-
seurs appreciated his lively use of color, the meticulousness of his
draftsmanship, and his skillful technique. The portraits of the 1750s
were especially appealing due to their extraordinary quality, derived
from the artist's determination to establish and sustain his preemi-
nence (Clark 1981: 114 and Bowron 2007: 37–40). In the case of
the paintings of Lord Dartmouth and Robert Clements, they also
appear to represent accurately the personal interests of the sitters. In
addition to the introduction of motifs that Batoni later employed
repeatedly, such as the landscape background and the inclusion of
ancient sculpture, these two works seem to be carefully composed
to satisfy the established tastes and preconceived notions that these
two men brought to Rome.

The standing, three-quarter-length figure of Lord Dartmouth in
Batoni's painting, possibly begun as early as 1752 but not completed
until 1756, represents the sitter leaning to one side on a pedestal sit-
uated in a portico-like setting. A high balcony or balustrade behind
him opens onto a hilly landscape with unidentifiable structures in
the distance. The composition had been employed by Batoni before
and is often repeated by him later; he modeled it after an earlier
generation of Grand Tour portraits with landscape backgrounds.
For Lord Dartmouth, in particular, the Italian countryside was a
major focus of his visit to the southern European peninsula, and
he recorded it in numerous letters, acquisitions, and commissions.
Such notions reflected the eighteenth-century English fascination
with the picturesque landscape, and Batoni's portrait of Lord Dart-
mouth prominently featured the sitter's profound connection to
this tradition.

While the pose of Robert Clements in Batoni's oil painting of

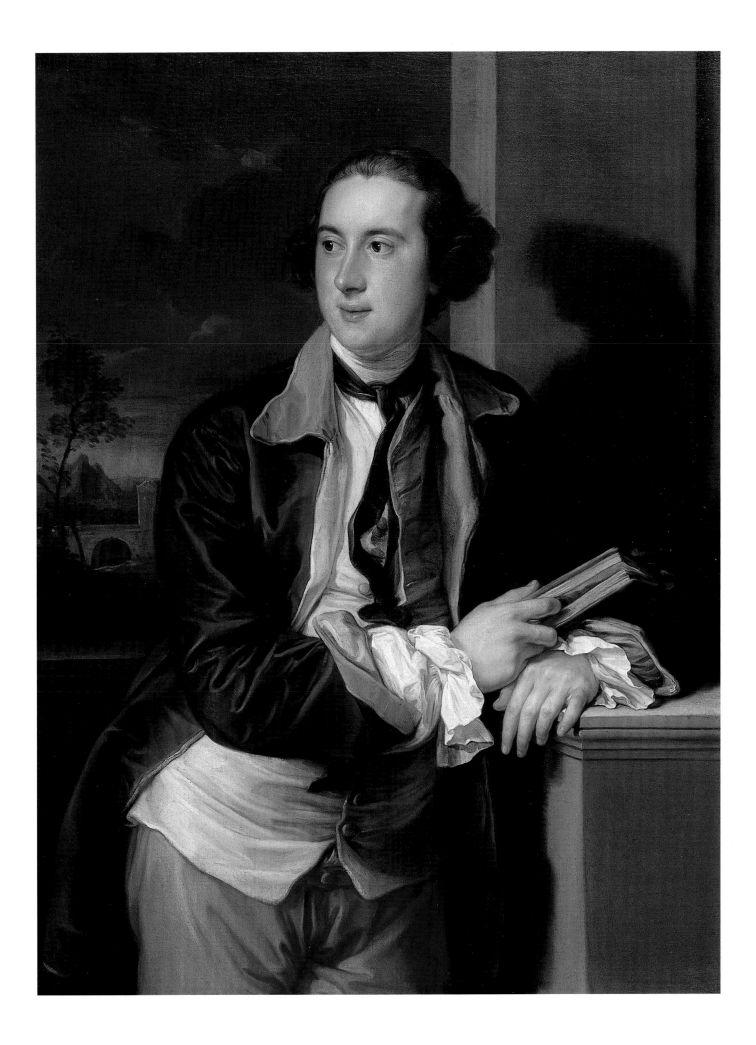

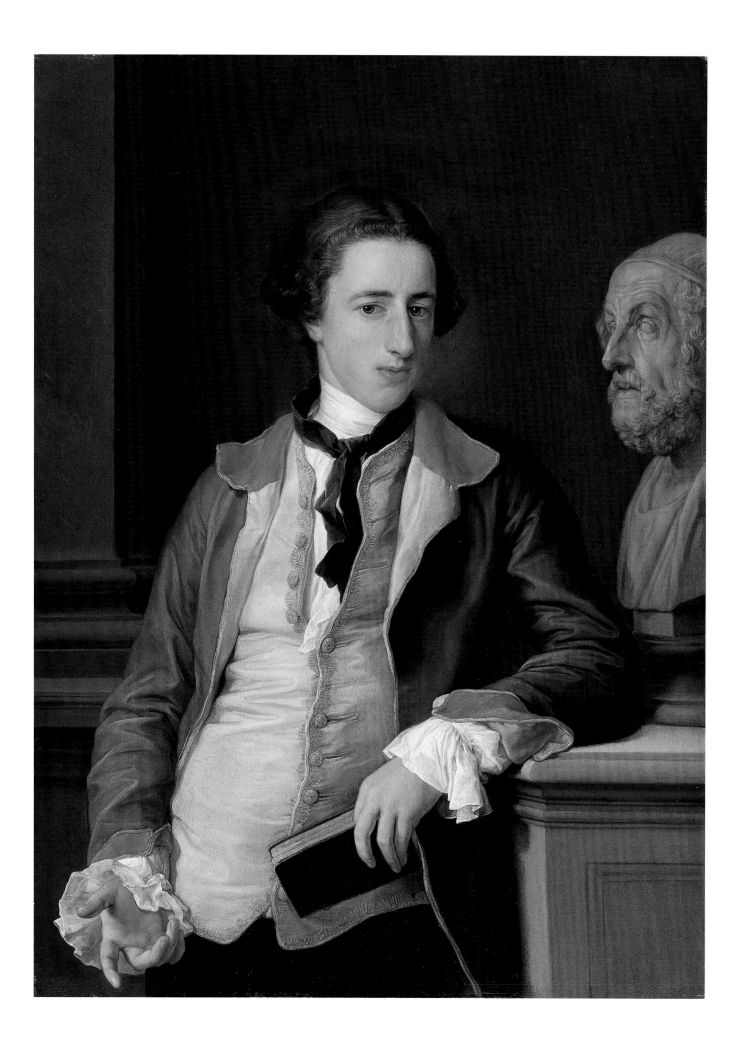

1753 is nearly identical to that shown in Lord Dartmouth's portrait, the setting is entirely different. Clements was portrayed indoors in front of a classically designed pilaster and next to a sculpted bust. Apparently this was the painter's first use of an antique sculpture to suggest the sitter's appreciation of ancient art (Russell 1973: 1609). The bust of Homer was carefully arranged on a pedestal and positioned almost as though the great poet were directing his gaze toward his admirer. The sculpture, one of a large number of replicas of the most celebrated of the invented portraits of antiquity, corresponded in all essential details with the one in the Farnese collection in Rome. For many readers of this era, Homer perfectly mirrored an ideal, heroic world that resonated with the one described by early-eighteenth-century British travelers writing about their own journeys to Italy. The inclusion of the bust of Homer here in fact suggests more than the sitter's immediate aesthetic response to the age and artistic qualities of the sculpture. For a number of contemporary observers, the ancient Greek author embodied the classical—and primarily male—virtues that visitors to Rome sought to revive and imitate.

Although there is no specific documentation indicating that Batoni's sitters instructed him about how they would like to be portrayed, undoubtedly the painter would have discussed in detail the proposed composition and other issues associated with a client's attitude, attire, and accessories. With regard to the latter, selections were most likely based on the preferences of the sitter, but they also often reflected the values and tastes of the leading figures promoting the aims of the Grand Tour. In addition, even though an earlier generation of Italian artists had included landscapes and antiquities in their portrayals of foreign visitors to Rome, Batoni popularized this particular type of portraiture, eventually creating an iconic image of the British traveler. [Clark and Bowron 1985: 257–58, no. 174; 267, no. 195; Bowron 2007: 37–40] TBT

28. Circle of Giambattista Tiepolo, Italian, 1696–1770 (possibly Giustino Menescardi, Italian, about 1720–after 1776)

The Resurrection of Christ, 1750s

Oil on canvas, 38½ x 21⅝ inches
Gift of Jane and W. David Dance, Class of 1940; P.987.64.1

This painting is a *ricordo,* a contemporary copy after an original composition by Giambattista Tiepolo for an altarpiece in the Chapel of the Sacrament in the Cathedral of Udine. The artist was commissioned by a local confraternity to decorate the entire space in the summer of 1726. Christ's miraculous resurrection three days after his burial was a particularly appropriate subject for the altar, providing a visual metaphor for the saving grace of communion that was celebrated in front of the painting.

According to published documents and the large number of surviving examples, Tiepolo regularly ordered copies of his designs, but it is unclear to what extent he prepared them himself. Undoubtedly,

many *ricordi* were done by his assistants and used to document projects in distant locations and to instruct his pupils. These record copies turned out later to be marketable, since both of Tiepolo's sons, Giandomenico (1727–1804) and Lorenzo (1736–1772), as well as another assistant, Giovanni Riggi (1712–1792/94), continued the practice and greatly profited by it (Brown 1993: 18).

Tiepolo had an active studio that assisted him with a number of different projects. Giustino Menescardi came from Milan and by 1751 had settled in Venice, where he developed a style closely dependent on the early work of the master. TBT

29. Gaetano Gandolfi, Italian, 1734–1802

Study of a Male Head, about 1770

Oil on paper mounted on panel, 14 x 10¾ inches
Purchased through the Julia L. Whittier Fund; P.984.5.1

Filippo Baldinucci (1625–1697), a Florentine collector, art historian, and writer, described sketches as "some drawings, as well as some paintings, made with extraordinary facility, and with harmony and freshness, without much ink or paint, and in such a way that they almost seem not made by the hand of artifice, but as if they appeared by themselves on paper or on canvas" (1681: 1:86). From the Renaissance until the late eighteenth century, rapidly executed studies were generally prepared in connection with large, multi-figure religious or historical commissions—compared to their more limited appeal for portraiture, landscapes, and still-lifes. Their ability to retain a direct association with the artist's conception was especially valued by contemporary collectors, who appreciated sketches for their apparent spontaneity and reference to the creative process. As Denis Diderot (1713–1784) observed, "Why does a beautiful sketch please us more than a beautiful picture? It is because there is more life and fewer forms. As one introduces these forms, the life of it disappears" (cited in Seydl 2005: 14).

Gaetano Gandolfi was the most talented member of a family of painters that dominated the field of art in Bologna in the second half of the 1700s. A prolific painter of altarpieces and frescoes, he later became highly regarded for his drawings and oil sketches. A surprisingly large number of these works have survived.

The present oil sketch has not been definitively associated with a particular finished project. It recalls some figures that appear in several large paintings depicting the effects of the plague. The fluid brushwork and sensitive treatment of light over the features of the subject underscores the sophistication of Gandolfi's technique.

TBT

73

30. Louis de Moni, Dutch, 1698–1771

The Kitchen Maid at the Window, 1770–71

Oil on panel, 13¼ x 10 inches
Signed lower right: Louis De Moni
Gift of Jane and W. David Dance, Class of 1940; P.989.25

Louis de Moni's carefully finished painting is part of a tradition in Dutch art called *fijnshilderijn* ("fine painting") that was first popularized by Gerrit Dou (1613–1675) and his pupils in Leiden from about 1630 onward. Dou and his followers made a specialty of these scenes, often focused on a woman leaning out a stone-framed window and surrounded by precisely rendered objects, both natural and manufactured. Some of these items (such as the empty birdcage in the middle of the room) may have embodied a symbolic, moralizing meaning, but De Moni's refined work of art as a whole was probably intended more to delight than to instruct.

De Moni studied and traveled with Philip van Dijk (1680–1753), from whom he learned to produce paintings with convincing illusionistic effects and smooth finishes. He also learned the trade of art dealing from him, and De Moni sold both originals and copies of seventeenth-century genre pictures. These works continued to be popular well into the eighteenth and even nineteenth centuries due to their small scale, technical virtuosity, and everyday themes.

In spite of the appearance of a realistic setting, the composition is entirely fanciful, and contemporary viewers would have recognized that there were no windows of this kind in Holland. Yet the woman's activity of preparing a meal in a warmly lit space created a familiar atmosphere, and the playful juxtaposition of fictive and naturalistic effects would have appealed to art collectors, contributing to the long-lasting influence of such subjects. TBT

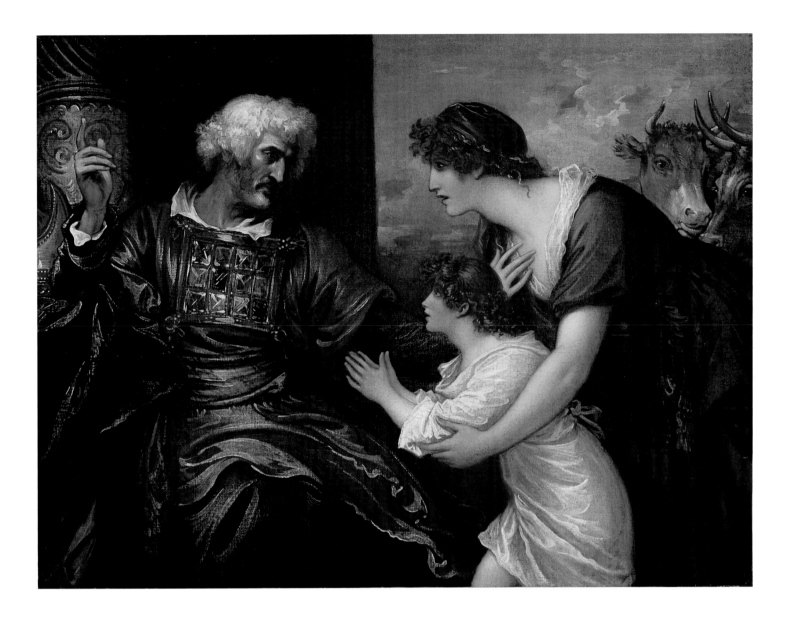

31. Benjamin West, American, active in England, 1738–1820

Hannah Presenting Samuel to Eli, 1800

Oil on canvas, 13¼ x 17¼ inches
Purchased through the Mrs. Harvey P. Hood W'18 Fund; P.993.24

Benjamin West was the first American artist to achieve an international reputation and influence artistic trends in Europe. He has been widely acknowledged as the foremost history painter working in England at the end of the eighteenth century and as a pioneer of the neoclassical and romantic styles. In 1792, West was elected as the second president of the Royal Academy, which greatly enhanced his status and influence. He painted this picture during his tenure as historical painter to King George III (1738–1820). At the time he was working on the decoration of the Chapel of Revealed Religion that was planned for Windsor Castle. After sponsoring the elaborate project for two decades, the king abruptly canceled it in 1801. As late as 1806, West hoped that he would be allowed to resume it, but his deteriorating relationship with the court prohibited him from ever realizing his grand scheme.

Made for West's own collection and exhibited at the Royal Academy in 1801, the painting portrays Samuel, the Old Testament Patriarch. Christians consider him to be a precursor of Jesus, and he figured prominently in the scheme developed by the artist for the Chapel of Revealed Religion. Here, Samuel's mother, Hannah, who was previously thought to be barren but has miraculously given birth, presents her young son to the High Priest Eli (1 Samuel 1:24–28). Eli wears the traditional high priest's breastplate, which bears twelve gemstones representing the tribes of Israel and signals the presence of God at ritual occasions. In the background to the right are two heifers brought for sacrificing. West focuses on the exchange between the mother and the priest as Hannah, meek and humbled before the commanding Eli, nudges a tentative Samuel forward. The precise profiles of mother and son reflect West's earlier neoclassicism, while the painting's vigorous baroque flourish is in keeping with the artist's late manner. [Von Erffa and Staley 1986]

BJM

75

32. George Romney, British, 1734–1802

William Henry Irby, 1776–77

Oil on canvas, 29½ x 25 inches
Gift of Julia and Richard H. Rush, Class of 1937, Tuck 1938; P.980.72

33. George Romney

Edward Bootle-Wilbraham, Baron Skelmersdale,
late 18th century

Oil on canvas, 29½ x 25 inches
Gift of Julia and Richard H. Rush, Class of 1937, Tuck 1938; P.982.29

George Romney ranked alongside Joshua Reynolds (1723–1792) and Thomas Gainsborough (1727–1788) as one of the most popular British society portraitists at the end of the eighteenth century. After establishing himself as an artist in London during the 1760s, Romney traveled to Italy for his Grand Tour in 1773. His quick rise to success as a portraitist occurred after he returned to London in 1775. At the height of the social season during the following decades, Romney reportedly offered between three and seven sittings a day at his studio in Cavendish Square, and his record books document at least fifteen hundred sitters (often for multiple portraits) through the year 1795.

William Henry Irby was the second son of Sir William Irby, the First Baron Boston (1750–1830). In this portrait, Romney positions him before a dark, stormy background. Irby wears the uniform of the British Army with an epaulette on his right shoulder, indicating his status as an officer of the battalion. Although the details of Irby's military career are unknown, in 1781 he married Mary Blackman and acquired plantations in Barbados and Antigua from her father, which surely provided a steady income. Romney's record books for 1776 and 1777 record five sittings for Irby (mistakenly noted as "Mr. Erby" by the artist). Across these same years, the diary also shows that Romney painted the portraits of William's brother, the Lord Boston, his brother's wife, Lady Boston, her father, Mr. Paul Methuen, and her brother, Mr. Methuen Jr. In family portraits intended to hang together on the walls of a grand home, Romney's style was highly valued for its consistency.

The other portrait here presents Edward Bootle-Wilbraham (1771–1853) as a gentleman surveying his land. Holding his walking stick, he rests his hand on a barely visible classically inspired stone relief. Bootle-Wilbraham began a parliamentary career in 1795, when he was elected to the House of Commons for Westbury. He continued to serve in the Commons until 1828, with only a two-year break from 1818 to 1820. In 1828 he was raised to the peerage and named Baron Skelmersdale, of Skelmersdale in northwest England.

In both of these portraits, Romney depicts the sitter with a pensive, almost melancholic expression and a far-off gaze. In the years following his return to England, a heavy, mournful air was frequently evident in his portraiture. Scholars have suggested that this was part of Romney's desire to raise portraiture from an art of imitation to a deeper philosophical exercise that could convey something of a person's soul (Kidson 2002: 180). Grief and darkness were associated with perception, virtue, and substance. By incorporating these elements into his portraiture, Romney likely sought to set himself apart as an artist capable not only of copying a face but also of presenting a thoughtful portrayal of his sitter's character. [Ward and Roberts 1904: 1:65] MWL

34. Elisabeth-Louise Vigée Le Brun and studio, French, 1755–1842

Vicomtesse de Vaudreuil, after 1785
(probably early 19th century)
Oil on canvas, 37½ x 27½ inches
Gift of Timotheus Pohl; 2005.18

The celebrated and ambitious artist Elisabeth Vigée Le Brun was known throughout Europe for her flattering portraits of royal and aristocratic sitters, in which she combined the sensuality and refinement characteristic of the Ancien Régime with the bolder naturalism and emotional restraint of her contemporary Jacques-Louis David (1748–1825). Vigée Le Brun achieved fame and social status early in her life, rising to become an official painter to Queen Marie-Antoinette (1755–1793) and one of only a few female members of the Royal Academy. Her association with the queen and with aristocratic society complicated her career at the outset of the French Revolution. In 1789, Vigée Le Brun left France with her infant daughter, Jeanne-Julie-Louise, spending the next twelve years in exile as an itinerant portraitist traveling throughout Europe but especially in Italy, Austria, and Russia.

Vigée Le Brun first painted this composition in 1785 on an oval wood panel (now in the collection of the J. Paul Getty Museum). The Hood's rectangular replica on canvas can probably be identified with a work recorded in her catalogue of approximately two decades later. Joseph Baillio, who doubts the attribution of the Hood's version to Vigée Le Brun, has identified the elegant young woman portrayed in both paintings as the Vicomtesse de Vaudreil (1764–1834, née Victoire Pauline de Riquet de Caraman). The painting shows the vicomtesse leaning on a mossy pedestal before a landscape dominated by a deep blue sky with scattered clouds. The thumb of her right hand lies between the pages of a small book, suggesting that she has interrupted her reading to engage the viewer. The painting thus flatters both the sitter's learning and her polite sociability, while her elegant purple satin dress, elaborate lace collar and cuffs, and gauzy, broad-brimmed hat underscore her sophistication. With its energetic brushwork and stylish mood, this work speaks to both the cultural ambit within which it was produced and its maker's extraordinary talent. [Baillio 1982: cat. 16 (copy)] AR

35. Sir William Beechey, British, 1753–1839

Portrait of Robert Lindley, about 1810

Oil on canvas, 81 x 57⅜ inches
Gift of Irving S. Manheimer; P.959.35

Robert Lindley (1776–1855) was one of the most celebrated musicians of his time, which explains the unusual prominence given here to his instrument, the violoncello, now commonly referred to as the cello. While Lindley's spiked hairstyle, fashionable in the early nineteenth century, may amuse present-day viewers, the large size and vibrant colors of this portrait nevertheless create a powerful impression. Lindley reportedly began playing the violoncello when he was nine years old, and he became the principal violoncellist at the London Opera by the age of eighteen. He played with orchestras throughout England and also composed his own music. On the founding of London's Royal Academy of Music in 1822, he was named the first professor of violoncello.

This portrait appears quite faithful to written descriptions of Lindley that characterize him as unpretentious, kind, and apt to exchange congratulatory smiles with his fellow musicians and audiences. Lindley rests his hand on his loyal dog, suggesting the musician's domestic, approachable nature, and the dog's shiny gold collar hints at his master's success. The lavish furnishings also serve to indicate the sitter's wealth, while the red curtain perhaps refers to Lindley's career as a performer. A recently opened letter and large stacked books point to Lindley's intellectual pursuits as a composer and instructor.

The artist Sir William Beechey initially trained as a lawyer before undertaking artistic study at London's Royal Academy in 1772. Presumably at this time he made a large number of copies after old master portraits in the king's collection (recorded in the Christie's sales of June 9–11, 1836). He first participated in the academy's annual exhibition four years later and was named portrait painter to Queen Charlotte (1744–1818) in 1793. He continued to enjoy royal patronage throughout his career and was knighted in 1798 for a monumental group portrait featuring King George III (1738–1820). As much a portrait of Robert Lindley's instrument as of the man himself, this lively painting demonstrates why Beechey remained in high demand as a portraitist throughout his career. [Leppert 1988: 22]

MWL

36. Jean-Claude Bonnefond, French, 1796–1860

A Farrier near a Forge, 1822

Oil on canvas, 39 x 49 inches
Signed and dated lower left: Bonnefond de Lyon 1822
Gift of Mr. and Mrs. Charles F. McGoughran, Class of 1920; P.961.245

Jean-Claude Bonnefond's minutely detailed genre scene, recently restored to dazzling effect, continued a long-established trend in European art that celebrated the artist's ability to simulate nature through the medium of oil paint. This style reached its pinnacle in early-nineteenth-century France in the work of Louis-Léopold Boilly (cat. 105), who usually focused on the daily life of the Parisian bourgeoisie. By choosing to depict a subject from the world of the rural working class, Bonnefond, a provincial artist from Lyon trying to establish his reputation in Paris, aligned himself with more avant-garde painters, such as Théodore Géricault (cat. 109) and Eugène Delacroix (cat. 112).

A Farrier near a Forge—possibly Bonnefond's masterpiece of genre painting—was exhibited at the 1822 Paris Salon, where it drew mixed reviews from critics. While one writer hailed it as "a little masterpiece, with its naive truth . . . and astonishing finish in the details," another complained, "God, what harsh reality! How unfortunate that nature so well understood could be so laboriously rendered."

Bonnefond's genre painting followed a tradition dating back to at least the early seventeenth century, when Adrian Brouwer (1605/6–1638) painted *Smith's Forge* (later reproduced in the eighteenth century in a mezzotint). According to David Solkin (2003: 170), this example served as the starting point for a series of five paintings executed by the English painter Joseph Wright of Derby (1734–1797) between 1771 and 1773. There were many formal similarities between the various versions, such as the depiction of full-length blacksmiths and foundry workers seen from the rear and silhouetted against the light of the burning metal. However, compared to the Dutch precedent, Wright elevated his portrayals of the laborers to make them appear more as individuals working as a team with specialized skills (fig. 1). These were not images of brute strength and men deformed by the hazards of their trade but rather ironworkers proud of their abilities (ibid.).

Similarly, Bonnefond shows the men working in a humble but organized setting. They are productive, industrious citizens transforming natural materials into useful, manmade objects—not unlike the artist of this painting. TBT

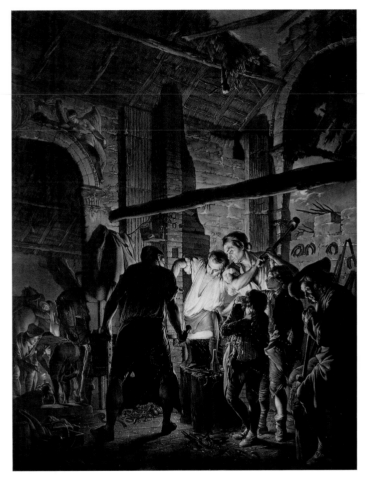

FIG. 1. Richard Earlom, after Joseph Wright of Derby, *A Blacksmith's Shop*, 1771, mezzotint, 21¾ x 17 inches. Purchased through the Julia L. Whittier Fund; PR.952.66.

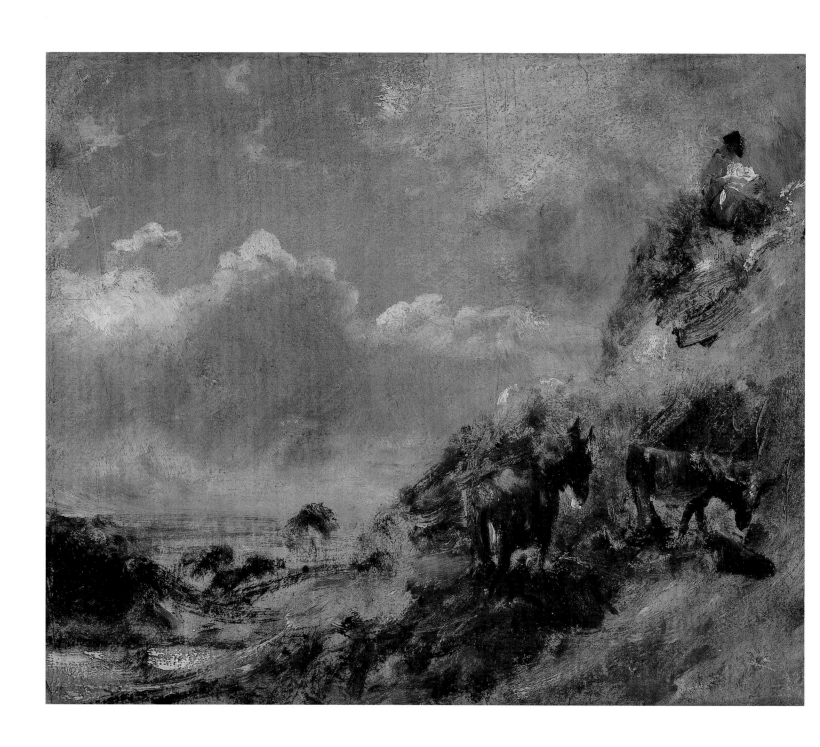

37. John Constable, British, 1776–1837

Hampstead Heath, Branch Hill Pond, about 1822

Oil on paper mounted on canvas, 9¾ x 11½ inches
Inscribed on the stretcher in ink: English School John Constable R A
bought from Charles Constable Capt. [John Constable's son,
1821–1879]
Gift of Adolph Weil Jr., Class of 1935; P.988.57

Along with Joseph Millord Turner (1775–1851), John Constable was the preeminent landscape artist of the nineteenth century in England. His paintings have been praised for their nostalgic evocation of the English countryside. While his large, finished canvases often drew inspiration from Dutch and French landscapes of the seventeenth century, Constable's open-air oil sketches of the early 1820s demonstrated that he was also an acute observer, rejecting traditional compositional models in favor of a direct record of actual scenes. Without relying on mythological or allegorical subjects, the artist gave meaning to his landscapes by documenting his personal responses to nature. These studies marked an important evolution of his ideas, which were later disseminated in a series of twenty-two prints that he commissioned to reproduce an equal number of paintings accompanied by moral and philosophical inscriptions (fig. 1).

This particular sketch is a remarkable example of Constable's spontaneous execution and intimacy of approach. The artist allows the brown paper support to show throughout, unifying the composition. It is similar to a version of about 1822 in the collection of the Louvre, as well as other paintings of this date now in the Victoria and Albert Museum in London. The evocative stormy sky recalls his famous studies of clouds, which were also executed during this period.

Beginning in 1819, Constable rented a house in Hampstead nearly every year until he acquired a permanent home there in 1827. Branch Hill Pond was one of his favorite motifs, and he sometimes incorporated elements from sketches like this one into his finished pictures. [Reynolds 1984: 1:114, no. 22.70; 2: pl. 392] TBT

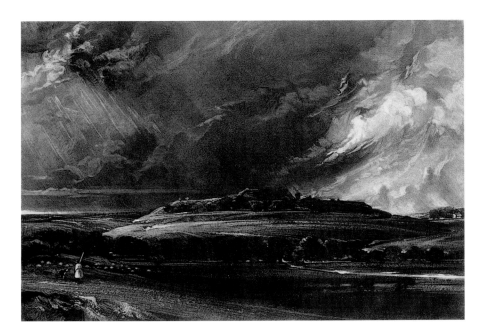

FIG. 1. David Lucas, after John Constable, *Old Sarum* (second plate), from a set titled *English Landscape,* 1833, mezzotint, state ii/III, 7 x 10¹⁄₁₆ inches. Gift of Adolph Weil Jr., Class of 1935; PR.992.12.16.

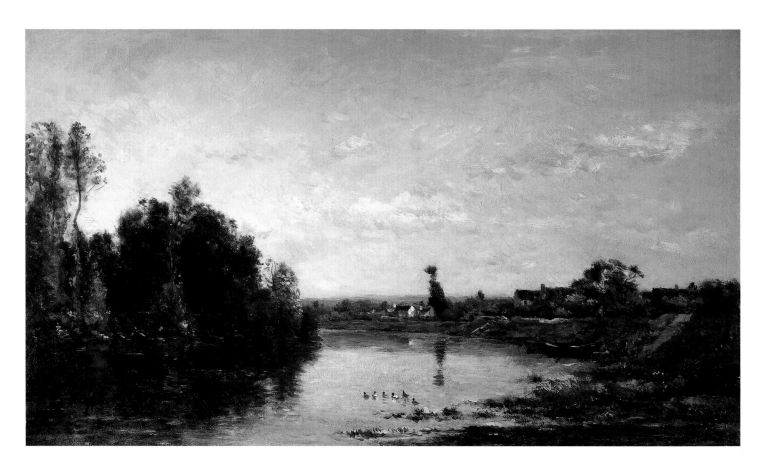

38. Charles-François Daubigny, French, 1817–1878

The Banks of the Oise River at Mériel, 1867

Oil on panel, 15 x 26½ inches
Signed and dated lower right: Daubigny 1867
Promised gift of Patricia Hewitt and Dale C. Christensen Jr.,
Class of 1969

This landscape represents a picturesque setting along the Oise River near Mériel, north of Paris. The carefully juxtaposed strokes of unblended color and flickering white on the water reveal the artist's interest in capturing atmospheric effects. In addition, this work appears to have been completed entirely *en plein air* ("in the open air") in the late evening during the summer. Daubigny's emphasis on direct observation and spontaneous execution in order to capture the look of changing weather, times of day, and seasons formed a vision that inspired other artists to paint outdoors as well.

The Oise River was one of Daubigny's favorite subjects. He moved to Auvers-sur-Oise in 1861 and remained there until his death in 1878. Traveling on a boat that had been converted into a studio, he continuously explored the surrounding waterways (fig. 1). Daubigny was evidently the first artist to paint his large works from nature. He was also one of the first to take an interest in the varying aspects of a particular scene and the rendering of these ephemeral effects with quick brushstrokes. These qualities made Daubigny central to the development of a more naturalistic approach toward landscape painting, linking him ultimately to the impressionists, whose work he encouraged.

The interpretation of water, whether the sea, streams, rivers, pools, ponds, or lakes, always occupied the painter. He was particularly adept at catching the shimmering appearance of light on its surface, as well as the reflections of the sky and other features. At times he used a palette knife to apply the paint, employing a method later adapted by several impressionists. As a result, his subject matter, style, and technique marked a clear transition toward more modern forms of artistic expression. [Hellebranth 1976: 63, no. 168; Thurber 2005: 36–37, no. 9] TBT

FIG. 1. Charles-François Daubigny, *The Studio Boat,* 1861, etching, state ii/II, 4¹⁄₃₂ x 5³⁄₁₆ inches. Purchased through the Phyllis and Bertram Geller 1937 Memorial Fund; PR.985.28.

39. Charles Fairfax Murray, British, 1849–1919

The Triumph of Love, 1870s

Oil on panel, 6¼ x 30½ inches
Gift of Margaret Trevisani Erbe, Tuck 1989, and Henry H. Erbe III,
Class of 1984; 2006.85.1

40. Charles Fairfax Murray

Preparatory Study for the Triumph of Death, 1870s

Ink and opaque watercolor on paper, 6½ x 30½ inches
Gift of Margaret Trevisani Erbe, Tuck 1989, and Henry H. Erbe III,
Class of 1984; 2006.85.2

Charles Fairfax Murray began his career as a poor but talented draftsman with a keen interest in prints, illustrated books, and other works of art. At the age of seventeen, Sir Edward Burne-Jones (1833–1895) hired him to transfer cartoons. His association with the Pre-Raphaelites eventually led to his introduction to John Ruskin (1819–1900), who hired him to copy old master paintings in Italy. Already in 1867 Murray was exhibiting at London's Royal Academy and after 1877 at the Grosvenor Gallery as well. He quickly became a close collaborator of Dante Gabriel Rossetti (1828–1882) and William Morris (1834–1896), working on book illustrations and other decorative projects. By the late 1870s, Murray had become a successful art dealer, assembling various collections, including, for

example, old master drawings (which he eventually sold in 1909 to J. Pierpont Morgan [1837–1913] for the equivalent of three million pounds [Barrington 1994: 20]).

Beginning at an early age, Murray was commissioned by Collinson and Lock to paint panels to adorn deluxe cabinets and furniture. *The Triumph of Love* and *The Triumph of Death* were presumably made in conjunction with one of these projects. The scene in the oil painting is associated with Francesco Petrarch's (1304–1374) "Triumph of Love," one of his most illustrated works during the Renaissance. Murray chose to combine classical imagery with biblical inscriptions to symbolize an ideal union between secular and religious love stories. The other panel is thought to be a preparatory study for a companion work, *The Triumph of Death.* The format of the panels conforms to those used to decorate *cassoni,* Italian Renaissance chests, which were traditionally given as wedding gifts.

The eclectic mixture of historic, literary, and iconographic references and arts and crafts design was characteristic of the Pre-Raphaelite Brotherhood, originally established in 1848. The founding members advocated an aesthetic modeled after Italian art before the introduction of High Renaissance principles. Later proponents, such as William Morris, promoted a return to the production of handcrafted decorative arts. Murray adhered to the group's nostalgic ambitions, which are fully articulated in these two works.

TBT

41. Sir Lawrence Alma-Tadema, Dutch, active in England, 1836–1912

The Sculpture Gallery, 1874

Oil on canvas, 88 x 67½ inches
Signed and numbered at the base of the labrum and lower right:
Alma-Tadema op. CXXV
Gift of Arthur M. Loew, Class of 1921AM; P.961.125

Lawrence Alma-Tadema's largest painting, and one of his most ambitious, *The Sculpture Gallery* was exhibited at the Paris Salon in 1874 and the Royal Academy in 1875. Like its companion piece, *The Picture Gallery* (Towneley Hall Art Gallery and Museums, England), the painting was a tour-de-force of illusionism, recreating with archaeological precision actual Roman architecture, sculpture, and decorative objects. The artist studied many of these ancient works of art during his visits to Herculaneum and Pompeii in the 1860s and recorded a number of the objects in sketches and photographs. However, in addition to portraying sumptuous antique works of art in an exquisitely rendered interior, Alma-Tadema also introduced a number of innovative features in his painting.

A slave, identified by the crescent-shaped plaque hanging from his neck, displays a dark-colored *labrum,* or basin, decorated with the mythological creature Scylla. Admiring the work is an aristocratic family, actually comprised of portraits of Alma-Tadema, his wife and children, and his brother- and sister-in-law.

For the Victorian-era critic John Ruskin (1819–1900), the picture is a biting commentary on the acquisitive nature of ancient Romans and their supposed inability to distinguish between decorative works and art of true distinction (Ruskin 1875: 16–17). According to this interpretation, the family is enraptured by the dazzling scale of the *labrum* while they ignore the more noble sculptures that surround them, such as, on the left, a marble bust of Pericles, and, on the right, a seated statue of Agrippina. This explanation of the subject draws on the observations of the Roman writer Pliny the Elder (23/24 CE–79 CE), who complained that his contemporaries were more interested in the cost of a work than its artistic value (see, for example, *Natural History* 34.5 and 35.50, cited in *Sir Lawrence Alma-Tadema* 1997: 182).

On another level, Alma-Tadema's painted representation of the display and sale of ancient statues and other works emphasizes the role of sculpture in original, daily settings, instead of drawing attention to their significance as timeless ideals. The similar treatment of both utilitarian and luxurious objects undermines traditional hierarchies between different categories, such as decorative accessories and fine art. As David Getsy of the School of the Art Institute has noted (private correspondence), the sculptures are no longer presented as representative artifacts of a Golden Age to be reproduced or recreate, but rather as an integral part of everyday life in antiquity.

The complexities involved in interpreting the meaning of the painting correspond with the apparent intricacies of its conception and execution. A recent set of radiographs reveals that Alma-Tadema's picture is the result of an elaborate process that required many changes (fig. 1). The most startling alteration shows that the principal male figure on the left originally was standing and looking toward the *labrum*. It also appears that it was not originally intended to be a self-portrait. Other modifications include the standing red-headed woman, whose pasty white heaviness suggest that she may have been inserted—possibly along with the children—after the marble background was already completed. She also wears a long veil in the earlier version. Other areas of extensive reworking indicate that even though the basic theme of the painting did not change, Alma-Tadema labored over the final composition and particular details in order to produce "a work [of] artistic skill and classic learning, both in high degree" (Ruskin 1875: 16). [Swanson 1989–90: 64–72; *Sir Lawrence Alma-Tadema* 1997: 103–105, and no. 35, 182–186] TBT

FIG. 1. Composite radiograph of the lower portion of *The Sculpture Gallery*. Courtesy of the Williamstown Art Conservation Center, Inc.

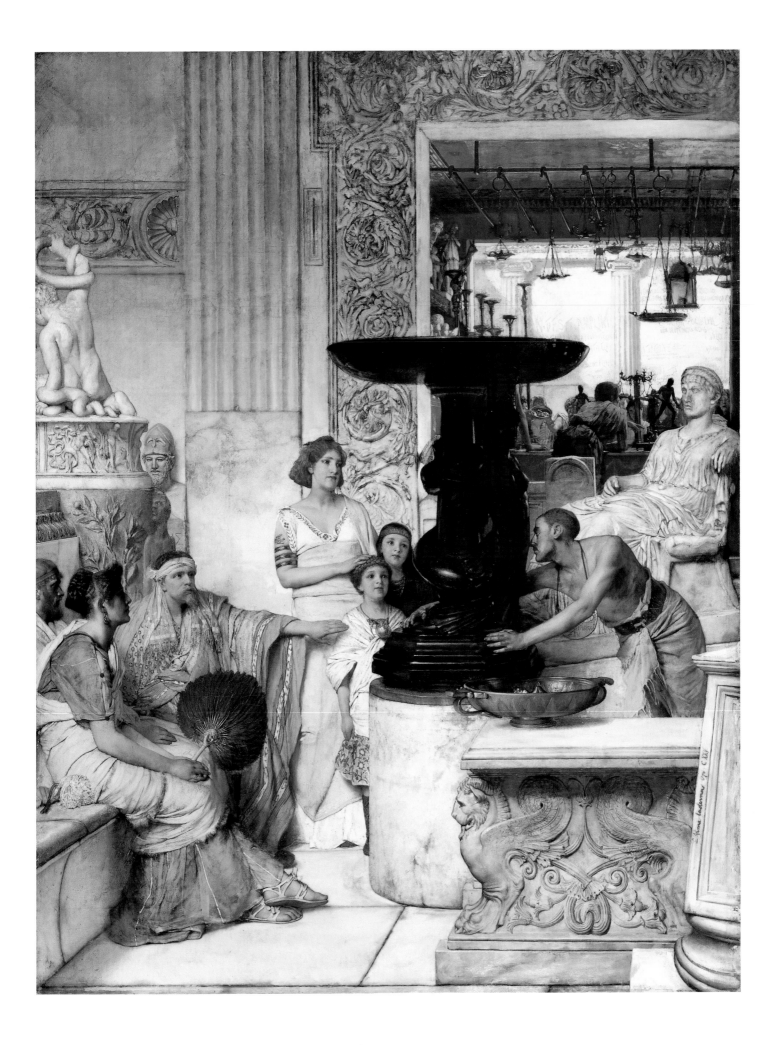

42. Albert-Ernest Carrier-Belleuse, French, 1824–1887

Abduction of Hippodamia (L'Enlèvement), 1877/79, cast after 1877

Bronze, 25½ x 21½ x 11 inches
Signed on top of base front left: CARRIER BELLEUSE
Purchased through a gift from Jane and W. David Dance, Class of 1940; S.999.5.1

Ovid's early-first-century account of the battle between Lapiths and Centaurs at the wedding of the Lapith king Pirithous to Hippodamia served as the inspiration for this superb bronze by Albert-Ernest Carrier-Belleuse. The sculptor chose to depict a key moment in this myth, when the intoxicated Centaur Eurytus seized the bride in a fit of passion and precipitated the violent melee that ended with the defeat of the Centaurs and the triumph of reason and order over base instinct.

Carrier-Belleuse's choice of this subject (*Hippodamia* means "tamer of horses" in ancient Greek) was entirely appropriate, because the first version of this subject was commissioned as a prize, cast in solid silver, that was awarded by the Jockey Club at the celebrated horse races in the Bois de Boulogne in 1874. Shortly thereafter he revised the design—presumably to sidestep a contractual obligation that the prize be unique—by making several changes, most notably altering Hippodamia's position and modeling the figure of the Centaur more vigorously. The resulting work surely ranks amongst the finest small sculptures produced in France in the second half of the nineteenth century. It was also one of the most animated of Carrier-Belleuse's compositions, and in this respect fully Baroque in its spirit—both in terms of the rich modeling of the surfaces of the Centaur and Hippodamia, who swoons in an attitude of near erotic abandon in his grasp, and the complex, interlocking poses of these two figures.

One of the most widely admired artists of his time, Carrier-Belleuse received his initial training in the workshop of a goldsmith and achieved early success as a designer for manufacturers of decorative objects in porcelain and metalwork. By the late 1850s he had begun to exhibit at the annual Salons in Paris and thereafter enjoyed a regular stream of commissions from both public and private patrons for work in many different genres. In addition to maintaining a lifelong interest in the decorative arts, which culminated with his appointment as artistic director of the great porcelain manufactory at Sèvres, Carrier-Belleuse was also a gifted teacher who trained a number of the most important sculptors of the succeeding generation. TR

43. Marius-Jean-Antonin Mercié, French, 1845–1916

Gloria Victis, about 1874, cast after 1879

Bronze, 42⅜ x 25¼ x 19 inches
Signed on base: A. MERCIE; inscribed on base: F. BARBEDIENNE, Fondeur
Purchased through a gift from Jane and W. David Dance, Class of 1940; S.999.5.2

Winner of the Prix de Rome as a young student, recipient of numerous medals awarded at the annual Salons held in Paris, and later a professor at the École des Beaux-Arts, Marius-Jean-Antonin Mercié achieved his greatest critical success at the start of his long and distinguished career with the exhibition of works such as *David Victorious* (1872) and *Gloria Victis*. First shown as a plaster at the Salon of 1874, *Gloria Victis* ("Glory to the Vanquished") was greeted with acclaim and perceived by the public as a response to France's humiliating defeat by Germany in the Franco-Prussian War of 1870–71. Indeed, it was said that the image of the young warrior borne aloft by a winged female figure was intended by Mercié to honor Henri Regnault (1843–1871), a friend and fellow artist who had died in the conflict.

Because it so eloquently expressed a sense of sacrifice and loss with an affirmation of the proud and resurgent spirit of France, *Gloria Victis* enjoyed an immediate and long-lasting popularity. In the decade after its initial exhibition, replicas were commissioned to adorn monuments to those who served in the Franco-Prussian War in cities and towns throughout France, and reproductions in bronze in a variety of sizes could be ordered from the Barbedienne foundry, which cast this version. Equally appealing to contemporary taste was Mercié's thoughtful transformation of a classical model (the third-century BCE Greek sculpture of Winged Victory in the collection of the Louvre) that he used as the basis for this composition. Moreover, his chaste yet sophisticated modeling of the forms and surfaces of the two figures reflected a deep appreciation of the work of the Florentine sculptors of the Renaissance. TR

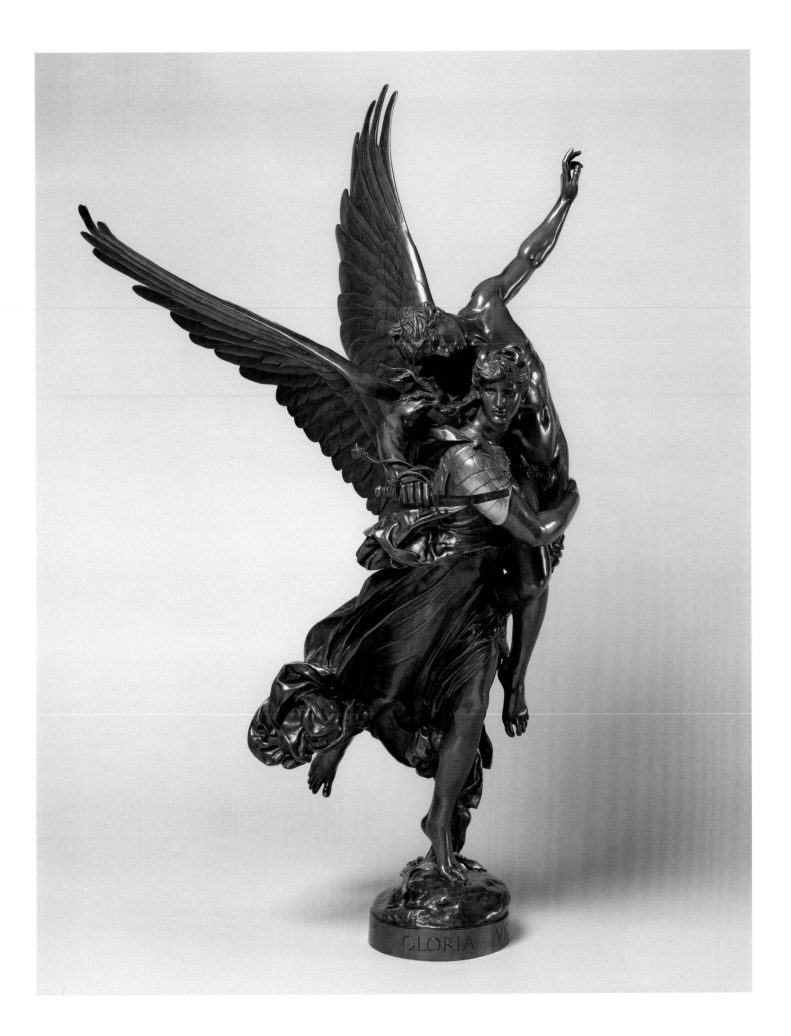

44. Jean-Baptiste Carpeaux, French, 1827–1865

Portrait of Jean-Léon Gérôme, 1872–73

Plaster, 23⅞ x 9½ x 10 inches
Signed on right side of socle: J Bte Carpeaux; front of socle: GEROME;
left side of socle: all'Sommo / Pittore Gerome
Purchased through a gift from Jane and W. David Dance, Class of 1940;
S.995.11

> M. Carpeaux, let me say very quickly, has something else than
> gaiety—he has a feeling for the portrait, and he is exhibiting an
> excellent bust of M. Gérôme . . . where the character of the mod-
> eling is ingeniously studied, is surprisingly lifelike; it moves, it
> breathes, and freedom in execution here has a wonderful aspect.
> —Paul Mantz (1872: 63, cited in Wagner 1986: 265)

The son of a mason from Valenciennes, Jean-Baptiste Carpeaux
studied at the École des Beaux-Arts in Paris in the studios of two
of the most accomplished sculptors of mid-nineteenth-century
France, François Rude (1784–1855) and Francisque Joseph Duret
(1804–1865). Carpeaux succeeded in winning the Prix de Rome in
1854. By the end of the decade he had firmly established his repu-
tation through a number of accomplished and challenging works,
including the superbly modeled *Ugolino and His Sons* (1857–61).

Carpeaux enjoyed enormous popular success during the remain-
ing years of the Second Empire, securing major commissions for
public monuments such as the *Fountain of the Observatory* in the
Luxembourg Gardens (1867–74) and architectural decorations, in-
cluding most notably an important sculptural group entitled *The
Dance* (1866–69) for the new opera house in Paris, designed by
friend and celebrated architect Charles Garnier (1825–1898).

Perhaps the most gifted portraitist of his generation, Carpeaux
produced many superb busts of both aristocratic clients and friends,
including musicians and artists such as Charles Gounod (1818–
1893) and the acclaimed painter Jean-Leon Gérôme (1824–1904).
The latter bust was modeled in 1871 in London, where Carpeaux,
Gérôme, and many other French artists had fled to avoid the politi-
cal strife created by the establishment of the short-lived Commune
in Paris at the end of the Franco-Prussian War. His portrait revealed
Carpeaux's remarkable talent for capturing both the likeness and
the spirit of his sitter, whose handsome face is animated by the deli-
cate modeling of the surface. Numerous examples of this work were
produced in bronze, marble, terra cotta, and, as here, plaster. TR

FIG. 1. Pierre-Auguste Renoir, *Portrait of Auguste Rodin,* 1910, lithograph, 19¾ x 26 inches. Purchased through the Julia L. Whittier Fund; PR.959.2.

45. Auguste Rodin, French, 1840–1917

The Creator (Self-Portrait), modeled about 1898–1900; cast 1984

Bronze, 16⅛ x 14⅜ x 5⅜ inches
Gift of Joan and Harold Gordon, Class of 1956; 2005.68

Auguste Rodin designed *The Gates of Hell* (1880–about 1900), the first major commission received by the artist, for the entrance to a museum of decorative arts. Even though it was never completed, the project served as a supreme demonstration of Rodin's expressive interpretation of the human body. He modeled hundreds of figures for the commission, and already by the late 1880s some of them had become independent works. *The Creator* was one of two lower moldings in extremely low relief added to the door panels after 1898. It depicted a self-portrait of the artist, the only known work of this kind, with a nude female muse over his shoulder.

Although the relief was described by at least two of Rodin's contemporaries, it was not identified as a portrait until 1966 (Alhadeff). The powerful face, long thick beard, and full mustache corresponded with characteristic features described by the artist's friends and depicted in photographs and other images of the sculptor from this period (fig. 1).

The small-scale female form perched behind the crouching man appears to have been produced by his thought process. Like the mythological story of Athena, who sprang fully grown from the head of her father, Zeus, she seems like a manifestation of the artist's creative imagination.

As Rodin's overall project evolved, he modified countless details. The alterations underscored the artist's inductive approach to his work, demonstrating that the final design could not have been envisioned at the outset. By deciding against a continuous narrative and developing independent compartments unrelated to specific textual sources, Rodin was free to introduce individual or paired figures and groups according to his own compositional or structural needs. As Alhadeff suggested, the relief located on the inside left reveal served as a form of signature, using the artist's own physiognomy to mark his creation. TBT

46. Edouard Vuillard, French, 1868–1940

The Sea at Vasouy, 1903–4
Oil on paper mounted on hardboard, 23 x 15½ inches
Artist's studio stamp lower right
Gift of Evelyn A. and William B. Jaffe, Class of 1964H; P.954.92
© 2007 Artists Rights Society (ARS), New York / ADAGP, Paris

Born in a small town in eastern France, Edouard Vuillard moved with his family to Paris at the age of nine. Although he studied at the École des Beaux-Arts, he gravitated toward the avant-garde movements of the late nineteenth century and ultimately became a member of the Nabis (Hebrew and Arabic for "prophet"), a group of artists who emphasized the decorative and symbolic functions of art. Best known for his intimate interior scenes often celebrating the life of bourgeois women, Vuillard also painted—from 1900 onward—a number of landscapes and marine subjects. Though on the surface contradictory, these subjects were united by the artist's overall comfort with his surroundings, given that he selected his outdoor sites (like his indoor ones) for their associations with close friends and colleagues. He first exhibited his outdoor compositions in 1901 at the Salon des Indépendants, where they received critical recognition. Seven years later he showed a large number of landscapes as

part of a monographic exhibition at the Galerie Bernheim-Jeune in 1908, when they were again praised (*Edouard Vuillard* 2003: 252).

This suggestively abstract work depicts the beach at Vasouy, a small resort southwest from Honfleur on the Normandy coast. Beginning in the summer of 1901, Vuillard visited friends who rented a villa, La Terrasse, that featured a view corresponding to the present composition. There is a small preparatory drawing for this work showing the same vantage point, with the ramp projecting into the sea (Salomon and Cogeval 2003: 2:VIII-118b). The artist often preferred such discreet locations, avoiding many of the busier sites that Claude Monet (1840–1926) had popularized in his art (*Edouard Vuillard* 2003: 441).

True to his subject, Vuillard abandoned his preferred technique of patterned brushstrokes for a broader, more fluid handling of paint, recapturing the style of impressionism. The bright palette heightens the idyllic atmosphere of a sun-drenched Normandy seacoast, "entirely pervaded by the smell of the sea" (cited in *Edouard Vuillard* 2003: 451). [Salomon and Cogeval 2003: 2:VIII-118] TBT

47. Albert Marquet, French, 1875–1947

Fishing Boats, about 1906

Oil on canvas, 10⅛ x 12 inches
Signed lower right: Marquet
Gift of Evelyn A. and William B. Jaffe, Class of 1964H; P.954.93
© 2007 Artists Rights Society (ARS), New York / ADAGP, Paris

With its deliberately simplified draftsmanship and expressive color, this small canvas reflects the style developed by a group of artists who came to be known as *Les Fauves* ("wild beasts"). The term, coined by influential French art critic Louis Vauxcelles (1870–1943), who admired their youthful exuberance and absolute disregard for the canons of academic painting, described a loose association of painters who shared similar interests and influences. The movement lacked any coherent theoretical principles, and one writer in 1912 in *The Burlington Magazine* even considered Pablo Picasso (cats. 52, 121, 130, and 131) to be a representative of the group.

After studying at the École des Beaux-Arts under Gustave Moreau (1826–1898), Albert Marquet became a close friend of Henri Matisse (cat. 123), with whom he collaborated on a commission in 1900. Soon afterward he developed a style that emphasized spontaneous handling and the application of vivid colors. Although he painted some figurative compositions, he preferred landscapes subjects, especially water scenes. His canvases generally evoke a calm and unperturbed serenity, while his depiction of flat, outlined forms recalls the influence of Japanese prints in late-nineteenth-century French art.

Many of Marquet's finest works in this manner were done during the summers of 1905, which he spent in the small town of Saint-Tropez on the French Riviera, and 1906, when he traveled to the seaside resort of Sainte-Adresse, on the northern coast of Normandy. Presumably this painting depicted one of these sites. The thick contours, strong colors, and lack of clear articulation of space and volume suggest that it was painted early in his career. TBT

97

48. Maurice de Vlaminck, French, 1876–1958

Saint-Maffre after the Storm, about 1915

Oil on canvas, 19 x 22¾ inches
Signed lower left: Vlaminck; label on reverse upper right handwritten
in sepia ink: Saint Maffre / 10- apres l'Orage
Gift of the Estate of C. Morrison Fitch, Class of 1924; P.969.64.7
© 2007 Artists Rights Society (ARS), New York / ADAGP, Paris

Born in Paris to Flemish parents, Maurice de Vlaminck pursued a style of painting that combined French modernism with the northern landscape tradition. His early work was heavily influenced by the style of Vincent van Gogh (1853–1890), but major posthumous exhibitions of Paul Cézanne's (cat. 117) paintings engendered a profound change in Vlaminck's technique. He ultimately rejected the use of bold, primary colors in favor of a greater engagement with structure, developing a dramatic view of landscape that became characteristic of his later work.

Vlaminck firmly believed in painting directly from nature, and the sites he chose were typically ordinary villages. His interest in simple architecture and rustic settings imbued the scenes with a timeless character. Yet, compared to the examples of Cézanne,

Vlaminck chose to animate his landscapes with a heightened sense of tension, often depicting windy or stormy conditions in an attempt to capture the emotion of his surroundings.

Saint-Maffre after the Storm is representative of the artist's mature work. Its colors recall the intense yet balanced palette of northern European landscape painting, while the oblique angling of spatial planes—the road rising up the canvas, the dynamic perspective of the houses and hills—reveals the influence of Cézanne. As one critic wrote in *The Burlington Magazine* in 1919, "The pictures of Vlaminck are much alike in colour—a scheme of blue and green with a few red roofs—but with this severely limited material he composes his landscapes with a mastery that is essentially classic."

TBT

49. Kees van Dongen, Dutch, 1877–1968

Tangiers, Morocco, about 1910

Oil on canvas, 21⅝ x 18⅛ inches
Signed lower left: Van Dongen
Purchased through the Mr. and Mrs. Joseph H. Hazen Fund; P.960.104

This work may at first seem to be an anomaly for Kees van Dongen, whose subjects more typically comprise sensuous nudes or fashionably dressed members of Parisian society. *Tangiers, Morocco,* however, fits comfortably into the artist's overarching quest for the new: "I love novelty, the unpublished, that which has not been made before" (cited in Steadman and Denys Sutton 1971: 46). It was Van Dongen's appetite for novelty that led him to abandon his native Rotterdam in 1897 for Paris, a city he said attracted him "like a lighthouse" (quoted in Hopmans 1996: 26). The commercial success of his first major exhibition in Paris provided him with the financial resources to travel. In 1910, after a short stay in Holland and Italy, he went to Spain and finally Morocco. He returned to Paris with numerous sketchbooks and a few paintings that heralded a new palette and an interest in exotic subject matter.

The appeal of Morocco for Van Dongen is evident. Since Eugène

Delacroix's (cat. 112) visit in 1832, Tangiers had been an attractive destination for foreign artists who saw in its culture a manifestation of Orientalism and in its landscape a source of distinctive color and light. Van Dongen's art already exhibited the rich and sometimes vehement colors that earned him a reputation among the Fauves. *Tangiers, Morocco* is witness to the immediate and dramatic impact that the artist's Mediterranean travels had on his painting. Its colors are more subdued and harmonious yet retain an intensity characteristic of Van Dongen's palette. The complexity of the composition also reveals a new approach. As two women in white burkas advance toward the viewer, a young boy to the left looks directly out. An archway frames three sides of the painting, thereby heightening the presence of the figures. The buildings' cubic forms dominate the background, also comprised of water, mountains, and sky. Although Van Dongen's fascination with Orientalism continued to influence his choice of subjects, *Tangiers, Morocco* provides a rare and direct insight into the artist's response to North African culture. ᴬᴳ

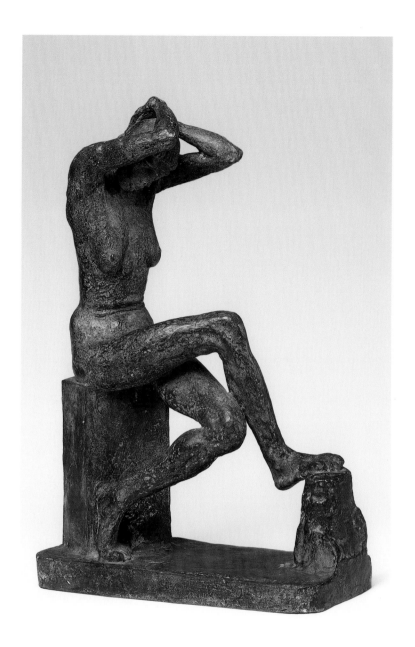

50. Jacob Epstein, born in America
and active in England, 1880–1959

Nan Seated, 1911

Bronze, 19½ x 13 x 6 inches
Gift of Josephine Patterson Albright, Class of 1978HW; S.984.47

The period from 1910 to 1914 in London witnessed an unprecedented explosion of pioneering painting and sculpture. This was at least partly in response to the impact of a number of British exhibitions and publications that presented avant-garde continental European art. Jacob Epstein, a sculptor who had settled in England in 1905, was especially attentive to these developments. He studied the work of contemporaries such as Constantin Brancusi (1876–1957), Amadeo Modigliani (cat. 128), and Pablo Picasso (cats. 52, 121, 130, and 131), whose interest in Oceanic and African art profoundly influenced him. Epstein ultimately borrowed from both traditional and novel trends in his intimate interpretations of the human figure. Beginning in 1910, he embarked on a series of small-scale, smooth-textured bronzes, often portraits of close friends or members of the artist's family.

Nan Seated portrays one of Epstein's favorite models, Nan Condron, a young gypsy woman and professional model whom he had met at the Café Royal on Regent Street. For several years she modeled exclusively for Epstein, and he made several sculptures and

drawings of her. This work is typical of the artist's early combination of carefully executed features (the raised arms adjusting her hair) and angular, attenuated extremities (her lower limbs). The modeling is pared and simplified to the point of appearing stark. The small scale and unusual pose add to the dynamism of the statuette, which marked the culmination of his attempt to blend traditional and abstract forms. Within a year his work would appear more geometrical.

Epstein's clear preference for non-European models was frequently criticized during his lifetime, but these women inspired him to create some of his most remarkable sculptures. Among his most recognizable sitters, in addition to Nan Condron, was Kashmiri model Amina Patel (known as Sunita). He also produced studies of Chinese, Russian, Ethiopian, Senegalese, and Arab women. At the same time, Epstein was one of the first British-based artists to assemble a collection of non-Western artifacts, which eventually numbered over one thousand pieces. TBT

51. Alexander Archipenko, Ukrainian, active in France and America, 1887–1964

White Torso, modeled 1916, cast before 1930

Coated bronze, 18 x 4 x 3⅝ inches
Signed on surface of base: Archipenko
Gift of Harry T. Lewis Jr., Class of 1955, Tuck 1956, 1981P; S.2004.44
© 2007 Estate of Alexander Archipenko / Artists Rights Society
(ARS), New York

Alexander Archipenko was an artist, working mainly in sculpture, who strove endlessly for innovation and creative invention in his work. Extremely ambitious and independent, he was forced to leave the School of Art in Kiev in 1905 after three years of study because he criticized the academic approach of his teachers. Later, in Paris, following only two weeks of instruction at the École des Beaux-Arts, he decided to turn to the collections of the Musée du Louvre for his education. Although he always resisted being defined by any specific movements, Archipenko's early work reflects the sculpture of contemporaries including Constantin Brancusi (1876–1957), as well as the aesthetic notions of cubism.

Archipenko produced *White Torso* in 1916, while residing in a villa at Cimiez, a suburb of Nice, where he remained throughout World War I. Marble, bronze, and plaster versions of this sculpture exist. The graceful nude form was a central focus of Archipenko's work throughout his career. He wrote, "If muscles or bones interfere with the line, I eliminate them in order to obtain simplicity, purity, and the expression of stylistic line and form" (quoted in Wasserman and Cuno 1980: 62). In this quest for purity, he was certainly inspired by Brancusi, who was one of the first artists to represent the body as a simple arrangement of abstract volumes. Archipenko used polished metal that reflects the light to insist on the qualities of the object's surface and its interaction with the surrounding space.

After he immigrated to the United States in 1923, he directed the production of several early casts of this sculpture with different finishes at the Kunst Foundry in New York. In 1929, Archipenko included a version of this work in a Saks Fifth Avenue window display that he designed, which featured a machined metal backdrop (Karshan 1969: 73). The simplicity of design so central to Archipenko's art easily found a place within the commercial and decorative aesthetics of the 1920s and 1930s. MWL

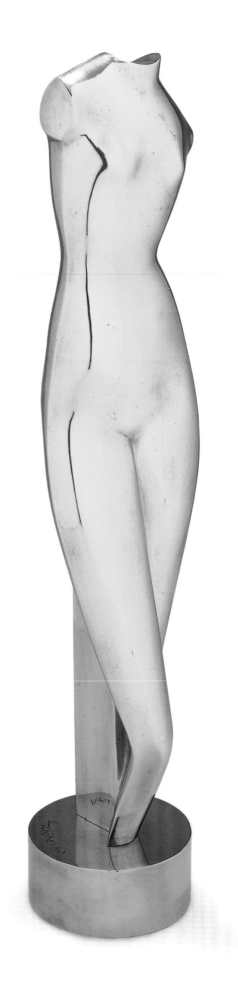

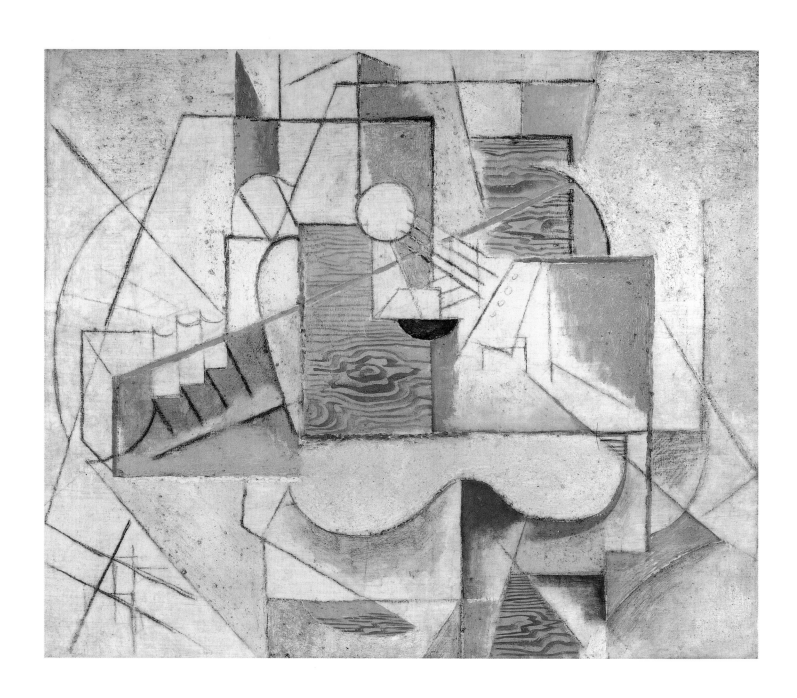

52. Pablo Picasso, Spanish, active in France, 1881–1973

Guitar on a Table, 1912

Oil, sand, and charcoal on canvas, 20⅛ x 24¼ inches
Gift of Nelson A. Rockefeller, Class of 1930; P.975.79
© Estate of Pablo Picasso / Artists Rights Society (ARS), New York

Pablo Picasso's *Guitar on a Table* is a masterful example of the style known as cubism. One of a series of similar compositions Picasso produced during the autumn of 1912, the still life conveys the typical geometric and collage-like features of cubist representation. The formal subject matter—a guitar and books on a table—is here rendered as a series of textures, colors, volumes, and fragmented geometric planes. The effect on the viewer, far from that of a classic still life painting, is stimulating and unsettling. To look at this relatively small painting is to feel the full, challenging force of one of the most important movements of European modernism.

By 1912, Picasso had already embarked on a remarkable path of artistic innovation. His 1907 masterpiece *Les Demoiselles d'Avignon,* a work that in its powerful, monstrous rendering of the female form remains shocking to this day, is credited with initiating the cubist movement. But in fact it was Picasso's meeting in that same year with a young French painter named Georges Braque (cat. 122) that provided the stimulus for an extraordinary new direction in art. Over the next seven years, from 1907 to 1914, Picasso and Braque challenged each other to begin thinking about painting in ways that

diverged radically from pre-twentieth-century conceptions of visual representation. Questioning the primacy of three-dimensionality and the single unified scene, the cubists fragmented perspective in favor of multiple points of view to underscore the illusoriness of pictorial depth. Challenging the realist notion of the art work as a mirror or faithful reflection of reality, cubism emphasized the opacity of the canvas, its sheer presence as an object in itself. In two successive periods of concentrated work—the "analytical" period of 1907–12, which focused on the disassembling and reassembling of form, and the "synthetic" period of 1912–14, which sought to reduce form to color, abstract shape, and texture—Picasso and Braque radically reshaped the terrain of modern art. "Mountaineers roped together" (Braque's description of himself and Picasso), the two painters saw their cubist work as heroic, subversive, and revolutionary, epitomizing the modernist edict to be "absolutely new."

All of cubism's shattering energy can be felt in Picasso's *Guitar on a Table.* The form of the guitar remains recognizable in this painting only as a series of fragments, planes, and volumes. Intersecting charcoal lines define and disperse these volumes. Sharp angles and supple curves are juxtaposed and layered, producing unusual visual combinations that both suggest and resist formal meaning. Blue, green, pink, and turquoise coloration provide contradictory cues about depth and perspective. Two surface textures—imitation wood grain and sand—are used in surprisingly rich, startling ways. Inspired by Braque's use of artificially wood-grained wallpaper in an earlier composition, Picasso employs wood grain to signify a

FIG. 1. Man Ray, *Gertrude Stein and Alice B. Toklas in the Atelier at 27 rue de Fleurs,* 1922. Yale Collection of American Literature, Beinecke Rare Book and Manuscript Library, Yale University, New Haven © 2007 Man Ray Trust / Artists Rights Society (ARS), New York / ADAGP, Paris

variety of meanings: the realism of the guitar/table, the painterly illusion of this composition, and his own intertextual relationship to Braque. And in an early foreshadowing of his great synthetic collages of 1912–13, Picasso glues sand to his painting, drawing attention both to the surface of the work and to the marine subtheme at play in this composition.

The intellectual richness and emotional energy of *Guitar on a Table* would have appealed greatly to the woman who bought Picasso's painting in 1913, the American modernist writer and art collector Gertrude Stein (1874–1946; fig. 1). Stein had been one of Picasso's most devoted patrons since 1905 and was herself the subject of a famous 1906 portrait by the artist. She would later claim that her own radical experiments in literature, including the famous short story "Melanctha" (1906), were inspired by conversations with Picasso as she sat for his portrait. Although Picasso himself never acknowledged any collaboration with Stein—as he would do with Braque—Stein's creative connection to the artist adds yet another layer of meaning to *Guitar on a Table*. During the same period in which she purchased the still life, Stein was creating a form of literature characterized by a fragmentation of grammar, syntax, and meaning. Her most accomplished example of this effort, a work called *Tender Buttons* (1914), could almost be seen as a literary blueprint for the cubist movement in art.

In the final section of *Tender Buttons,* Stein writes, "Act so that there is no use in a center." This phrase seems to carry particular resonance for how we see Picasso's painting and how we comprehend the artistic imperatives of cubism. In *Guitar on a Table,* the center of the canvas is occupied by a small black semicircle, a sort of half-moon that seems to serve as a counterweight to the open full circle above it. Undoubtedly here Picasso is experimenting with varying perspectives on the guitar's central sound hole. Yet he also seems to be commenting on cubism's own lack of use for a "center," its rejection of unitary meaning and perspective in favor of multiplicity, indeterminacy, and fragmentation. Drawing us in while eluding any final understanding, *Guitar on a Table* is a stunning example of cubism at its most demanding and most rewarding. [Zervos 1932–1978: 2: no. 373; Daix and Rosselet 1979: no. 509] BEW

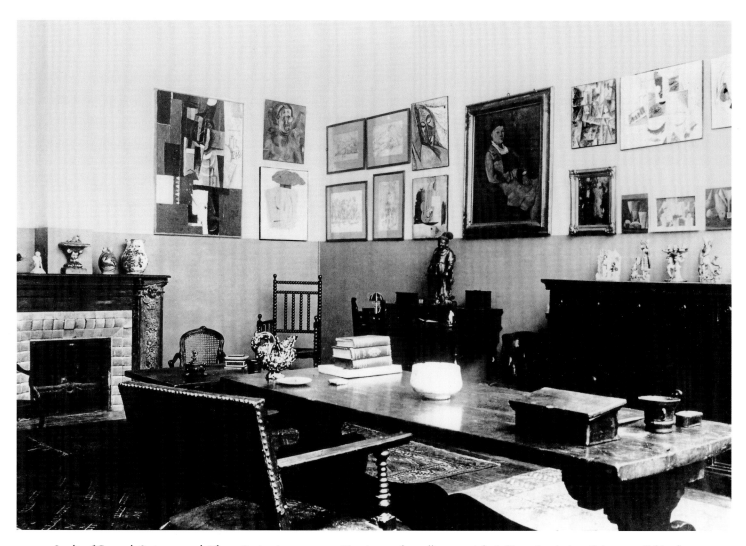

FIG. 2. *Studio of Gertrude Stein, 27 rue de Fleurs, Paris*, winter 1914–15. Hanging on the wall on top right is Picasso's painting *Guitar on a Table* of 1912 (cat. 52), donated in 1975 by Nelson A. Rockefeller, Class of 1930. Courtesy of the Baltimore Museum of Art, Cone Collection.

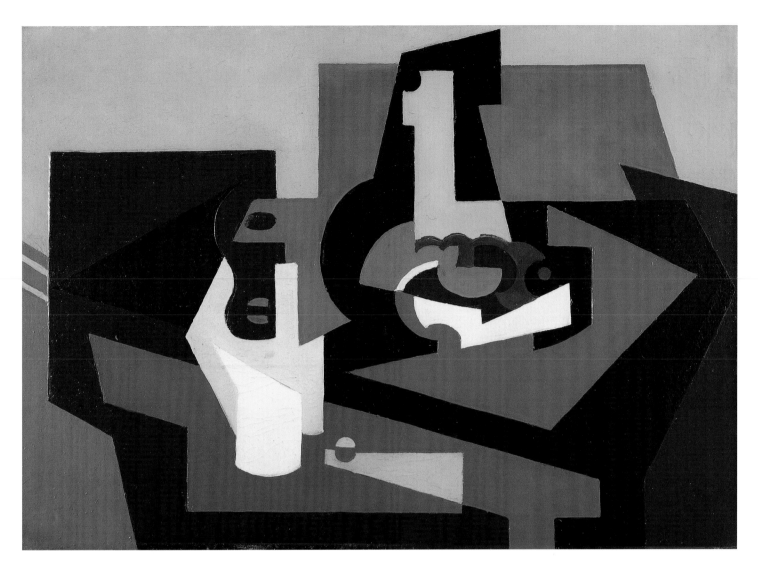

53. Maria Blanchard, Spanish, 1881–1932

Sill-Life, 1916–18

Oil on canvas, 25⅝ x 36¼ inches
Signed by artist on reverse: M. Blanchard
Gift of Evelyn A. and William B. Jaffe, Class of 1964H, by exchange;
P.968.32

54. Juan Gris, Spanish, 1887–1927

Mandolin and Pipe, 1925

Oil on canvas, 24 x 29 inches
Signed and dated lower left: Juan Gris / 25
Gift of Ruth M. and Charles Lachman; P.959.128

At the end of the sixteenth century and again at the end of the nineteenth century—two transformative moments in the history of art when painters strived for new modes of artistic expression—still life emerged as an important vehicle for experimentation and innovation. Around 1600 many artists explored the descriptive and dramatic potential of the natural world in pure landscapes, floral arrangements, and other nonfigurative subjects. Three centuries later, when some painters investigated diverse conventions of verisimilitude, still life once again served as a laboratory for the development of alternative representational techniques.

Maria Blanchard had only one short cubist period, from 1916 to 1920 (Caffin Madaule 1992–94). Born in the small Spanish city of Santander, Blanchard suffered as a child: her father died early, her family struggled financially, and she was a dwarf mocked by her peers. On moving to Paris in 1916 and with support and encouragement from Juan Gris and Jacques Lipchitz (cat. 56), she immediately embraced the cubist vocabulary. By 1920, in spite of increasing success through sales, commissions, and exhibitions, Blanchard abruptly abandoned cubism and returned to a more personal, expressionist style.

While some other artists who had experimented with cubism before World War I reverted to traditional styles after 1918, such as André Derain (1880–1954; fig. 1), Juan Gris continued to produce canvases in this manner until his death in 1927. He was generally appreciated more for the depth and consistency of his method than for his innovation. Gris was more methodical than the other members of the movement, who tended to take a more intuitive

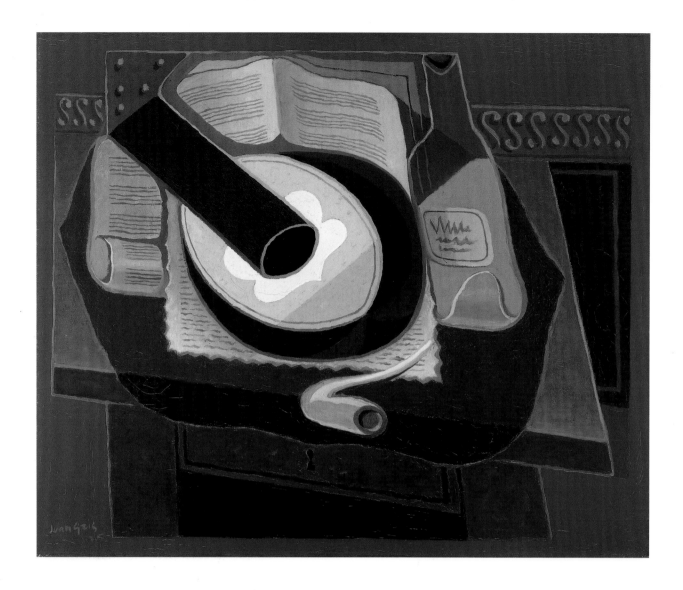

approach to their art. The first retrospective devoted to his work took place in 1933 in Zurich, and three years later the Museum of Modern Art treated Gris as a significant figure in its survey exhibition *Cubism and Abstract Art.*

Executed only two years before the artist's death, *Mandolin and Pipe* belongs to a series of works that reveal Gris's particular brand of cubism in that period: an adherence to the still-life, undulating shapes contrasted with obtuse and acute angles, and a striking sense of color. His dealer and biographer Daniel-Hentry Kahnweiler (1884–1979), who once owned this work, considered the paintings of the 1920s to be "the most fruitful and beautiful of the whole of Juan Gris' oeuvre" (*Treasures of the Hood Museum of Art* 1985: 129, no. 119). [Cooper 1977: 2:533] TBT

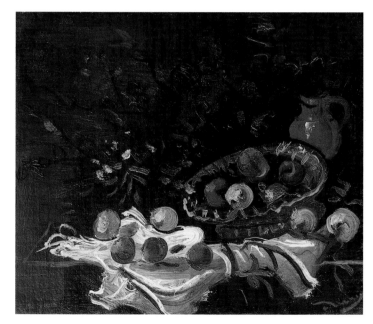

FIG. 1. André Derain, *Still-Life,* about 1920, oil on panel, 8⅛ x 9½ inches. Gift of Nancy Parker; 2006.68.

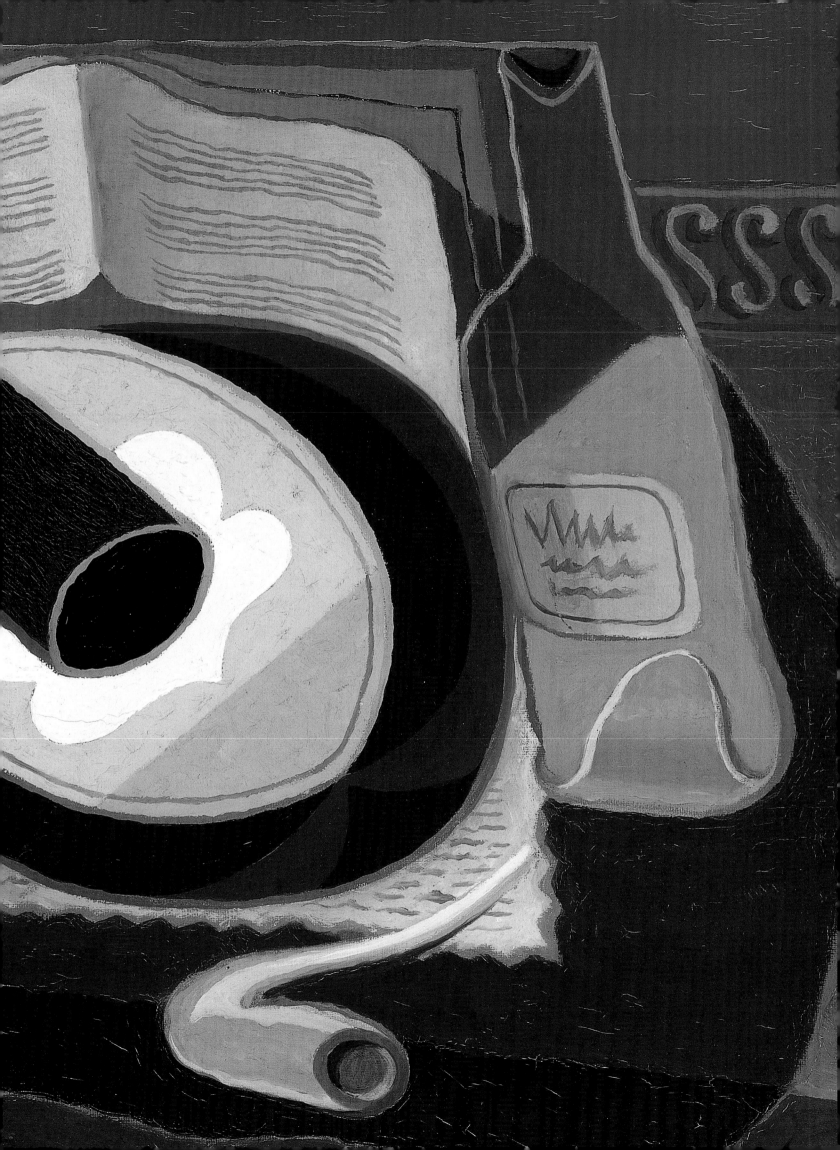

55. Jacques Lipchitz, born in Lithuania and active in France and America, 1891–1973

Woman Reading, 1919

Stained terracotta, height 15¼ inches
Signed on the back: J. L.
Purchased through the William B. and Evelyn A. Jaffe Fund; S.965.13

56. Henri Laurens, French, 1885–1954

Standing Female Nude, 1921

Unglazed buff terracotta, height 15½ inches
Purchased through the William B. and Evelyn A. Jaffe Fund; S.964.174
© 2007 Artists Rights Society (ARS), New York / ADAGP, Paris

Beginning in 1914 and 1915, Jacques Lipchitz, one of the most innovative sculptors of the twentieth century, produced a number of bronzes that brilliantly explored the potential of cubism as a sculptural language. Following the lead of Pablo Picasso (cats. 52, 121, 130, and 131) and others, Lipchitz designed these pieces in a manner that defied traditional conventions of sculpture as a static, commemorative art form. At the heart of all of his early creations, no matter how abstract they appeared, was an anthropomorphic focus. "In them," he later wrote, "I was definitely building up and composing the idea of the human figure from abstract sculptural elements of line, plane, volume, [and] of mass contrasted with void completely realized in three dimensions" (Lipchitz 1972: 34). Over the course

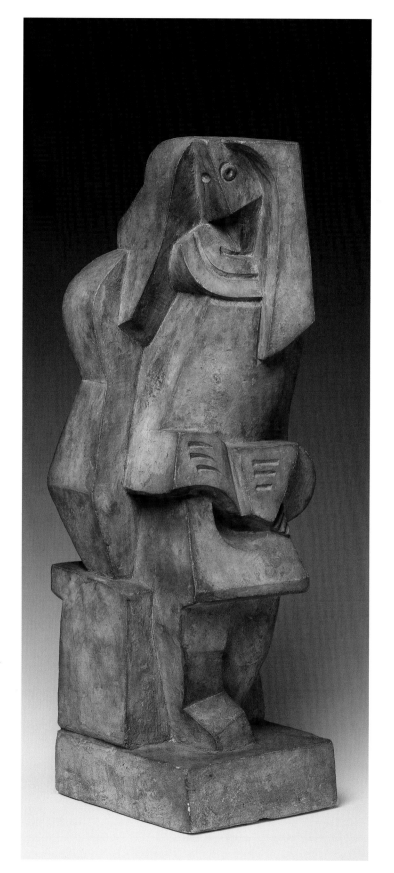

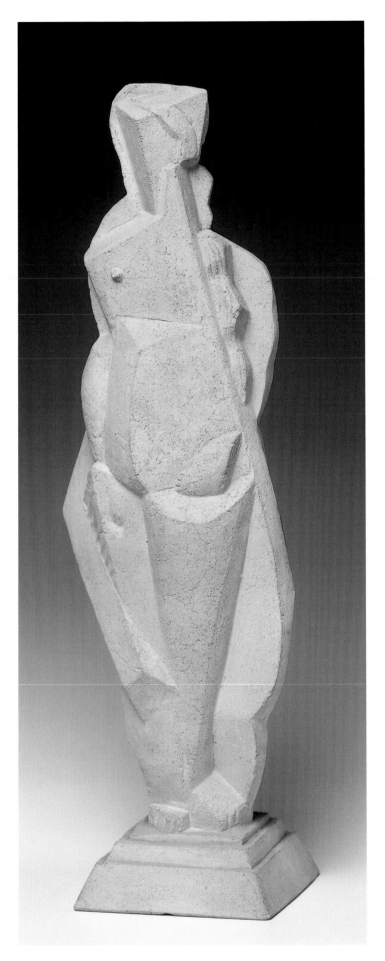

of his long career Lipchitz created a variety of forms, believing that cubism could be infinitely modified to express individual feelings and emotions.

Lipchitz's *Woman Reading* corresponds to a subject that he explored in a series of works cast in bronze in 1919 entitled *The Reader*. It followed his close collaboration and fertile exchanges with the Spanish cubist artist Juan Gris (cat. 54) and the Chilean poet Vicente Huidobro (1893–1948), who lived together with their families outside Paris in the final years of World War I. Both Lipchitz and Gris assisted Huidobro in his poetic rendering of cubist themes, while at the same time incorporating literary references in some of their works of this period (De Costa 1989: 685).

The small terracotta is a rare preparatory work for one of the bronzes. Lipchitz's preferred practice was to begin modeling his composition in clay, after which—when he was satisfied with it—he would fire it in a kiln in preparation for a large plaster maquette to serve as a mold. Few of his study pieces survive. The plaster version would then be used to make a bronze cast, generally in editions of seven (such as the later example in the collection of the Hood Museum of Art, S.960.88.8; see Wilkinson 1996–2000: 1:93—listed as stone, "whereabouts unknown").

Like Lipchitz, the Parisian-born Henri Laurens played a pivotal role in developing the vocabulary of cubism as a sculptural style during the second decade of the twentieth century. He was introduced to modern art through his friendship with Georges Braque (cat. 122), but he was also influenced by the three-dimensional constructions of Picasso. Laurens began in 1919 to experiment with cutouts and superimposed planes in bas-relief—initially in stone and terracotta—that was both uncolored and polychromed. Soon afterward he turned to the execution of freestanding sculptures, which became more clearly figurative but retained angular, faceted forms.

Standing Female Nude is a study of line and plane as formal compositional elements from which the figure is constructed rather than modeled. Yet, in spite of the innovative treatment of surfaces and volumes, Laurens consciously employs a conventional subject to highlight his relationship to a long-established figurative tradition. The diminutive scale of the sculpture is also associated with the history of statuettes dating back to antiquity. Ultimately, as Laurens himself noted, "Tradition is continuous beneath the appearances of the epochs" (cited in Green 2000: 215). TBT

57. Fernand Léger, French, 1881–1955

Two Profiles No. 1, 1933
Oil on canvas, 50¾ x 38 inches
Signed and dated lower right: F. Leger 33; on reverse: COMPOSITION
AUX. 2 PROFILS NO.I / F. LEGER.33
Gift of Wallace K. Harrison, Class of 1950H; P.966.3
© 2007 Artists Rights Society (ARS), New York / ADAGP, Paris

58. Fernand Léger

The Tri-Colored Flower, 1937

Oil on canvas, 38 x 51½ inches
Signed and dated lower right: F. LEGER 37; on reverse:
La Fleur tricolore / F. LEGER '37.
Gift of Wallace K. Harrison, Class of 1950H; P.961.263
© 2007 Artists Rights Society (ARS), New York / ADAGP, Paris

As a young man, the French artist Fernand Léger spent several years working as an architectural draftsman in Caen and then in Paris, where he also studied with various artists including the realist painter Jean Léon Gérôme (1824–1904). The modern cityscape and built environment continued to engage him when he turned to painting as a career after he finished his studies, and they would influence his work throughout his career. He was also greatly enamored by color and its ability to influence surroundings; *The Tri-Colored Flower*

is an example of his later style, in which he favored flat planes of colors—mostly primary ones of blue, yellow, and red—bounded by distinct graphic outlines. In the 1940s he began to disassociate color from outlines, superimposing bands of color across the canvas surface.

Léger's earliest paintings were influenced by impressionism, neo-impressionism, and then cubism, but it was his experience as a soldier in World War I that inspired the first distinctive phase of his

work. In the midst of the brutality of mechanized combat, he saw the sun falling on the cylindrical curves of large guns and was struck by the visual impact of the light transforming the metal. In the years immediately following the war, he devoted himself to an "aesthetic of the machine," through which he depicted the energy of modern life and the industrial world of the city (see cat. 127). This "mechanical" period would give way to the use of more organic, biomorphic abstract forms in the 1930s, as evidenced in *Two Profiles, No. 1* and *The Tri-Colored Flower*. Léger eschewed narrative and the sentimental in his work; even when he employed the figure, he made no reference to human interaction or emotion.

Two Profiles also demonstrates his evocative and disjunctive use of recognizable forms, such as the abstract profile of the human face, in association with abstract biomorphic imagery with no stable correspondence to known objects. The "object" on the right in *Two Profiles*—there is no word that describes it effectively—is both machine-like (a gear or a round saw blade) but also organic (the upper elements are like seaweed flowing in a current). The bifurcated black and white areas that describe the fronds emerging from the object's central core and the core itself lend the work a stark sculptural quality that recalls the artist's memory of intense light falling on metal and creating bright whites and dark shadows.

In the 1930s, Léger's creation of these types of associative and bizarre forms can be partly ascribed to his interest in surrealism; his version of dreamlike imagery, however, is unlike anything else in the surrealist canon. *The Tri-Colored Flower* also displays this tendency toward the strangely abstract. The flower at its center is singularly unflowerlike. The avocado-shaped center has bulbous and phallic petals of red, blue, and green, and the growth at the top is similar to that of a cactus such as the prickly pear. The architectural background behind the flower creates a shallow depth of field, and there are echoes of the contemporaneous art deco style in the bands that run in back of the central yellow screen. The use of this geometric screen behind the main figurative elements of the picture is a compositional device that appears in much of Léger's work. Both of the paintings in the collection of the Hood Museum of Art reveal the highly individualistic nature of this artist's artistic practice. There is no other major twentieth-century artist whose work is as exuberantly colorful, rigorously imagined, and resistant to the seductive pleasures of definitive interpretation. [Bauquier 1996: 5:832 and 954; Lanchner 2002: 47–52] KWH

Drawings and Prints

59. Unknown, French, active mid-15th century

The Annunciation, from a *Book of Hours,* about 1440

Tempera[?] on vellum illustrations with manuscript text, rebound and trimmed in 18th-century binding and red Moroccan box container, 7 x 5½ inches
Dartmouth College Library, Rauner Special Collections: Gift of Madelyn C. Hickmott

Books of Hours, devotional volumes that guided the daily prayers of lay men and women, became increasingly popular during the later Middle Ages, reflecting a personalization and secularization of late medieval religious practices. Invariably, they included images that served as a pendant to the prayers in the devotional experience.

In this particular volume, thirteen full-page illuminations, presented in typical arched frames, illustrate principally episodes from the lives of the Virgin and Christ. Twenty-four smaller images decorate the calendar at the opening of the manuscript, which is organized around the feast days of the year, and illustrate seasonal themes and the signs of the Zodiac.

The image of the Annunciation, which marks the opening of the Hours of the Virgin, highlights Mary's purity and devotion, her worthiness to be the vessel of the Incarnation. It shows the angel Gabriel approaching Mary, who sits, arms crossed over her breast in a demure gesture of surprise, inside a gothic interior—perhaps a church or a private chapel. She reads at a *prie-dieu,* or prayer stand, while the dove of the Holy Spirit descends toward her on rays of light from an image of God the Father, who appears in the small roundel in the upper left. The scroll in Gabriel's hand, which floats heavenward, reads *Ave gratia plena dominus* ("Hail, lady full of grace, the Lord is with you," Luke 1:28). The central image is surrounded by four smaller miniatures illustrating other episodes from the life of the Virgin: the meeting of her parents, Joachim and Anna, at the Golden Gate, the birth of the Virgin, the Virgin sewing (a reference to an Old Testament prophecy), and the Virgin's marriage to the aged Joseph—the last three depicted in the same sacred interior as the main Annunciation image. Hidden in the foliate margins are animals and flowers that symbolized Salvation and Redemption.

This is a beautiful example of a high-end luxury prayer book, written in a clean gothic script and made in or around Paris for an unknown but certainly elite patron. MCG

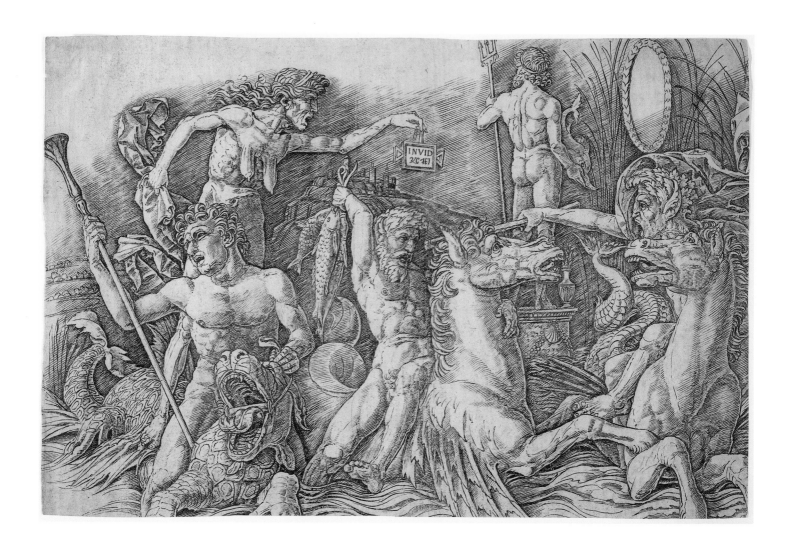

60. Andrea Mantegna, Italian, 1431–1506

Battle of the Sea Gods (left half), 1470s

Engraving, only state, 9⅝ x 14¹¹⁄₁₆ inches
Gift of Jean K. Weil in memory of Adolph Weil Jr., Class of 1935;
PR.997.5.85

61. Andrea Mantegna

The Risen Christ between St. Andrew and St. Longinus, about 1472

Engraving, only state, 17⅞ x 13⅛ inches
Gift of Jean K. Weil in memory of Adolph Weil Jr., Class of 1935;
PR.997.5.86

Andrea Mantegna, credited by Giorgio Vasari (1511–1574) and Benvenuto Cellini (1500–1571) as the inventor of copperplate engraving, is central to the history of printmaking. Although he did not invent it, Mantegna was perhaps the first important Italian painter to approach copperplate engraving as an equal and viable art form.

Mantegna in fact made a very small number of prints, and the two engravings by the artist in the Hood Museum of Art's collection, *The Risen Christ between St. Andrew and Longinus* and *Battle of the Sea Gods,* comprise a rare opportunity to study some of the earliest known examples of Italian printmaking.

The exact subject of *Battle of the Sea Gods,* one of Mantegna's most famous mythological works, has been much debated. The print from the Weil Collection represents only the left half of a larger composition that was engraved on two copper plates. This format, along with an unusual upward-looking perspective, lends to the work the monumentality of a classical architectural frieze, and the figures themselves appear to be derived from Roman sources. The grotesque personification of Envy—identifying herself by the plaque inscribed INVID—presides over and wildly encourages a fight between two marine deities whose fantastical *hippocampi,* or horse-beasts, seem caught up in the violence as well. The wickedness

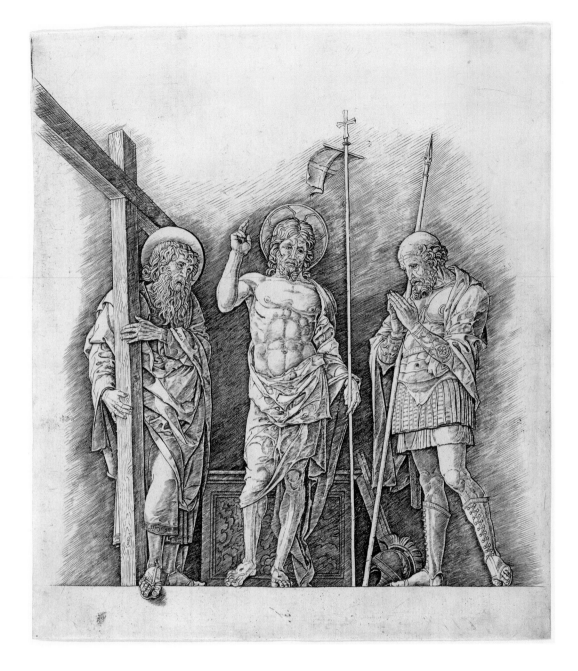

of these actions, inspired by jealousy, is implied by the presence of a heroic sculpture of Neptune, ruler of the seas, turning his back on the distasteful scene.

The subject of this work has often been interpreted as a personal statement by Mantegna about the nature of envy among artists, the printmaker having had well-documented troubles with rivals himself. The scene might also be an allegory of a tournament, with Envy ironically replacing the Queen of Beauty, the expected patroness of such events. The man to the far left holds a tournament wand in his right hand and looks away in anguish as he realizes that the game has proceeded beyond his control. Whatever the subject, it is clear Mantegna sought to depict in *Battle of the Sea Gods* the violence of jealousy inherent in human nature.

The iconography of *The Risen Christ between St. Andrew and Longinus* is tied to the city of Mantua, where Mantegna worked for many years, and especially the church of Sant'Andrea, which housed the sacred relic of a vial of Christ's blood thought to have been brought to Mantua by Longinus himself. Starkly iconic in its simple yet monumental presentation of the three figures, the print is also extremely sculptural in effect, due to the artist's coupling of precisely engraved lines with drypoint for shading.

Mantegna's printmaking technique is very closely related to that of his painting and drawing, and all are guided by his preference for sculptural forms and bold chiaroscuro. Unfortunately, Mantegna often engraved both sides of a plate, and the double printing very rapidly wore down the engraving, producing a finished work that was more evenly toned than intended. This engraving probably dates to the 1470s. Although it is trimmed at the lower edge, it is nevertheless an early impression possibly printed by the artist himself, as indicated by the early watermark that the paper bears.

JMB

Per laqle cosa di curiosa auiditate grademéte icitato, ítrogresso mótai
Oue cauo tutto & uacuo il maximo & prodigioso monstro, & cauernato
il trouai. Excepto, che il medesimo sodo era relicto ancora itestino, qle ex
timo staua subiecto. Et hauea tanta itione, & uerso il capo, & uerso la par
te postrema, quanto che lhomo naturale facea transito. Et quiui nel con
uexo del dorso suspensa, cú laquei erei ardea una lampada íextinguibile.
cum illuminatione carceraria. Per laqle in qsta posterga parte, mirai uno
antiquario sepulchro cócesso alla propria petra, cú una psecta imagine ui
rile & nuda, quáto il naturale cómune, in coronata, dil Saxo, nigerrima.
Cum gli denti, ochii, & ungue di lucente argento intecti. Soprastante al
sepulchrale coperto in arcuato, & disquammea operatura inuestito, & di
altri exquisiti liniamenti. Monstraua cum uno inaurato sceptro di ramo
extenso il bracio, la parte anteriore. Et nella sinistra teniua uno carinato
scuto, exacta la forma da losso capitale equino, inscripto di tri idiomi, cú
picole notule. Hebræo, Attico, & Latino, ditale sentétia.

אם לא כי הבהמה כסתה את בשרי
אזי הייתי ערום ותמצא חפש ותמצא הגיחבר

ΓΥΜΝΟΣ ΗΝ, ΕΙ ΜΗ ΑΝ ΘΗΡΙ-
ΟΝ ΕΜΕ ΚΑΛΥΨΕΝ. ΖΗΤΕΙ. ΕΥ-
ΡΗΣΗ ΔΕ ΕΑΣΟΝ ΜΕ.

NVDVS ESSEM, BESTIA NI ME
TEXISSET, QVAERE, ET INVE
NIES. ME SINITO.

Per laquale inusitata cosa istetti non mediocremente stupido cum al-
quanto horrore, Dique nó troppo differendo conuerso ad lo ritorno, ui
di il simigliante ardere & lucere unaltra lucerna, come dinanti e dicto. Et
facédo transito sopra lo hiato dil salire, iui uerso il capo dillanimale. Et in
qsto lato ácora una medesima factura di ueterrima sepultura trouai. Et la

62. Unknown, Italian, active late 15th century

Elephant and Obelisk, in Francesco Colonna (author), Italian, died 1527, *Hypnerotomachia Poliphili* (Venice: Aldus Manutius, 1499)

Woodcut illustrations with printed text; bound volume:
11⅜ x 8½ inches
Collection of Dartmouth College Library, Rauner Special Collections

The representation of ancient places and objects in fifteenth-century Italy was not marked by archeological specificity or antiquarian precision; instead, antiquity for Renaissance artists and viewers was a repository of powerful motifs. While humanists trained in philology sought to reconstruct from the fragmentary textual and physical remains of ancient Rome a satisfying whole, most artists and viewers were more interested in the visual power of antiquity and its complex and indecipherable mysteries, for which the "ruin" stood as a concrete allegory.

Nowhere is this sensibility more clearly demonstrated than in the curious and fabulous book called the *Hypnerotomachia Poliphili,* first published at the press of Aldus Manutius (about 1450–1515) in 1499, although parts of the text may have been composed earlier. The book recounts—as its pseudo-Greek title suggests—a story of the "amorous" (*eroto*) "strife" (*machia*) of Poliphilo, who "loves much" (*poly + philo*) in a dream (*hypnos*). The text meanders with its dreaming protagonist through gardens and ruins, following the quest to secure the love of Polia. Along the way, Poliphilo and Polia encounter mythological deities and monumental sculptures (fig. 1).

In one case they discover the massive *Elephant and Obelisk.* Above and below the hollow stony beast was the pillar, "which tapered up to the pointed tip" and had "Egyptian characters beautifully drawn on three of its faces." Such hieroglyphics, which Renaissance humanists struggled unsuccessfully to read, were nonetheless revered in antiquarian circles as powerful symbols that represented the ideas of the gods.

The narrative and meaning of the book are as opaque as its rhetoric and illustrations are clear. The lucid vision of the enormous elephant and obelisk is oddly juxtaposed with the open-ended and puzzling inscriptions in antique characters. Tangible yet hermetic and distant, the monument seems to be an ironic allegory meditating on the hunger for a logical and grand past and on that past's actual composite and baffling nature. The restored Rome of the Renaissance, the author seems to suggest, was as empty as the elephant and as ultimately indecipherable as the hieroglyphics on the obelisk.

AWBR

FIG. 1. Unknown, Italian, *Scene from the Hypnerotomachia Poliphili,* woodcuts and printed text, 1499.

63. Michael Wolgemut, German, 1434–1519, and Wilhelm Pleydenwurff, German, about 1458–1494

God the Father Enthroned, from Hartmann Schedel (author), German, 1440–1514, *Liber chronicarum* (Nuremberg: Printed by Antonius Koberger for Sebald Schreyer and Sebastian Kammermeister, July 12, 1493)

Handcolored woodcut with letterpress, 16 x 10⅝ inches
Purchased through a gift from the Cremer Foundation in memory of J. Theodore Cremer; PR.2006.57

In 1493 the most ambitious printed book to date appeared in Nuremberg. Properly known as the *Liber Chronicarum* but more familiarly as the Nuremberg Chronicle, it was a joint financial, publishing, scholarly, and artistic endeavor that told the story of human history from the Creation to 1493. It contains over 1,800 images created from more than 640 woodcuts, many of which were used repeatedly. Thus Lyon and Bologna were produced from the same block, while Dante, Plutarch, and Cato are depicted by the same figure. Approximately two thousand copies of this lavishly illustrated volume were produced in both the vernacular German and the more learned Latin. Luxurious versions were hand colored, and truly lavish ones, like the present example, had gold embossed letters (fig. 1).

As a document of its time, the Nuremberg Chronicle represents the merging of tradition with new humanist ideas. Its historical and literary framework of the Seven Ages was borrowed from medieval chronicles, yet the inclusion of mythology and classical scholars reveals a Renaissance influence. The contemporary awe at this achievement can be heard in the book's advertising text: "Indeed, I venture to promise you, reader, so great delight in reading it that you will think you are not reading a series of stories, but looking at them with your own eyes."

The images begin with the full-page frontispiece *God the Father Enthroned*. God sits in heaven surrounded by a ribbon-like cloud and raises his right hand in blessing while the left one holds an orb. On his head is the crown of the Holy Roman Emperor, a detail that connects the Free Imperial City of Nuremberg with its only overlord. On a banderole above God's head are parts of Psalm 33 (here numbered 32), while *putti* tumble about in the greenery above. At God's feet are two wild men who hold blank escutcheons onto which the purchaser could inscribe his own device. God looks off to the right and seems to set into motion the Creation recounted in the text. JLC

FIG. 1.

120

64. Albrecht Dürer, German, 1471–1528

Saint Jerome in His Study, 1514

Engraving, only state, 10 x 7½ inches
Signed and dated lower right: AD 1514
Promised gift of Jean K. Weil in memory of
Adolph Weil Jr., Class of 1935

No other print by Albrecht Dürer is as beloved as this image of Saint Jerome (331–420) in his study. The artist turned to the subject of Saint Jerome seven times in his career, but none of his other depictions captures the cozy scholar's den found in this version. Here the holy figure sits in the middle distance, away from any interruptions, bent over his writing table and absorbed, perhaps, in his great task of translating the books of the Bible into Latin (known as the Vulgate). Saint Jerome is engulfed in the peace of divine wisdom. A sleeping dog and his loyal companion, the lion, guard the saint's privacy and effectively block the viewer's entry into that room, which renowned medieval art historian Erwin Panofsky described as "enchanted beatitude" (1943). Dürer delineates a sixteenth-century space for the fourth-century theologian, transforming Saint Jerome into a contemporary Nuremberg humanist. His inspiration may have been the German translation of Giovanni d'Andrea Bolognese's fourteenth-century biography of the saint by Lazarus Spengler (1479–1534), a friend and neighbor of the artist.

Saint Jerome in His Study, which scholars have long regarded as one of Dürer's *Meisterstücke,* or "Masterpieces," is an outstanding example of the artist's consummate skill as a printmaker. The patterns of light on the wall, the grain of the wood, the fur of the lion, and the softness of a feather cushion are conveyed through the nuanced manipulation of hatching and crosshatching. The extraordinary naturalism of the image is evidence of a virtuoso printmaker whose manipulation of line to create volume and texture has never been surpassed.

It is also important to note that Albrecht Dürer was as skillful a businessman as he was an artist. In creating a great array of prints, both woodcuts and the more expensive copper engravings, he was assured that his fame would grow as those highly portable images on paper traveled throughout Europe and beyond. On each of his prints Dürer prominently placed his monogram, AD. In *Saint Jerome in His Study,* those initials can be found between the lion and the chair, symbolizing the artist's role as a bridge to translate the quiet, contemplative inner world of the saint for the secular world beyond the foreground steps. [*Gift to the College* 1998: 48–49, cat. 99]

JLC

65. Albrecht Dürer, German, 1471–1528

Christ in Limbo (*The Harrowing of Hell*), from *The Large Passion,* 1510

Woodcut, proof impression, 15⅜ x 11 inches
Signed lower right and dated center right: AD 1510
Gift of Jean K. Weil in memory of
Adolph Weil Jr., Class of 1935; PR.997.5.65

This work depicts Christ, rising from the dead, as he rescues the souls of his Old Testament forerunners. In Albrecht Dürer's woodcut, a haloed Savior kneels and extends his right hand to individuals framed in the Inferno's dark, arched entryway, one of whom seems to be John the Baptist in his fur tunic. As John's gaze meets Christ's, the connection between the last prophet of the old order and the man who fulfilled that prophecy is made visible. Those whom Christ has already saved stand behind him in the middle distance, outlined by the larger light-filled arch of salvation. The vanquished devils gather on the right side and rage at the breach of their domain and Christ's triumph over death.

The Hood Museum of Art's impression of *Christ in Limbo* is especially fine. It contains Dürer's characteristic variety of hatching and crosshatching, with its stark contrast of dense black lines and crisp white forms, as well as his strong contours, which lift the figures off the sheet (Erwin Panofsky in 1943 labeled his style "dynamic calligraphy"). This technique is characterized by flowing lines that are carved without regard for the grain of the woodblock. While this method is technically demanding, it yields a range of tonal values that are the hallmark of Dürer's woodcut style. Such innovations moved the woodcut beyond its elementary origins to more complex, detailed images.

The print series *The Large Passion* occupied Dürer for thirteen years during the pinnacle of his career. Completed in 1510–11, it represents the achievement of a supremely confident and ambitious man. The artist first created seven woodcuts that he issued individually, to which he later added a frontispiece and four additional scenes, all with Latin verses by Benedictus Chelidonius (about 1460–1521). The resulting set was then published as a large-scale book, *Passio domini nostri Jesu Christi* (The Passion of Our Lord Jesus Christ), which was to inspire devotion in the home. Dürer had a longstanding commitment to devotional subjects, especially the Passion of Christ, which he depicted in two woodcut sets and one engraved series. [*Gift to the College* 1998: 46–47, cat. 95] JLC

122

66. Lucas van Leyden, Netherlandish, about 1489 or 1494–1533

Christ in Limbo (or *The Harrowing of Hell*), from *The Passion of Christ,* 1521

Engraving, state i/II, 4⁹/₁₆ x 2¹⁵/₁₆ inches
Signed center right and dated top left: L 1521
Gift of Jean K. Weil in memory of Adolph Weil Jr.,
Class of 1935; PR.997.5.81

In 1508 the young Lucas van Leyden burst upon the art world with a group of striking engravings depicting sensational subject matter. Like his older contemporary Albrecht Dürer (cats. 64 and 65), Lucas was the son of an artist and had shown promise at an early age. Yet as printmakers, the two artists were initially dissimilar. Dürer conceived of form in terms of line, while Lucas, even in his prints, composed his images through gradations of color and light. Giorgio Vasari (1511–1574), for example, extolled Lucas for his ability to create atmospheric perspective through contrasts of shading and spatial relationships.

All that changed in June 1521, when Lucas journeyed to Antwerp to meet Dürer, an encounter that transformed Lucas's style. The prints from Lucas's engraved *Passion of Christ,* done that same year, owe their increased drama and detail, stronger contrasts, and more animated gestures to Dürer's prints of the same subject, especially his engraved Passion series from 1507–12 (cat. 65). Both masters' scenes of *Christ in Limbo* depict a triumphant Christ rescuing Old Testament figures from the foreground flames of Hell. In each version, Christ is illuminated by a starburst halo as he reaches forward into the viewer's space to grasp the hand of John the Baptist, the man who foretold his coming. Adam and Eve, the reason for Christ's incarnation, stand in the background, while impotent devils look on from the right, accentuating the Savior's triumph over death. The compositional and figural borrowings are striking and make Lucas's Passion series a homage to the older artist, though his continued use of idiosyncratic silvery grey ink makes the engraving purely Lucas in its tonality.

Lucas's series was comprised of fourteen episodes, four of which emphasized the extreme humiliation of Jesus. Thus the final two sheets in the series, *Christ in Limbo* and *Resurrection,* become the grace notes of salvation at the end of a story of challenge and sacrifice. They also provide us with a narrative of copying and learning between two Renaissance masters. JLC

67. Parmigianino, also known as Girolamo Francesco Maria Mazzola, Italian, 1503–1540

The Presentation in the Temple, about 1524–30
Black chalk with pen and brown and black ink, 15⅝ x 10 inches
Inscribed lower right (in another hand): Parmigianino
Purchased through the Florence and Lansing Porter Moore 1937 Fund; 2007.52

68. Nicolò Vicentino, Italian, active around the second quarter of the 16th century, after Parmigianino

The Presentation in the Temple, 1530s, published 1608
Chiaroscuro woodcut printed from three blocks (black and two shades of olive green), 16⅝ x 12³⁄₁₆ inches
Inscribed lower right: AA [publisher Andrea Andreani's monogram] in Mantova 1608
Purchased through the Jane and Adolph Weil Jr. 1935 Fund; 2006.52

Already in the sixteenth century a number of Francesco Parmigianino's contemporaries praised his drawings for their elegance and creativity. His working method typically involved the preparation of numerous studies, documenting a wide range of designs and daily scenes. The artist's surviving graphic oeuvre was one of the most compelling and prolific of this period; Popham's 1971 catalogue raisonné contained over eight hundred entries and nearly two hundred listings documenting old copies of lost drawings and reproductions (including prints). Given the enthusiasm for the collection and preservation of his drawings, there have been many new discoveries since then. The present sheet was attributed to Parmigianino by David Ekserdjian (1999: 22).

The Presentation in the Temple depicts the biblical episode (Luke 2:21–24) of Mary and Joseph bringing the infant Jesus to the temple in Jerusalem to be "consecrated to the Lord." According to Mosaic Law the firstborn of all species was sacrificed, but children were redeemed by the payment of five shekels (Num. 18:15–16) and the sacrifice of a pair of turtledoves or two young pigeons (Lev. 12:8).

The drawing is related to a chiaroscuro woodcut in the same direction. As Ekserdjian noted, the "sheet gives every indication of being preparatory for rather than derived from [the print]. It differs in various respects, and reveals all the sketchiness and changes of mind one would expect in a creative drawing" (1999: 22–23). In addition to the notable changes in the scale of the foreground figures and other details, the sheet is about five centimeters narrower. The extra width in the final print provides greater spatial clarity (on the left side of the table) and more room for the elaboration of the prominent female figure (on the right). The modifications are significant enough to imagine that Parmigianino may have executed another drawing more closely associated with the final design and with greater definition—possibly in reverse in preparation for transfer to the woodblock.

The composition is closely related to a drawing and painting by Parmigianino of the Circumcision of about 1523–24 (Franklin 2003: 107–12, nos. 19–20). In particular, the treatment of multiple light sources—such as the rays emanating from the head of the

Christ child and in the background—conforms to both the study and presumed description of the painting in the sixteenth century by Giorgio Vasari (1550: 846–47, discussed in Freedberg 1950: 50 and 159–60). The more elaborate spatial organization of the present sheet, as well as the treatment of the half-length foreground figures, is typical of the artist's designs for prints prepared during his Roman and Bolognese sojourns from about 1524 to 1530. Parmigianino's composition epitomizes his mannerist style, which was characterized by a rejection of symmetrical or logical spatial structure and the inclusion of unnaturally elongated figures.

As the infrared photograph demonstrates (fig. 1), the entire drawing was initially executed exclusively in black chalk. Many of the figures were subsequently drawn over in pen and ink by a different, "notably weaker" hand (Ekserdjian 1999: 23), possibly by the woodcut artist Niccolò Vicentino. TBT

FIG. 1. Composite infrared photograph of the black chalk drawing beneath the pen and ink lines.

PLAVSTRVM BELGICVM

69. Joannes and Lucas van Doetecum, Netherlandish, active about 1554–1600, after Pieter Bruegel the Elder, about 1528–1569, Netherlandish

Plaustrum belgicum (Belgian Wagon), from the *Large Landscapes,* about 1556–57

Etching with engraving, state ii/II, 12¹³⁄₁₆ x 16¹¹⁄₁₆ inches
Inscribed lower right: BRVEGHEL INVE H. Cock excude
Purchased through the Class of 1935 Memorial Fund and the
Jean and Adolph Weil Jr. 1935 Fund; PR.997.29.1

Pieter Bruegel's rather naturalistic conception of the landscape in *Plaustrum belgicum* (*Belgium Wagon*) was radical for its time. One of twelve *Large Landscapes* done after Bruegel's designs by the Doetecum brothers, artisans noted for their ability to "imitate engraved lines with etching," it was published at Antwerp by Hieronymus Cock around 1556–57 (Orenstein 2001: 120). Unlike the fanciful landscapes of northern artists such as Joachim Patinier (about 1480–1524), this one is filled with closely observed details specific to Bruegel's own time and place—the covered wagon, peasant with his market basket, wayside cross, and typical Flemish village with its church and inn. On the other hand, however, the landscape is not the record of a particular place but an artful composite of the seen and the imagined. Bruegel had recently returned from an extended sojourn in Italy, and rather than the Netherlandish countryside, the mountains in the distance recall the alpine vistas he had sketched during his travels.

Bruegel's skillful manipulation of reality in *Plaustrum belgicum* is both plausible and thought provoking. As the wagon moves down the slope from the high ground toward the village, the city with its crenellated walls, the castle on a crag, and the rivers flowing past a distant range of mountains and on into the ocean beyond, the intimacy of daily life is placed in a larger, more inclusive context. In the 1550s landscape usually had a secondary role as the setting for a traditional religious, allegorical, or classical subject. In *Plaustrum belgicum* man and nature instead become the subject. Bruegel gives visual form to a philosophical question of central concern in the Renaissance, the natural world and man's relation to it. Hieronymus Cock (about 1510–1570) was cultivating buyers with Renaissance interests when he published Bruegel's landscape. The Latin titles are written in the square Roman capitals the humanists derived from ancient monuments. In the classical world, admiration was reserved for the artist who could achieve unity from diversity—Lucian's *multum in parvo* ("much in little"). In *Plaustrum belgicum* Bruegel meets this high standard, creating an immense and complex world within the confines of a small piece of paper. MAS

70. Hans Bol, Flemish, 1534–1593

Landscape with Hunters, about 1572–75

Pen and ink, 7 x 10½ inches
Signed lower right: HB
Gift of Mrs. Henry Egginton in memory of her son, Everett Egginton,
Class of 1921; D.954.20.644

One of the most productive landscapists in the Netherlands in the sixteenth century, Hans Bol was admired for his fluidity with pen and ink, a talent evident in this drawing of hunters pursuing their quarry though a mountainous landscape. The drawing is undated, but the high foreground, convoluted tree branches, deep space, lively penwork, and use of wash evoke the drawing *Landscape with the Sacrifice of Isaac,* signed "H. Bol 1573," now in the Uffizi (Franz 1969: 2, fig. 313). Bol's early training was in Mechelen, where the technique of *waterschilderen* was common, and in both of these drawings his expertise with watercolor is apparent in his use of wash over parallel lines to indicate subtle contrasts of light and shade. Despite its apparent spontaneity, *Landscape with Hunters* was probably composed in the studio as a finished work of art made either for sale or as a gift. The composition, with its high foreground giving way to a rapidly descending slope and increasingly amorphous view of river, mountains, and sky, is carefully arranged and accommodates many anecdotal elements that enliven the drawing.

Hunting scenes were usually restricted to a temporal artistic context as part of a series representing the seasons or months, but by the 1570s hunting on horseback, the privilege of the wealthy, had become a subject in its own right, and Bol returned to it on a number of occasions. His *Stag Hunt,* for example, a large etching on two plates, includes well-dressed hunters on horseback, a distant landscape, and in the right foreground a hunter bending to load his crossbow (Riggs 1977: fig. 85). Made shortly after religious troubles forced Bol's move from Mechelen to Antwerp in 1572, *Stag Hunt* was published by Hieronymus Cock (about 1510–1570), the entrepreneur responsible for Pieter Bruegel's *Large Landscapes.* Their influence on Bol's *Landscape with Hunters* can be seen in the high foreground and landscape details; the hunters disappearing down the slope, for example, draw the viewer into the landscape in much the same way as the wagon lumbering downhill in Bruegel's *Plaustrum belgicum* (cat. 69). MAS

127

Fred Zuccaro.

71. Taddeo Zuccaro, Italian, 1529–1566

Two Nymphs, about 1561–66

Red and black chalk, 9 x 10⅝ inches
Purchased through the Mrs. Harvey P. Hood W'18 Fund; D.995.9.1

Like many young Italian artists, Taddeo Zuccaro was attracted to Rome to study the works of the most well-known painters of the early sixteenth century. Consequently, his own style combined natural proportion and idealized form in the depiction of human figures. In spite of his early struggles, Zuccaro eventually established a successful studio that received numerous commissions and earned him praise from his colleagues.

According to Giorgio Vasari (1511–1574), the turning point in Zuccaro's career came when Cardinal Alessandro Farnese (1520–1589) put him charge of designing the frescoes and stucco work for one of the most opulent Renaissance residences built outside Rome, the Villa Farnese at Caprarola. This complex iconographical program was developed by leading scholars to celebrate the accomplishments of the Farnese family and reflect the spiritual, intellectual, and dynastic interests of their patron. The result was a series

of cycles that rank among the most impressive of the late sixteenth century. Within two years after construction commenced on the villa in 1559, work began on the decorations in the first large room on the main level, the Hall of Jupiter. The present sketch is a preparatory study for two nymphs depicted in the central section of the ceiling (although the final fresco portrays three). The subject is described by Vasari in connection with Jupiter's youth, when the god was cared for by nymphs and nourished by a goat (in Italian, *capra*, in association with the site, Caprarola). The position and gestures of the figures are nearly identical to those in the finished work of art.

Combinations of black and red chalk began to appear in Italy early in the sixteenth century. Initially artists employed the technique as a means of differentiating structure, surface, and contour in figure drawing. Later in the century the method became more common, and both Taddeo and his brother, Federico (1542–1609), made consistent use of it, as in the case of the latter's study titled *The Madonna of Saint Jerome* (cat. 74) after Correggio (about 1490–1534). [Acidini Luchinat 1998–99, 1:161 and 2:1]　　　　TBT

72. Alessandro Tiarini, Italian, 1577–1668

Male Nude, about 1615–20

Red chalk, 17½ x 11½ inches

Inscribed in brown ink lower left: Tiarino da Bologna

Purchased through the Mrs. Harvey P. Hood W'18 Fund; D.995.10

Early in his career Alessandro Tiarini studied in his hometown of Bologna with Prospero Fontana (1512–1597), a collaborator of Taddeo Zuccari's (cat. 71) in Rome. Tiarini later worked from 1599 to 1606 in Florence and Tuscany, where he adopted a more naturalistic style of figure painting. Soon after Tiarini's return to his native city, Guido Reni (1575–1642), occupied with projects in the Eternal City, transferred a commission to him at the cloister of San Michele in Bosco. By 1615 or so Tiarini had reached his artistic maturity and was patronized by the leading individuals and churches in Bologna and Reggio Emilia.

Renaissance aesthetic theories generally advocated the presentation of the human form in a perfect state modeled after classical sculpture and the art of early-sixteenth-century masters. By around 1600 the so-called Carracci academy (Accademia degli Incamminati) at Bologna promoted art education based on a strong emphasis on life drawing. Tiarini's study of an elderly male nude reflected an interest in anatomical accuracy rather than a celebration of sensual beauty. Nevertheless, the intensely dramatic pose and highly finished rendering suggested that the drawing was not merely a routine exercise.

Also by 1600 a number of Bolognese artists regularly executed drawings in black and red chalk. The light-colored medium, ranging from a warm blood-red to a cooler red, depended on the minerals found in the source material. Usually harder than black chalk, the natural red type, also called sanguine, was suitable for more detailed drawings. Its lighter tone and ability to produce a range of shades simulating the color of flesh made it an ideal medium for figure studies, and Tiarini's sheet demonstrates his remarkable command of the material. TBT

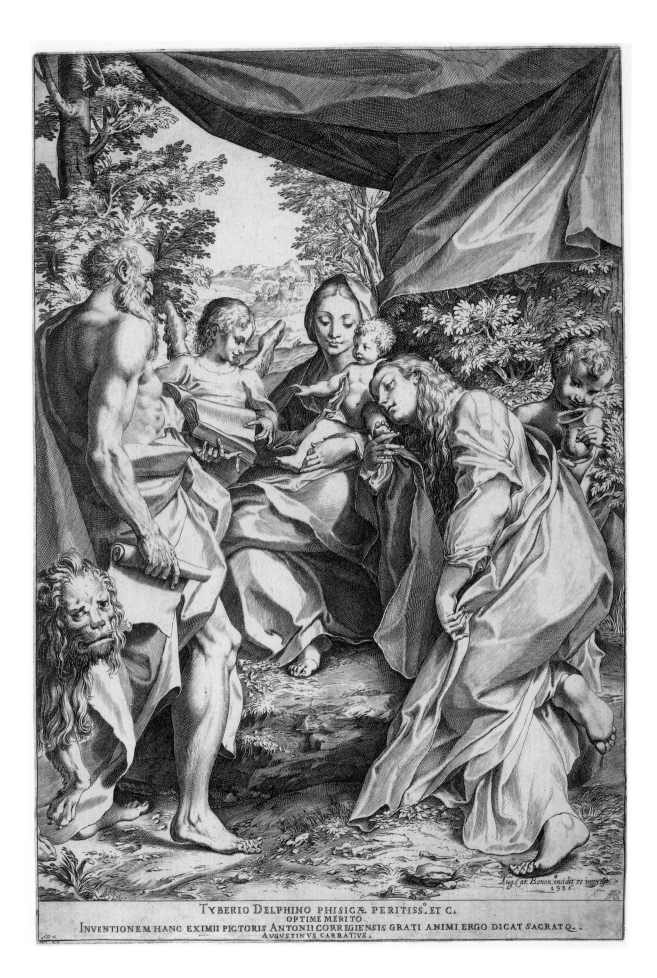

Aug. Car. Bonon. incidit et imprisit.
1586.

TYBERIO DELPHINO PHISICÆ PERITISS.° ET C.
OPTIME MERITO
INVENTIONEM HANC EXIMII PICTORIS ANTONII CORREGIENSIS GRATI ANIMI ERGO DICAT SACRAT Q.
AVGVSTINVS CARRATIVS.

73. Agostino Carracci, Italian, 1557–1602, after Correggio, Italian, about 1489–1534

The Madonna of Saint Jerome, 1586

Engraving, state ii/III, 19³⁄₁₆ x 13¹⁄₁₆ inches
Signed and dated at the bottom: Aug. Car. Bonon.
Incidibat et impressit / 1586
Purchased through the Jean and Adolph Weil Jr. 1935 Fund;
2005.45

74. Federico Zuccaro, Italian, 1543–1609, after Correggio

The Madonna of Saint Jerome, about 1607–8

Black and red chalk on laid paper pasted onto a fictive mount,
9¹³⁄₁₆ x 7¼ inches
Inscribed (on mount): ANT. ALLEGRI dict. CORREGO pinx.
FRED. ZUCCARO delin.
Purchased through the Julia L. Whittier Fund; 2005.40

In the *Lives of the Painters* by Giorgio Vasari (1511–1574), published in 1550, he described Correggio's painting *The Madonna of Saint Jerome* (about 1527–28) in Parma as "so wonderful and astounding that painters revere it . . . and it is scarcely possible to paint better" (583). Such praise quickly elevated the status of the work to the point that it was considered one of the supreme masterpieces of the Renaissance. Later generations of artists carefully studied Correggio's altarpiece (measuring approximately 6½ x 4½ feet) in order to assimilate its distinct qualities, and from the late sixteenth century onward Correggio was regarded by artists as a consummate Renaissance master. There were an estimated twenty-eight printed copies of *The Madonna of Saint Jerome* executed between 1586 and 1876 (Mussini 1995).

Prints after Correggio's paintings were extremely rare before 1600, and the first print to reproduce *The Madonna of Saint Jerome* was Carracci's large engraving, based on a drawing he had executed six years before. Agostino was an accomplished printmaker, whose works numbered over two hundred. This engraving is regarded as one of his greatest prints. However, Carracci did not merely replicate the original composition in the proper orientation. He introduced a number of modifications in order to create a successful print,

particularly by increasing the density of the foliage in the background, thereby limiting the space behind the figures and heightening one's attention on the foreground. Within a few months, two other printmakers copied Carracci's print and produced slightly smaller versions that included the same alterations.

The practice of making drawings after the works of other masters was one that Federico Zuccaro maintained throughout his long and distinguished career. He was associated with the art academies in Florence and Rome, and it has been suggested that these copies may also have been used by him as teaching aids. Nearly all of the sheets were executed in a combination of red and black chalk, which in this particular example highlight the scarlet fabrics and light skin tones. This drawing was acquired by a succession of Frenchmen in the seventeenth and eighteenth centuries, dating back as early as Everard Jasbach (1618–1695), one of the most prestigious private collectors of his day. At some point during the early history of the sheet, a fictive mount was added and inscribed with the names of both Zuccaro and Correggio (Py 2007: 28–29). The practice of mounting important drawings on separate sheets and surrounding them with decorative borders dated back to the sixteenth century.
[De Grazia 1979: no. 142; Mussini 1995: no. 362; Bury 2001: no. 76] TBT

Ostendit Christus se se Franciscus aderat,
O quæ animæ hic pascit sit sua cuique salus
Annuit æterne firmat sub fœdere templum
O veri Aligerum nomine sancta domus

FEDERICVS BAROCIVS VRBINAS
Inuentor incidebat 1581
GREGORII XIII PRIVILEGIO
AD X

75. Federico Barocci, Italian, about 1535–1612

The Vision of Saint Francis (Il perdono), 1581

Etching and engraving, only state, 21⁵⁄₁₆ x 12¹³⁄₁₆ inches
Inscribed lower left: *Ostendit Christus . . . domus;* lower right:
FEDERICVS BAROCIVS VRBINAS / INVENTOR INCIDEBAT
1581 / GREGORII XIII PRIVLEGIO / AD X
Purchased through the Jean and Adolph Weil Jr. 1935 Fund; 2006.30

Even though Federico Barocci executed only four prints, all in the 1580s, they served as important sources of inspiration for generations of artists. His etchings helped to establish the technique as the preferred method of a number of draftsmen and painters who also worked as printmakers. Barocci's unprecedented use of stop-out varnish and stipple to produce a variety of tonal values in etching led to its growing popularity in the next century as a powerfully expressive medium. *The Vision of Saint Francis,* the largest plate he ever made, demonstrates the artist's remarkable technical virtuosity. While a combination of dots and dashes sensitively models the features of the figures, the contrast between the brightly lit linear treatment of the architectural elements and the dark areas of cross-hatched shadows on the walls enhances the mystical atmosphere of the setting.

The print reproduces in the same direction the spatial complexity, luminous effects, and formal innovations of Barocci's painting of this subject, completed about 1576 for the high altar of the Capuchin church of San Francisco at Urbino. Both works depict Saint Francis (1182–1226) asking Christ for a plenary indulgence for all those who visited and confessed at the so-called Portiuncula shrine in the church of Santa Maria degli Angeli near Assisi, visible in the background. The artist often included references to actual sites in order to localize religious events. At this time the religious structure housing the chapel outside the saint's hometown was undergoing a total rebuilding, which coincided with the renovation of the Franciscan religious movement and the spread of Capuchin reforms (Lavin 1964: 253).

Following the design of the *Transfiguration* of 1516–20 by Raphael (1483–1520), Barocci divided his composition into upper and lower sections. In this example the parts are unified in the foreground by the supernatural illumination from above, complemented by the dim flame of the candle in the distant room from which Saint Francis emerges into the glow of heavenly light. The dynamic pose was inspired by traditional representations of the saint's stigmatization, yet it also reinforces the meaning of the work (Pillsbury 1996).

Barocci's enormous etching was immensely popular and helped to publicize the plenary indulgence that was extended in the late fifteenth century to all visitors to Franciscan and Capuchin churches on August 2 (Lavin 1964: 253). Although the artist had an exclusive copyright from papal authorities that was valid until 1591 (Bury 2001: 81), Francesco Villamena (1564–1624) was permitted

FIG. 1. Francesco Villamena, after Federico Barocci, *The Vision of Saint Francis,* 1581, engraving, 21⁵⁄₁₆ x 12¹³⁄₁₆ inches. Promised gift of Robert Dance, Class of 1977.

to produce an engraved copy of the etching three years before the expiration of the privilege (fig. 1). Michael Bury suggested that since the plate was not listed in Barocci's inventory, prepared around the time of his death in 1612, the Franciscans themselves must have arranged for the production and sale of the prints (2001: 82). TBT

133

76. Francesco Villamena, Italian, 1566–1624

Bruttobuono Stoned by His Enemies, 1601

Engraving, state i/II, 14⅞ x 20⅛ inches
Signed lower left: F. Villamena / Inventor
Purchased through the Adelbert Ames Jr. 1919 Fund; 2007.10

Francesco Villamena is recognized as one of the leading engravers working independently in Rome from about 1590 to 1624. His known oeuvre includes a large number of figurative and decorative prints encompassing religious and historical subjects, city maps and views, book illustrations and frontispieces, and architectural and sculptural reproductions, many drawn from works designed by other artists. All of the plates share the same distinctive use of the burin tool to cut parallel lines that swell and taper and flow fluidly. This technique, developed initially in Italy by Cornelis Cort (1533–1578), allows the engraver to model form, suggest contour, and regulate tone without having to rely on outline and crosshatching. Villamena employs this method with great effectiveness, producing an elegant and expressive manner that is known to have been widely imitated and highly acclaimed.

This unusual scene of 1601 was designed by Villamena and dedicated to the great patron of the arts Ciriaco Mattei (1545–1614),

whose villa on the outskirts of the city of Rome is partially depicted in the background. The print represents a street fight between the so-called "Bruttobuono" (presumably laying on the ground), who supported the Spanish, and several stone-throwing, pro-French thugs. Fights between these factions in Rome were common during this period of time.

In the inscription below, the artist apologizes to the illustrious patrician for designing such a "lowly subject" but explains that he thinks he will appreciate it since Mattei himself is a supporter of Spain who had given sanctuary to the mortally wounded Bruttobuono following the brawl. In fact, after the man's death, Mattei had him commemorated in a statuary group made of soft volcanic stone erected in the gardens behind his villa, which undoubtedly served as a source for Villamena's composition.

The original copper plate was among the artist's possessions at the time of his own death. Since printmakers could not keep commissioned works and only had rights to those they dedicated to others, the inclusion of the plate in the 1626 inventory of his property indicates that he designed and published this engraving independently. [Kühn-Hattenhauer 1979: 32–33 and 237–40; Franca Trinchieri Camiz 1994: 508–10, fig. 32; Bury 2001: 163–64, no. 112] TBT

134

77. Francesco Villamena, Italian, 1564–1624

Portrait of Giovanni Alto, Antiquarian, 1623

Engraving with black and red chalk, working proof, 14⅛ x 20¹¹⁄₁₆ inches
Signed lower left: F. V. F.
Purchased through the Class of 1935 Memorial Fund and the
Jean and Adolph Weil Jr. 1935 Fund; PR.997.29.2

The present sheet, a preparatory engraving with black and red chalk drawing presumably by Francesco Villamena, is a particularly interesting portrait. The inscription hails the latter-day humanist and antiquarian Cassiano dal Pozzo (1588–1657), although the actual portrait subject is one Giovanni Alto, who, as the inscription tells us, was a (Swiss) guard who moonlighted as a guide to the famous sights of Rome. He is pictured standing tall, in a pose at least vaguely reminiscent of the ancient sculpture known as the *Apollo Belvedere,* gesturing with an elegantly gloved hand toward the wonders spread out behind him, evoking those ruler portraits in which the potentate's dominions lie behind him as well. In the left foreground an ancient altar on its side would soon be inscribed with Villamena's signature and a dedication to Apollo and the Muses. Alto's foot is neatly paired with a colossal foot reminiscent of the fragment of a colossal statue of the Emperor Constantine that is still visible in

Rome. In the rear on the left is the renowned pairing titled *Horse Tamers,* the dome of the Pantheon, the newly completed Saint Peter's basilica, the Castel St. Angelo, and, in the middle ground, the Quirinal Palace of the pope. The starving, mangy dog seems to exhort the viewer to generous patronage, though Alto himself could scarcely look more prosperous in his lace and feathers. The horse's skull and snake allude to frail mortality.

Cassiano dal Pozzo was godfather to Villamena's first child, born nine years previously, so the dedication to him is likely to reveal genuine respect rather than crass prospecting. The work was probably not commissioned, given this dedication, but made "on spec" and presumably self-published. Giovanni Alto's portrait would likely have been readily bought by the tourists, especially from northern Europe, to whom he showed the sights. The Grand Tour had barely begun, but Villamena here helped to inaugurate a tradition of highly respectable souvenir art that would continue through Canaletto (cat. 93) and Piranesi (cats. 95–96) in the eighteenth century. [Bury 2001: 17–18, nos. 1–2; Thurber 2003: 100–115, fig. 4; Emison 2006: 84–85, no. 56]

PE

78. Jan Harmensz Muller, Dutch, 1571–1628

ET VENUS IN VINIS (And Love [Is Engendered] by Wine), about 1605

Drawing in pen and two inks on vellum, 17 x 15⅛ inches
Signed upper left: OPUS. I. MVLLER
Museum purchase; D. 970.57

The caption for Muller's drawing is a variant of an idea inherited from antiquity: "without wine and food love grows cold." Although first introduced in northern Europe in a moralizing context, by 1600 the ancient proverb was more apt to serve as an erudite cover for emphasizing the pleasures rather than the dangers of the male/female relationship. Muller's drawing is typical of this development, undercutting the cautionary message with the sensuous elegance of the amorous couple. There is no age discrepancy or exchange of money between the man and woman to make Muller's drawing a satire in the tradition of "unequal couples." Instead, the delicate penwork evident in the convoluted plumes and luxuriant curls, the large size, and the references to the ancient world—such as the Roman arch in the upper corner, the wine cup, and the footed cup

derived from antiquity—make the drawing a luxury object to be enjoyed for its sexual innuendoes and display of the artist's technical skill. Like a print from the series *The Four Lessons of Love* published in 1600, where the visual message (the obvious pleasure of well-dressed couples) counters the caption ("A festive meal can lead to lasciviousness"), Muller's drawing makes the amorous dalliance of the couple more inviting than worrisome.

Muller was a prolific artist credited with one hundred engravings and at least sixty drawings. Between 1594 and 1602 he was in Italy, and this drawing, probably created shortly after his return, shows the effects of that experience as well as the classicizing influence of northern artists. The graceful figures and classical orientation here have much in common with prints such as Muller's engraving of Spranger's *Bacchus and Ceres Leaving Venus* (Riggs and Silver 1993: fig. 5). Some of Muller's penwork, as in the cross-hatching of the woman's dress, also suggests the influence of Goltzius's *Federkunststücke,* pen-and-ink drawings imitating the technique of engraving. If innovation was not Muller's forte, he was nevertheless quite adept at creating the kind of fashionable art enjoyed by his contemporaries. [Hollstein 1965: 14; Reznicek 1965 (quotation) and 1956] MAS

Quisnam igitur liber? Sapiens, sibi qui imperiosus Dueghd Verhueght. Responsare cupidinibus, contemnere honores C. Cornelis Harlem.¹ invent.
Quem neq; pauperies, neq; mors neq; vincula terrent: Fortis, et in seipso totus teres atq; rotundus. Haman Mullerus excud.
 Amstelrodami

79. Jan Harmensz Muller, Dutch, 1571–1628, after Cornelis Cornelisz van Haarlem, Dutch, 1562–1638

Arion on a Dolphin, about 1590

Engraving, state i/III, 13⅞ x 13¹⁵⁄₁₆ inches
Inscribed in plate in the lower margin: C. Cornelis Harlemen invent. / Haman Mullerus excud.
Purchased through the Hood Museum of Art Acquisitions Fund and a gift from the Cremer Foundation in memory of J. Theodor Cremer; PR.994.24

Produced by one of the most accomplished draftsmen and print-makers working in Haarlem, this superb engraving exemplifies Dutch mannerism at its finest. It is a bold and striking image that demonstrates a fascination with the heroic male nude that characterized the art of Hendrick Goltzius (cat. 80) and his circle. The brilliance of Muller's burin technique at an early stage in his career is evidently apparent, particularly in the definition of the muscula-ture of Arion and in the rolling clouds above. The theatrical con-trasts of light and dark produce a powerfully expressive image that is appropriate to the story depicted.

Arion, a legendary singer and poet, was tossed overboard by a jealous ship's crew as he traveled to a musical contest. His singing attracted a dolphin, which carried him to safety. In Muller's print Arion is represented turning to the light of heaven, as if giving thanks, while riding off on a fierce dolphin. The ship is shown in the distance on the right.

In this work Muller reproduces a design by Cornelis Cornelisz van Haarlem, one of the foremost Antwerp mannerists and an as-sociate of Goltzius and Karel van Mander (1548–1606). A surviving drawing by Muller of the figure of Arion indicates that the print-maker did not simply transfer the composition but rather made ev-ery effort to properly render it in a different medium. It is thought that the print was commissioned by the Amsterdam poet Hendrick Laurensz Spiegel (1549–1612), who liked to associate himself with Arion. The print bears Spiegel's personal motto, *Dueghd Verhueght* (or "Virtue gives delight"), and verses from the Roman lyric poet Horace (*Sermonum* 2.7:83–86, cited in Thiel 1999: chap. 9). A later woodcut version in reverse of the composition appears on the title page of Spiegel's posthumous book of poems outlining his philo-sophical vision that united Christian and Platonic ideas.

TBT

80. Hendrick Goltzius, Dutch, 1558–1617

Proserpine, about 1588–90

Chiaroscuro woodcut printed from three blocks
(black, ochre, and brown), only state, 13¹³⁄₁₆ x 10⁵⁄₁₆ inches
Signed lower left in tan block: HG
Purchased through the Julia L. Whittier Fund, the Class of 1935
Memorial Fund, and the Hood Museum of Art Acquisitions Fund;
PR.993.23

Hendrick Goltzius achieved international fame at the end of the sixteenth century as Europe's premier printmaker and draftsman. Born in Mülbracht on the German border, he studied engraving with Dirk Volertsz Coornhert (1522–1590). In 1577 he settled in Haarlem, where he met the painters Cornelis Cornelisz van Haarlem (1562–1638) and Karel van Mander (1548–1606), who introduced him to the paintings of Bartholomäus Spranger (1546–1611). Goltzius engraved many of Spranger's compositions, which were a distillation of the Roman mannerist style that Spranger had formed in Italy and perfected at the courts of Vienna and Prague. A trip to Italy in the early 1590s exposed Goltzius to the classical grandeur of ancient Roman and Italian Renaissance art, and his style correspondingly became at once more normative and more idealized. Around 1600, according to Van Mander, Goltzius took up painting, which he practiced until the end of his life.

Proserpine is among Goltzius's most virtuosic accomplishments in printmaking and a superb example of northern mannerism. It is one of a series of seven chiaroscuros entitled *The Deities* that depicts three pairs of male and female gods after an introductory print titled *Demogorgon in the Cave of Eternity.* The story of Proserpine (Persephone in Greek) is related by Ovid (43 BCE–about 17 CE) in *Metamorphoses* (5:385–424). The daughter of the goddess Ceres, she was abducted by Pluto, the king of the underworld, who carried her down to Hades. Jupiter interceded to set her free, but because she had eaten several pomegranate seeds while in Hades, she was forced to divide her time equally between Hades and Earth. Proserpine's time with Pluto in Hades was thus associated with autumn and winter, and her time on Earth with spring and summer. Goltzius shows Proserpine during the latter phase, in a verdant garden, with a garland around her waist and flowers in her hair, surrounded by fruits and vegetables. The pendant print represents her consort, Pluto, seen from behind in a fiery landscape. TBT

81. Jan Saenredam, Dutch, about 1565–1607, after Abraham Bloemaert, Dutch, 1564–1651

Vertumnus and Pomona in a Garden, 1605

Engraving, state iv/IV, 18⅝ x 14⁵⁄₃₂ inches
Inscribed in plate lower right: A. Bloemaert inve. / J. Saenredam Sculp.
/ et excu. / A°. 1605
Gift of Todd Butler; PR.977.163

Jan Saenredam, who worked briefly with both Hendrick Goltzius (cat. 80) and Jacques de Gheyn II (1565–1629), translated many drawings by his Dutch contemporaries into remarkable engravings. Abraham Bloemaert designed over six hundred prints, which were engraved by a number of different master printmakers. This composition was the result of the prolific collaboration between the two artists that primarily focused on outdoor biblical scenes. Compared to his earlier body of work modeled after Goltzius's distinctive swelling burin technique, Saenredam's prints after Bloemaert were characterized by fine lines that produced rich tonal and textural contrasts.

Vertumnus and Pomona in the Garden was the first independent print to represent the mythological story, which became extremely popular in the Netherlands during the seventeenth century (Roethlisberger 1993: 133). According to Ovid (43 BCE–about 17 CE), Pomona had a garden from which she excluded men, among them Vertumnus, who could disguise himself as different characters. After repeated refusals he took on the appearance of an old woman, who advised Pomona to marry Vertumnus. After convincing her, he resumed his natural appearance as a young man and won her love. Contemporary interpretations emphasized the moral implications of overcoming adversity in order to obtain virtue (Karel van Mander [1604], cited in Hellerstedt 1986: 21). The subject also recalled Dutch proverbs of the time that warned of the transience of beauty (Roethlisberger 1993: 134).

The print, the third largest of Saenredam's engravings after a drawing by Bloemaert, depicts an enormous forked tree, suggesting a conflict between the figures. In the background on the left is a small figure of Vertumnus as an elderly woman, while a couple embracing on the right indicates the ultimate union of the two protagonists. The other exquisitely rendered details, which were admired by later collectors, have symbolic meanings as well. TBT

82. Jacques Callot, French, 1592–1635

The Stag Hunt, about 1619

Etching, state i/IV, irregular: 7¾ x 18⁵⁄₁₆ inches
Inscribed in plate lower left: Iac Callot Inv. et Fe
Gift of Jean K. Weil in memory of Adolph Weil Jr., Class of 1935;
PR.995.5.121

Born in the Duchy of Lorraine, Jacques Callot spent a major part of his early career as a professional printmaker in Italy, particularly in Rome and Florence. Over the course of his relatively short life (he died of stomach cancer at the age of forty-three), Callot created some fourteen hundred prints, many of which were commissioned by the most prestigious European leaders of his time, including Duke Cosimo II de'Medici of Florence, the dukes of Lorraine, and King Louis XIII of France. His prints were collected not only during his lifetime but also in the eighteenth century by illustrious connoisseur Pierre-Jean Mariette (1694–1774), whose documentation of Callot's work has provided an invaluable foundation for contemporary scholarship. It was during Callot's time in Florence that he executed *The Stag Hunt,* perhaps the most widely recognized and admired etching in his entire oeuvre.

Although Callot devoted much of his time to the depiction of religious subjects, his personal love of the theater and hunting provided material for a great number of etchings. These interests are combined in *The Stag Hunt,* which is a fancifully staged, though realistically situated, depiction of a private hunting party in the hills of Tuscany. The location is quite possibly the town of Signa, the site of the castle built for the Medici by the architect Bernardo Buontalenti that is seen in the left background of the print (Lieure 1927: 2:11, no. 353). The balanced, stagelike setting is suggested not only by the "beholder's" perspective and the extreme contrast between dark and light from foreground to background but also in the juxtaposition of animated figures and curved trees, all of which focus the beholder's attention inward, toward the center of the print. This perfect harmony of perspective, technique, and subject is Callot's

signature, and it is testimony to his mastery of the only craft he ever pursued.

Perhaps the most far-reaching contributions Callot made to the art of printmaking were his technical innovations. Having begun his training as an engraver, Callot soon became fascinated with etching and worked almost exclusively in this technique for the rest of his career. While in Florence, he developed a new, very stable ground of mastic and linseed oil that adhered well to the copper plate, giving him much greater control over the quality of his lines while eliminating the chance of foul biting. Using the *échoppe,* an etching tool with an oval cutting edge rather than a sharp needle, Callot was able to create etched lines that took on the characteristics of those engraved with a burin. This allowed him to model the figures and elements of the landscape in *The Stag Hunt* with remarkable elegance and fluidity. In addition, his deft use of stop-out and the different lengths of time for biting various parts of the plate enabled him to combine strong deep lines with those of greater delicacy, as seen in the heavily inked and articulated trees of the foreground and the faint hills and castle in the far distance.

Callot was a very methodical artist, often completely working out every detail of a composition on paper before pulling a single image off the plate. Unlike artists such as Rembrandt, he seldom returned to the plate when he considered a work to be finished. *The Stag Hunt* does exist in four states, yet the changes from one to the next are relatively minor. The very rare first state of the print from the Weil collection is a remarkably rich and vivid impression of one of Callot's largest and most complex works. JMB

P. P. Rub. delin. & exc.
CVM PRIVILEGIIS.

Christoffel Iegher sc.

83. Christoffel Jegher, Flemish, 1596–1652/53, after Peter Paul Rubens, Flemish, 1577–1640

Susanna and the Elders, 1630

Woodcut, state ii/II, 17⁷/₁₆ x 22¾ inches
Signed below: P. P. Rub. delin. & exe. / Christoffel Iegher fe.
Purchased through the Class of 1935 Memorial Fund; PR.2002.14

Following the example of several Italian Renaissance artists, Peter Paul Rubens solidified his reputation and influence beginning in the middle of his career by hiring several printmakers to translate his compositions into engravings and woodcuts. He ultimately supervised the production of around one hundred prints representing various subjects (see fig. 1). Rubens recognized the distinct requirements of printmaking compared to painting and drawing, and he frequently modified his designs to allow for differences of scale, function, and technique in order to create independent works of outstanding quality.

The number of Rubens-inspired woodcuts was small, only nine, but they have been considered some of the finest executed during this period in northern Europe. They were all prepared by Christoffel Jegher, who generally worked on book illustrations for a publishing house in Antwerp from 1625 to about 1643. A member of Rubens's studio would typically prepare a model for the printmaker, which the master would review and occasionally modify. In the case of *Susanna and the Elders*, Rubens retouched in ink a pupil's drawing, perhaps after a lost picture (Meyers 1966: 15–16). Jegher's sweeping curved lines and dark crosshatching imitated techniques borrowed from engraving to transition from light to shade. His command of the medium is especially evident in the treatment of the figures.

The story of Susanna and the Elders, based on apocryphal versions of the Bible, is comparable to other accounts of heroines and victims in the Old Testament. Susanna's portrayal as an ideally virtuous wife, based on her willingness to die even when falsely accused of adultery, made her an especially appealing subject. Yet the artistic representations of the time did not escape the ambivalence and erotic suggestiveness seen in images of other female protagonists. Compared to such other late-sixteenth- and early-seventeenth-century depictions—in which Susanna is often depicted as a voluptuous nude who appears to beseech the elders—Rubens shows her in a pose that seems to suggest genuine aversion, as she pushes away one of the elders while looking away from both (Russell 1990: 58, no. 19). TBT

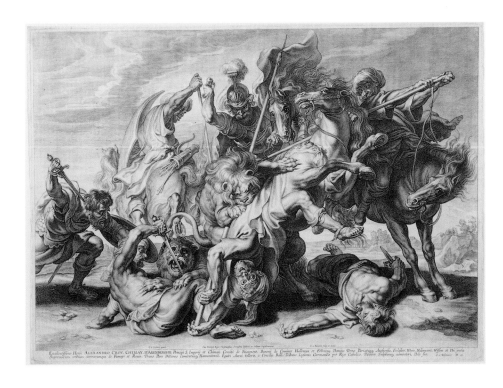

FIG. 1. Boetius Adams Bolswert after Peter Paul Rubens, *The Lion Hunt,* 1633–35, engraving, only state, 17 x 23½ inches. Purchased through the Class of 1935 Memorial Fund; PR.994.17.2

84. Bartolomeo Coriolano, Italian, about 1599– about 1676, after Guido Reni, Italian, 1575–1642

Fall of the Giants, 1641 (this state, 1647)
Chiaroscuro woodcut on four sheets, each sheet printed from
three blocks, state iii/III, 34⁹⁄₃₂ x 24⁹⁄₃₂ inches
Signed and dated lower left: G. R. Im. / Barthol. Coriolanus. Eques. /
Sculp. & Form. Bonon. / 1641
Purchased through the William B. Jaffe and Evelyn A. Jaffe Hall Fund;
PR.974.370

Among the many printmakers Guido Reni enlisted to help disseminate his artistic inventions was a fellow Bolognese, Bartolomeo Coriolano, one of the few seventeenth-century practitioners of the chiaroscuro woodcut technique. This prolific partnership commenced as early as 1627 and flourished in their native city until the elder artist's death in 1642. Reni executed drawings that Coriolano interpreted in chiaroscuro, developing a distinctive graphic vocabulary of disciplined cutting that evinces the draftsman's fluid calligraphy. Their collaboration was both an artistic and a commercial endeavor, the two frequently sharing publishing responsibilities and presumably dividing costs and profits.

Fall of the Giants, their most ambitious project in size and technical complexity, illustrates Jupiter's punishment of the giants as recounted by Ovid (43 BCE–17/18 CE) in the first book of his *Metamorphoses.* The title appears on the shield at the upper right, while there is a reference at the top left to the *Gigantomachia,* or *Battle of the Giants,* by Claudian (active about 395–404). Jealous of the gods, the giants had piled up mountains while endeavoring to attain the heavens. Jupiter, depicted here brandishing a fistful of lightning bolts, struck down the giants and crushed them under massive rocks. Reni's design and Coriolano's printmaking and publishing responsibilities are credited after the title at top right, and again at bottom left.

Coriolano executed two versions of *Fall of the Giants.* In the second version, of which the present sheet is an example, the composition in the upper register, the inscriptions, and the heraldry were all modified. This version was first published in 1641, and then issued in multiple states, variably printed from a total of twelve or sixteen woodblocks. The Hood's impression was published in 1647 from twelve blocks, the new date on the shield at the top right having been applied with a stamp. Chiaroscuro woodcuts are executed by the superimposed printing of blocks, in this case in a palette of closely related hues that vary in color and order of printing from one impression to the next. The survival of a large number of impressions of this sizable print is a testimony to its success among contemporary collectors. [McBurney and Turner 1988] NT

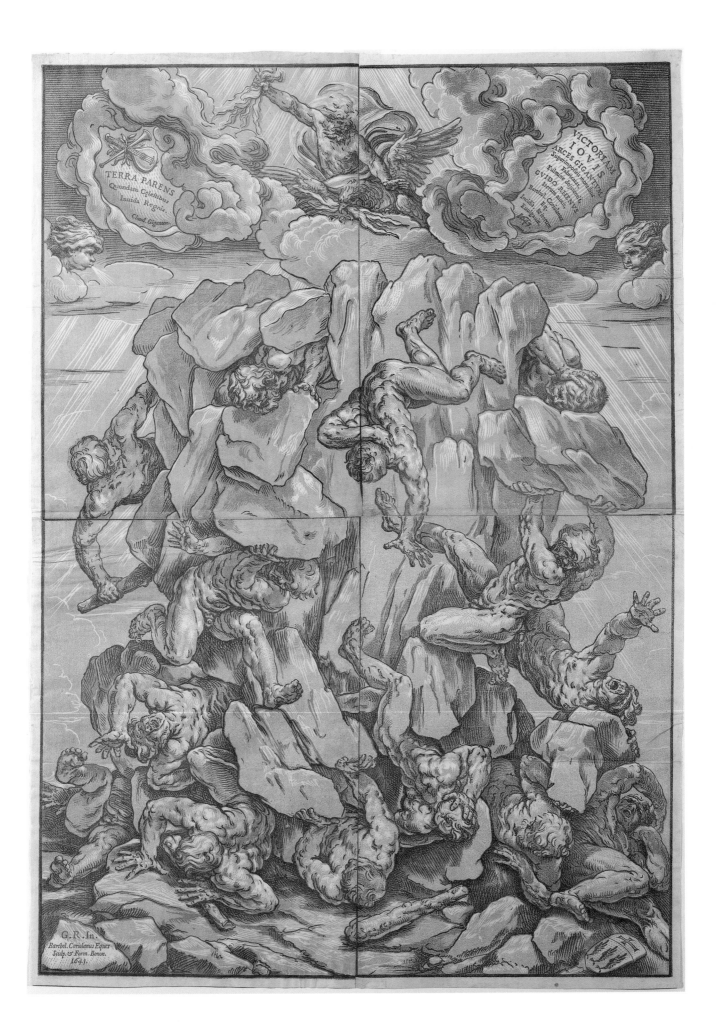

TERRA PARENS
Quondam Cælestibus
Inuida Regnis.

Claud Gigantom.

VICTORIAM
IOVIS
ARCES GIGANTEI
Superimpositas montes
Fabricant.
Fulmine dejecitur,
GVIDO RHENVS
Iterum inuit.
Barthol Coriolanus
Incidit. Fig.
& Excud.

G. R. In.
Barthol. Coriolanus Eques
Sculp. & Form. Bonon.
1641.

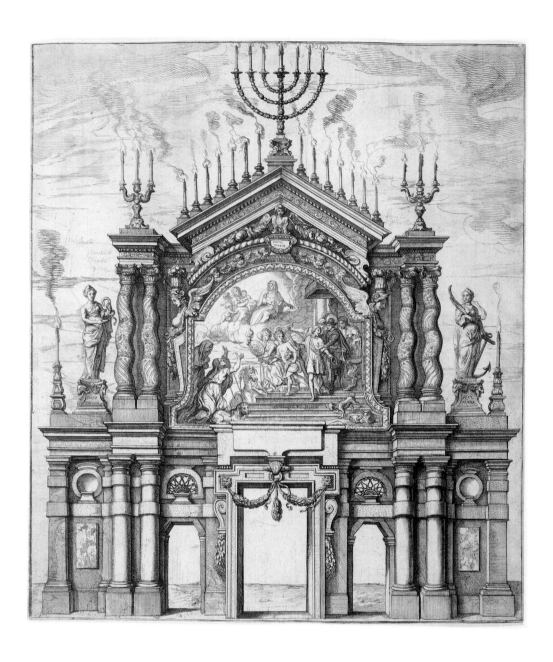

85. Theodor van Thulden, Flemish, 1606–1669, after Peter Paul Rubens, Flemish, 1577–1640

Triumphal Arch: Philip IV Appoints Ferdinand Governor of the Netherlands (Central Panel of the Stage in Memory of Isabella Clara Eugenia, Deceased Spanish Regent), 1641

(a) Proof impression: engraving with graphite and ink, 16⅞ x 15¹⁄₁₆ inches (trimmed to the platemark)

(b) Final state: engraving, (i) 16¹¹⁄₁₆ x 15³⁄₁₆ and (ii) 3 x 15³⁄₁₆ inches

Purchased with funds provided by Jane and W. David Dance, Class of 1940; PR.2004.7.2–3

The greatest pictorial program executed by Peter Paul Rubens for his home city of Antwerp was a commission to provide decorations for the entry on April 16, 1635, of the new Spanish governor of the Netherlands, the Cardinal Infante Ferdinand of Hapsburg (1609–1641). Rubens supervised the design of triumphal arches, stage architecture, and tableaux vivants. With regard to the paintings executed by the artist's workshop, including those by his talented pupil Theodore van Thulden, only fragments have survived, along with a number of renowned original oil sketches.

In 1641, a year after Rubens's death, Thulden and the Antwerp humanist Caspar Gevaerts (1593–1666) published a complete description of the decorations with extensive explanations and engraved

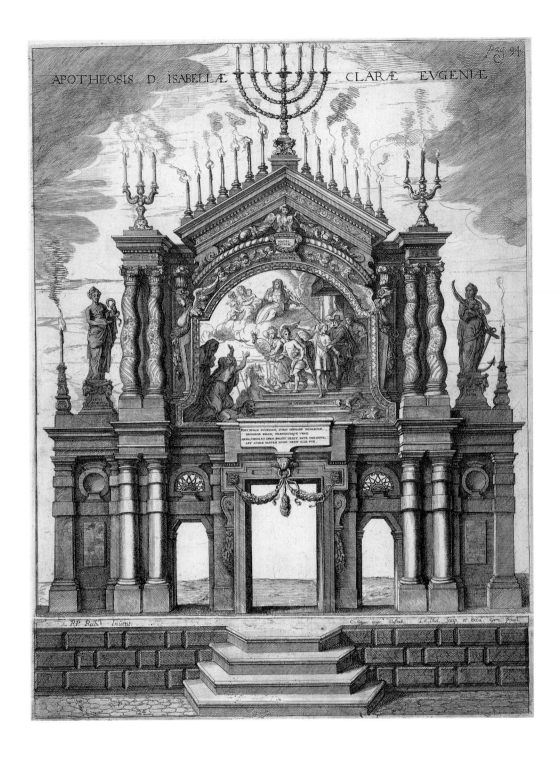

illustrations, one of the most elaborate publications ever produced of a pageant series. The comparison between a proof impression—before considerable overwork with burin, and featuring handwritten inscriptions in graphite and ink—and a completed state vividly demonstrates the complex process of transforming Rubens's ephemeral work into a permanent achievement. This project also played an important role in further promoting the Flemish artist's international reputation.

The proof impression and the complete state of the print represent one of the triumphal arches in the first part of the entry that shows the Hapsburg dynasty of rulers and Ferdinand as the victor of the Battle of Nördlingen, Germany, in 1634 (part of the Thirty Years' War). Here his expected role as "Pacificator" is repeatedly emphasized, particularly in the street theater devoted to his late predecessor, the Archduchess of Austria Isabella Clara Eugenia (1566–1633). The kneeling figure of Belgica, an allegorical female character symbolizing the Flemish people, awaits the new governor with an imploring gesture, while, from the clouds, Isabella designates him as the promised prince, the one who will lead the way to peace (Martin 1972: nos. 34–35). Interestingly, the addition of a second engraved plate at the bottom of the sheet in the final state shows a rusticated base, which transforms the ephemeral triumphal arch into an apparently permanent structure. [Simson 1996: 444–74]

TBT

147

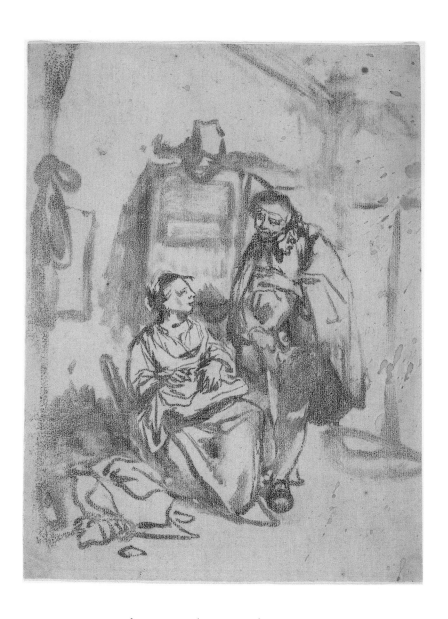

86. Cornelis Pietersz Bega, Dutch, about 1631–1664

The Quack's Visit, about 1654–58

Monotype, 9⅜ x 7³⁄₁₆ inches
Museum purchase; PR.972.98

Cornelis Bega was born into a prosperous artistic family; his mother had inherited half of the estate of the renowned mannerist painter Cornelis Cornelisz van Haarlem (1562–1638) and his father was a gold- and silversmith. Bega studied with Adriaen van Ostade (1610–1684), Holland's leading painter of peasant and "low-life" genre scenes. Following this tradition, Bega's principal subjects included domestic interiors, taverns, and village settings, as well as depictions of alchemists, fools, and street figures. His primary medium was oil paint on both panel and canvas, but he also executed drawings, etchings, and a small number of monotypes—apparently the first Dutch artist to experiment with the printing of unique images.

Monotypes are produced through a process in which a drawing or painting is executed in oil or ink on a smooth, non-absorbent, hard surface and transferred by applying pressure to a superimposed sheet of paper. This creates a unique, single impression in reverse of the original composition, and examples dating from the mid-

seventeenth century, when it was first invented, to the end of the eighteenth century are extremely rare. Like many artists attracted by its spontaneous effects, Bega used monotypes to capture the liveliness and originality found in his best graphic works.

The present sheet, one of only six monotypes attributed to Bega, depicts an interior with a seated woman apparently conversing with a man standing beside her. Long thought to portray a peasant couple, the upright male figure is now considered to be a quack, someone posing as a doctor, radically modifying the significance of the scene (Scott 1984: 194–96). The subject, common in mid-seventeenth-century Dutch art, emphasizes the folly of seeking outside aid to improve one's physical, emotional, spiritual, or financial status. The man's true identity is revealed in his clothing, especially the white collar and dark cape associated with the theatrical attire of the period worn by comedians playing medical doctors. As a result, instead of creating an intimate representation of a couple, presumably related to one another, the artist ridicules the single woman for seeking advice, possibly to cure her lovesickness. The sketchy manner seems to reflect the playful theme of the composition. [Scott 1984: 439–40, no. M.3, fig. 234] TBT

148

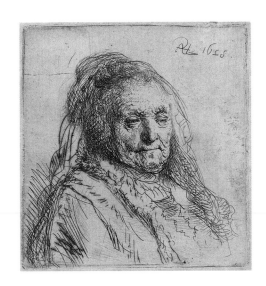

ACTUAL SIZE

87. Rembrandt Harmensz van Rijn, Dutch,
1606–1669

*An Elderly Woman (Rembrandt's Mother,
Head and Bust),* 1628

Etching and drypoint, state ii/II, 2⁹⁄₁₆ x 2½ inches
Signed and dated upper right: RHL 1628
Gift of Jean K. Weil in memory of Adolph Weil Jr., Class of 1935;
PR.997.5.115

88. Rembrandt Harmensz van Rijn

The Three Trees, 1643

Etching, drypoint, and engraving, only state, 8⅜ x 11¹⁄₁₆ inches
Promised gift of Jean K. Weil, lent in memory of Adolph Weil Jr.,
Class of 1935

89. Rembrandt Harmensz van Rijn

*Christ Crucified between the Two Thieves:
The Three Crosses,* 1653–55

Drypoint, state iv/V, 15¼ x 17⅞ inches (trimmed to platemark)
Gift of Jean K. Weil in memory of Adolph Weil Jr., Class of 1935;
PR.997.5.93

Rembrandt's etchings are some of the most inventive and influential of all his works. He thought about printmaking in new ways, offering the viewer not only carefully finished masterpieces but also more roughly sketched glimpses into his artistic processes. From his years as a young artist in Leiden to the last etchings of his career, Rembrandt continued to devise solutions to the problem of depicting light and dark with the printed line. The Hood Museum of Art's collection of Rembrandt etchings spans his life's work, providing an overview of thirty years of his evolving ideas about printmaking.

While his contemporaries generally used etching to imitate engraving, Rembrandt reveled in the spontaneity it offered. In *An Elderly Woman* of 1628, for example, the scribbled shadows and abbreviated indications of the woman's clothing lend an air of informality to the print and form a striking contrast to the careful delineation of her face. Within a few years of learning to etch, Rembrandt had mastered the technique to such a degree that he could successfully communicate the texture of this fragile, wrinkled flesh. Indeed, the loving depiction of the woman's face accounts in part for the traditional identification of the sitter as the artist's mother. Whoever she may be, the compassion with which she is portrayed is a recurring theme in Rembrandt's printmaking, and in his art as a whole: from the sensitive description of this elderly face all the way to the religious subjects at the end of his career, Rembrandt's ability to convince us of the humanity of his subjects is one of the most remarkable aspects of his art.

The 1640s marked a period of technical experimentation for Rembrandt, accompanied by an expansion in his repertoire as he explored landscape and formal portraiture to a greater degree than

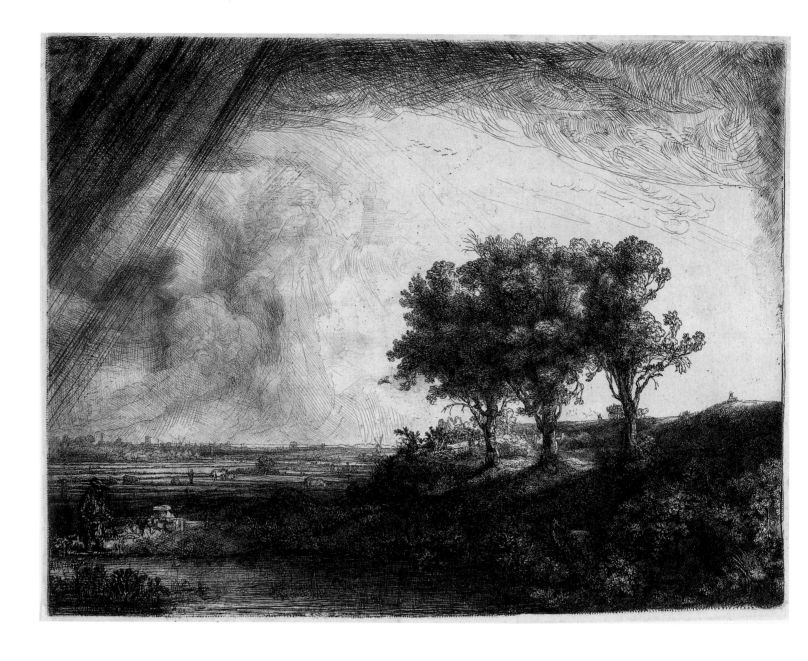

he had in the previous decade. His landscape etchings of this period range from rapid sketches to the elaborate and dramatic *The Three Trees*. With its threatening sky and varied, half-hidden human population, this print has been subject to art historical interpretations for centuries, ranging from speculation as to the Christian significance of the three trees to ideas about nature's power over man. Certainly in part, however, the subject of this print is the artist's virtuoso ability to depict diaphanous clouds and light via etching, because the simpler linear hatching used by most printmakers was decidedly insufficient for this challenge. Instead, Rembrandt achieved more painterly effects with a complex mixture of techniques. Using a seamless blend of etching and drypoint with engraving, he created blacks so rich that by contrast the white paper seems to glow with sunlight. The sketchy treatment of the clouds in the upper right gives them a momentary quality, suggesting changing weather

more effectively than the precise modeling many of Rembrandt's contemporaries might have used. In addition to the soft burr of the drypoint, he used granular tone to provide more surface texture. It is easy to imagine an early collector spending hours poring over this impression, considering various meanings and discovering new aspects of the artist's printmaking techniques.

Although he continued to etch both portraits and landscapes in the 1650s, Rembrandt created some of his most memorable religious images during this last full decade of his printmaking career as well. With their combination of a lifetime's practice in the depiction of human emotion and decades of technical experience, these are some of his most moving works. It was during this period that he produced his two great drypoints, *Christ Crucified between the Two Thieves (The Three Crosses)* and *Christ Presented to the People (Ecce Homo)*. Although other artists had been using the technique

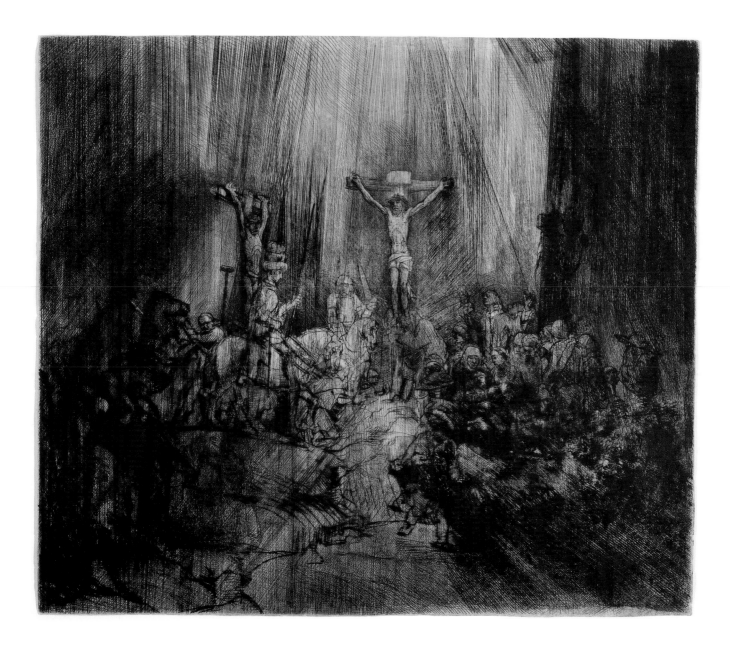

for over a century, Rembrandt's decision to work such large plates exclusively in drypoint was unprecedented: because the rich burr wears down so quickly, the time spent on a large, multi-figured composition like either of these would be repaid with comparatively few excellent impressions. He often experimented in the printing of *The Three Crosses,* using different kinds of paper or inking and wiping the plate to highlight or obscure different parts of the scene and creating a variety of unique impressions. Although the blocky, abbreviated figures in both *The Three Crosses* and *Ecce Homo* are typical of Rembrandt's draftsmanship during the 1650s, this tendency is particularly well suited to drypoint, as the resistance of the bare metal to the needle encourages the artist to work in short, straight lines. It has been suggested that the experience of working extensively in drypoint may have encouraged Rembrandt to develop this aspect of his figural style in his paintings and drawings.

During his final years, Rembrandt set aside etching and instead concentrated on painting. The reasons for this shift are unknown. The inventory made at the time of his death included copper plates, suggesting that he had not given up on the idea of returning to printmaking. By the end of his life, Rembrandt's prints had spread his fame throughout Europe. Because they are produced in multiple and because of their small size, prints were an effective way to demonstrate an artistic style, and collectors and other artists who had never seen a Rembrandt painting studied his work through his etchings. For both his technique and his ability to convey the humanity of his subjects, Rembrandt's etchings rank among his greatest works and the most inspiring prints of all time. [Goldfarb 1988; *Gift to the College* 1998; Sell 2006] SLS

90. Domenico Piola, Italian, 1627–1703

The Seven Sorrows of the Virgin, about 1650

Black chalk, pen, ink, and wash, 15⅜ x 9⅞ inches
Gift of Mrs. Hersey Egginton in memory of her son,
Everett Egginton, Class of 1921; D.954.20.666

91. Domenico Piola

The Adoration of the Shepherds, about 1680

Pen and brown ink with brown wash over black chalk, 16¾ x 10⅞ inches
Inscribed in yellow-brown ink lower center: MB
Purchased through the Mrs. Harvey P. Hood W'18 Fund; D.995.9.2

Domenico Piola was one of the most prolific and influential artists working in Genoa during the second half of the seventeenth century. He and his son-in-law, Gregorio de Ferrari (1644–1726), established a high baroque style in the north that reflected contemporaneous developments in Rome. Aside from his many frescoes, easel pictures, and prints, he produced a great number of finished drawings to be sold to collectors. According to an eighteenth-century biographer, Piola "spent every night drawing his various ideas on paper . . . and never repeated a design in the more than 4,000 sheets still owned by his heirs" (cited in Sanguineti 2004: 1:115). He had an enormous impact on the next generation of Genoese artists, and his prodigious graphic output, including frontispieces and other types of prints, contributed to his reputation throughout Europe.

These highly rendered wash drawings are entirely characteristic of Piola's presentation sheets, which were intended as independent works of art rather than as preparatory studies for his paintings. They reflect his regular practice of using the brightness of the paper to indicate the effects of light. His figures are often draped in billowing clothes that provide a sense of movement and emotion in his scenes. The curving contours in pen and ink reinforce the dynamic appearance of his drawings.

Like his predecessors, Piola studied a vast array of sources. *The Seven Sorrows of the Virgin* reflects a devotional type popularized in the thirteenth and fourteenth centuries throughout the continent. The drawing represents Mary's intense suffering during the passion and death of Christ, commonly referred to as *The Seven Dolors.* The more static composition and light rendering technique suggest an

early date for this work.

Although Piola made several paintings on the subject of the *Adoration of the Shepherds,* none of the extant pictures resembles the present composition. Compared to many painted and etched versions of the theme by Piola's renowned predecessor, Giovanni Benedetto Castiglione (1609–1664), the younger artist has given unusual prominence to Saint Joseph, who through his gestures emphasizes the divine nature of the Christ Child. The portrayal of the crowded scene demonstrates Piola's ability to coherently depict a throng of people in a compressed space. TBT

92. Dominique Barrière, French, active in Rome, 1618–1678

Perspective View of the Church of Santa Maria della Pace in Rome, in Giovanni Giacomo de Rossi (publisher), Italian, active 17th century, *Insignium Romae templorum prospectus exteriors interioresque* (Rome: A Jo[sephus] Jacobo de Rubeis romano, 1684)

Etching and engraving; bound volume: 10¼ x 14½ inches
Inscribed at lower right: Dominicus Barriere delin et sculp.
Dartmouth College Library, Rauner Special Collections

Pietro Berrettini da Cortona (1596–1669) commenced designs for the façade of the Church of Santa Maria della Pace shortly after the election of Pope Alexander VII Chigi in 1655. Starting with a program to improve the arrival of carriages to the church, these extant architectural drawings demonstrate its rapid evolution into one that would transform the entire urban context by the completion of the façade in 1659. This expanded project reworked access along the flanks of the church leading to a remodeled entry and conceived a larger piazza to create a theatrical setting for the arrival of Rome's fashionable residents.

With architectural drama that was very characteristic of the Baroque, Cortona's design both projects toward the viewer, emphasizing a hierarchical organization of the façade, and retreats to carve a larger open space from the dense urban fabric. At street level, the design buttresses the piazza against the encroaching palace facades at left and right. Thrusting forward into the center of the composition, the half-oval portico seemingly lifts the mass of the nave on eight columns, while sweeping supports squeeze the composite piers upward. The diminutive size of the figures moving about the piazza contributes an unreal scale and lightness to it. Dominique Barrière casts the concave second-story wall into dark shadow, isolating the church at the center and confounding the eye with the portrayal of the façade as a thin membrane masking an interminable volume within. Accentuating Cortona's delight in contrasting architectural elements, the engraver's dense hatching of the blind portal at left emphasizes the solidity of the bracing wings, an impression in turn undone by the white field of exposed paper within the opposite portal. At right, the thin architectural frame of the opening and Barrière's unrendered, perspectival space into the narrow street beyond reduce the façade to an undulating screen unfolded across the piazza. Finally, the overscaled altar within the central door foreshortens any spatial reading to the point of collapsing the interior volume altogether. Barrière's plate captures the dynamism of Cortona's design and presents a view of the urban square as an outdoor theater envisioned by Alexander VII and preserved even today in Rome. GST

Prospetiua della Chiesa di S.ta Maria della Pace di Roma

Petrus Berrettin. Cortor. Arch.

Dominicus Barriere Marsiliens. delen et sculp.

ALEXANDRO VII PONTIFICI OPTIMO MAXIMO

VAE olim, Beatißime Pater, sub Glandibus Pax Aurea Terras incoluit, sub ijsdem vel ferreo hoc seculo reditum parat, vbi Tu illi conditum a Sixto IV. Templum, nouum quaſi nidum, inſtauras. Quæque Virginis in Partu, Stellam habuit ducem; Geminas nunc habet, vt Terras repetat, ac Virgini famuletur; edoctura Mortales, Cæleſtem Virginem non minus inter Glandes, quam ſpicas, auream ſerere felicitatem. Huius ego rudimentum tuæ Arboris exaratam in Folio Tibi ad plantas ſubmitto; vt mihi in Aſyli vmbram, Benefactori Optimo Ciuicas degenerer in Coronas.

Jo: Jacobus de Rubeis 72.

A. Canal. f. V.

93. Canaletto, also known as Giovanni Antonio Canal, Italian, 1697–1768

The Portico with the Lantern, about 1740–44

Etching, state ii/III, 11¹⁵⁄₁₆ x 17¼ inches
Gift of Jean K. Weil in memory of Adolph Weil Jr., Class of 1935;
PR.997.5.31

Famous as a painter of topographical views of Venice and London, Canaletto is less well known as a printmaker, largely due to the relatively small number of etchings that comprise his oeuvre in this medium. Trained as a set designer, he began painting scenes of Venice in 1725 and on occasion also produced the imaginary landscapes that were popular among Italian art patrons in the early eighteenth century. After a lucrative period as a painter—particularly for foreign visitors who came to Italy on the Grand Tour—his commissions declined in the early 1730s. It was at this time that Canaletto began to produce a series of masterful etchings, the entire set of which was donated to the Hood Museum of Art by Mr. and Mrs. Weil. Created between 1735 and the early 1740s, these prints were sold by the individual sheet as well as bound together in a single volume.

The Portico with the Lantern is perhaps the best known of the artist's prints. It combines a number of different elements found in the other etchings in the series, such as ancient buildings, a lagoon, domestic Venetian architecture, and a bishop's tomb. Canaletto did not title this etching; its current appellation is taken from the lantern, with its open hatch and broken pane of glass, that hangs picturesquely from the center arch of the portico. The point of view here is unusual: the composition is framed by the shadowed portico, through which one looks out on a scene drenched in sunlight. One of Canaletto's achievements in these prints is his ability to convey a profound sense of atmosphere solely by means of etched lines.

The etchings by Canaletto in this collection were brought together by Mr. Weil over the course of nearly fourteen years. Many of the prints, particularly those that are larger in format, are particularly fine examples (such as figs. 1 and 2). The richness of the impressions and the early watermarks on several of the sheets indicate that they are among the earliest prints of these celebrated plates. [*Gift to the College* 1998: 70–71] KWH and KP

FIG. 1. Canaletto, *Imaginary View of Venice: The House with the Inscription,* 1741, etching, only state, 11⁵⁄₈ x 8½ inches. Gift of Jean K. Weil in memory of Adolph Weil Jr., Class of 1935; PR.997.5.33.

FIG. 2. Canaletto, *Imaginary View of Venice: The House with the Peristyle,* about 1740–44, etching, state ii/II, 11⁵⁄₈ x 8½ inches. Gift of Jean K. Weil in memory of Adolph Weil Jr., Class of 1935; PR.997.5.34.

94. Giovanni Battista Piazzetta, Italian, 1682–1754

Jerusalem Delivered: Frontispiece, Border,
Head-Piece, and Initial Letter for Cantos 7 and 15,
in Torquato Tasso (author), Italian, 1544–1595,
La Gerusalemme liberata (Venice: Stampato da
Giambattista Albrizzi Q[uod] Girol[amo], 1745)

Engraving with printed text; bound volume: 18⅛ x 26½ inches
(open book)
Dartmouth College Library, Rauner Special Collections

This edition of Torquato Tasso's epic poem, first published in 1581 without illustrations, is generally regarded as the most beautiful Venetian book of the eighteenth century. In the prospectus for the work, the publisher states, "I have endeavored to distinguish my edition with the singularity and perfection of more than sixty plates, all of different designs, drawn by the celebrated painter Piazzetta, and incised in copper by the most talented engravers. This printing will satisfy not only the poets, but also the painters and the sculptors; and I expect that so many, and such fine ornaments may never be seen again in any book" (cited in Martineau and Robison 1994: 478). The exceptional quality of the publication, dedicated to young Maria Theresa, Empress of Austria (1717–1780), attracted no less than 333 subscribers from around Europe, including prominent political and cultural figures (Robison 1974).

Tasso's text followed the Christian warrior Rinaldo on his adventures to free Jerusalem during the First Crusades in the late eleventh century. It was modeled after ancient literary works, especially those by Virgil (70–19 BCE), and Renaissance romance stories. The poem's idyllic episodes, exotic settings, and amorous scenes served as the inspiration for painted representations in the

seventeenth and eighteenth centuries. The familiar themes of escape from the complexities of urban life and references to a historic Golden Age contributed to the popularity of the images (such as fig. 1; Lee 1967: 48).

Piazzetta's elaborate designs for the large plates at the beginning of each canto illustrated specific episodes in the narrative. However, the head- and tail-pieces, mostly pastoral scenes, were often only loosely—if at all—associated with the stories (Martineau and Robison 1994: 163). The distinctive format, unified appearance of the illustrations, and elegant typeface set a new standard for Venetian book production.

From 1736 onward, Piazzetta began collaborating with the book publisher Giovanni Battista Albrizzi (1698–1777) to illustrate a number of volumes. In the case of the edition of *Jerusalem Delivered,* the artist prepared hundreds of chalk drawings, focusing particular attention on the twenty compositions introducing each of the cantos. As the publisher and editor of the volume, Albrizzi likely worked together closely with Piazzetta on the selection of the subjects for the principal engravings. Johann Caspar Goethe (1710–1782), the poet's father, saw the drawings in 1740 during his visit to Venice, indicating that the project took several years to complete.

TBT

FIG. 1. Unknown, central Italian, *Rinaldo and Armida,* about 1620, oil on canvas, 37 x 51 inches. Collection of Barbara Dau Southwell, Class of 1978, and David Southwell, Tuck 1988.

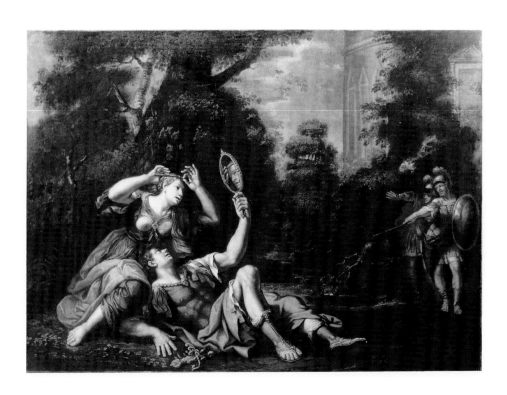

Veduta della Basilica e Piazza di S. Pietro in Vaticano

95. Giovanni Battista Piranesi, Italian, 1720–1778

View of the Basilica and Piazza of St. Peter in the Vatican, probably 1747–48

Etching, 15¾ x 21¹⁄₁₆ inches
Signed below image lower right: Piranesi del. scul.; inscribed below:
Veduta della Basilica, e Piazza di S. Pietro Vaticano . . .
Hood Museum of Art, Dartmouth College; PR.977.24.6

96. Giovanni Battista Piranesi

The Grand Piazza, from the series *Imaginary Prisons,* 1749–50

Etching, 21⅜ x 16¼ inches
Signed in image lower right: Piranesi
Hood Museum of Art, Dartmouth College; PR.977.25.52

Giovanni Battista Piranesi derived the principal inspiration for his vast production of etching from firsthand examinations of classical antiquities and modern monuments. Throughout his career he produced carefully prepared views and studies of structures in and around Rome. He infused conventional topographical scenes of well-known buildings and ideal reconstructions with novel compositional devices, such as exaggerating the scale and manipulating the perspective through the use of multiple vanishing points. Piranesi's oeuvre reflected a unique combination of a remarkable imagination and a deep understanding of construction, which helped to cultivate an unprecedented appreciation of Roman architecture. As a result of Piranesi's exceptional ability to both document and recreate the heritage of the Eternal City, contemporary—and future—artists, writers, and others were inspired to reassess the magnificence of Rome.

Piranesi's *View of the Basilica and Piazza of St. Peter in the Vatican,* the ceremonial center of Rome from the Renaissance onward, represents one of the artist's earliest prints, dated 1747–48. Like many of his other representations of ancient and modern sites, he consciously juxtaposes the grandeur of the architecture in the background with socially disparate groups of figures in the foreground. The contrast between the demeanor of the visiting dignitaries on the left and the behavior of the beggars and vagrants on the right could not be more striking. Piranesi appears to be as fascinated with the extremes of the city's social life as he is with the enduring legacy of Rome's buildings.

Piranesi adopted the same strategy of presenting realistic settings

imbued with an innovative creative spirit in several other works. Chief among them was his highly unusual series of prints called *Imaginary Prisons*. These etchings were first issued as a collection of fourteen plates around 1749, and then issued again, after significant reworking, as a set of sixteen in 1761. Basing his work on sketches of actual locations, Piranesi composed fantastic new spaces. Populated with indistinguishable figures that emphasized the scale and complexity of the scenes, the greater detail and stronger tonal contrasts of the final series enhanced their sinister character. Even more importantly, while the first edition evoked the simplicity and utility for which Roman architecture was renowned, the later set represented a conscious attempt to recreate the majesty and grandeur of classical design. The immensity and ambiguity of these structures reinforced the sensation of wonderment.

Most of the approximately two hundred Piranesi prints in the collection of the Hood Museum of Art were acquired in 1754 by Sir Robert Throckmorton (1702–1791), fourth baronet of Coughton Court, Warwick (Rand and Varriano 1995: 21–23). Throckmorton's purchase of the first-state impressions, originally contained in two albums, may have been at least partially inspired by his vivid recollections of his own visit to Rome in 1729. Moreover, by the middle of the eighteenth century, etchings and engravings had attained considerable prestige as desirable works of art collected and displayed for their large size and impressive visual impact, which Piranesi—more than any other eighteenth-century printmaker—had elevated to an extraordinary level of mastery. TBT

97. James MacArdell, British, about 1729–65, after Peter Paul Rubens, Flemish, 1577–1640

Rubens, His Wife Helena Fourment, and Their Son Peter Paul, about 1752

Mezzotint on satin, state i/II, 18⅝ x 14⅛ inches
Purchased through the Jean and Adolph Weil Jr. 1935 Fund; 2005.65.2

In the eighteenth century, mezzotint was the printmaking technique preferred above all others for conveying the tones and richness of painting, albeit generally only in black and white. Rarely used today, mezzotint was essentially a tone process in which a metal plate was roughened using a rocker, a tool with a curved and serrated edge. The main feature that distinguished mezzotint was that the artist worked from dark to light—from black ground to the highlights rather than white ground to the shadows. Mezzotints that were printed on satin, such as this example after a painting by Rubens, were given as luxurious gifts to only those closely associated with the commission. These impressions were printed before letters, or inscriptions, and usually only five were pulled from the plate. It is thought that in this case a limited number of early impressions were made for George Spencer, Third Duke of Marlborough (1706–1758), whose family owned the original painting by Rubens (now in the Metropolitan Museum of Art) from the time of its presentation to the first duke by the city of Brussels in 1704

until its purchase by Baron Alphonse de Rothschild in the late nineteenth century.

James MacArdell, one of the most accomplished mezzotint artists of the eighteenth century, moved in 1746 from Dublin to London, where he worked with his master, the engraver James Brooks (flourished 1730–56). By 1750, MacArdell had branched out on his own, determined to make a living as a mezzotint engraver, mostly through the growing business of copying paintings by well-known old masters and contemporary artists. In the course of his career, MacArdell engraved about two hundred mezzotints after other artists, nearly all of which were portraits. The Rubens painting after which this print was made demonstrates the artist's bravura treatment of a sumptuous array of satin, silk, and other fabrics in the clothing of himself and his wife. MacArdell revealed his skill in his translation of this work into the mezzotint medium, his virtuosity further enhanced by the white satin material on which it was printed. BK and TBT

98. Thomas Frye, Irish, 1710–1762

Ipse (Self-Portrait), 1760

Mezzotint, state ii/II, 19⅞ x 13⅞ inches
Inscribed lower left in plate: .T.F.; lower center in plate: .Ipse [meaning
"self" in Latin]; lower left in plate: T, Frye Pictor Inv, t & Sculp; lower
right in plate: Hatton Garden 1760
Purchased through a gift from the Cremer Foundation
in memory of J. Theodore Cremer; 2006.53

Since the fifteenth century and the rise of the mirror as an artistic device, artists have used themselves as models. At their best, such works depicting the self stand as uniquely individual expressions of the artist's persona at a particular point in time. At their most functional, they are useful studies of different poses and expressions. Regardless of intent, artists throughout the history of European art since the Renaissance have attempted to explore their own identities through portraying themselves on canvas or paper and, more rarely, in sculpture. Thomas Frye, the author of one of the most compelling self-portraits created in any media, was an Irish-born painter who traveled to London in the 1730s and set himself up as a portrait specialist. He also patented a method for producing porcelain and became manager of the Bow Factory from 1744 until 1759, when he retired due to ill health (Wynne 1972 and 1982).

A close friend of painter Sir Joshua Reynolds (1732–1792), later president of the newly founded Royal Academy and a significant influence on Joseph Wright of Darby (1737–1797), Frye made his most significant artistic contribution during the last two years of his life. Soon after his return from Wales, he took the unusual step of announcing a subscription for "Twelve Mezzotinto Prints, from Designs in the Manner of [Giovanni Battista] Piazzetta [cat. 94], drawn from Nature and as large as life," at two guineas a set—to be closed when two hundred sets had been sold. The result was a novel series of varied portrait studies, unnamed except for this self-portrait. The striking poses, and Frye's successful use of the dramatic light effects that mezzotint could supply, made an immediate impact. Frye published a second set of six in 1761–62.

Mezzotint was invented in Germany in the middle of the seventeenth century and soon introduced to England. It rapidly achieved a success there that it did not retain on the Continent and as a result came to be known as *la maniére anglaise*. It was used first and foremost for the reproduction of portraits. Frye's mezzotints were better known than his oil paintings, watercolors, and pastels, of which approximately ninety have now been located.

Ipse is a striking image of a man who stares pensively out at the viewer, his left hand cupped around his brow, his lips slightly parted in concentration. His right hand rests on the edge of the desk, and he holds a drawing implement; in attitude and expression he appears to emphasize substance of character and the power of the mind. In this manner the self-portrait speaks to eighteenth-century enlightenment ideals, which valued human intelligence, sensibility, and the superiority of reason over all other traits and attributes.

BK and TBT

.F.

J. Faye Potter Pinx.ᵗ & Sculpᵗ. Hatton Garden 176.

99. William Hogarth, English, 1697–1764

The Laughing Audience, 1733

Etching, iii/IV, sheet: 9 x 6½ inches

Inscribed in the plate and in ink: Rec.d 14th of April 1745 from Mr. Campbell Half a Guinea being the first Payment for Nine Prints, 8 of Which Represent a Rakes Progress & the 9th a Fair, Which I Promise to Deliver when finish'd on Receiving one Guinea more, the Print of the Fair being Deliver'd at the time of Subscribing. NB: the Rakes alone will be two Guineas after the time of Subscribing; signed, in ink, lower right: WDHogarth

Gift of Hamilton Gibson, Class of 1897; PR.955.89

100. Louis Gérard Scotin, French, active in England, 1698–after 1755, after William Hogarth

Marriage á-la-Mode, plate 1, 1745

Etching and engraving, state: vi/VIII, sheet: 17¾ x 22¼ inches

Inscribed: Invented Painted & Published by W Hogarth . . . Engraved by G. Scotin . . .

Purchased through a gift of the Hermit Hill Charitable Lead Trust; PR.997.21.1

The eighteenth-century English artist William Hogarth is known for his sequential narrative paintings and prints, through which he chronicled the foibles and vicissitudes of a cast of character types. In these works, young men are tempted by vice, country women travel to London and become lured into prostitution, and ill-suited couples from disparate backgrounds are shackled together in marriage by avaricious and social climbing parents. His exuberant depictions of these figures from the high, low, and in-between rungs of the social ladder, his ability to craft meaning from a display of myriad details and symbols, his concern that his work reflect contemporary society, and his commitment to visual narrative as a dominant mode of expression combine to give him a truly unique place in the history of Western art. Hogarth, in addition, was an entrepreneurial businessman. He either himself etched and engraved prints after his paintings or commissioned other artists to do the work, frequently French engravers, who were among the best trained. He often directly sold his prints through subscription (see below) and

in this way funded his artistic enterprise, enabling him to determine the subjects of his work, free of the whims and requests of patrons. Curators at the Hood Museum of Art have been gradually building its collection of Hogarth prints for many years.

The Laughing Audience demonstrates Hogarth's practice of using a small print as a subscription ticket for a larger series, in this case *A Rake's Progress,* which he sold as a package with the print *Southwark Fair* (1733). This particular impression was perhaps used as a direct bill of sale ten years after the subscription to *A Rake's Progress* was closed in 1735. However, the signature itself and the inked entry of the buyer Campbell's name may be a later annotation by an owner who felt that filling in the blanks would make the print more valuable. The image shows the audience at a comic performance that is accompanied by music. By presenting these spectators overcome by laughter, Hogarth appears to be promising amusement to his potential buyers as well as marketing his mastery of delineating character and class.

One of William Hogarth's most celebrated series, which he

executed first in paint and then had engraved for sale by subscription, was *Marriage á-la-Mode,* a commentary on what the artist would term "Modern Occurrences in High Life." Hogarth used these prints as a vehicle for condemning the practice of arranged marriages between the merchant class and the aristocracy as a way of satisfying the former's social ambitions and the latter's venality. The subject itself would inspire similarly plotted plays not many years later (Paulson 1989: no. 158). The prints were based on the artist's paintings (National Gallery, London), which he completed in 1743. Shortly thereafter, Hogarth contracted out the engraving of the series to a group of French artists, although he stated in an advertisement for the series that he himself would do the heads. *Marriage á-la-Mode* is most closely related to the artist's earlier narrative series *A Harlot's Progress* (1731–32) and *A Rake's Progress* (1734–35), each of which tells a morality tale over the course of six or more prints. As in all of his works, the composition of each print is full of clues to the character and fate of its main group of players. KWH

167

101. Thomas Rowlandson, British, 1756–1827

The Gaming Table, about 1780s

Watercolor over black ink and graphite on wove paper, 4¾ x 7⅜ inches
Gift of Mr. and Mrs. Arthur E. Allen Jr., Class of 1932; W.982.47

102. Thomas Rowlandson

A Comic Actor Rehearsing, possibly 1789

Ink and colored wash, 8⅞ x 7⅜ inches
Signed and dated lower right: Rowlandson 1789
Gift of Henry C. Cutler in memory of his wife, Hattie M. Cutler,
mother of Paul Wilson Cutler, Class of 1928, and John Alden
Cutler, Class of 1938, and gift of the Friends of Dartmouth Library;
D.955.46.2B

Thomas Rowlandson was a consummate draftsman, known for his
dexterity and facility with line. Although he produced a prodigious
number of watercolors, drawings, and prints throughout his long
career, very little is known about the details of his life. The son of
a wool and silk merchant who went bankrupt when Rowlandson
was three, he was raised by his aunt, who left him her estate when

she died in 1789. Apparently he soon went through this money
(thought to be about two thousand pounds)—his penchant for
high living and gambling made him far from frugal—and by 1793
was living in straitened circumstances, thereafter relying on his tal-
ent to survive. In 1797 his work for Rudolph Ackermann made him
somewhat prosperous, but he never reclaimed the lifestyle he briefly
enjoyed in the early 1790s. Rowlandson's artistic career began at
the age of sixteen, when he entered the Royal Academy Schools
in 1772, and he exhibited his first drawing at its annual exhibition
three years later. He left off exhibiting at the academy after 1787,
and his subsequent work often vacillated between the picturesque,
the comic, and the downright obscene. He made numerous erotic
and pornographic drawings, for instance, many showing older men
ogling young females and couples, a staple that undoubtedly found
a steady clientele but led to the waning of his reputation in the Vic-
torian era.

The drawings in the collection of the Hood Museum of Art am-
ply demonstrate why Rowlandson is now recognized for his supreme
virtuosity as a graphic artist. His most bravura technique is evident

in *A Comic Actor Rehearsing* (its companion, *The Tragic Actor Rehearsing,* is also in the museum's collection; fig. 1), whose Falstaffian subject is rendered with vigorous swipes of the pen. Rowlandson dated very few of his works, and the faltering signature and date on the *Comic Actor,* so at odds with the character of the overall work, is most probably a later addition. *The Gaming Table* reveals the elegant rococo style more typical of the 1780s (compare with drawings such as J. Paul Getty Museum's *Box-Lobby Loungers,* 1785, or *The English Review,* about 1785, the Royal Collection). Its delicate and witty description of a variety of characters, from the sprightly waiter to the dejected loser in the left foreground gazing disconsolately over the back of his chair, is characteristic of his multi-figure compositions of this period. [Hayes 1972: 135, pl. 71] KWH

FIG. 1. Thomas Rowlandson, *A Tragic Actor Rehearsing,* possibly 1789, ink and colored wash, 8⅞ x 7⅜ inches. Gift of Henry C. Cutler in memory of his wife, Hattie M. Cutler, mother of Paul Wilson Cutler, Class of 1928, and John Alden Cutler, Class of 1938, and gift of the Friends of Dartmouth Library; D.955.46.2A.

103. François-André Vincent, French, 1746–1816

Bust of Lucius Junius Brutus (The Capitoline Brutus), about 1774

Red chalk and wash, 20½ x 11⅝ inches
Purchased through a gift from the Cremer Foundation in memory of
J. Theodor Cremer and a gift from John W. Thompson, Class of 1908,
and Dorothy M. Litzinger, by exchange; D.988.16

From around 1600 onward, the study of Roman antiquities became a central tenet of the art academies that were founded throughout Europe. In one instance, as part of an effort to secure original antique works of art and high-quality reproductions of celebrated ancient monuments, a branch of the French Académie was established in Rome in 1666. In exchange for a full scholarship to record the marvels of antiquity, students were required to produce and send to Paris copies and casts of all of the most valuable objects in Rome.

One beneficiary of this system was François-André Vincent, who left for Rome in 1771 and returned to Paris in 1775. He was one of the most innovative French artists of the third quarter of the eighteenth century, becoming a full member of the Académie and exhibiting his work at the Salon until about 1800. His energetic drawing of the famous bust supposedly portraying Lucius Junius Brutus (lived 500 BCE) in the Capitoline Museum was undoubt-

edly made during his residency in the Eternal City. It depicts one of the city's most renowned antiquities, a bronze portrait of the man who established republican government in Rome.

Vincent's drawing is comparable to a similarly sized sheet executed in 1774 in the same manner depicting Cicero (106–43 BCE), a champion of the traditional republican government. The use of vigorous lines of varying density demonstrates the young artist's control of his medium. However, both sheets also display a technical flair that exceeds the goal of merely reproducing ancient sculptures. They reveal his ability to imbue the drawings with a sense of the individual characteristics of the original sitter.

Bust of Lucius Junius Brutus reflects the recurring interest in utilizing classical objects not only as figurative models but also as a means of expressing specific ideals, suggesting that Vincent may have been a supporter of the republican principles that were popular in France during the years leading up to the French Revolution.
[Campbell and Carlson 1993: no. 36] TBT

104. Pierre-Paul Prud'hon,
French, 1758–1823

*Diana Imploring Jupiter Not to Subject
Her to Marry Hymen,* about 1803

Black, white, and red chalk on blue paper, 10⅞ x 10⅝ inches
Purchased through a gift from the Cremer Foundation in memory of
J. Theodor Cremer, the Phyllis and Bertram Geller 1937 Memorial
Fund, the William B. Jaffe and Evelyn A. Jaffe Hall Fund, and the
Hood Museum of Art Acquisitions Fund; D.985.52

Pierre-Paul Prud'hon was born at Cluny, educated at the Dijon
Academy, and residing in Paris by 1780. After studying in Italy he
returned to the French capital in 1787 and made a living prepar-
ing drawings for engravers and painting portraits for provincial
patrons. His independent personality led to the development of a
softer, more lyrical style compared to the slavish imitation of the
followers of Jacques-Louis David's (1748–1825) heroic manner. His
competition design for a large circular ceiling decoration for the
Louvre in Paris in 1799 won him considerable recognition. This
success, combined with his friendship with the powerful Prefect
of the Seine, Nicholas Frochot (1761–1828), led to other large-scale
painting projects. He eventually became a leading court artist dur-
ing the period of the First Empire (1804–15) and later worked for
the Bourbon government.

His regular method of working began with black-and-white
chalk studies on tinted paper before proceeding to an actual paint-
ing. In this preparatory drawing for a commission of 1803 to deco-
rate another ceiling in the Louvre, Jupiter listens to his daughter
Diana beg him not to make her marry Hymen, the Greek god of
marriage. Diana desired to remain chaste; her interest lay in hunt-
ing, not domestic love. Jupiter conceded to her, and Diana re-
mained a virgin goddess. The drawing embodies the final stage in
the evolution of this composition. However, the black chalk reveals
alterations in the poses of the head and hands of Jupiter and the feet
of Diana, which were modified after the completion of a painted
model (Louvre, inv. 20115).

Prud'hon's work was greatly admired during the nineteenth cen-
tury, and Eugène Delacroix (cat. 112) considered his drawings to be
a consummate expression of the artist's unique style.

The subject of Diana's resistance to marriage was an unusual
choice in comparison with the other painted and sculpted deco-
rations in the same room by other artists. It was derived from
the Greek poet Callimachus's (about 310/5–240 BCE) *Hymn to
Artemis.* TBT

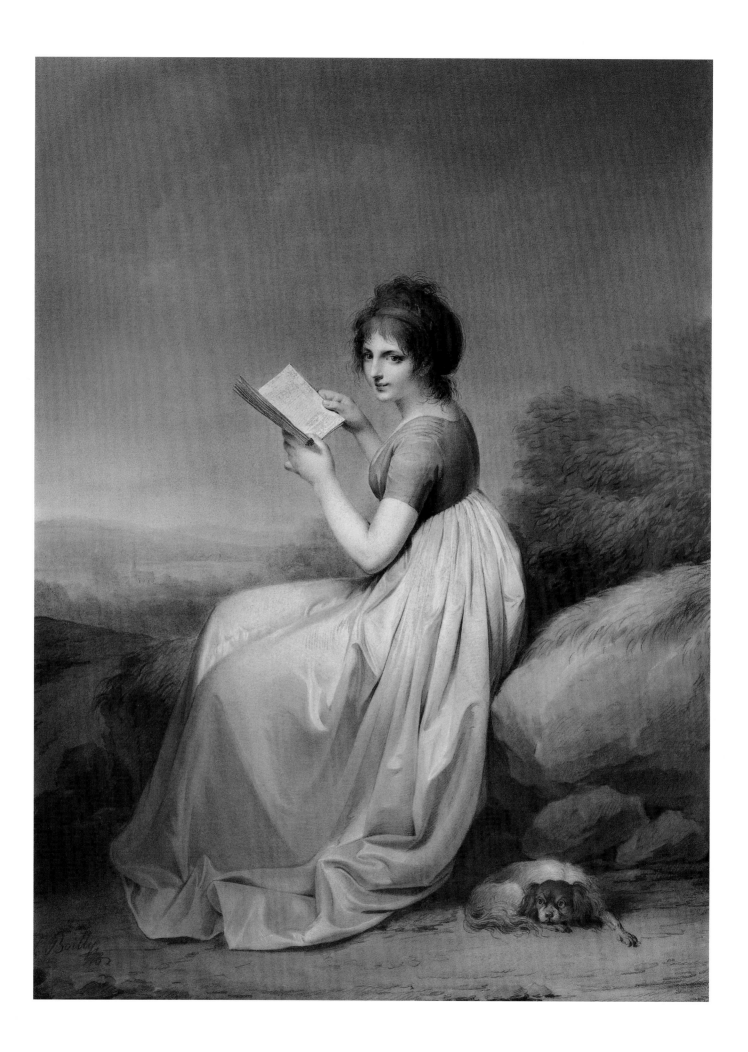

105. Louis Leopold Boilly, French, 1761–1845

Young Woman Reading in a Landscape, 1798

Black chalk with pen and ink, wash, white lead, and sanguine
highlights, 17⁵/₁₆ x 12¹⁵/₁₆ inches
Signed lower left: L Boilly
Purchased through the Florence and Lansing Porter Moore 1937 Fund;
D.2003.19

The notion that drawing was the basis for all of the fine arts co-alesced in Italy during the Renaissance and was described by the term *disegno,* meaning both skill in rendering and creative design. Beginning in the early 1500s, the inventive process of drawing became more or less standardized, starting with preparatory sketches, continuing with more refined studies, and generally ending in elaborate compositions. By the end of the sixteenth century, the same approach was adopted by the early art academies, which also introduced the practices of copying masterworks and drawing nude models. While most of these sketches and studies functioned as fundamental parts of creating paintings, sculptures, and architecture, many artists also executed drawings as independent works of art. These finished compositions were done as early as the fifteenth century as studio models, mementos, and gifts for friends and colleagues. As singular works they were circulated within workshops, exchanged between patrons and artists, and occasionally displayed and sold publicly. Some were fully rendered, in order to explore various styles, media, and techniques of draftsmanship. Others were rapidly delineated inspirations based on existing works. The continuous appreciation by both artists and collectors for examples of unique artistic invention made finished drawings highly desirable objects in their own right.

By the mid-1700s, contemporary drawings were exhibited at major venues throughout Europe, including the Paris Salon organized by the Académie des Beaux-Arts (held consistently after 1737), the Accademia di San Luca in Rome (which established regular competitions beginning in 1754), and the annual exhibitions at London's Royal Academy of Art (which opened in 1769). Although public displays undoubtedly elevated the status of drawings, the main focus of the art world remained centered around large-scale history paintings, and the academic tradition throughout Europe continued to emphasize primarily the utilitarian function of preparatory sketches and refined studies.

It was not until the 1790s, after the French Académie lost control of the Paris Salon exhibitions and they were then opened to all artists, that finished drawings became more prominent at the biennial event and received increased public attention. The more liberal conditions for exhibition and the larger number of objects that could be displayed allowed for the presentation of a variety of fully rendered sheets. The popular appeal of more private, intimate works of art remained strong into the beginning of the nineteenth century. It was in this context that Louis-Léopold Boilly presented *Young Woman Reading in a Landscape* at the Salon in 1798 (Heim 1989). Boilly established his reputation as a talented portraitist and genre painter at the Paris exhibitions beginning in 1789. This particular example's technical virtuosity, attention to detail, and evocative atmosphere made it one of the artist's most accomplished graphic compositions. The subject of a female figure reading in a pastoral setting also reflected the contemporary taste for informal scenes and landscapes. *Young Woman Reading* was apparently the only presentation drawing that Boilly ever exhibited at the Salon, where he continued to display his paintings until 1824. [Siegfried 1995: 167–68, pl. 141, and 214 n. 12; Hallam 1979: 63, 229, and 312 fig. 71]

TBT

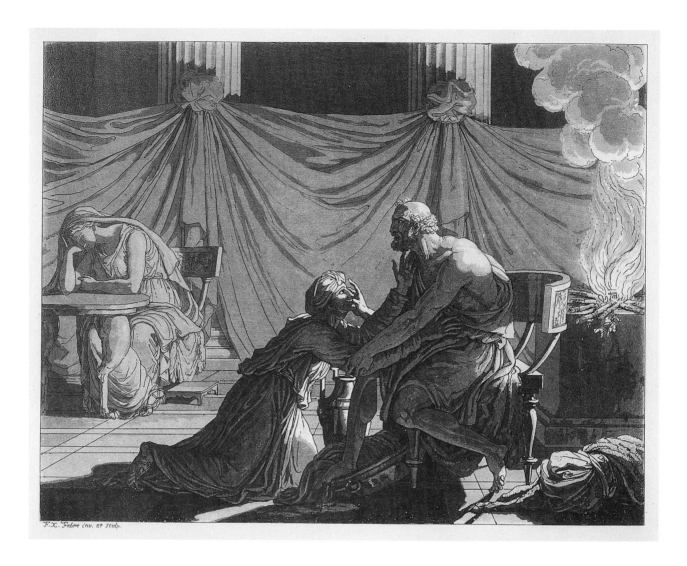

106. François-Xavier Fabre, French 1766–1837

Alcmeon or the Return of Ulysses, about 1799

Etching and aquatint, only state, 7⅜ x 9¹³⁄₁₆ inches
Inscribed in the plate lower left margin: F. X. Fabre inv. et sculp.
Purchased through the Class of 1935 Memorial Fund; PR.995.29

François-Xavier Fabre was born in Montpelier, France, studied at the academy there, and then moved to Paris in 1783, where he entered the studio of the celebrated neoclassical painter Jacques-Louis David (1748–1825). He won the prestigious Prix de Rome in 1787, which allowed him to travel to Italy to study the antique; there he continued to paint works in the neoclassical style. He settled permanently in Florence in the early 1790s, in part to escape the upheaval of the French revolution. He joined the Florentine academy, became a collector, and produced portraits of aristocratic Florentines and Englishmen on the grand tour, landscapes, and religious subjects, as well as the occasional history painting of a classical subject. Toward the end of his life he returned to Montpelier, and at his death he bequeathed his collection to the city, which built a museum named after him to house it.

The subject of this print is not identified, but it has been suggested that it depicts the ancient Greek tale of Alcmeon, who was ordered by his father, Amphiaraüs, and the oracle of Delphi to kill his betraying mother, Eriphyle, and was then driven to madness by his deed. Fabre shows him in his house, where he has set a sacrificial pyre to assuage the Furies (who relentlessly pursue those guilty of killing kin), only to be visited by the ghost of his mother. He pushes her away, covering her mouth with his hand. In the left background, Alcmeon's wife, Phegia, made barren by his crime, mourns their fate. As in David's famous painting *Brutus,* the scene is rigorously composed, with the elements arranged in horizontal planes and with an attempt at archaeological exactitude in the setting and furnishings. Like *Brutus* as well, Alcmeon is depicted in shadow, suggesting his inner turmoil. The print has also been identified as depicting the return of Ulysses, with the kneeling figure being instead the hero's nurse Eurycleia, who alone has recognized him after his absence of twenty years. She kneels at his feet while he admonishes her to keep his identity secret until he can dispatch his wife's suitors, who have made free with his household. KWH

107. Pierre-Narcisse Guérin, French, 1774–1833

The Vigilant One, 1816

Lithograph, only state, 17⁹⁄₁₆ x 12⅛ inches
Purchased through the Jean and Adolph Weil Jr. 1935 Fund; PR.994.6.2

This print and its pendant, *The Lazy One,* were produced for a commission, then assembled by the Académie Royale des Beaux-Arts in Paris to study the new technique of lithography. It thus represents one of the first lithographs made in France. Lithography had been invented by Alois Senefelder (1771–1834) in Munich in 1798; a colonel who was part of the Napoleonic occupation of Bavaria brought the new printmaking method back to Paris (Lochnan and Rix 1988: 1). Lithography only took hold in France after Napoleon's fall in 1815, however, when two presses were set up, one of them by the publisher Godefroy Engelmann (1788–1839), who would become well known for his promotion of the technique.

Pierre-Narcisse Guérin, who had studied with Jacques-Louis David's (1748–1825) rival Jean-Baptiste Regnault (1754–1829), had made his artistic reputation during the Napoleonic period with critically lauded neoclassical paintings such as *The Return of Marcus Sextus* (1799) and *Phaedra and Hippolytus* (1802). He was never closely linked with Napoleon (1769–1821); therefore, soon after the restoration of the monarchy, he was happily favored with Bourbon patronage. He became a member of the Institut de France and in 1816 was asked by the academy to look into the new medium of lithography. In order to test out the potential of this printmaking method, he created six lithographs during the next two years (Lochnan and Rix 1988: 26), including *The Vigilant One.* In this print, the artist, who has diligently worked through the night, is shown pushing back the dawn so he can continue his work. In the window the cock crows to signal the beginning of the day, and at the artist's feet Cupid is curled up in sleep, presumably having failed to lure him to other, more pleasure-seeking pursuits. Guerin has exploited the medium's ability to translate drawing, and the soft, pearly grey tones of the print reflect his interest in evoking the subtle touch of the artist's mark. KWH

108. Joseph Denis Odevaere, Flemish, 1778–1830

Self-Portrait of the Artist Drawing on a Lithographic Stone, 1816

Crayon-manner lithograph, only state, 19 x 13½ inches
Signed within the image (on the side of the lithographic stone):
J. Odevaere se ipsum lithographice del. Parissiis 1816
Purchased through the Jean and Adolph Weil Jr. 1935 Fund;
PR.2004.7.3

Joseph Dionysius Odevaere was born in Bruges and educated at the academy there before traveling to Paris to study first in the studio of fellow Belgian Joseph Benoît Suvée (1743–1807) and then in 1801 with the famous neoclassical painter Jacques-Louis David (1748–1825). In 1804, Odevaere won the coveted Prix de Rome for his painting *The Death of Phocion,* which granted him the privilege of studying in Rome at the French Academy. He stayed in that city from 1805 though 1812, concentrating on studying the antique and works by Renaissance artists, particularly Raphael. About 1811 he was selected to aid in the decoration of the Palazzo del Quirinale

for a visit by Napoleon (1769–1821), but his sketch was never realized. After returning to Paris in 1812 and successfully exhibiting there, he moved to Ghent, where he was appointed painter to King William I (1772–1843) in 1815. He was soon commissioned to create works on the history of the Dutch royal family (1817–20) and also worked on paintings based on ancient history and on the Greek war of independence.

After Louis XVIII's (reigned 1815–25) return to the throne in the wake of the defeat of Napoleon in 1815, Odevaere was commissioned to recover works of art taken from the Low Countries following the occupation by France in 1795. It was perhaps during this period that he was in Paris and produced this lithographic self-portrait, published by Godfroy Engelmann (1788–1839), who was instrumental in introducing the new medium of lithography to France in 1816. It is the first large-scale self-portrait of an artist portraying himself working on a lithographic stone. The image shows him both as a working artist surrounded by his printmaking tools and as a gentleman, well dressed, self-confident, and justifiably proud, having been recently named painter to the king. TBT and KWH

109. Theodore Géricault, French, 1791–1824

A Mameluke of the Imperial Guard Defending a Wounded Trumpeter against a Cossack, 1818

Crayon and pen lithograph, only state, 18⅜ x 13¹⁄₁₆ inches
Purchased through gifts from the Lathrop Fellows; PR.993.39

This print exemplifies Theodore Géricault's seminal contribution to the development of Romantic art in France. The subject is drawn from the Napoleonic wars and records the artist's enduring fascination with the natural power of horses and the exhilaration of mortal combat, similar in spirit to his first great painting, *Charging Chasseur of the Imperial Guard* (1812). The lithograph brilliantly illustrates the nineteenth-century French interest in Near Eastern and Northern African cultures by incorporating a Mameluke as the principal protagonist. Of Turkish origin, Mamelukes were members of a powerful military caste in Egypt who were conscripted into the French army. Géricault emphasizes the exotic nature of the central figure by turning him away from the viewer, showing his chiseled face in lost profile and articulating the details of his costume and weaponry in pointed contrast to the French bugler and charging Cossack.

The lithograph is one of a series that Géricault produced between 1818 and 1819, soon after the restoration of the Bourbon monarchy and the introduction of this new printmaking technique in Paris. Most of these prints depict scenes from the Napoleonic campaigns, with many showing the effects of war on the ordinary solider. The group can be interpreted both as a general statement about the costs of conflict and as a nostalgic look back at the glory of the empire. The present image accomplishes both at once, showing the suffering of the dead and wounded while celebrating the bravery of the French army as embodied in the heroic form of the Mameluke. In its depiction of the triumph of the human spirit over great physical hardship, as well as in its general composition and in several details, the print relates closely to the artist's celebrated masterpiece in painting, *The Raft of the Medusa,* on which he was also working at the time. The neo-baroque energy and dynamism of the composition mark an important break from the neoclassical style of the previous generation and herald the fullblown Romantic art of Géricault's student Eugène Delacroix (cat. 112). TBT

27 *No se puede mirar.*

110. Francisco Goya, Spanish, 1746–1828

One Cannot Look from *The Disasters of War,* about 1810–20 (published 1863)

Etching and aquatint, 5⅝ x 8³⁄₁₆ inches
Inscribed below: No se puede mirar
Gift of Adolph Weil Jr., Class of 1935; PR.991.50.1.26

The Disasters of War is Francisco Goya's response to the invasion of Spain by the forces of Napoleon (1769–1821) in 1808. Not a chronicle of the war itself but a psychological reflection on the atrocities characteristic of the military campaign, this series of eighty prints shows horrific scenes of torture, murder, and rape. It marked a great departure from earlier depictions of war, which tended to glorify battle, often using allegorical symbols of nation or abstract ideals. Indeed, Goya's prints were not created to rally support for his homeland—in a few cases he even makes references to the venality of Spanish clerics or the brutality of Spanish patriots. The series probably evolved instead from Goya's own visceral reaction to witnessing the war's effects on both the invaders and their victims.

To create this series, which is a tour de force of printmaking, Goya used an extremely complicated mixture of intaglio techniques, producing effects that range from subtly atmospheric to darkly foreboding. Although the artist printed a number of proofs of these plates during his lifetime, it was not until 1863, long after his death, that *The Disasters of War* was published in its entirety. The set donated by Mr. and Mrs. Weil to the Hood Museum of Art is one of the earliest to be printed for the published edition.

One Cannot Look (*No se puede mirar*) shows the execution of Spanish civilians by firing squad. Its composition bears close relation to the artist's masterpiece, the large-scale painting *The Executions of the Third of May, 1808,* which documented the killings that took place on the day following the failed civilian uprising against the occupation forces. The title of this plate refers not only to the people about to be killed but also to the viewer, implying that the scene is too horrible for anyone to witness, even the artist himself. One of the most powerful themes of the series is the psychological ramifications of watching atrocities. By showing only the tips of the executioners' bayonets, Goya focuses instead on the humanity of the victims, who meet their deaths with dignity and resignation. [*Gift to the College* 1998: 72–73] KWH and KP

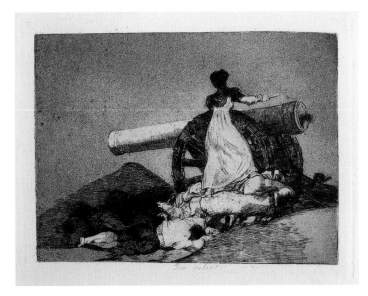

FIG. 1. Francisco Goya, *What Courage!* from *The Disasters of War,* about 1810–20 (published 1863), etching and aquatint, 6⅛ x 8¹⁄₁₆ inches. Gift of Adolph Weil Jr., Class of 1935; PR.991.50.1.26.

179

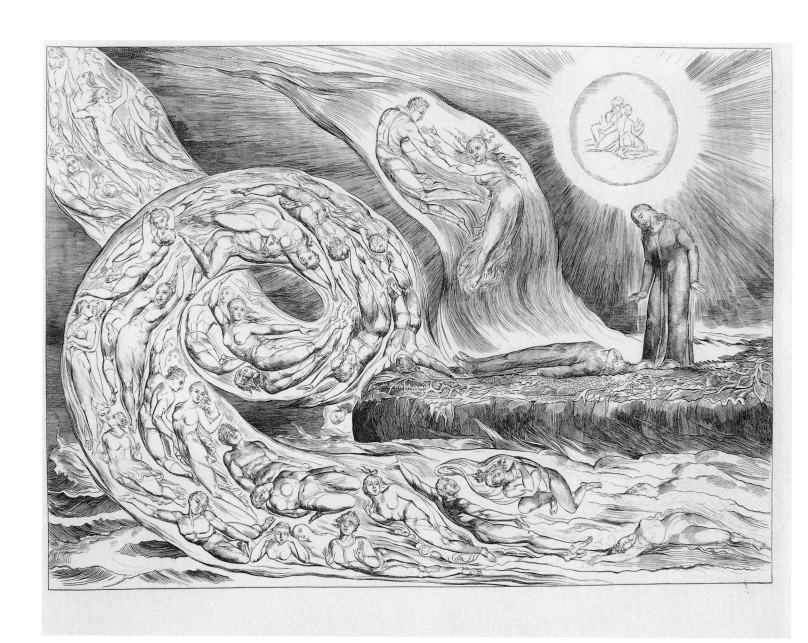

III. William Blake, English, 1757–1827

The Circle of the Lustful: Paolo and Francesca from Dante's Divine Comedy, 1827 (probably printed 1828)

Engraving on chine collé, only state (probably first edition),
11 x 14 inches
Gift of Jean K. Weil in memory of Adolph Weil Jr., Class of 1935;
PR.997.5.117

William Blake's illustrations of Dante's *Divine Comedy* were commissioned in 1824 by the artist's friend and patron John Linnell (1729–1796). Blake had completed over one hundred sketches and watercolor illustrations for the project by the time of his death in 1827, and he had begun work on engraving seven episodes from the *Inferno*. The series of prints was published a year after Blake's death in an edition of thirty-eight sets and reissued in 1892 in an edition of another fifty. It is likely that the present impression comes from the first edition.

The Circle of the Lustful: Paolo and Francesca was the first of the series that Blake engraved and in some ways the most expressive of his ambivalence toward the moral universe of Dante's poem. For Blake, whose philosophy in both his poetic and literary work eschewed the idea of eternal punishment, Dante's *Inferno* may seem an unlikely subject. Many critics have read Blake's illustrations as counterpoints to the *Inferno*'s totalizing system, offering sympathy toward individuals suffering beneath a scheme that figures their resistance as sin.

Francesca da Rimini was an Italian noblewoman whose nephew was Dante's host during his visit to Ravenna late in his life. Married in a political alliance to Giovanni Malatesta, Francesca became the lover of Paolo, Giovanni's younger brother. The lovers were murdered by Giovanni, thus condemning him, too, to the Inferno as a fratricide. Boccaccio, in his commentary on the *Divine Comedy*, explained that Francesca was tricked by her father into marrying Giovanni, thus providing some justification for her sin. Yet for Dante's Francesca there are no extenuating circumstances; she sins by yielding to desire, unable to overcome her lust with reason.

Blake's print illustrates the end of this episode, where Dante faints—in sorrow or sympathy—after Francesca has told her story. Dante lies at the feet of Virgil, who bends over him in pity. Paolo and Francesca rise together in a pillar of flame behind Dante, with Francesca turned toward the viewer in the act of speaking. Other lovers emerge and are tossed in a vortex that impels some upward toward Paradise and hurls other individually below. Above Virgil is the Sun, with two symbolic lovers within, reunited in Paradise.
[Tambling 1998; Gnappi 2005] LRB

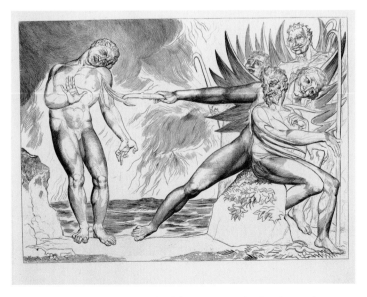

FIG. 1. William Blake, *The Circle of the Corrupt Officials: The Devils Tormenting Ciampolo* from Dante's *Divine Comedy*, 1827, engraving, 11 x 14 inches. Gift of Jean K. Weil in memory of Adolph Weil Jr., Class of 1935; PR.997.5.117

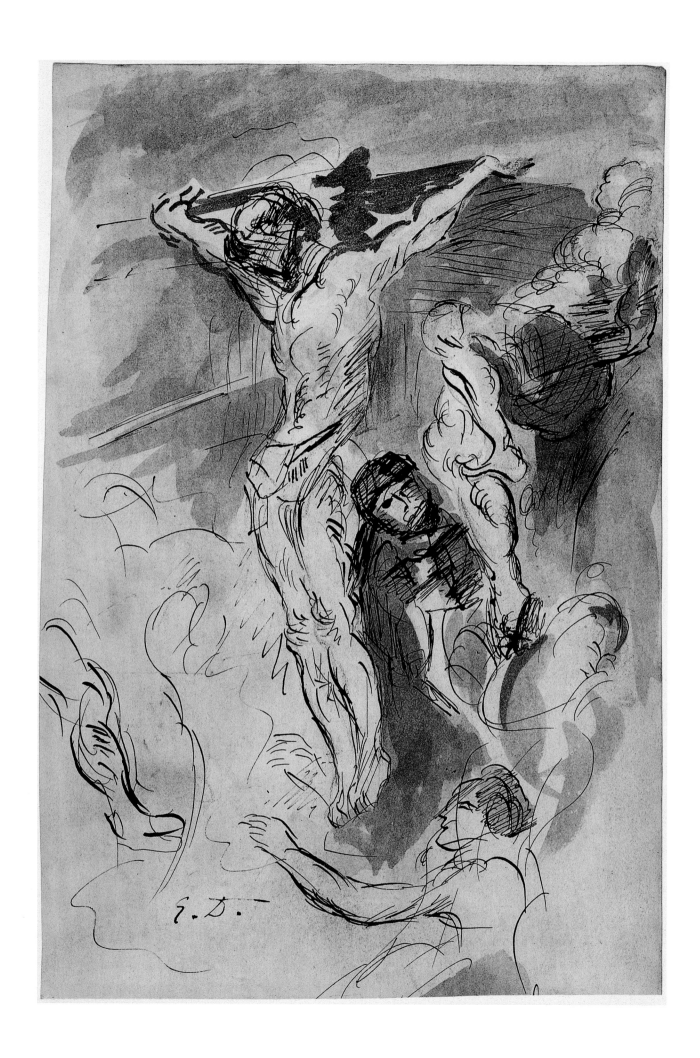

112. Eugène Delacroix, French, 1798–1863, after Peter Paul Rubens, Flemish, 1577–1640

Christ on the Cross (or *Coup de Lance*), about 1850

Pen and black ink and grey wash, 8⅝ x 6 inches
Signed bottom left center: E. D.
Purchased through the Phyllis and Bertram Geller 1937 Memorial Fund; D.962.109

Peter Paul Rubens's *Christ on the Cross* of 1619–20 was one of his most famous paintings. It presents us with a unique insight into his painting style, the operation of his atelier, and his use of antique, medieval, and seventeenth-century history, iconography, and religious writings. There were more than fifty copies of this image made in the form of paintings, drawings, and prints. Although Rubens's atelier helped to complete the altarpiece, it was still considered to be a prime example of his personal working method. Consequently, it was studied and copied by his countrymen and foreigners from the seventeenth through the nineteenth centuries, and it held a particular fascination for Eugène Delacroix.

That the French artist held Rubens in such high esteem is attested to by the numerous painted and drawn copies made by him after the Flemish master's originals, and by the large quantity of prints Delacroix owned after his works. Delacroix also wrote extensive descriptions of Rubens's techniques and paintings in his journal (White 1967: 139). Like Rubens, Delacroix studied and copied his forerunners but did not produce exact imitations. The nineteenth-century artist's studies here are highly original adaptations of Rubens's procedure and technique in producing dramatic compositions. They are, in general, considerably looser, less complete, and more suggestive than the originals. Delacroix's interest in the past may very well have been fostered by Rubens's absorption in earlier artists and attention to historical accuracy.

Delacroix's attraction to *Christ on the Cross* was not evident until late in the Frenchman's second journey to the Netherlands in 1850. During his stay in Brussels from July 6 to August 14 of that year, he made several excursions to Antwerp to study Rubens's works. His journal entry of August 10 contains a detailed analysis of the technique used in the painting (1:406–8). It obviously had a profound effect upon him as he made five drawings, a pastel, and a painting after *Christ on the Cross*. Several of these drawings were executed directly in front of the painting, while others were done from memory. It is probable that the present sheet was one of those copied directly from the original. The quick, lively, scribble-like application of the pen indicating the major shapes and forms suggests the work of an artist making visual notes in the presence of his subject.

All of Delacroix's interpretations suggest that he was attempting to focus our attention on Christ and the main figures in the scene. It is impossible to say whether or not Delacroix was concerned about the uneven execution of the figures or the strong possibility that

Rubens's hand is only evident in the painting of the more important ones. In Delacroix's journal there is no mention of this, but his drawings produced in front of the original emphasize the figures that are generally accepted as those painted by the master.

Rubens's ideals as set forth in *Christ on the Cross* were not only decisive for the seventeenth century but clearly also an inspiration for artists of subsequent generations like Delacroix. All of the French artist's copies after Rubens demonstrate his intense interest in creating dramatic, emotional, and monumental figures. Delacroix, the Rubenist par excellence, translates the seventeenth-century idiom into a nineteenth-century style that is less detailed but more dramatic in its impact. [Judson 1997: 110–11, figs. 4–6] JRJ

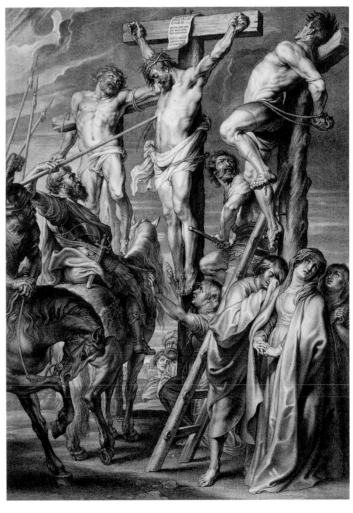

FIG. 1. Boetius Adams Bolswert after Peter Paul Rubens, *Christ on the Cross* (or *Coup de Lance*), 1631, engraving, 24⅛ x 17¼ inches. Purchased through the Class of 1935 Memorial Fund; PR.995.19.

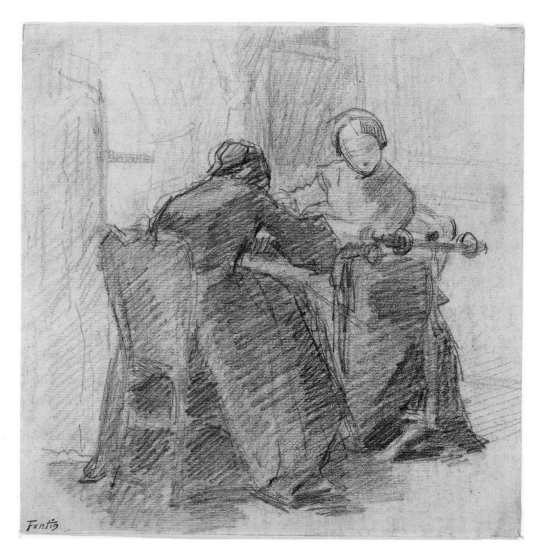

113. Henri Fantin-Latour, French, 1836–1904

The Embroiderers, about 1855–59

Black chalk and graphite, 8⅞ x 9⅛ inches
Stamped signature lower left: Fantin [estate of the artist]
Gift of Abby Aldrich Rockefeller; D.935.1.101

Henri Fantin-Latour is best known for his mature works, which focus primarily on portraits, still-lifes, and imaginary themes. Compared to many of his contemporaries and friends, including several impressionist artists, he executed relatively few paintings outdoors; Fantin is instead regarded primarily as a studio artist. There are also more than 150 prints attributed to him. His drawings, although apparently simple and straightforward, are in fact carefully rendered to define the contours and forms of his subjects while only faintly hinting at the setting. His technique often involves applying layers of cross-hatching to delineate a range of tones in black chalk or charcoal—from brightest to darkest—and then using sharper graphite to highlight the outlines. The overall effect creates textural variety and subtle suggestions of the mood.

Early in his career Fantin produced more than a dozen drawings, prints, and paintings of women sewing or embroidering, reflecting his attraction to everyday domestic surroundings. The models were his two sisters, Nathalie and Marie, but rather than treating these works as portraits, focused on depicting specific features, the artist concentrated on outward physical forms. The low viewpoint, selection of an angle that joins the two women, and apparent unification of the figures and the furniture heighten the sense that Fantin was principally interested in capturing their overall shapes and the effects of light and shadows, transforming an otherwise familiar scene into an exercise in observation.

By the time Fantin arrived in Paris in 1850 to study art, Thomas Couture (cat. 114) had established an independent school and was a popular teacher. Although the younger artist did not work directly with Couture, his friendship with some of Couture's pupils made him aware of the master's innovative approach and emphasis on preserving the qualities of the sketch throughout the various stages in the execution of a work of art. With regard to drawing, Couture famously recommended that the first step should be to observe the subject through half-closed eyes, to distinguish the "major divisions of light and dark" (Druick and Hoog 1983: 90). Fantin evidently adapted some of Couture's lessons to serve his own objectives.

TBT

114. Thomas Couture, French, 1815–1879

Portrait of a Gentleman, 1864

Black and white chalk on blue paper, 21⅞ x 17 inches
Signed and dated center right: T. C. / 1864
Purchased through the Julia L. Whittier Fund; D.967.99

Portraiture was a popular genre for finished drawings from the Renaissance onward. The face has always been an enduring subject for artists when exploring human emotion, social status, and individual identity, and portrait drawings were commissioned and collected as early as the 1470s. They were often valued for their intimate quality and cherished as souvenirs of personal associations and public affiliations. Compared to large-scale, formal, painted representations, drawings could be easily exchanged and casually displayed. While the conventions and techniques of finished portraits have varied over the centuries, they have all shared a desire to portray either the illusion or the reality of physical likeness and individual personality.

By the middle of the nineteenth century, Thomas Couture was the most popular artist in France. He was celebrated and idolized by a generation of French and American students, who flocked to his newly established art school in Paris. In the studio he demonstrated his procedures for the benefit of pupils, eventually publishing a summary of his teaching methodology and practical techniques titled *Conversations on Art Methods* that was widely read on both continents after it appeared in French (1867) and English (1879). With regard to drawings, Couture generally advised students to work quickly and to draw figures engaged in everyday tasks. His preferred medium was black chalk. While his own sheets showed varying degrees of finish and vitality, he greatly appreciated the qualities of a sketch and promoted its status as a self-sufficient work.

Couture was generally renowned for his grand history paintings, but he also achieved recognition as a portrait artist. In *Portrait of a Gentleman* Couture convincingly renders a strong sense of the sitter's physiognomy, meticulously executing his three-quarter view of the figure's head and shoulders in such a way that the high degree of finish does not compromise a sense of spontaneity. The addition of the artist's initials and date suggest that this portrait was conceived as an independent work of art. TBT

185

ACTUAL SIZE

115. Edgar Degas, French, 1834–1917

On Stage I, 1876

Soft-ground etching and drypoint, state iv/V, 4¹¹⁄₁₆ x 6⅜ inches
Signed in the plate lower right: Degas
Purchased through gifts from the Lathrop Fellows; 2007.79

116. Edgar Degas

On Stage III, 1876–77

Soft-ground etching, drypoint, and roulette, state v/V, 3⅞ x 5 inches
Signed in the plate bottom left: Degas
Purchased through gifts from the Lathrop Fellows; 2007.27

Edgar Degas produced a large number of prints, including etchings, lithographs, and monotypes (unique works of paint or ink transferred from a metal plate). Those completed during the middle of the 1870s marked a fruitful and transitional period in Degas's career, when he moved away from his conservative earlier style and traditional techniques. Like the layered application of media in the artist's pastels and paintings from these years, his etchings revealed a complex array of lines, gouges, scraping, hatching, and crosshatching.

Degas's *Ballet at the Paris Opéra* (Art Institute of Chicago), a pastel over a monotype, served as the source for three separate prints executed in 1876 and 1877, all titled *On Stage.* The principal motivation behind the series was the invitation to create an etching to accompany a pastel—one of two works he contributed—for an exhibition sponsored by Les Amis des Arts de Pau, a town in southern France where Degas had several friends. Degas used the pastel and prints to explore one of his favorite early vantage points at the Opéra, the center seats behind the orchestra pit.

On the rare occasions when Degas executed a print for publication, he went through an elaborate process of preparing drawings and experimenting with various states until he was satisfied with the finished work. According to Reed and Shapiro (1984: 62–66, no. 22), the procedure began with *On Stage I,* a plate that underwent a number of changes until it was finally abandoned in the fifth and final state. Degas focused on the heads of several musicians, depicting a virtual group portrait of a section of the orchestra, while portraying the dancers on stage in a sketchy manner. He continued to develop the composition primarily through scraping in order to achieve greater spatial clarity.

The fifth state of *On Stage III* resolved the artist's struggle with the complex arrangement of the space and content of the setting. This was largely achieved by subtly redefining the spatial relationships between the backdrop, dancers, and orchestra members, and by creating greater depth in the foreground. A striking feature is the way the heads of a pair of double basses block a clear view of what

would normally be the principle subject, the two dancers closest to the center stage. The apparently illogical composition obstructing the figures reinforced the sense of direct observation as the primary subject of the work, a theme that Degas would pursue with extraordinary results in a number of paintings in the 1880s.

This pair of prints, each executed in multiple states, demonstrates how the artist obsessively reworked his compositions. Degas's experimental approach reflected his emphasis on capturing the experience of real space in order to record diverse perceptions of an array of elements, in this case the musicians, dancers, and stage. The subject and formal features highlighted his keen interest in rendering momentary effects of light, atmosphere, and movement. [Bretell and McCullagh 1984: figs. 31–33 and Reed and Shapiro 1984: fig. 24.5]

TBT

117. Paul Cézanne, French, 1839–1906

Large Bathers, 1896–98

Color lithograph, state ii/III, 16¼ x 20½ inches
Signed on the stone lower right: P. Cézanne
Gift of Herbert E. Hirschland, Class of 1939; PR.964.91

Paul Cézanne, renowned as one of the leading French impressionist painters, produced only eight prints during his career. This lithograph, done at the urging of the dealer and entrepreneur Ambroise Vollard (about 1867–1939), is based on one of the artist's most famous oil paintings, *The Bathers at Rest,* executed in 1875–76 and exhibited at the third impressionist display in 1877 (now owned by the Barnes Foundation, Merion, Penn.). Prepared with great care under Cézanne's guidance following watercolor models (applied to black-and-white impressions of the first state of the lithograph, such as fig. 1), the colors were printed from separate stone plates. The size of the lithograph corresponded with some of Cézanne's most prized watercolors and was not much smaller than his canvases. One edition of approximately one hundred impressions—of which this was one—was prepared during the artist's lifetime (Druick in Rubin 1977: 134).

The subject of the print reflected two dominant themes in Cézanne's work: bathers in landscape settings and views of Mont Sainte-Victoire in his native Aix-en-Provence. The theme of the bathers, which preoccupied him during his entire career, was based on a variety of sources, including Renaissance and baroque heroic outdoor scenes (Tsiakama 1977–78). However, in Cézanne's case, there is an absence of any action that might provide a narrative meaning. The emphasis is purely on the physical aspects of the human body, which he had explored in numerous sketches and occasional life studies. By comparison, the landscape is dominated by the profile of Mont Sainte-Victoire, the largest geological mass in the region, situated east of his home. The flattened space created by the blending of the foreground and background served as a towering backdrop. The setting reinforced the sense of timelessness given the permanence and stability of the location.

The appearance of the *Large Bathers* coincided with a revival of color lithography in France in the 1890s, and Vollard was one of the leading publishers to market sets of prints. Interest in the medium was spurred by posters, the increasing popularity of impressionism, and the influx of Japanese color woodcuts. In spite of its complex and time-consuming process, lithography offered the most direct means of creating color prints, because artists could either apply inks and paints onto the stone or provide drawings that could be transferred by expert printmakers (Cate, Murray, and Thomson 2000). TBT

FIG. 1. Paul Cézanne, *Large Bathers,* 1896–97, lithograph, state i/III, 16¼ x 20½ inches. Purchased through the Julia L. Whittier Fund; PR.955.109.

118. Henri Marie Raymond de Toulouse-Lautrec, French, 1864–1901

The Jockey, 1899
Color lithograph, 20⅜ x 14¼ inches
Signed and dated in reverse on the stone lower right:
HTL [monogram] / 1899
Gift of Mrs. Daisy V. Shapiro in memory of her son,
Richard David Shapiro, Class of 1943; PR.966.44

Henri de Toulouse-Lautrec began his career as a painter in Paris during the early 1880s. In spite of childhood accidents that stunted his growth, he was a thoroughly cosmopolitan artist with links to the commercial world of the dance halls and other forms of popular entertainment. In the early 1890s, Toulouse-Lautrec turned to lithography in the form of posters, song sheets, and single-sheet prints for collectors; in it he found a sympathetic medium that allowed him to retain the appearance of a spontaneous sketch.

Like several other French artists of the period, Toulouse-Lautrec developed a fondness for Japanese color woodcuts. He incorporated the use of diagonal perspectives, bold compositions, flat areas of color, and prominent contours to create powerful images that exceeded the more decorative illustrations of other poster makers. The present print employed several of these features, such as the unusual point of view, expressive color, and cropped image.

This print was intended to have been one of a series of racetrack subjects. By the second half of the nineteenth century, horseracing was immensely popular, and it appealed to all social classes. Edgar Degas (cats. 115 and 116) had already taken up the subject beginning in the 1860s and soon immortalized the increasingly fashionable competitions. Horseracing was not only a modern form of entertainment but also an excellent source for the study of movement and athletic grace.

Although Toulouse-Lautrec completed other compositions for the series, his health did not allow him to continue the project, and he died less than two years later. *The Jockey* was published in two editions, one in black-and-white and the other in color. TBT

119. James Tissot, French, 1836–1902

A Summer Evening, 1881

Etching and drypoint, state ii/II, 9⅛ x 15²¹⁄₃₂ inches
Signed and dated in plate lower left: J.J. Tissot / 1881
Purchased through the Julia L. Whittier Fund; PR.971.7

James Tissot, a French painter who exhibited regularly at the Paris Salon and London's Royal Academy, was an early participant in the etching revival at the end of the nineteenth century. Many of the artist's eighty-eight prints were modeled after his own paintings, which he translated in an elaborate manner to reflect the texture and light in his pictures. Inspired by his friend James McNeil Whistler (1834–1903), he produced most of his prints while living and practicing in London from 1871 to 1882. After Tissot returned to Paris, he largely abandoned graphic work, turning almost exclusively to depicting religious scenes from the Old Testament and the life of Christ.

One of Tissot's favorite subjects during his most intense period of printmaking was his mistress, Kathleen Newton (1854–1882), who eventually died of tuberculosis at the age of twenty-eight. His new familial lifestyle led to a series of works concentrating on domestic and leisure themes. As Newton's illness progressed, he sometimes portrayed her convalescing, as in the present composition, entitled *A Summer Evening,* which reproduced a painting in the same direction (now in the collection of the Musée d'Orsay, Paris). The sitter reclines alone outdoors in an impeccably rendered dress, and the atmosphere appears relaxed and spontaneous. The combination of the intimate setting and somber mood made it one of Tissot's most admired prints.

The narrow, horizontal arrangement and compressed space indicate Tissot's familiarity with Japanese prints. Like his close colleague Edgar Degas (cats. 115 and 116), Tissot collected Asian art. However, compared to some other artists in London and Paris in the late nineteenth century who modeled their designs after Japanese motifs, Tissot adopted primarily Asian formats and compositional effects instead. TBT

120. Kees van Dongen, Dutch, 1877–1968

The Clowns Sausage and Gimp, 1904

Brush with black ink, watercolor, and white gouache, 24 x 15 inches
Signed upper left in green watercolor: van Dongen
Gift of Mr. and Mrs. Preston Harrison; W.940.43

Dutch-born Kees van Dongen is best known as a Fauve artist who produced stunning, vividly colored paintings. Later in life, Van Dongen was celebrated as the portraitist of fashionable Parisian society: Anatole France, the Marquise Casati, Yves Mirande, and Brigitte Bardot were among his subjects. Less well known is the artist's exquisite output of early drawings, among which *The Clowns Sausage and Gimp* is a fine example. A prolific and masterful drafts-man, Van Dongen was said to "walk after people, drawing them in action, with a bottle of Indian ink always ready in his breast pocket" (quoted in Hopmans 1996: 38).

Drawings were the mainstay of Van Dongen's early artistic out-put; they were first published in Rotterdam, then in Paris, where Van Dongen settled in 1899. His participation in anarchist circles as well as his fascination with street life and the world of the *demi-monde* greatly influenced his choice of subject matter. In 1904–5, while living at the Bateau-Lavoir, the residence of many painters and literary figures in Paris, Van Dongen adopted a style close to neo-impressionism to convey the drama of the spectacles that took place in Montmartre. *The Clowns Sausage and Gimp* is part of a series of drawings depicting acrobats and clowns, subjects that the artist knew intimately not only because he, along with his friend Picasso, were regular visitors to the popular Cirque Médrano, but because Van Dongen actually worked as a porter and stooge among the audience for the ambulant Paris circus Chez Marseille (Hopmans 1996: 200). While the palette of this drawing is limited to black and white, with a few areas highlighted in yellow and brown-ish-red watercolor, its fluid lines and loose, dotted brushwork an-ticipate the vigor and expressiveness of his Fauve works of the fol-lowing year.

Van Dongen had great admiration for circus performers, whose presence he captures eloquently and economically in this charming portrait. The inclusion of this drawing in a major exhibition of Van Dongen's work at Ambrose Vollard's gallery in Paris in November 1904 may be seen as proof of the esteem in which the artist held it.

AG

121. Pablo Picasso, Spanish, active in France, 1881–1973

Still-Life with Table and Fruit Dish, 1908

Graphite, 12½ x 9½ inches
Signed and dated upper right: Picasso / 1908
Gift of the Estate of C. Morrison Fitch, Class of 1924; D.969.64.6

The period between 1907 and 1909 was critical in the development of Pablo Picasso's novel style, which sought to abandon illusionistic perspective in favor of representing all aspects of what existed in three dimensions on a flat surface. He increasingly imposed a more rigorous control of the treatment of space, shapes, materials, and colors in figure paintings, landscapes, and still-lifes. This innovative mode of expression introduced a profound shift from observation to conceptualization of his subject matter that contributed to his later recognition as the most important figure in the history of modern art.

The present sheet was executed in the middle of this crucial two-year interval, signed and dated in 1908. It depicts a vigorously rendered still-life comprised of several simple elements: a sewing table with spirally turned legs partially covered by a rumpled tablecloth; a fruit dish, or compote, with an undulating edge positioned in the center; and a curtain in the background. The symmetrical arrangement is animated by the trapezoidal shape of the table with its acutely angled lines, strong contours, energetic execution, and contrasting areas of light and dark. Two scholars have linked this drawing to a series of vertical still-lifes prepared on canvas between fall 1908 and spring 1909, as well as another sheet of sketches (Rubin 1972: 301 and Boggs 1992: 64–67). The painting that most closely corresponds to this work, traditionally dated 1908–9, eliminates most of the table and focuses on a more simplified version of the fruit dish (MoMA inv. no. 263.44).

Perhaps due to his early academic training, Picasso often made multiple sketches in preparation for his finished paintings. The drawings executed in various media—such as graphite, pen and ink, watercolor, and gouache—occasionally contain several sketches referring to different themes. A selection of the early cubist studies reveals the artist's analytical method of transforming the visible appearance of natural and manmade objects into the geometrical reconstruction of its component parts—at times shown from a variety of angles. These sheets provide invaluable evidence of the complex evolution of Picasso's compositions, which sometimes lasted for several months, and document his extraordinary ability to express form and volume through simple lines and shading. [Zervos 1932–78: 6:1076; Rubin 1972: fig. 37] TBT

122. Georges Braque, French, 1882–1963

Fox, 1911, published 1912

Drypoint, 21⁹⁄₁₆ x 14¹⁵⁄₁₆ inches
Signed in graphite lower right: G Braque
Purchased through the Florence and Lansing Porter
Moore 1937 Fund; PR.2004.53

Georges Braque's one-man exhibition at the Galerie Kahnweiler in 1908 prompted the coining of the term *cubism,* derived from a critic's reference to "geometric schemas and cubes." The gallery owner, Daniel-Henry Kahnweiler (1884–1979), promoted the work of both Picasso (cats. 52, 121, 130, and 131) and Braque, and he commissioned the latter to produce several prints. Only two of these were published at the time of their completion in 1911–12. The large drypoint, *Fox,* demonstrates Braque's proficiency in printmaking.

Fox was named after an English-style bar in Paris where the artist and his painter and writer friends gathered. The composition followed the spirit of the drawings Braque made in preparation for the canvases executed during this period, yet none of these were used as models for his prints. Large sections of the plate were delineated with lines and cross-hatchings in order to create distinct shapes of glasses, cards, and other objects, interspersed with words, symbols, and numbers. In addition to the name of the bar, "Old Tom Gin" referred to a popular British-made sweetened gin. Other references included a playing card with a heart and the number "75," possibly

an allusion to a contemporary slang term for cheating at dice (Wye 2004: 68). Similar characters appeared in other related paintings by Braque during this period of time. Picasso was commissioned to create a counterpart to his colleague's print, which he entitled *Still-Life with a Bottle of Marc* (1911).

Braque prepared a total of ten cubist prints, but eight of them were not published until the 1950s. His first color lithograph was a still-life executed in 1921. He returned to printmaking in earnest in the 1930s, mastering the techniques of etching, lithography, aquatint, and woodcut. The still-life theme remained central throughout this period. His later prints were mostly produced to illustrate books, including a series of poems written by René Char (1907–1988) to accompany lithographs by the artist. Throughout his career Braque used prints as an important medium for experimenting with his favorite themes and motifs, creating some of the most striking and impressive images of the twentieth century. [Engelberts 1958: no. 5; Vallier 1984: no. 6] TBT

Henri Matisse

123. Henri Matisse, French, 1869–1954

Three Female Nude Studies, about 1906–8

Pen and black ink with brush, 12¼ x 9¼ inches
Signed lower left: Henri Matisse
Gift of A. Conger Goodyear; D.940.22

The female nude has been a ubiquitous subject in Western art from antiquity to the present, especially in mythological, allegorical, or other narrative compositions. Most importantly, representations of a single naked figure highlighting the essential physical differences between men and women have been commonly perceived as establishing standards of idealism, naturalism, and other notions. The treatment of the female form in particular has often been considered a means of measuring the degree of continuity or change between styles and periods. Not surprisingly, many artists throughout history have studied the examples of their predecessors in order to compare and contrast different modes of expression.

One of the most intriguing poses is a nude female—either standing, seated, or reclining, and either from the side or from behind—with arms raised up to cradle the head and obscure the face. Although the inability to identify the sitter seems to heighten the erotic associations, it also enhances the image's impersonal formal qualities. These characteristics are further amplified when the artist focuses on an individual figure, independent of a context, accessories, or other bodies.

On one level, Henri Matisse's *Three Female Nude Studies* reflects the artist's routine concentration on outward contours rather than on volume as he gradually refined his impressions in order to distill the subject into its essential elements (Fisher 2007). In this case, the reductive process apparently began with the central, heavily drawn figure, moving next to the sketch on the right and then finally to the small study on the left, composed of only sixteen lines. According to the notes of 1908 by one of Matisse's pupils, the artist described the procedure in the following manner: "The model must not be made to agree with a preconceived theory or effect. It must impress you, awaken in you an emotion, which in turn you seek to express . . . by masses in relation to one another, and large sweeps of line in interrelation. One must determine the characteristic form of the different parts of the body and the direction of the contours which will give this form" (Flam 1995: 49–50, cited in part in Fisher 2007: 32).

On another level, the drawing is closely modeled after several works of a similar type by Paul Cézanne (cat. 117), whom early in his career Matisse considered to be "a sort of God of painting" (Flam 1995: 80). However, Cézanne's depictions of naked bathers in landscape settings mostly emphasize the structural interaction between the figures and the natural environment, and his studies and finished compositions of women in interiors of the 1890s chiefly explore the sensual aspects of the nude in intimate spaces (fig. 1;

Rewald 1983). Other historical and contemporary comparisons extend from the Renaissance to Pablo Picasso's (cats. 52, 121, 130, and 131) *Les Demoiselles d'Avignon* (Brodsky 1986: 142–51; Steinberg in Baldassari 2008).

The present drawing was originally owned by John Quinn (1870–1924), the foremost collector of post-impressionist and cubist works in North America in the early twentieth century, and listed in his posthumous catalogue of 1926 (11). A. Conger Goodyear (1877–1964) acquired it either before or during the renowned auction of 1927 (Zilczer 1979: 17–18) and donated it to Dartmouth College in 1940 (see the introduction to this catalogue). TBT

FIG. 1. Paul Cézanne, *Woman at Her Toilette,* about 1895, pencil and watercolor, 6¼ x 5¼ inches. Gift of Josephine P. and Ivan Albright, Class of 1978H, in honor of Churchill P. Lathrop; W.978.175.

124. Emil Nolde, German, 1867–1956

Somber Head of a Man, 1907/1915

Transfer lithograph printed in black with a light, greenish-tan border,
22½ x 16⅜ inches
Signed in graphite lower right: Emil Nolde
Purchased through a gift from Robert and Karen Hoehn,
Classes of 2009P and 2010P; 2005.71

125. Otto Dix, German, 1891–1969

Sailor and Prostitute, 1923

Four-color trial proof lithograph, 18¹⁵⁄₁₆ x 14⅝ inches
Inscribed on reverse in graphite bottom center:
Original litho von Otto Dix / Martha Dix
Purchased through the Robert J. Strasenburgh II 1942 Fund; 2006.14

The artists who produced these lithographs are generally associated with a movement in the first decades of the last century called expressionism, a style in which the intention is not to reproduce a subject accurately but to portray some of the deeper feelings and issues with which people struggle. Aesthetically, expressionists moved away from realistic representation and instead emphasized symbolic representation through simplicity, boldness, and flat planes with little attention to depth. The subjects they portrayed often attempt to convey intense and disturbing psychological states, such as despair and alienation.

The self-portrait by Emil Nolde represents the pinnacle of the artist's interest in rendering a face solely from highlights that emerge from a dark ground. Like several other printed portraits executed in this manner in 1906–7, it is a dramatic study in three-dimensional form constructed solely from strongly contrasting patterns of light

and shadow. Throughout the approximately five hundred prints made by Nolde during his career, he consistently experimented with various techniques during short periods of sustained activity. In lithography his interpretations were neither abstract nor fully articulated; this was instead an ideal medium for employing his fluid and intuitive style aimed at expressing psychological tension. The addition of a colored border through the application of broad, sweeping brushstrokes in 1915—a method used by Nolde for several earlier lithographs at this time—imbued the surface of the original image with a new sense of animated, vigorous execution.

Otto Dix depicted the corruption and indifference of German society after World War I in starkly rendered paintings, drawings, and prints. Completing some three hundred prints during his lifetime, he experimented extensively with all media. Many of his woodcuts, etchings, and lithographs produced in the early 1920s represent images of soldiers, sailors, war veterans, proletarians, and prostitutes. Among these varied stereotypes, the sailor is repeatedly depicted to emphasize lecherous and lewd behavior, often in the company of a

prostitute. Viewed in this light, the male figure appears to personify unrestrained sexual activity. Yet Dix's personal perception of sailors was formed by his observations of their conduct during the war in occupied countries. Quasi-official brothels populated with local women were established within these territories for the benefit of enlisted men. From this perspective, the demonized imagery apparently transforms military occupation into sexual aggression.

Both prints exploit lithography's ability to reproduce the spontaneity of the artist's original drawing. Compared to other printing methods, in which the relationship between the initial conception and its final execution is mediated through highly skilled transfer techniques in wood or copper, this medium allows the printmaker to draw directly on a stone surface using wax and oil-based crayons. Many artists preferred the freedom of the lithographic technique, often creating more fully realized compositions than those produced in drawings and more spontaneous ones than those produced in paintings. TBT

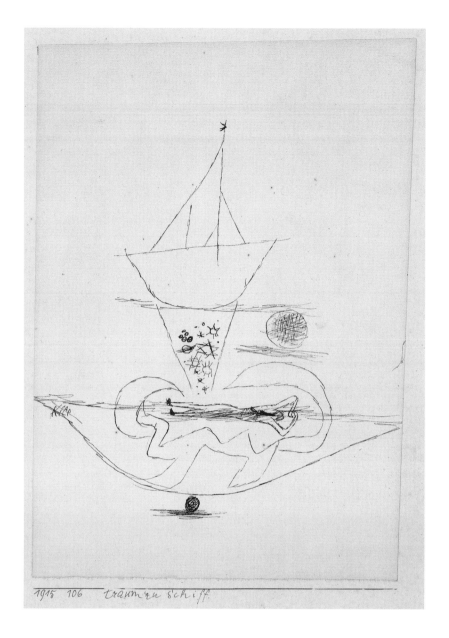

1915 106 traum zu Schiff

126. Paul Klee, Swiss, 1879–1940

Dream Aboard, 1915

Ink on paper, 9⅝ x 6³⁄₁₆ inches
Signed in image lower left: Klee; inscribed on mount lower left:
1915 106 traum zu Schiff.
Gift of Elizabeth E. Craig, Class of 1944W; D.2002.30.1

127. Fernand Léger, French, 1881–1955

The Disk in the City, 1920

Ink and gouache on paper, 12¼ x 9¾ inches
Signed lower right: F. LEGER / 20; inscribed on reverse top left:
le disque dans la ville
Gift of Elizabeth E. Craig, Class of 1944W; D.2002.30.3

Both Paul Klee and Fernand Léger served in the military—on op-posite sides—during World War I, and both artists were profoundly transformed by the experience. Each man had experimented with abstraction before the war but largely renounced it in favor of an artistic approach grounded, however indirectly, in nature and the manmade environment. Klee adopted a figurative style infused with fantasy and humor that, in his words, alluded to "mystical, timeless messages." Léger claimed to have discovered the beauty of common objects, which he described as "everyday poetic images." While Klee executed his works of this period with exquisitely precise and sensi-tive lines, Léger delineated his bold compositions with clarity and simplicity. Both sheets emphasize surface lines and volumes instead of traditional spatial illusions.

Klee had collaborated with Herwarth Walden (1878–1941) on the publication of the avant-garde magazine *Der Strum* (1910–32), associated with the eponymous gallery in Berlin that functioned as a champion of futurism, cubism, and expressionism. In conjunction with an exhibition of his work in the spring of 1916, Klee suggested that they publish some of his drawings, "something new from 1915" (Werckmeister 1989: 68). Walden agreed and selected one of the

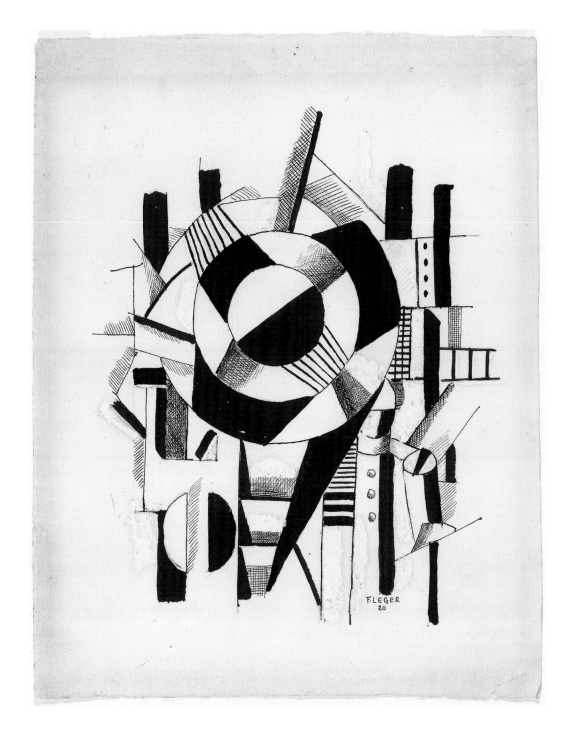

works he had on hand, *Dream Aboard,* to appear on the front page of the first issue in April of that year. The romantic image represents a reclining figure floating on a body of water contained in a hull-shaped vessel balanced on a small globe. Above, or beyond, is a sailboat linked to the figure by a trail of moons and stars that appear to be reflected on a connecting surface. An amorphous substance frames the figure in either a threatening or a protective manner. Given the fact that the war had already been underway for a year when the drawing was produced, the dreamlike atmosphere could have been interpreted positively as a sign of future victory or, alternatively, as a representation of an existence after death.

Following military service that left Léger hospitalized for more than a year due to a gas attack, he returned to Paris in 1918 and began introducing themes that established a new vision of modernity as a dynamic, chaotic urban landscape. His geometric representations included overlapping planes, broken surfaces, and fragmented forms. The confusion between negative and positive space makes it difficult to interpret *The Disk in the City* as a three-dimensional picture, yet the inclusion of certain shapes recalling smokestacks and other industrial imagery conveys a sense of familiarity. The mechanical elements partially reflect Léger's wartime experiences, which—in combination with his exclusion of figurative references—make a powerful impression. Overall, it appears that he was attempting to synthesize the complexities of the material world into a densely constructed design. TBT

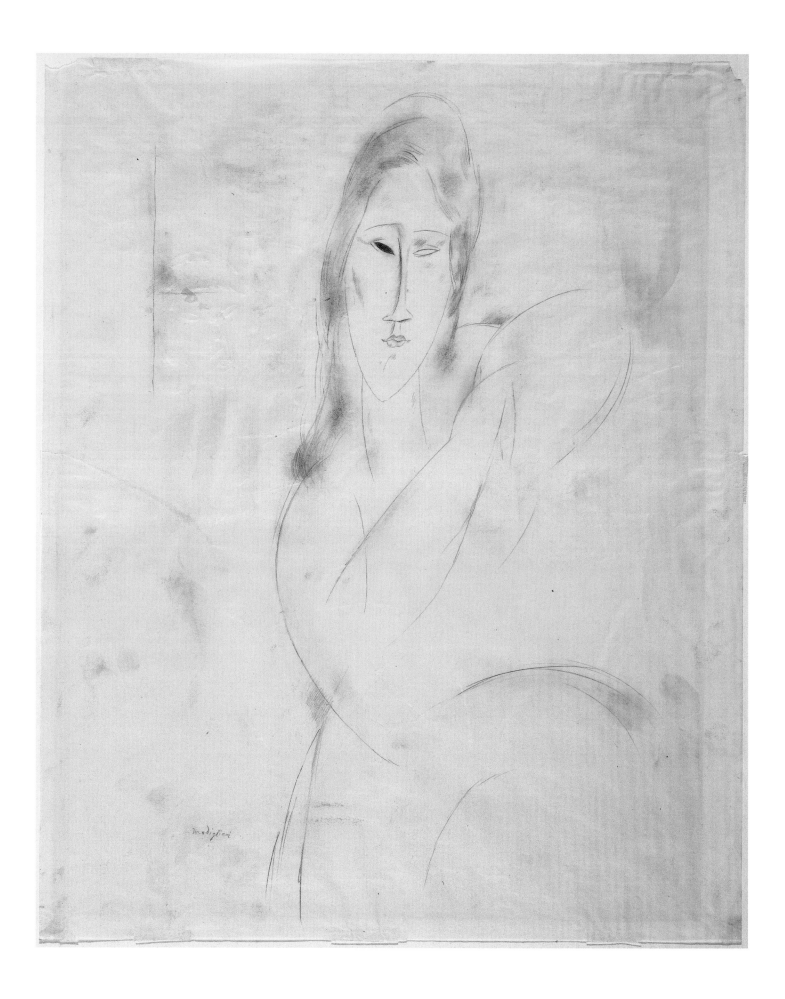

128. Amedeo Modigliani, Italian, 1884–1920

Jeanne Hébuterne, about 1919

Graphite and crayon, 16⅞ x 14 inches
Signed lower left: Modigliani
Gift of A. Conger Goodyear; D.940.23

From his arrival in Paris in 1906 until his premature death in 1920 at the age of thirty-five, Modigliani's career and personal life have taken on, through fact and anecdote, almost legendary qualities. Plagued by illness, victimized by the circumstance of foreign birth and religious origin, unable to completely free himself financially or psychologically from his family, he was perhaps sure to face a career filled with challenges. Yet his art was possessed by a singular sense of purpose and style that found its roots not only in a fascination with African masks and the expressive, clean forms of contemporary sculpture but also in the Italian Gothic art of his native country. Like Pablo Picasso (cats. 52, 121, 130, and 131) before him, Modigliani drew upon Toulouse-Lautrec (cat. 118) for inspiration in his early portrayals of the people around him.

Few artists of the twentieth century have discovered in portraiture such prolonged inspiration. With the exception of a limited number of landscapes, a couple of sculptures, and a magnificent group of nudes, Modigliani's accomplishment consisted primarily in recording individuals. His subjects were the people who befriended and sustained him during the turbulent years of World War I, but the imposition of his style infused these portraits with a distinct character.

The many drawings from his hand that have survived are often immediate renderings of the sitter, sometimes hastily sketched (fig. 1). Nevertheless, his line has nothing tentative about it. These sheets remain the essence of Modigliani, their simplicity a key characteristic of an intensely personal style.

In 1917, Modigliani met a young, russet-haired Parisian art student, Jeanne Hébuterne (1898–1920), with whom he lived until his death. His many portraits and half-length studies of her define his late, mannered style, in which the elongation of the neck is increasingly exaggerated. In this portrait, instead of concentrating on psychological characterization, Modigliani emphasized the elegance and simplicity of the contour lines and the stylization of her features. In spite of having a child together, two days after Modigliani died of tubercular meningitis Hébuterne committed suicide.

Of particular note on this sheet are the visible indentations of another drawing from the same sketch pad. The drawing from the previous sheet, now apparently lost, depicted a study of a female figure. TBT

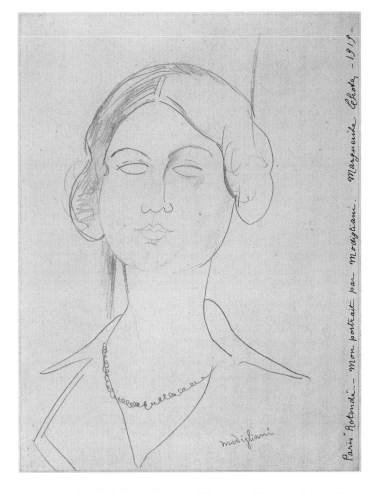

FIG. 1. Amedeo Modigliani, *Portrait of Marguerite Lhote,* graphite, 10⁹⁄₁₆ x 8³⁄₁₆ inches. Gift of Elizabeth E. Craig, Class of 1944 W; D.2002.30.4.

129. Vasily Kandinsky, born in Russia and active in Germany and France, 1866–1944

Circling, 1924

Pen, black ink, graphite, and watercolor, 14¼ x 14½ inches
Gift of Wallace K. Harrison, Class of 1950H, in honor of
Nelson A. Rockefeller, Class of 1930; W.966.1

By the early twentieth century artists more readily produced works on paper as independent compositions, due in part to a growing preoccupation with artistic process and in part to an interest in exploring each medium to the fullest extent. Throughout all of the representational and abstract movements of this period, the boundaries between drawings, watercolors, and other media became blurred. Just as importantly, the increased opportunities to exhibit and sell these sheets as independent art forms raised their status in the eyes of both artists and the general public.

FIG. 1. Vasily Kandinsky, *Small Worlds VI,* 1922, woodcut, 14¹⁄₃₂ x 11¹⁄₃₂ inches. PR.984.32.4F.

FIG. 2. Rudolf Bauer, *Untitled,* about 1925–26, charcoal, 22½ x 17⅝ inches. Gift of Anthony H. Dingman, Class of 1957, and his wife, Ellen F. Dingman, in memory of her mother, Marian W. Freedman, and Louise Bauer Parry; D.997.56.

One of the first proponents of nonrepresentational imagery, Vasily Kandinsky prepared finished compositions in all media, allowing historians to trace his mature development in each art form. Print-making, for example, played a central role in the artist's imagination and creative activity. He produced a series of twelve prints entitled *Small Worlds (Kleine Welten)* in 1922 (fig. 1), soon after his arrival at the Bauhaus, a school of architecture and applied art established in Weimar in 1919 where Kandinsky taught from 1922 to 1933. In the introduction to the portfolio of prints, he stated that they fell into distinct groups of woodcuts, etchings, and lithographs that reflected the individual character and outward nature of different "small worlds." He conceived of each abstract composition, either in black and white or in color, as its own independent visual environment. Collectively, the series formed one of the most developed expressions of Kandinsky's art of this period (Röthel 1970: no. 301).

Similarly, in the case of the watercolors of the 1920s, Kandinsky gave titles to his works in order to convey the intrinsic formal relationships he intended to represent. *Circling,* executed in 1924, employed a warm palette of colors juxtaposed with purely abstract forms in order to endow the design with innately artistic significance. Kandinsky's use of watercolor in this case allowed him to create more subtle effects of layering and geometric compartmentalization. However, he did not consistently exploit the medium's translucence; sometimes he used watercolor to create the appearance of spontaneity, and other times he applied it more

deliberately. Frequently he mixed pencil, ink, chalk, and gouache with his watercolors. From about 1922 until 1933, Kandinsky's watercolors assumed an important and independent role in his work (Barnett 1992–94: 1 no. 687; Whitford 1999).

Beginning in 1912, Kandinsky's work was prominently shown in Berlin at the Sturm-Galerie, an important forum for European avant-garde art. Another nonrepresentational artist that exhibited at the gallery starting in 1915 was Rudolph Bauer (1889–1953), who in 1917 openly acknowledged the older artist's influence: "The strongest and most advanced of all—theoretically and practically, synthetically and analytically—is Kandinsky" (Lukach 1983: 29). Gradually, however, Bauer moved to a more geometrical style, which he launched with a series of large works on paper in late 1925 to early 1926 (fig. 2). His enduring support of Kandinsky has recently been confirmed in the correspondence between Bauer and the personal curator of Solomon R. Guggenheim (1861–1949), whose collection included an enormous number of works by both artists (*Art of Tomorrow* 2005: 88–91). TBT

130. Pablo Picasso, Spanish, 1881–1973

Sculptor and Kneeling Model, from the *Vollard Suite,* April 8, 1933

Etching, 14¹⁵⁄₃₂ x 11¾ inches
Gift of Ellen and Wallace K. Harrison, Class of 1950H, in honor of Nelson A. Rockefeller, Class of 1930; PR.965.23.40

131. Pablo Picasso

Blind Minotaur Guided by a Young Girl through the Night, from the *Vollard Suite,* December 3–7 and December 31, 1934, and/or January 1, 1935

Aquatint, scraper, drypoint, and burin, 9²³⁄₃₂ x 13²¹⁄₃₂ inches
Gift of Ellen and Wallace K. Harrison, Class of 1950H, in honor of Nelson A. Rockefeller, Class of 1930; PR.965.23.93

The *Vollard Suite,* a compilation of one hundred prints from the 1930s, offers a fascinating glimpse into the artistic process of Pablo Picasso. While the artist's thoughts are not literally revealed, his subjects—the sculptor's studio, the artist's relationship with the model, the minotaur, rape, sexual desire, and domination—are played out in the series like a musical performance full of variations, nuances, and repetitions. Almost every plate is dated with the month, day, and year—a practice that lays bare the artist's interweaving of certain themes and subjects—with the bulk of the images falling in 1933 and 1934.

The art dealer Ambroise Vollard (1867–1939), after whom the series is named, possessed a remarkable talent for discovering genius—he gave Cézanne, Matisse, and Picasso their first solo exhibitions. He was also a shrewd businessman and would often take advantage of destitute artists, buying low and selling high. The equally astute Picasso, who met Vollard after he came to Paris in 1901, quickly learned that it was to his advantage to limit his dealings with him. After their early association in the first decade of the century, the artist did not work with Vollard again until 1925, when the dealer commissioned him to make a series of prints after a Balzac short story. Without a doubt, this renewed association between the two men led to Picasso's increased print production

in the 1930s. Picasso's main print project of that decade, the *Vollard Suite,* was not a commissioned project based on a particular narrative. Its genesis is, in fact, unknown. Perhaps as early as 1931, when Picasso had already completed a number of the plates that would later be included in the suite, Vollard arranged to trade some paintings to Picasso for one hundred plates—most of which had yet to be created. Vollard eventually gained possession of his promised ninety-nine plates (one is etched on both sides) sometime in 1937 or shortly thereafter. They were probably chosen by both Picasso and Vollard from a larger stockpile of the artist's print production from these years. When Vollard died in 1939, the suite remained unpublished, even though he had commissioned special paper for its printing and had assigned the plates to the print atelier of Roger Lacourière. Lacourière later printed ninety-seven of the plates in three editions: three signed sets on vellum, fifty unsigned sets on paper half the size of the vellum, and between 245 and 250 unsigned sets on the Picasso-Vollard watermarked Montval paper. Most of the sets were then acquired during World War II from the Vollard estate by the print dealer Henri Petiet and released to the market between 1946 and 1948. Ninety-seven prints of the Hood Museum of Art's *Vollard Suite* are from the edition of 250 sets printed on Picasso-Vollard watermarked Montval paper. They were given to

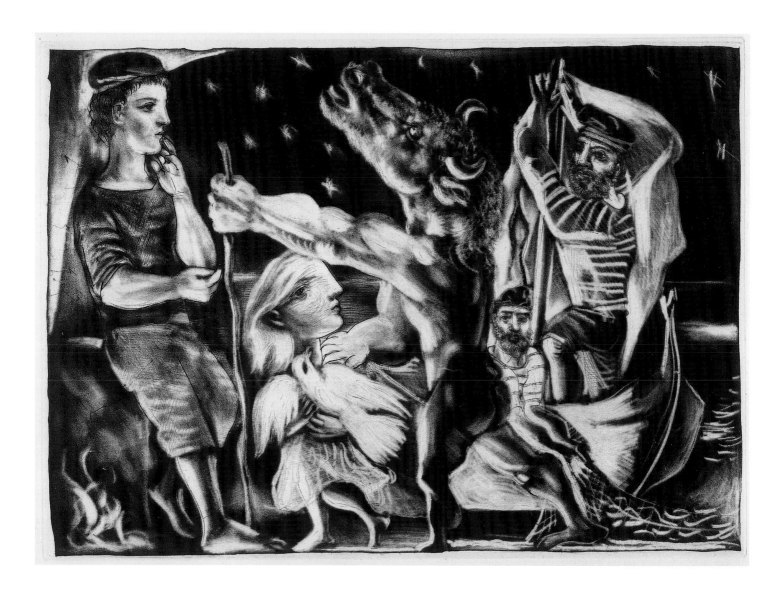

the college in 1965 by Wallace K. Harrison, in honor of Nelson K. Rockefeller, Class of 1930. The last three prints in the series, all portraits of Vollard, were purchased a short time later.

Art historians have identified the dominant technique Picasso employs in the suite as part of his "classical" style, which is characterized by simple, elegant lines that are freely drawn on the surface of the etching plate. *Sculptor and Kneeling Model* is an example of the linear-style works that dominate the suite and is one of numerous prints (over thirty-five) in the series that are meditations on the creative process. The bearded man, legs splayed in an open and vulnerable position, stares at the model, who in turn gazes at herself in the mirror that is propped up on a sculpted, Zeus-like head. In contrast to other scenes where the model forms part of a triad along with the artist and the sculpture, here she is absorbed in her reflection and not in the man watching her intently. Her head, right shoulder, and hand are realized via a network of densely worked lines, while her lower body and legs are realized via only five elegant strokes of the etching needle. Perhaps her gaze marks a moment of self-awakening

and self-determination, or she may simply join a long line of female nudes whose self-regard is a signifier of vanity. Picasso has made her partly solid or sculptural and partly line or drawing, playing on the Pygmalion theme of life breathed into a creation of the artist's imagination. The cerebral head on which the mirror is propped, perhaps an alter ego for the artist, stares out with furrowed brow, lending a disquieting tone to the contemplative scene.

In late April 1933, Picasso began to experiment with the printmaking medium by using various etching methods to scar and scratch the plate, allowing for a spontaneity and freedom that came quite naturally to an artist of such confidence and independence. It is this unfinished quality, which allows room for failure as well as success, that makes Picasso's prints of the 1930s so remarkable. *The Blind Minotaur Guided by a Young Girl* of 1934 is one of the late works in the suite and also the most highly finished and well-known. The plates he created just before it (see figs. 1–3) show the development of his imagery for the *Blind Minotaur* and reveal the solidification of its mythic content. In the first print from September 22 (fig. 1),

FIG. 1. Pablo Picasso, *Blind Minotaur Guided by a Young Girl, I,*
September 22, 1934, etching and engraving, 9¹⁵⁄₁₆ x 13²³⁄₃₂ inches. Gift of
Ellen and Wallace K. Harrison, Class of 1950H, in honor of Nelson A.
Rockefeller, Class of 1930; PR.965.23.90.

the small girl who resembles Picasso's lover, Marie-Thérèse, carries flowers as she leads the dependent blind Minotaur. A young sailor in a striped shirt watches in a pose typical of Ingres's Oedipus, who ponders the sphinx before he answers her riddle. Sailors, one of whom draws a net, also watch the processing figures.

In contrast to the image of the innocent young girl, Picasso has included a crude crossed-out scene in the upper left of the print, an upside-down image of Charlotte Corday killing the French revolutionary Marat in his bath. Picasso had done a small print of the same subject on July 21. The murderous female is shown with the *vagina dentata* (a vagina with teeth) typical of his female images of the late 1920s, and she appears to be yelling as she stabs the knife into Marat. Picasso's relationship with his wife Olga was disintegrating at this time, and some scholars relate the violence of these female figures to Picasso's reaction to the increasing turmoil in his personal life. (He officially separates from Olga in June 1935.) In the next print in the series (fig. 2), the Marat scene is eliminated and the young girl now carries a white dove, a symbol of innocence and, in the Biblical story of Noah, of hope. In the final print of the blind Minotaur, Picasso uses aquatint to create a rich, velvety black tonality and has scraped and burnished the plate to reveal the figures and the night sky. The Minotaur puts one arm on Marie-Thérèse's shoulder as she leads him while looking back at him instead of forward. Picasso would return to the theme of night fishing in a painting of the same name of 1939 (Museum of Modern Art, New York). [*Picasso's Vollard Suite* 1980; *Thank You, Wallace K. Harrison* 1985]

KWH

FIG. 2. Pablo Picasso, *Blind Minotaur Guided by a Young Girl, II,*
October 23, 1934, etching and engraving, 9⁵⁄₁₆ x 11¾ inches. Gift of Ellen
and Wallace K. Harrison, Class of 1950H, in honor of Nelson A.
Rockefeller, Class of 1930; PR.965.23.91.

FIG. 3. Pablo Picasso, *Blind Minotaur Guided by a Young Girl, III,*
November 4, 1934, etching and engraving, 8²⁹⁄₃₂ x 12⁹⁄₃₂ inches. Gift of
Ellen and Wallace K. Harrison, Class of 1950H, in honor of Nelson A.
Rockefeller, Class of 1930; PR.965.23.92.

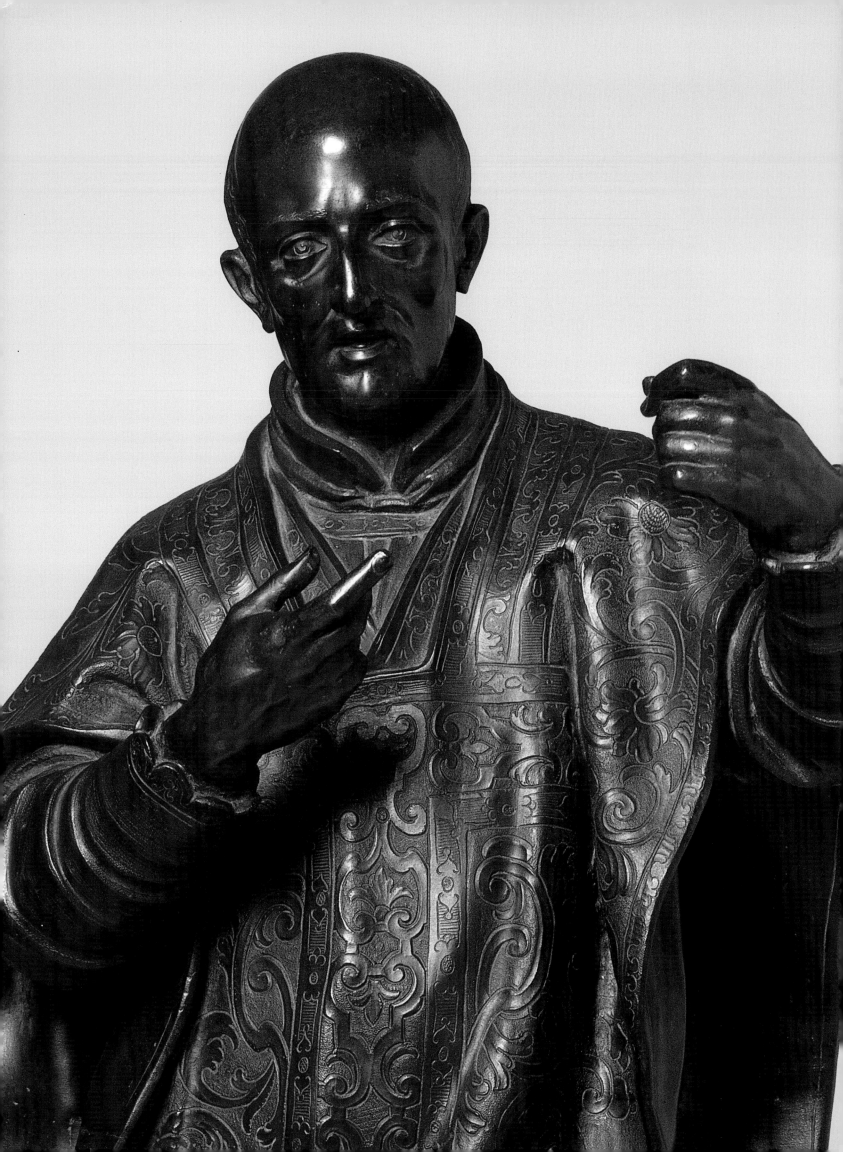

SELECTED BIBLIOGRAPHY

Acidini Luchinat, Cristina. *Taddeo e Federico Zuccari: fratelli pittori del Cinquecento*. 2 vols. Milan: Jandi Sapi, 1998–99.

Acquisitions, 1974–1978. Hanover, N.H.: Dartmouth College Museum and Galleries, 1979.

Alhadeff, Albert. "Rodin: A Self-Portrait in the Gates of Hell." *Art Bulletin* 48, nos. 3–4 (September–December 1966): 393–95.

Annual Report, 2005–6. Hanover, N.H.: Hood Museum of Art, Dartmouth College, 2006.

Art of Tomorrow: Hilla Rebay and Solomon R. Guggenheim. Exhibition catalogue. New York: Guggenheim Museum, distributed through D.A.P. / Distributed Art Publishers, 2005.

Asleson, Robyn. "Atlantic Crossings: British Paintings in America, 1630–1930." In *Great British Paintings from American Collections: Holbein to Hockney,* ed. Malcolm Warner and Robyn Aselson. New Haven: Yale University Press, 2001. 19–45.

Baas, Jacquelynn. "'The Epic of American Civilization': The Mural at Dartmouth College." In *José Clemente Orozco in the United States, 1927–1934,* ed. Renato González Mello and Diane Miliotes. Hanover, N.H.: Hood Museum of Art, Dartmouth College, in association with W. W. Norton, 2002. 142–85.

———. "From 'A Few Curious Elephant Bones' to Picasso." *Dartmouth Alumni Magazine* 77, no. 11 (September 1985).

———. "A History of the Dartmouth College Museum Collections." In *Treasures of the Hood Museum of Art*. Hanover, N.H.: Hood Museum of Art, Dartmouth College, in association with Hudson Hills Press, 1985.

Baillio, Joseph. *Elisabeth Louise Vigée Le Brun, 1755–1842*. Exhibition catalogue. Fort Worth, Texas: Kimbell Art Museum, 1982.

Baldassari, Anne, ed., with essays by Pierre Daix, Irving Lavin, and Leo Steinberg. *Cubist Picasso*. Paris: Flammarion, distributed in North America by Rizzoli, 2008.

Baldinucci, Filippo. *Notizie de' professori del disegno da Cimabue in qua . . .* Florence: Per Santi Franchi, 1681.

Barnett, Vivian Endicott, and Armin Zweite, eds. *Kandinsky: Watercolors and Drawings*. Exhibition catalogue. Munich: Prestel, distributed in the United States and Canada by Neues Pub. Co., 1992.

Barr, Alfred H. Papers: J: 1960–1965. Modern Museum of Art.

Barrington, Robert. "Copyist, Connoisseur, Collector: Charles Fairfax Murray (1849–1919). *Apollo: The International Magazine of the Arts* 140, no. 393 (November 1994): 15–21.

Bauquier, Georges, with Nelly Maillard. *Fernand Léger: Catalogue raisonné de l'oeuvre peint*. 8 vols. Paris: A. Maeght, 1990–2000.

Belknap, Jeremy. "Diary of a Trip to Dartmouth College" (1774). Massachusetts Historical Society, Belknap Papers, Box 5, Folder 14.

Bentini, Jadranka, Gian Piero Cammarota, Angelo Mazza, Daniela Kelescian Scaglietti, and Anna Stanzani. *Pinacoteca Nazionale di Bologna. Catalogo generale. 2. Da Raffaello ai Carracci*. Venice: Marsilio, 2006.

Bialer, Nancy. *Chiaroscuro Woodcuts: Hendrick Goltzius (1558–1617) and His Time*. Amsterdam: Rijksmuseum, in association with Snoeck-Ducaju and Zoon, 1992.

Bliss, Joseph R. "Italian Renaissance and Baroque Bronzes at the Minneapolis Institute of Arts." Ph.D. diss., Case Western Reserve University, 1997.

Blumenthal, Arthur R. *Portraits at Dartmouth*. Exhibition catalogue. Hanover, N.H.: Dartmouth College Museum and Galleries, 1978.

———. *Theater Art of the Medici*. Exhibition catalogue. Hanover, N.H.: Dartmouth College Museum and Galleries, distributed by the University Press of New England, 1980.

Boggs, Jean Sutherland, with essays by Marie-Laure Bernadac and Brigitte Léal. *Picasso and Things*. Exhibition catalogue. Cleveland: Cleveland Museum of Art, distributed by Rizzoli International Publications, 1992.

Bowen, W. Wedgwood. *A Pioneer Museum in the Wilderness*. Hanover, N.H.: Dartmouth College Museum, 1958.

Bowron, Edgar Peters. *Pompeo Batoni: Prince of Painters in Eighteenth-Century Rome*. Exhibition catalogue. Houston: Museum of Fine Arts, in association with Yale University Press, 2007.

Boyer, Ferdinand. "Catalogue raisonné de l'oeuvre de Charles Natoire." *Archives de l'art français* n.s. 21 (1949): 29–106.

Bretell, Richard R., and Suzanne Folds McCullagh. *Degas in the Art Institute of Chicago*. Exhibition catalogue. Chicago: Art Institute of Chicago, in association with H. N. Abrams, 1984.

Brigstocke, Hugh, and John Somerville. *Italian Paintings from Burghley House*. Exhibition catalogue. Alexandria, Va.: Art Services International, 1995.

Brink, Goldsmith, Jane Ten, et al. *Jesuit Art in North American Collections*. Exhibition catalogue. Milwaukee, Wisc.: Patrick and Beatrice Haggerty Museum of Art, Marquette University, 1991.

Bull, Duncan. "Trevisani's 'St. Felicity,' a Gift from Cardinal Ottoboni to the Marquis de Torcy." *The Burlington Magazine* 150, no. 1258 (January 2008): 4–14.

Bulletin of the Hopkins Center Art Galleries, Dartmouth College 1 (January 1966).

Burke, Marcus B. *Jesuit Art and Iconography, 1550–1800.* Exhibition catalogue. Jersey City, N.J.: Saint Peter's College, Art Gallery, 1993.

Bury, Michael. *The Print in Italy, 1550–1620.* Exhibition catalogue. London: British Museum, 2001.

Caffin Madaule, Liliane. *Catalogue raisonné des oeuvres de Maria Blanchard.* 2 vols. London: Editions Liliane Caffin Madule, 1992–94.

Carter, Nathan H. *Letters from Europe.* 2nd ed. 2 vols. New York: G and C and H Carvill, 1829.

Catalogue des tableaux composant la galerie de feu son Eminence le Cardinal Fesch. Rome: Joseph Salvucci et Fils, 1841.

Catalogue of Dartmouth College. Hanover, N.H.: Printed for the College by the Rumford Press, 1913.

Catalogue of Dartmouth College. Hanover, N.H.: Printed for the College by the Rumford Press, 1914.

Cate, Phillip Dennis, Gale B. Murray, and Richard Thomson. *Prints Abound: Paris in the 1890s from the Collections of Virginia and Ira Jackson and the National Gallery of Art.* Exhibition catalogue. Washington, D.C.: National Gallery of Art, in association with Lund Humphries, 2000.

Celebrating Twenty Years: Gifts in Honor of the Hood Museum of Art. Hanover, N.H.: Hood Museum of Art, Dartmouth College, 2005.

Chase, Frederick. *A History of Dartmouth College and the Town of Hanover,* ed. John K. Lord. Cambridge, Mass.: J. Wilson, 1891–1913.

Clark, Anthony M. *Studies in Roman Eighteenth-Century Painting,* selected and edited by Edgar Peters Bowron. Washington, D.C.: Decatur House Press, 1981.

———. *Pompeo Batoni: A Complete Catalogue of His Works,* ed. Edgar Peters Bowron. Oxford: Phaidon, 1985.

Cohn, Marjorie B. *Francis Calley Gray and Art Collecting for America.* Cambridge, Mass.: Harvard University Art Museums, distributed by Harvard University Press, 1986.

Cooper, Douglas, with the collaboration of Margaret Potter. *Juan Gris: Catalogue raisonné de l'oeuvre peint.* 2 vols. Paris: Berggruen, 1977.

Costa, René de. "Juan Gris and Petry: From Illusionism to Creation." *Art Bulletin* 71, no. 4 (December 1989): 674–92.

Crowe, J. A., and G. B. Cavalcaselle. *A History of Painting in Italy. Vol. 5: Umbrian and Sienese Masters of the Fifteenth Century,* ed. Tancred Borenius. New York: Charles Scribner's Sons, 1914.

Daix, Pierre, and Joan Rosselet. *Picasso: The Cubist Years, 1907–1916. A Catalogue Raisonné of the Paintings and Related Works.* Boston: New York Graphic Society, 1979.

Dance, W. David. *Memoirs.* Naples, Fla.: Privately printed, 2007.

Dartmouth, William Legge, Earl of. Letter to Nathan Lord, September 6, 1830. Dartmouth College Library, Rauner Special Collections, Manuscript 830506.

Dartmouth College Catalogue. Hanover, N.H.: Dartmouth College Publications, 1930.

Dartmouth College Handbook 9. Hanover, N.H.: Dartmouth Christian Association, 1897–98.

Dedication of Rollins Chapel and Wilson Hall. Printed for the College, 1886.

De Grazia, Diane. *Prints and Related Drawings by the Carracci Family: A Catalogue Raisonné.* Exhibition catalogue. Washington, D.C.: National Gallery of Art, 1979.

Delacroix, Eugène. *Journal de Eugène Delacroix.* Introduction and notes by André Joubin. 3 vols. Paris: Plon, 1932.

Dézallier d'Argenville, Antoine-Nicolas. *Voyage picturesque de Paris.* Paris: Chez De Bure, 1749.

Di Federico, Frank R. *Francesco Trevisani: Eighteenth-Century Painter in Rome; A Catalogue Raisonné.* Washington, D.C.: Decatur House Press, 1977.

Druick, Douglas W., and Michel Hoog. *Fantin-Latour.* Exhibition catalogue. Ottawa: National Gallery of Ottawa, in association with National Museums of Canada, 1983.

Edouard Vuillard. Exhibition catalogue. Washington, D.C.: National Gallery of Art, 2003.

Ehrlich White, Barbara. "Delacroix's Painted Copies after Rubens." *Art Bulletin* 49, no. 1 (March 1967): 37–51.

Ekserdjian, David. "Unpublished Drawings by Parmigianino: Towards a Supplement to Popham's Catalogue Raisonne." *Apollo Magazine* 150, no. 450 (August 1999): 3–41.

Emison, Patricia, with contributions by Wendy Smith Rappa and Sean Roberts. *The Simple Art: Printed Images in an Age of Magnificence.* Exhibition catalogue. Durham, N.H.: The Art Gallery, University of New Hampshire, 2006.

Engelberts, Edwin. *Georges Braque: Oeuvre graphique original.* Exhibition catalogue. Geneva: C. Pezzotti, 1958.

Erffa, Helmut von, and Allen Staley. *The Paintings of Benjamin West.* New Haven: Yale University Press, 1986.

Evans, George H. *Catalogue of Portraits and Other Works of Art in the Gallery of Dartmouth College.* Hanover, N.H.: no publisher, 1901.

"Exhibition of Old Masters." *Dartmouth Alumni Magazine* 10, no. 4 (February 1918): 199.

Fawcett, Trevor. "Visual Facts and the Nineteenth-Century Art Lecture," *Art History* 6 (December 1983): 442–60.

Ferri Chulio, Andrés de Sales. *Francisco Vergara Bartual, Escultor, 1713–1761.* Sueca, Spain: A. de S. Ferri, 1998.

Fisher, Jay McKean. "Drawing Is Sculpture Is Drawing." In *Matisse: Painter as Sculptor,* ed. Dorothy Kosinski, Jay McKean Fisher, and Steven Nash. Exhibition catalogue. Baltimore: Baltimore Museum of Art, in association with the Dallas Museum of Art and Nasher Sculpture Center and Yale University Press, 2007. 27–47.

Fitz Darby, Delphine. "Ribera and the Blind Men." *Art Bulletin* 39, no. 3 (September 1957): 195–217.

———. "Ribera and the Wise Men." *Art Bulletin* 44, no. 4 (December 1962): 279–307.

Flam, Jack, ed. *Matisse on Art*. Rev ed. Berkeley: University of California Press, 1995.

Folds McCullagh, Suzanne, and Laura M. Giles. *Italian Drawings before 1600 in the Art Institute of Chicago: A Catalogue of the Collection*. Chicago: Art Institute of Chicago, 1997.

Franklin, David, with an essay by David Ekserdjian. *The Art of Parmigianino*. Exhibition catalogue. New Haven: Yale University Press, in association with the National Gallery of Canada, Ottawa, 2003.

Franz, Heinrich Gerhard. *Niederländische Landschaftsmalerei im Zeitalter des Manierismus*. 2 vols. Graz: Akademische Druck-u. Verlagsanstalt, 1969.

Freedberg, Sydney J. *Parmigianino: His Works in Painting*. Cambridge, Mass.: Harvard University Press, 1950

A Gift to the College: The Mr. and Mrs. Adolph Weil Jr. Collection of Master Prints, with essays by Timothy Rub and Egbert Haverkamp-Begemann, catalogue by Kelley Pask, and contributions by Juliette Bianco et al. Exhibition catalogue. Hanover, N.H.: Hood Museum of Art, Dartmouth College, in association with Abaris Books, 1998.

Gillerman, Dorothy. *Gothic Sculpture in America*. Publications of the International Center of Medieval Art 2. New York: Garland Publications, 1989.

Gnappi, Carla Maria. "The Sunflower and the Rose: Notes towards a Reassessment of Blake's Illustrations of Dante." In *British Romanticism and Italian Literature: Translating, Reviewing, Rewriting*, ed. Laura Bandiera and Diego Saglia. New York: Rodopi, 2005. 55–68.

Goldfarb, Hilliard T. "Recent Accessions in European and Graphic Art at the Hood." *Dartmouth Alumni Magazine* 78, no. 7 (April 1986): 44–45.

———. *A Humanist Vision: The Adolph Weil Jr. Collection of Rembrandt Prints*. Exhibition catalogue. Hanover, N.H.: Hood Museum of Art, 1988.

Goldfarb, Hilliard T., and Reva Wolf. *Fatal Consequences: Callot, Goya, and the Horrors of War*. Exhibition catalogue. Hanover, N.H.: Hood Museum of Art, 1990.

Goldfarb, Hilliard T., ed. *Richelieu: Art and Power*. Exhibition catalogue. Montreal: Montreal Museum of Fine Arts, in association with the Wallraf-Richartz Museum—Foundation Corboud of the City of Cologne and Snoeck-Ducaju and Zoon, Ghent, 2002.

Golhany, Amy. "Review of 'The Age of the Marvelous.'" *Sixteenth-Century Journal* 24, no. 4 (Winter 1993): 972–73.

Green, Christopher. *Art in France: 1900–1940*. New Haven: Yale University Press, 2000.

Hagen, Charles. "A Commodious Omnium-Gatherum at Dartmouth." *New York Times* (November 10, 1991): 33.

Hallam, John Stephen. "The Genre Works of Louis-Leopold Boilly." Ph.D. diss., University of Washington, 1979.

Hand, John Oliver, Catherine A. Metzger, and Ron Spronk. *Prayers and Portraits: Unfolding the Netherlandish Diptych*. Exhibition catalogue. Washington, D.C.: National Gallery of Art and Koinklijk Museum voor Schoone Kunsten, Antwerp, in association with Harvard University Art Museums and Yale University Press, 2006.

Hardouin-Fugier, Elizabeth, and Etienne Grafe. *Le peinture lyonnaise au XIXe siècle*. Paris: Editions de l'amateur, 1995.

Harris, Neil. "The Gilded Age Revisited: Boston and the Museum Movement." *American Quarterly* 14, no. 4 (Winter 1962): 545–66.

Hayes, John. *Rowlandson: Watercolours and Drawings*. London: Phaidon Press, 1972.

Heard, Patricia L. *With Faithfulness and Quiet Dignity: Albert Gallatin Hoit, 1809–1856*. Concord, N.H.: New Hampshire Historical Society, 1985.

Hébert. *Almanach pittoresque historique et alphabétique des riches monuments que renferme la ville de Paris*. Paris: s.n., 1779.

Heim, Jean-François, Claire Béraud, and Philippe Heim. *Les salons de peinture de la Révolution française, 1789–1799*. Paris: C.A.A. S.A.R.L. Edition, 1989.

Hellebranth, Robert. *Charles-François Daubigny, 1817–1878*. Morges: Matute, 1976.

Hellerstedt, Kahren. *Gardens of Earthly Delight: Sixteenth- and Seventeenth-Century Netherlandish Gardens*. Exhibition catalogue. Pittsburgh: Frick Art Museum, distributed by Indiana University Press, 1986.

Hilard, George S., ed., assisted by Anna Eliot Ticknor. *Life, Letters, and Journals of George Ticknor*. 2 vols. Boston: J. R. Osgood, 1876.

Hiller von Gaertringen, Rudolf. "Uso e risuo del cartone nell'opera del Perugino: l'arte fra vita contemplativa e produttiva." In *Pietro Vannucci: Il Perugino*, ed. Laura Teza. Perugia: Volumnia, 2004. 335–50.

Hoefnagel, Dick, and Jeffrey L. Horrell. "The Sherman Art Library Fireplace-Mantel: From Paris to Dartmouth." *Dartmouth College Library Bulletin* n.s. 29, no. 2 (April 1989): 72–82.

Hogarth and His School: Paintings and Prints from the Collection of Earle W. Newton. Exhibition brochure. Hanover, N.H.: Carpenter Galleries, Dartmouth College, 1960.

Hollstein, F. W. H. *Dutch and Flemish Etchings, Engravings, and Woodcuts, ca. 1450–1700*. 72 vols. Amsterdam: M. Hertzberger, 1949–.

The Hood Museum of Art, 1985–1995. Brochure. Hanover, N.H.: Hood Museum of Art, Dartmouth College, 1996.

Höper, Corinna. *Katalog der Gemälde des 14. bis 18. Jahhunderts in der Kunsthalle Bremen*. Bremen: Kunsthalle, 1990.

Hopmans, Anita. *The Van Dongen Nobody Knows: Early and Fauvist Drawings, 1895–1912*. Rotterdam: Boijmans Van Beuningen Museum, 1996.

Jackson, Robert. Miscellaneous correspondence. Dartmouth College Library, Rauner Special Collections, Manuscript 301.

John Quinn, 1870–1925: Collection of Paintings, Water Colors, Drawings, and Sculpture. Huntington, N.Y.: Pidgeon Hill Press, 1926.

Jordan, William B. *Juan van der Hamen y León and the Court of Madrid.* New Haven: Yale University Press, 2005.

Judson, J. Richard. "Comments on Rubens' 'Coup de Lance': Its Iconography, Style, and Importance for Eugène Delacroix." In *Rembrandt, Rubens, and the Art of Their Time: Recent Perspectives,* ed. Roland E. Fleischer and Susan Claire Scott. Papers in Art History from the Pennsylvania State University 11. University Park: Pennsylvania State University, 1997. 106–21.

Kanter, Laurence B., with an introduction by Eric Zafran. *Italian Paintings in the Museum of Fine Arts, Boston.* Boston: Museum of Fine Arts, distributed by Northeastern University Press, 1994.

Karshan, Donald H. *Archipenko: The Sculpture and Graphic Art, Including a Print Catalogue Raisonné.* Tübingen: Wasmuth, 1974.

Kemeny, John G. Papers: DP-13 (46): R file; and DP-13 (51): Gifts. Dartmouth College Library, Rauner Special Collections.

Kenseth, Joy, ed. *The Age of the Marvelous.* Exhibition catalogue. Hanover, N.H.: Hood Museum of Art, distributed by the University of Chicago Press, 1991.

———. "Splendor at the Table: The Artistry of Jan Davidsz. de Heem." *Hood Museum of Art Quarterly* 16 (Summer 2006): 4–5.

Kidson, Alex. *George Romney, 1734–1802.* Princeton, N.J.: Princeton University Press, 2002.

———. *Those Delightful Regions of Imagination: Essays on George Romney.* Studies in British Art 9. New Haven: Published for the Paul Mellon Centre for Studies in British Art, Yale Center for British Art, 2002.

Kitson, Michael. "Further Unpublished Paintings by Claude." *The Burlington Magazine* 122, no. 933 (December 1980): 834–37.

Kühn-Hattenhauer, Dorothee. "Das grafische Oeuvre Francesco Villamena." Ph.D. diss., Freie Universität, Berlin, 1979.

Kuretsky, Susan Donahue, with contributions by Walter S. Gibson et al. *Time and Transformation in Seventeenth-Century Dutch Art.* Poughkeepsie, N.Y.: Frances Lehman Loeb Art Center, Vassar College, distributed by University of Washington Press, 2005.

Lanchner, Carolyn. *Fernand Léger.* New York: Museum of Modern Art and Harry N. Abrams, 2002.

Lansburgh, Mark, with an introduction by Peter Fusco. *2000 Years of Sculpture from the Classical Age to the Baroque: Collection of Mark Lansburgh.* Exhibition catalogue. Santa Barbara, Cal.: Santa Barbara Museum of Art, 1977.

Lathrop, Churchill P. "The Story of Art at Dartmouth." *College Art Journal* 10, no. 4 (Summer 1951): 395–411.

———. Letter to A. Conger Goodyear. June 5, 1961. Hood Museum of Art donor files.

———. "A Collector's Choice: Selected Gifts Presented by Mr. and Mrs. William B. Jaffe . . . , 1955–1972." Hanover, N.H.: Hopkins Center, Dartmouth College, 1972.

Lavin, Marilyn Aronberg. "Review of 'Federico Barocci' by Harald Olsen." *Art Bulletin* 46, no. 2 (June 1964): 251–54.

Lee, Rensselaer W. *Ut picture poesis. The Humanistic Theory of Painting.* New York and London: W. W. Norton and Company, 1967.

Leone de Castris, Pierluigi, with Mariella Utili and Rossana Muzii. *Museo e gallerie nazionali di Capodimonte. La collezione Farnese. 1. La scuola emiliana: I dipinti e i disegni,* ed. Nicola Spinosa. Naples: Electa Napoli, 1994.

Leppert, Richard D. *Music and Image: Domesticity, Ideology, and Socio-Cultural Formation in Eighteenth-Century England.* Cambridge: Cambridge University Press, 1988.

Lieure, Jules. *Jacques Callot. Deuxième partie. Catalogue de l'oeuvre grave.* 3 vols. Paris: Gazette des Beaux-Arts, 1924–27.

Lipchitz, Jacques, with Harvard H. Arnason. *My Life in Sculpture.* The Documents of 20th-Century Art. New York: Viking Press, 1972.

Lo Bianco, Anna. *Pietro da Cortona, 1597–1669.* Exhibition catalogue. Milan: Electa, 1997.

Lochnan, Katharine, and Brenda Rix. *Printmaking in Nineteenth-Century France.* Toronto: Art Gallery of Ontario, 1988.

Lord, George D. "Description of Stereopticon View Relating to the Early History of Dartmouth" (1904). Dartmouth College Library, Rauner Special Collections.

Lord, John K. *A History of Dartmouth College.* Concord, N.H.: Rumford Press, 1913.

Luca Giordano, 1634–1705. Exhibition catalogue. Naples: Electa Napoli, 2001.

Lukach, Joan M. *Hilla Rebay: In Search of the Spirit of Art.* New York: G. Braziller, 1983.

MacAdam, Barbara J. "American Drawings and Watercolors at Dartmouth: A History." In *Marks of Distinction: Two Hundred Years of American Drawings and Watercolors from the Hood Museum of Art.* Exhibition catalogue. Hanover, N.H.: Hood Museum of Art, Dartmouth College, in association with Hudson Hills Press, 2005.

———. *American Art at Dartmouth: Highlights from the Hood Museum of Art.* Hanover, N.H.: Hood Museum of Art, Dartmouth College, in association with University Press of New England, 2007.

Malvasia, Carlo Cesare. *Felsina pittrice: Vite de pittori bolognesi.* 2 vols. Bologna: Erede di D. Barbieri, 1678.

Manuscripts of the Earl of Dartmouth. 3 vols. London: Printed for H. M. Stationery Office by Eyre and Spottiswoode, 1887–96.

Marandet, François. "Les deux tableaux peints pour l'oratoire de la Dauphine au château de Versailles: La Visitation et La Fuite en Egypte par Louis de Silvestre (1675–1760)." *La Revue des Musées de France* 2 (April 2004): 74–77.

Marquis, Albert N., ed. *Who's Who in New England*. 2nd ed. Chicago: A. N. Marquis and Co., 1916.

Marsh, Caroline C. *Life and Letters of George Perkins Marsh*. 2 vols. New York: C. Scribner's Sons, 1888.

Martin, John Rupert. *The Decorations for the Pompa Introitus Ferdinandi*. Corpus Rubenianum Ludwig Burchard, part 16. London: Phaidon, 1972.

Martineau, Jane, and Andrew Robison, eds. *The Glory of Venice: Art in the Eighteenth Century*. New Haven: Yale University Press, 1994.

Marx, Harald. *Die Gemälde des Louis de Sylvestre*. Dresden: Staatl. Kunstsammlungen, 1975.

Mayer, August L. *Jusepe de Ribera (Lo Spagnoletto)*. Kunstgeschichtliche monographien 10. Leipzig: K. W. Hiersemann, 1923.

Mazza, Angelo. "Imitazione, emulazione, inganni: Alcuni esempi nella quadreria dell'Opera Pia dei Poveri Vergognosi." In *Gli splendori della vergogna: La collezione dei dipinti dell'Opera Pia dei Poveri Vergognosi*, ed. Celide Masini. Bologna: Nuova Alfa Editoriale, 1995. 21–49.

McBurney, Henrietta, and Nicholas Turner. "Drawings by Guido Reni for Woodcuts by Bartolomeo Coriolano." *Print Quarterly* 5, no. 3 (1988): 227–41.

McGill, Douglas. "New Hood Art Museum Opening at Dartmouth." *New York Times* (September 26, 1985), C-17.

M'Clure, David, and Elijiah Parish. *Memoirs of the Rev. Eleazor Wheelock . . .* Newburyport, N.H.: E. Little and Co., C. Norris and Co., Printers, 1811.

Meacham, Scott B. "Charles Alonzo Rich Builds the New Dartmouth, 1893–1914." M.A. thesis, University of Virginia, 1998.

Meijer, Fred G. *Jan Davidsz. de Heem, 1606–1684: His Influences and His Followers*. Exhibition brochure. London: Rafael Vals Gallery, 2005.

Meyers, Mary L. "Rubens and the Woodcuts of Christoffel Jegher." *Metropolitan Museum of Art Bulletin* n.s. 25, no. 1 (Summer 1966): 7–23.

Miliotes, Diane. "On All Fronts: Posters from the World Wars in the Dartmouth Collection." In the exhibition brochure *War Posters*. Hanover, N.H: Hood Museum of Art, Dartmouth College, 1999.

Mormorando, Franco, ed. *Saints and Sinners: Caravaggio and the Baroque Image*. Exhibition catalogue. Boston: McMullen Museum of Art, Boston College, distributed by University of Chicago Press, 1999.

Mussini, Massimo, with assistance from Daniela Dagli Alberti et al. *Correggio tradotto; fortuna di Antonio Allegri nella stampa di riproduzioni fra Cinquecento e Ottocento*. Reggio Emilia: Cassa di Risparmio di Reggio Emilia, 1995.

Nesmith, George W. Letter to Samuel C. Bartlett. June 30, 1879. Dartmouth College Library, Rauner Special Collections, Manuscript 879380.

Nichols, Lawrence W. *Piranesi at Dartmouth: Etchings by Giovanni Battista Piranesi in the Dartmouth College Collections*. Hanover, N.H.: Hopkins Center, Dartmouth College, 1976.

Nicholson, Benedict. *Carvaggism in Europe*. 2nd ed., revised and enlarged by Lusia Vertova. 3 vols. Turin: U. Allemandi, 1990.

Nicolas Tournier, 1590–1639: Un peintre caravagesque. Exhibition catalogue. Paris: Somogy éditions d'art, in association with the Musée des Beaux-Arts de Toulouse, 2001.

Odom, Anne. "American Collectors of Russian Decorative Art." In *Treasures into Tractors: The Selling of Russia's Cultural Heritage, 1917–1937*. Forthcoming.

Olszewski, Edward J. *The Inventory of Cardinal Pietro Ottoboni, 1667–1740*. New York: Peter Lang, 2004.

Ornstein, Nadine M., ed. *Pieter Bruegel the Elder: Drawings and Prints*. Exhibition catalogue. New York: Metropolitan Museum of Art, in association with Yale University Press, 2001.

Panofsky, Erwin. *Albrecht Dürer*. 2 vols. Princeton, N.J.: Princeton University Press, 1943.

Paulson, Ronald. *Hogarth's Graphic Works*. 3rd rev. ed. London: Print Room, 1989.

Picasso's Vollard Suite: From the Collection of Dartmouth College Museum and Galleries, Hanover, New Hampshire. Hanover, N.H.: Trustees of Dartmouth College, 1980.

Pillsbury, Edmund P. "Federico Barocci." In *The Dictionary of Art*, ed. Jane Turner. New York: Grove's Dictionaries, 1996.

Pillsbury, Edmund P., and Louise S. Richards. *The Graphic Art of Federico Barocci: Selected Drawings and Prints*. Exhibition catalogue. New Haven: The Gallery, 1978.

Piotrowska, Anna. "Le Premier de son temps: Carle Vanloo (1705–1765) and the Dynamics of 18th-century French History Painting." Ph.D. diss., Institute of Fine Arts, New York University, forthcoming.

Planiscig, Leo. *Venezianische Bildhauer der Renaissance*. Vienna: Schroll, 1921.

Popham, A. E. *Catalogue of the Drawings of Parmigianino*. 3 vols. New Haven: Published for the Pierpont Morgan Library by Yale University Press, 1971.

Prince, Ann. *The Old Guard and the Avant-Garde: Modernism in Chicago, 1910–1940*. Chicago: University of Chicago Press, 1990.

The Protean Century, 1870–1970: A Loan Exhibition from the Dartmouth College Collection, Alumni, and Friends of the College. Exhibition catalogue. Lunenberg, Vt.: Designed and Printed at the Stinehour Press, 1970.

Py, Bernadette. "Everhard Jabach: Supplement of Identifiable Drawings from the 1695 Estate Inventory." *Master Drawings* 45, no. 1 (Spring 2007): 4–37.

Rand, Richard, and John Varriano. *Two Views of Italy: Master Prints by Canaletto and Piranesi*. Exhibition catalogue. Hanover, N.H.: Hood Museum of Art, Dartmouth College, 1995.

———. *A Decade of Collecting: 1985–1995; Old Master and Nineteenth-Century European Prints*. Exhibition brochure. Hanover, N.H.: Hood Museum of Art, Dartmouth College, 1996.

———. *Intimate Encounters: Love and Domesticity in Eighteenth-Century France*. Exhibition catalogue. Hanover, N.H.: Hood Museum of Art, Dartmouth College, in association with Princeton University Press, 1997.

Reed, Sue Welsh, and Barbara Stern Shapiro. *Edgar Degas, the Painter as Printmaker*. Exhibition catalogue. Boston: Museum of Fine Arts, 1984.

Reed, Sue Welsh, and Richard Wallace, with contributions by David Acton et al. *Italian Etchers of the Renaissance and Baroque*. Exhibition catalogue. Boston: Museum of Fine Arts, 1989.

Reff, Theodore et al. *Cézanne: The Late Work,* ed. William S. Rubin. Exhibition catalogue. New York: Museum of Modern Art, distributed by the New York Graphic Society, 1977.

Rewald, John. *Paul Cézanne, the Watercolors: A Catalogue Raisonné*. Boston: Little, Brown, 1983.

Reynolds, Graham. *The Later Paintings and Drawings of John Constable*. New Haven: Published for the Paul Mellon Centre for Studies in British Art by Yale University Press, 1984.

Reznicek, E. K. J. "Jan Harmensz Muller als tekenaar." *Nedelands Kunsthistorisch Jaarboek* 7 (1956): 65–102.

The Richard H. Rush Collection. Exhibition catalogue. Hanover, N.H.: Carpenter Art Galleries, 1959.

Richardson, Leon B. *History of Dartmouth College*. Hanover, N.H.: Dartmouth College Publications, 1932.

———. "John Wheelock's European Journey." *Dartmouth Alumni Magazine* (December 1932–January 1933).

Riggs, Timothy A. *Hieronymous Cock, Printmaker and Publisher*. New York: Garland Publications, 1977.

Robinson, Franklin W. *Selections from the Collection of Dutch Drawings of Maida and George Abrams: A Loan Exhibition*. Wellesley, Mass.: Wellesley College Museum, 1969.

Robison, Andrew. *Piranesi: Early Architectural Fantasies; a Catalogue Raisonné of the Etchings*. Washington, D.C.: National Gallery of Art, in association with the University of Chicago Press, 1986.

Roethlisberger, Marcel. *Claude Lorrain: The Drawings*. 2 vols. Berkeley: University of California Press, 1968.

Roethlisberger, Marcel, and Doretta Cecchi. *L'opera completa de Claude Lorrain*. Milan: Rizzoli, 1975.

———. *Abraham Bloemaert and His Sons: Paintings and Prints*. 2 vols. Aetas aurea 11. Doornspijk, The Netherlands: Davaco, 1993.

Rosenthal, Mark. *Juan Gris*. Exhibition catalogue. New York: Abbeville Press, 1983.

Röthel, Hans Konrad. *Kandinsky: Das graphische Werk*. Cologne: M. DuMont Schauberg, 1970.

Roy, Ashok. "Perugino's 'Certosa di Pavia Altarpiece': New Technical Perspectives." In *The Painting Technique of Pietro Vannucci called Il Perugino,* eds. Brunetto Giovanni Brunetti, Claudio Seccaroni, and Antonio Sgamellotti. Florence: Nardini Editore, 2003. 13–20.

Rubin, William S., with additional texts by Elaine L. Johnson and Riva Castleman. *Picasso in the Collection of the Museum of Modern Art*. New York: Museum of Modern Art, distributed by the New York Graphic Society, 1972.

Rubin, William S., ed., with essays by Theodore Reff et al. *Cézanne: The Late Work*. Exhibition catalogue. New York: Museum of Modern Art, distributed by the New York Graphic Society, 1977.

Russell, Francis. "Portraits on the Grand Tour: Batoni's British Sitters." *Country Life* 153 (June 7–14, 1973): 1608–10, 1754–56.

Ruskin, John. *Notes of Some of the Principal Pictures Exhibited in the Rooms of the Royal Academy: 1875*. London: Sunnyside, Orpington, Kent, G. Allen, etc., 1875.

Russell, H. Diane, with Bernadine Barnes. *Eva/Ave: Woman in Renaissance and Baroque Prints*. Exhibition catalogue. Washington, D.C.: National Gallery of Art, in association with the Feminist Press at the City University of New York, 1990.

Salmon, Antoine, and Guy Cogeval, with the collaboration of Mathias Chivot. *Vuillard: The Inexhaustible Glance; Critical Catalogue of Paintings and Pastels*. 3 vols. Milan: Skira, and the Wildenstein Institute, Paris; distributed in North America by Rizzoli, 2003.

Salmon, Xavier. "Hyacinthe Collin de Vermont ressuscité, quelques œuvres à sujets religieux." *Travaux de l'Institut d'Histoire de l'Art de Lyon* 14 (1991): 83–97.

———. *Un peintre français à la cour de Dresde*. Exhibition catalogue. Paris: Château de Versailles, 1997.

Sander, Dietulf. *Museum der Bildenden Künste Leipzig. Katalog der Gemälde*. Stuttgart: Hatje, 1995.

Sanguineti, Daniele, with an essay by Anna Orlando. *Domenico Piola e pittori della sua "casa."* 2 vols. Soncino: Edizioni dei Soncino, 2004.

Schnapper, Antoine. "Louis de Silvestre: Tableaux de jeunesse." *La Revue des Musées de France* 1 (1973): 21–26.

Scott, Katie. "Review of 'Intimate Encounters: Love and Domesticity in Eighteenth-Century France.'" *Burlington Magazine* 140, no. 1142 (May 1998): 334.

Scott, Mary Ann. "Cornelis Bega (1631/32–1664) as Painter and Draughtsman." Ph.D. diss., University of Maryland, 1984.

Seydl, Jon L. *Giambattista Tiepolo: Fifteen Oil Sketches*. Exhibition catalogue. Los Angeles: J. Paul Getty Museum, 2005.

Siegfried, Susan L. *The Art of Louis-Léopold Boilly: Modern Life in Napoleonic France*. Exhibition catalogue. New Haven: Yale University Press, in association with the Kimbell Art Museum, Fort Worth, and the National Gallery of Art, Washington, D.C., 1995.

Simson, Otto von. *Peter Paul Rubens (1577–1640): Humanist, Maler und Diplomat*. Berliner Schriften zur Kunst 8. Mainz: P. von Zabern, 1996.

Slatkes, Leonard J. "Master Jacomo, Trophime Bigot, and the Candlelight Master." In *Continuity, Innovation, and Connoisseurship: Old Master Paintings at the Palmer Museum of Art,* ed. Mary Jane Harris. Proceedings of an international symposium held at the Palmer Museum

of Art, March 31–April 2, 1995. University Park: Palmer Museum of Art, Pennsylvania State University, 2003. 62–83.

Smith, Baxter Perry. *History of Dartmouth College*. Boston: Houghton, Osgood and Company, 1878.

Sell, Stacey L. *Rembrandt Prints in the Collection of the Hood Museum of Art*. Exhibition brochure. Hanover, N.H.: Hood Museum of Art, Dartmouth College, 2006.

Sir Lawrence Alma-Tadema, ed. Edwin Becker, Edward Norris, Elizabeth Prettejohn, and Julian Treuherz. Exhibition catalogue. New York: Rizzoli, 1997.

Smyth, Craig Hugh, and Peter M. Lukehart, eds. *The Early Years of Art History in the United States: Notes and Essays on Departments, Teaching, and Scholars*. Princeton, N.J.: Princeton University Press, 1993.

Solkin, David H. "Joseph Wright of Derby and the Sublime Art of Labor." *Representations* 83 (Summer 2003): 167–94.

Spindler, Robert P. "Windows to the American Past: Lantern Slides as Historic Evidence." In *Art History through the Camera's Lens,* ed. Helene E. Roberts. Langhorne, Penn.: Gordon and Breach, 1995. 133–49.

Steadman, William E., and Denys Sutton. *Cornelis Theodorus Marie van Dongen, 1877–1968*. Exhibition catalogue. Tucson: University of Arizona Museum of Art, in association with the Nelson Gallery–Atkins Museum, Kansas City, 1971.

Stein, Gertrude. *Tender Buttons: Objects, Food, Rooms*. New York: Claire Marie, 1914.

Sutton, Peter C. *Masters of Seventeenth-Century Dutch Genre Painting*. Exhibition catalogue. Philadelphia: Philadelphia Museum of Art, 1984.

Swanson, Vern G. *The Biography and Catalogue Raisonné of the Paintings of Sir Lawrence Alma-Tadema*. London: Garton and Co., in association with Scolar, 1990.

———. "Alma-Tadma's 'A Sculpture Gallery.'" *Porticus: Journal of the Memorial Art Gallery of the University of Rochester* 12–13 (1989–90): 64–72.

Tambling, Jeremy. "Illustrating Accusation: Blake on Dante's Commedia." *Studies in Romanticism* 37, no. 3 (Fall 1998): 395–420.

Thank You, Wallace K. Harrison. Exhibition catalogue. Hanover, N.H.: Hood Museum of Art, Dartmouth College, 1985.

Thiel, Pieter J. J. van. *Cornelis Cornelisz van Haarlem, 1562–1638: A Monograph and Catalogue Raisonné*. Doornspijk, The Netherlands: Davaco, 1999.

Thurber, T. Barton, ed. *Antiquity in Rome from the Renaissance to the Age of Enlightenment: Selections from Dartmouth's Collections*. Hanover, N.H.: Hood Museum of Art, Dartmouth College, 2001.

———. "Multiple Personalities in Francesco Villamena's Portrait Print of Giovanni Alto Dedicated to Cassiano dal Pozzo." Special issue: *Likeness in an Age of Mechanical Reproduction: Printed and Medallic Portraits in Renaissance and Baroque Europe,* eds. Adrian W. B. Randolph and T. Barton Thurber. *Word and Image* 19, nos. 1–2 (January–June 2003): 100–114.

———. *Rococo to Modernism: European Drawings and Watercolors from the Permanent Collection and Dartmouth's Alumni*. Exhibition brochure. Hanover, N.H.: Hood Museum of Art, Dartmouth College, 2004.

———. "Twenty Years of Building a Collection: The Hood Museum of Art." *Apollo: The International Magazine of Art and Antiques* n.s. 162, no. 526 (December 2005): 46–53.

Todini, Filippo. *La pittura umbra dal Duecento al primo Cinquecento*. 2 vols. Milan: Longanesi, 1989.

Treasures of the Hood Museum of Art. Hanover, N.H.: Hood Museum of Art, Dartmouth College, in association with Hudson Hills Press, 1985.

Trinchieri Camiz, Franca. "The Roman 'Studio' of Francesco Villamena." *Burlington Magazine* 136, no 1097 (August 1994): 506–16.

Tsiaskma, Katia. "Cézanne's and Poussin's Nudes." *Art Journal* 37, no. 2 (Winter 1977–78): 120–32.

Twiehaus, Simone. *Dionisio Calvaert (um 1540–1619): Die Altarwerke*. Berlin: Reimer, 2002.

Vallier, Dora. *Braque: The Complete Graphics*. New York: Alpine, 1984.

Vasari, Giorgio. *Le vite de più eccellenti architetti, pittori et scultori italiani*. Florence: Stampato appresso Lorenzo Torrentino, 1550.

Wagner, Anne Middleton. *Jean-Baptiste Carpeaux: Sculptor of the Second Empire*. New Haven: Yale University Press, 1986.

Ward, Thomas Humphry, and William Roberts. *Romney: A Biographical and Critical Essay, with a Catalogue Raisonné of His Works*. London: T. Agnew and Sons, in association with Scribner's Sons, New York, 1904.

Wasserman, Jeanne L., with contributions by James B. Cuno. *Three American Sculptors and the Female Nude: Lachaise, Nadelman, Archipenko*. Cambridge, Mass.: Fogg Art Museum, 1980.

Werckmeister, O. K. *The Making of Paul Klee's Career, 1914–1920*. Chicago: University of Chicago Press, 1989.

Weil, Adolph. Letter to Jacquelynn Baas. June 11, 1985. Hood Museum of Art donor files.

Weil, Robert S. Letter to Jacquelynn Baas. November 3, 1987. Hood Museum of Art donor files.

Wheelock, Arthur K. Jr. *In Celebration of Jan Davidsz. de Heem's Still-Life with Grapes*. Exhibition brochure. Hanover, N.H.: Hood Museum of Art, Dartmouth College, 2006.

Wheelock, John. *An Essay on the Beauties and Excellencies of Painting, Music and Poetry*. Hartford, Conn.: Printed by Ebenzor Watson, 1774; reprinted by Charles Spear, Hanover, N.H., no date (possibly 1810).

———. "Account of My Tour in Europe Relative to the Prosperity of Dartmouth College" (1784). Dartmouth College Library, Rauner Special Collections, Manuscript 784157.

———. Letter to Baron van Hazerswoude. April 8, 1784. Dartmouth College Library, Rauner Special Collections, Manuscript 784251.1

White, Philip A. "Tenth Anniversary Report of the Carpenter Galleries." Typescript, July 1939. Hood Museum of Art archives.

Whitfield, Clovis, and Jane Martineau, eds. *Painting in Naples, 1606–1705: From Caravaggio to Giordano*. Exhibition catalogue. London: Royal Academy of Arts, in association with Weidenfeld and Nicolson, 1982.

Whitford, Frank. *Kandinsky: Watercolours and Other Works on Paper*. Exhibition catalogue. London: Thames and Hudson, 1999.

Wilkinson, Alan G. *The Sculpture of Jacques Lipchitz: A Catalogue Raisonné*. 2 vols. London: Thames and Hudson, 1996–2000.

Wolanin, Barbara C. *Costantino Brumidi: Artist of the Capitol*. Washington, D.C.: U.S.G.P.O., 1998.

Wright, Helen E. "Print Collecting in the Gilded Age." *Imprint: Journal of the American Historical Print Collectors Society* 29, no. 1 (Spring 2004).

Wye, Deborah, with texts by Starr Figura et al. *Artists and Prints: Masterworks from the Museum of Modern Art*. New York: Museum of Modern Art, distributed by D.A.P. / Distributed Art Publishers and Thames and Hudson, London, 2004.

Wynne, Thomas. "Thomas Frye (1710–1762)." *Burlington Magazine* 114, no. 827 (February 1972): 78–85.

———. "Thomas Frye (1710–1762) Reviewed." *Burlington Magazine* 124, no. 955 (October 1982): 624 and 626–28.

Zervos, Christian. *Pablo Picasso*. 33 vols. Paris: Éditions "Cahiers d'art," 1932–78.

Zilczer, Judith. "The Dispersal of the John Quinn Collection." *Archives of American Art Journal* 19, no. 3 (1979): 15–21.

Zug, George B. "Non-Technical Laboratory Work for the Student of the History of Art." *Bulletin of the College Art Association of America* 1, no. 3 (November 1917): 82–96.

INDEX OF ARTISTS AND TITLES